The Petroglyphs and Pictographs of Missouri

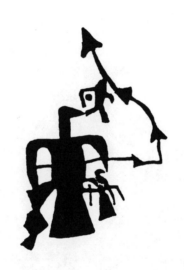

The Petroglyphs
and Pictographs
of Missouri

Carol Diaz-Granados

and

James R. Duncan

THE UNIVERSITY OF ALABAMA PRESS

Tuscaloosa and London

2 3 4 5 6 7 8 / 07 06 05 04 03 02

Cover design by Laura Lineberry
∞
The paper on which this book is printed meets the minimum require-
ments of American National Standard for Information Science–
Permanence of Paper for Printed Library Materials, ANSI Z39.48-
1984.

Library of Congress Cataloging-in-Publication Data

Diaz-Granados, Carol, 1943–
 The petroglyphs and pictographs of Missouri / Carol Diaz-Granados
 and
James R. Duncan.
 p. cm.
Includes bibliographical references and index.
 ISBN 0-8173-0988-8
 1. Indians of North America—Missouri—Antiquities. 2.
Petroglyphs—Missouri. 3. Rock paintings—Missouri. 4.
 Missouri—Antiquities. I. Duncan, James Richard, 1942- II. Title
 E78.M8D53 2000
 977.8′01—dc21
 99-006943

British Library Cataloguing-in-Publication Data available

Frontispiece: Bird motif (Washington State Park).

Above all, this book is dedicated to Frank P. Magre, who devoted more than fifty years of his life to recording and preserving Missouri's petroglyphs and pictographs. Through Frank's kindness and generosity with his time, slides, photographs, notes, maps, and knowledge, the core data for this book developed.

The past: To the late Frank P. Magre, Klaus Wellmann, and Campbell Grant, who spent a great deal of their lives in the field, behind a camera, and at a typewriter to preserve the rock art of North America and to engender in the public an appreciation of these precious cultural resources. It is dedicated to the late Carl and Eleanor Chapman, who worked long and hard to record, interpret, and preserve the Washington State Park petroglyphs.

The present: To Leonard W. Blake, without whose encouragement and pushing to do the project in the first place it might never have happened. It is dedicated to Robert Elgin and Benedict Ellis, who are responsible for preserving in photographs, notes, and writings a significant portion of the rock art sites in Missouri.

The future: To the archaeologists, anthropologists, and lay people who continue to record and preserve rock art, realizing that once these unique cultural resources are gone—through weathering, vandalism, or mismanagement—the information, iconography, and ideology they embody will also be lost.

Contents

Illustrations
Figures, Motif Charts, Motif Distribution Maps, Plates, and Tables

PLATES

The plates are in alphabetical order by site.

TABLES

Journal #1 Entry Date: March 10, 1990
Trip to the Bushberg-Meissner site in Jefferson County. Bright
sunny day, unusually hot for March. Here with Frank and Helen
Magre, Jean O'Brien, and Jim.

. . . After narrowly missing being hit by the Union-Pacific train
that flies around the projecting bluff, I descended the steep rocky
banks to the area where it levels out. Here, large boulders are
situated very close to the edge of the Mississippi River. It was
reported long ago and is well known that these "ancient carvings"
are here. The marks of a star drill, presumably left by early ex-
plorer Albert Koch, are visible proof of the trouble one will go
through to "own" a piece of the past. We searched and found
most of the previously reported motifs. Frank (84 years old) and
I were sitting on the edge of the largest boulder trying to relocate
the now faint carvings. Frank called my name. "Carol," he said,
in his usual soft voice, "I'm glad you're doing this report. I can't
believe how worn these have become. You'll probably be the last
serious researcher to work with them—they're disappearing fast."
His words were meaningful, and I felt a profound sadness at the
inevitable, impending loss.

Preface

This book presents findings of a survey conducted to document all known and identifiable petroglyph and pictograph sites in Missouri and to locate new sites. Between 1987 and 1992 I compiled an inventory of 134 rock art sites and then used this data base to produce line illustrations using a combination of slides, photographs, and drawings from original fieldwork, as well as from archival reports. In addition to undertaking a contextual examination of all sites, I generated a preliminary analysis of the predominant style groupings.

Two major petroglyph and pictograph styles along with ten minor styles are proposed. Study of the frequency of occurrence of motifs with their distributional patterns, site locations, and their associations has generated new information on the possible functions this rock art may have served. These include the recording of important events; ritual activities associated with namings, rites of passage, the harvest, the hunt, and related fertility rites; the retelling of oral traditions about origin or creation stories; and serving as possible identification markers for clans, game trails, water resources, trade routes, and territories.

While the majority of Missouri's rock art appears to fall within the late prehistoric period, a few sites contain motifs that suggest an earlier use of this means of information exchange than was previously proposed. The issue of assigning dates to pictographs and petroglyphs is problematical. Ongoing studies by a number of investigators are helping to alleviate the challenges in this area of rock art research. This book reports on four dates associated with pigment samples from a single pictograph site. Although this is a small number in regard to the number of available pictographs in Missouri, it is a strong beginning for placing into a chronological framework the myriad of motifs and panels in the state's rock art. Although we cannot yet tie Missouri's rock art to specific prehistoric groups, associations to peoples who are on record as sharing linguistic stocks and oral traditions with the state's early historic Native Americans offer intriguing possibilities that we explore preliminarily.

This book has been compiled largely from research done for my doctoral dissertation, completed in December 1993 in the Department of Anthropology at Washington University, St. Louis. For his assistance in the field, his abundant knowledge of the history and prehistory of Missouri, his help in

searching out references, and his major contributions to the section on oral tradition and rock art, I have included James Duncan as coauthor of this book.

Because of space and cost constraints, it was impossible to include photographs of all the sites, or even all seven hundred plus line illustrations. A selection of plates is grouped into one section and arranged in alphabetical order by the name of the site. It is not the purpose of this book to provide a detailed inventory of every Missouri petroglyph and pictograph, but it does provide an inventory that overviews these remarkable cultural resources. Although I have generated a preliminary style analysis of the major grouping of sites, we are aware that any classification is artificial barring communication with the original artists.

The Petroglyphs and Pictographs of Missouri is intended for a broad audience including professional archaeologists, rock art researchers, avocational archaeologists, historians, educators, students of Native American culture, and anyone who wishes to learn more about Missouri's prehistoric past. It is truly unfortunate that this segment of the archaeological record, and not just here in Missouri, has been so seriously neglected. We hope that this book raises awareness of this fragile cultural resource and its need for preservation. Through all of our research, analysis, and particularly the fieldwork, we have kept in the forefronts of our minds that the heart of our subject is not just the incredibly fascinating carved and painted rocks, but moreover the people who made them.

CAROL DIAZ-GRANADOS

Acknowledgments

When this project began, I decided to keep a careful list of every person who in any way helped move this study forward: informants, assistants, drivers, equipment carriers, librarians, scholars, and so on. As completion of the project drew near, I realized it would not only be impractical to list them all, but also impossible and possibly unwise—particularly in regard to landowners and informants. For cases in which I guaranteed credit to a person's photos, slides, or drawings, this is done. However, information on a number of sites was divulged with the stipulation that it would remain confidential, so the revelation of names of informants or property owners would not be appropriate. This in no way diminishes my appreciation for their assistance and cooperation but is done solely to protect their privacy and property and the rock art sites.

Preliminary analysis and writing was supported through fellowships from the Graduate School of Arts and Sciences of Washington University. The write-up period was supported by Washington University and the Cave Research Foundation. Special thanks are due to the foundation, to Dr. Patty Jo Watson for her promotion of this project through that foundation, and to Olga Munsterman for her support of the foundation and my research. I am extremely grateful for my committee's encouragement and help in obtaining the necessary funding to complete this project. The initial fieldwork was carried out under Grant BNS8912632 from the National Science Foundation.

Three informants were most instrumental in providing information and photographic materials of sites and took precious time to guide me to many of the sites with which they were familiar. They were Frank Magre, Robert Elgin, and Benedict Ellis. They were each responsible for sites within their areas and to them I owe a great debt of gratitude not only for their time and the loan of their files, but also for their help, their encouragement in this endeavor, many letters, phone calls, and *hours* of conversation, and especially for their friendship.

My research benefited from the assistance and/or advice of professional archaeologists, naturalists, conservators, conservationists, and chemists in various parts of the state and surrounding states (and countries) who were kind enough to provide me with information for those sites with which they were familiar or who helped with a particular facet of this report. They in-

clude Ian N. M. Wainwright, Linea Sundstrom, Marvin W. Rowe, Marian Hyman, R. Bruce McMillan, David Benn, Jon Muller, Steven Ahler, Robert Hall, Larry Grantham, Charles H. Faulkner, Miles Gilbert, Beryl Rosenthal, Neal Trubowitz, Richard Edging, Camille Lechliter, William Iseminger, Dorthy Heinze, Ken Cole, Jack Ray, Thomas Burge, William Haynes, Barbara Feldacker, Emily Brown, Cindy Wyant, Roger Boyd, Neal Lopinot, Maureen McHale, Bob Bray, Gary Walrath, Donald P. Heldman, Earl Lubensky, Michael Fuller, Ela White, George Hamell, Terry Norris, John Kelly, Charles Markman, James Price, Terry Majewski, Chris Pulliam, and Louis Vogele. Paul Picha and Eugene Marino, co-managers of the files at the Archaeological Survey of Missouri, provided information and assigned site numbers to the rock art sites I reported during this project. Five other archaeologists, Jerry Hilliard of the Arkansas Archaeological Survey, Mark Wagner and Mike McNerney in Illinois, and William Green and Tim Weitzel of the Office of the State Archaeologist, University of Iowa, were very helpful in regard to information on sites in their bordering states.

James Swauger, Curator Emeritus of Anthropology, Carnegie Institute, and author of the book *The Petroglyphs of Ohio,* provided many interesting (and humorous) letters and bits of information. Bob Salzer's interest in one of my sites and his correspondence was much appreciated. Dr. Fred Coy, Jr., has been very kind to supply me with a copious amount of information, particularly articles on "St. Gabriel's Footprints." His efforts, along with those of Swauger and Charles Faulkner, to resurrect the Eastern States Rock Art Conference are to be applauded.

One of the most rewarding aspects of this research project, and one of which I am particularly proud, was the help that came from the avocational archaeological community, private landowners, and the general public. Many of the members of the Missouri Archaeological Society replied to my mailed questionnaires, and to requests in the society's quarterly journal, with leads to sites. Some were familiar with rock art and others were not but were interested in seeing them and helping to record them. Their assistance was and always is most appreciated: Tim McLandsborough, Larry Wegmann, John Crowley, Bill Pfantz, Bruce Hensley, Bill Ehlers, Virgil Hayes, Mike Boynton, Tom Van Vleec, Sheila Kamenetsky, Jean O'Brien, Alan Banks, Robert Seelen, Harry Strange, Patsy Corbett, Kathy Rapp, Mrs. Andy Agers, John Chambers, Walter Martin, Philip Mallette, Myrtle Hinkley and David M. Hinkley, Randy Wimmer, Donald Zykan, and Gary Schoenberg. Special recognition goes to Bob Jenni and Corey Wilson for the time and trouble they took to haul out their boats and ferry us to various riverine sites and to Anna and Horace Hess for their time in securing an all-terrain vehicle to transport

us to remote sites. I would also like to thank Jean and Linda Magre for their many kindnesses and for sharing additional materials in the Frank Magre collection.

The Missouri Department of Conservation was instrumental in furthering my interest in rock art. It all began, so to speak, with a survey project of an endangered petroglyph site that they asked me to survey in 1982–1983. Coincidentally, the completion of my dissertation marked ten years since that first rock art project at the Rocky Hollow site. Those involved were John Wiley, Jim Keefe, and Jim H. Wilson. Leo and Kay Drey, owners of the Rocky Hollow site, deserve special mention for their stewardship of that site and for their friendship.

I would like to include in these acknowledgments the U.S. Geological Survey at Rolla, Missouri, and the help of Jerry Vineyard, Jim Martin, Mark Middendorf, Norman Brown, and Hank Groves (retired), along with the map department. In association with the Division of Geology and Land Survey, I became acquainted with the Missouri Speleological Survey, joined, and was able to meet some Missouri cavers who assisted me in a number of ways: checking caves, accompanying me (or I them!) on cave trips, and providing information. They include Philip Newell, Sally Kula, Kevin Berdak, Herb Samples, Don Rimbach, Jerry Jeremiah, Joe and Lois Walsh, Ron Jones, Jo Schaper, Lang Brod, and Pam Saberton. David and Debbie Foster of the American Cave Conservation Association were supportive through the 1991 Cave Management Symposium and the subsequent publication of those proceedings. Dr. Michael Friedlander of the Washington University Physics Department and Richard Heurmann of the Department of Earth and Planetary Sciences were most helpful in assisting with the section on astronomy and Dr. Harold Levin and Robert Osborne helped with the section on geology.

I wish to thank Pat Hays Baer for her expertise in drawing "the perfect Missouri map" that was needed for this project (and her "above and beyond" kindness in making petroglyph jewelry for me to wear). William Hill deserves a special mention for his unending patience in answering my questions on photography, film, and photographic equipment at Steve's Clayton Camera. And thanks to Steve Pozaric, too!

Particularly deserving of acknowledgment, and most prominent in this long list, are my advisors Dr. David L. Browman and Dr. Patty Jo Watson, who supported my efforts during my tenure as a graduate student in the Anthropology Department. I owe a great debt of gratitude to both of them. Special thanks are due to Dr. Watson for reading the final draft of the book and making critical suggestions. I thank my other department committee members, Drs. Gayle Fritz and Fiona Marshall. Special thanks go to my two

campus committee members, Dr. Carter Revard and Dr. Sarantis Symeonoglou, who were kind enough to join my committee and provided much support and encouragement. I thank Dr. Symeonoglou for his suggestions on recording techniques and his invaluable comments and advice. I thank Dr. Revard, of Osage heritage, for his sensitivity to the issue of using Native American oral traditions as a venue for interpretation, for his personal insight, and for shedding light on the "sacred rock." The seventh member of my committee, Dr. Leonard W. Blake, has been a source of knowledge, encouragement, and inspiration from my first days as a graduate student at Washington University.

Dr. Louis Burns, of Osage heritage, and his wife, Ruth Burns, have been an ongoing source of inspiration. I have treasured our visits and discussions on Osage culture and truly appreciate their generosity in sharing information and many kindnesses. It has been the interest and support of my many Osage friends that has furthered the interpretive portion of this study. I have found them to be keenly aware of our collective vanishing heritage and sensitive to recovering the Osage past. Their concerns have become our concerns and an integral part of our mission. I am deeply grateful to Kathryn RedCorn and her wonderful family for their assistance, sharing, and friendship.

I particularly would like to thank the staff of The University of Alabama Press, in particular Judith Knight, whose encouragement, advice, timely communications, and occasional "pushes," helped us over many publishing hurdles. I also thank Suzette Griffith and copy editor Kathy Cummins, for her careful and thoughtful editing.

Last, but not least, I offer my sincere thanks to Jim Duncan, my husband, who lived through my dissertation years and survived! His assistance in the field, his knowledge of the history and prehistory of Missouri, his major contributions to the section on mythology, his suggestions, and many conversations were invaluable. Our four sons, Tavo, Carlos, Rafael, and Sergio (*all five* of us were in college from 1989 to 1991!), are to be commended, too, for their support, patience, and enduring their mother's efforts to reach this goal.

CAROL DIAZ-GRANADOS

The Petroglyphs and Pictographs of Missouri

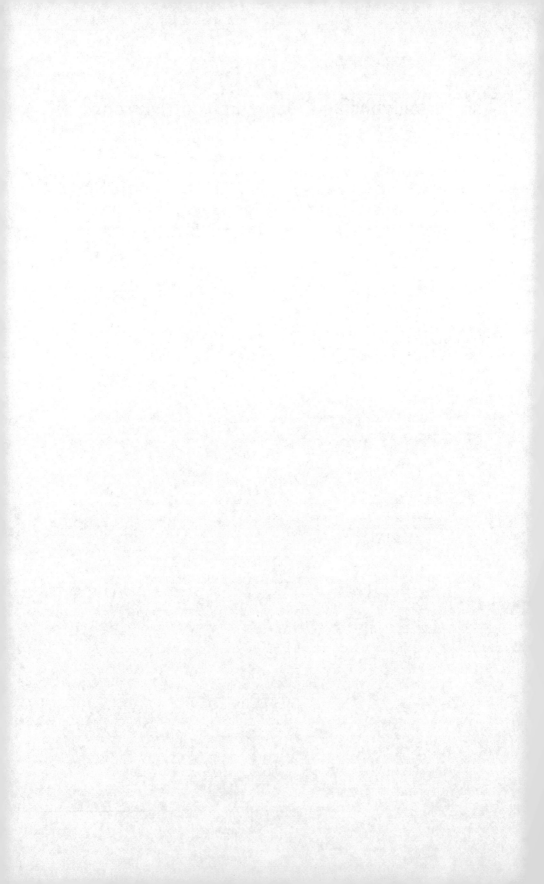

1 Introduction

The increasing number of substantive publications on rock art appearing during the past ten to twenty years has contributed to its elevated ranking in the area of archaeological analysis and theory. However, while considerable work has been done in the American Southwest, the Eastern Woodlands have been generally neglected as regards rock art research, synthesis, and style analysis. Missouri is rich in this cultural resource. Over a hundred petroglyphs (rock carvings) and pictographs (rock paintings) have been documented in the state. The state contains not only a substantial number of sites, but also the eastern portion of the state, centered around the confluence of the Missouri and Mississippi rivers, contains one of the major concentrations of rock art sites in the eastern United States. It is time to take a detailed look at these sites.

In this study we describe, discuss, and analyze the petroglyph and pictograph sites within the political boundaries of the state of Missouri in terms of styles, spatial distribution, content, and context. One of our fundamental goals is to illustrate how rock art production correlates with other facets of culture, particularly those of environment, specific placement of a rock art site, and ideology of cultural groups known to be related either linguistically or spatially to those who were documented as having inhabited the state at the time of contact as well as those known to have been in the area in recent times previous to contact.

In designing the initial project, Diaz-Granados chose to include the entire state for several reasons. Foremost was that a statewide inventory had never been attempted and even basic regional systematic documentation was lacking. The plan was to examine as many sites as possible to obtain a comprehensive understanding of rock art activity within Missouri, but this was by no means an exhaustive survey. Since the original project was completed, some new sites have been discovered and reported, and others will certainly come to light as research and survey work continue. Many resources were used, however, to locate sites in all parts of the state (see Chapter 4), and we are confident that the strongest pattern—a heavy concentration of sites in the greater Mississippi Valley region—will not be altered by future research.

Early in this study adjacent sections of the bordering states were consid-

ered for inclusion: Illinois (particularly the southwestern area), northern Arkansas, southern Iowa, and eastern Kansas. Rock art sites in these states are briefly reviewed in Chapter 2. Portable stone materials that contain incised graphics were also considered for inclusion. During this project several people brought us stone discs and small boulders and we were already familiar with the Utz tablets, Wech stone, and a few others. As the number of Missouri sites grew, the realization dawned that a gargantuan project was in the works, and the portable stone issue was placed on a back burner for later consideration.

Rock art sites have the special feature of being long-term *in situ* artifacts. Furthermore, as Schaafsma (1985:241) points out, rock art sites are not "destroyed in the course of being studied," as are subsurface sites that require excavation and hence destruction of the physical record. This means that as long as a rock art site can survive the elements of weathering and possible vandalism it can be reexamined. In fact, it may have been this conspicuousness of rock art—its availability—that rendered these sites so easy to avoid in place of the more "mysterious," stratified, subsurface sites. Most professionals maintain that it is the lack of stratigraphy and difficulty in dating. While North American rock art in the past traditionally attracted amateur archaeologists, the attitude of professionals seemed to convey, "Could anything so *obvious* be of any value?" Thus, these *in situ* artifacts were largely ignored in the archaeological record, rendering attention to them now all the more urgent.

The physical nature of rock art distinguishes it from many other archaeological materials. Rock art is *in situ* in the strictest sense of the term. Rock art sites are nontransportable artifacts as opposed to transportable lithics, pottery, bone, shell, and other prehistoric cultural materials. These other materials were often moved, traded, lost, abandoned, and so on, either in their original media form (clay, stone, bone) or in their finished form (pottery, tools). A petroglyph on a cave or bluff wall, or on a rock outcrop, is the mark of human activity that took place in the past at that precise location. The viewer must go to the artifact in order to study it in detail.

The terminology involved in the study of rock art has become almost as controversial as the subject itself. To begin with, there is the issue of the term *art*. That *art* is a difficult term to define is a lament that has been echoed by many. The term seems to have become a catchall for may things within a broad realm. And within the realm of Native American rock art production, the matter becomes especially problematical. Van Tilburg (1983:21) points out, "There seems to have been no word for art, as an independent concept, in most Native American tongues." The reader interested in this issue is referred

to a selection of scholars who have pondered the topic (Anderson 1990, 1992; Hardin 1991; Maquet 1991; Mithen 1996; Nobler 1966; Richardson 1973).

Although we will not take time to debate the question of whether petroglyphs and pictographs should be considered art, we mention a few of those who have offered commentary specific to that topic. They include Bahn and Vertut (1988), Bednarik (1988), Coy (1991a, 1991b), Diaz-Granados (1993), Odak (1991), and Schaafsma (1985). Bahn and Vertut (1988:10) briefly discuss the issue, saying that "vaguer terms" are now being used in preference to *art,* but they retain the original label "as a convenient blanket term for the decoration of objects, rocks and cave walls whatever its function or motivation may have been." Although we prefer the term *rock graphics* to *rock art,* we have chosen, on the recommendation of reviewers, to use the tag *rock art* so that this study will fit in with the general literature on the subject.

Furthermore, in the preliminary responsibility of description, various researchers often refer to a site's motifs and basic graphic elements differently. In other words, different rock art scholars use different terms for the same things. For example, a basic graphic form such as the square (□) will be called a *motif* by some and an *element,* or a *design,* or a *rectilinear form,* or something else by others. This situation causes confusion and makes it difficult to compare information from study to study. While the above semantic problem may cause confusion, it is not quite so troublesome as the following terminological issue.

It is crucial to define the difference among the terms *naturalistic/realistic, representational/stylized,* and *abstract.* There has been confusion in some past studies, but the distinctions are basically straightforward. We illustrate these terms graphically at the end of Appendix A and define them below as well, so that their meanings are clear to the reader.

Naturalistic/realistic is the easiest to define because it is self-explanatory: these terms describe figures drawn in their natural form. A bird that is depicted naturalistically is drawn or painted in a form that is true to nature. That is, the bird would be portrayed with eyes, beak, legs, claws, wings, and feathers (if these are prominent or distinctive). Sometimes, the word *naturalistic* is used simply to denote drawings of natural objects, that is, objects in nature: animals, plants, and so on.

Representational or stylized, two words that are often used interchangeably depending on the writer, generally mean a rendering that represents something but is stylized or simplified to the point that while it is not totally true to nature, it is nonetheless recognizable for what it is intended to portray. Some writers refer to such depictions as "schematizations." In other words, a representational or stylized bird depiction would retain its essentials: a recog-

nizable outline or form and enough details to suit the purpose of the carver or painter (claws, no claws, eyes, no eyes, etc.).

Abstract, possibly the most misunderstood designation, also is rather self-explanatory, but denotes the most complex category. Abstract can mean either a form that has been "abstracted" or changed into another form, which may or may not be recognizable, or a form that is totally unrecognizable in regard to known things, animals, or objects. In rock art publications, the term is usually used to designate a form that is totally unrecognizable or geometric. Calling a geometric form "abstract" may or may not be correct: only the carver or painter could answer to that point. That is to say, if a square is drawn to represent a house, then it is "representational," whereas a thousand years later we might look at the shape and label it "abstract."

On the subject of terminology, we have compiled a list of the terms most frequently employed in the study of rock art (see Appendix A, Glossary). This list includes words used in the present study as well as a few that are used synonymously by other researchers. We agree with those investigators who believe that the terminology, at least in English-speaking countries, should be standardized to enable meaningful comparative studies and to eliminate a large portion of the confusion.

We hope that this book, the first comprehensive study of Missouri's petroglyphs and pictographs, will be useful in providing methods for statewide retrieval of rock art data and analysis. It is also hoped that rock art researchers will continue, or begin, to refer to the ethnographic literature as well as the oral traditions still alive within many American Indian groups for aid in understanding and interpreting the rock art.

2 Background

Publication of rock art research in the United States has been, at best, sporadic. The first records appeared in 1680 and comprised drawings of the Massachusetts boulder known as Dighton Rock. They were executed by a Reverend Danforth of New England (Mallery 1972:86–87, 762–64). Williams (1991:213–17) gives an interesting account of the excitement stirred up by this earliest of noted petroglyphs. Although notes and occasional sketches are found in the diaries of some early explorers, the first extensive written account was published in 1886 by Colonel Garrick Mallery. He produced a paper, *Pictographs of the North American Indians,* that included a variety of ethnographic art in addition to rock art. In 1893 the Bureau of American Ethnology published his extensive work, *Picture-Writing of the American Indians,* which described and partially interpreted a considerable amount of material on rock carvings and many other forms of prehistoric graphics. To attest to the continuing popularity, or revival, of this turn-of-the-century work, it should be noted that Dover Press began reprinting it in 1972 and it remains an often-cited reference.

In 1929 Julian H. Steward published *Petroglyphs of California and Adjoining States,* a study that has been considered by many the first thorough survey of a state's petroglyphs. As his doctoral thesis research, he catalogued elements from 293 rock art sites in California and surrounding states and studied their geographical distributions. He is credited with the development of basic descriptive and methodological techniques in rock art research. His approach was to classify fifty elements (e.g., concentric circles, wavy or zigzag lines, human figures, sun discs, hands, human or bear tracks, spirals, stars, dots) from the "component designs" and compare how and to what extent they correlated with one another. His work included the production of maps classifying the individual sites by their styles.

In 1946, Robert Tatum published a report on the "Distribution and Bibliography of the Petroglyphs of the United States." In this report he listed fifty sites for eastern and southern Missouri and named Eugene Diesing and J. Allen Eichenberger as the authorities. During the 1970s and 1980s, Polly Schaafsma published a number of major reports on rock art of the American Southwest (Schaafsma 1971, 1975, 1980, 1985). Although her work is primarily descriptive, her later publications include increasing amounts of analysis and

interpretation through ethnographic information on chronology and the re-
lationships between styles. In 1985 Schaafsma published an overview of the-
ory and method in North American rock art studies. She addressed methods
of determining chronology, style, site function, and symbol systems includ-
ing archaeoastronomy. While she cited most major authors on the subject, her
emphasis is on the Southwest.

The most comprehensive and generally referenced surveys are those of
Campbell Grant (first published in 1967 and reprinted in 1981) and Klaus
Wellmann (1979a). Wellmann noted that most of the work up to 1979 took
place in three basic areas—the Southwest, the Great Plains, and the Eastern
Woodlands—and he illustrated the general trends in the literature to that
point (Wellmann 1980:537, table 6).

Partial surveys of states and of single sites by various researchers are too
numerous to mention. Those that apply to our discussion are referenced
where applicable. Complete surveys of individual states are few and center on
the southwestern part of the country (Schaafsma 1971, 1975, 1980; Steward
1929). In 1997, Coy et al. completed a statewide survey of Kentucky rock art,
which covered all twenty-two counties with known petroglyph and picto-
graph sites in the state. Examples of areas more sparsely covered include
Idaho (Erwin 1930), Ohio (Swauger 1984), and Pennsylvania and Wisconsin,
with a few published articles each. In May 1988, *The Wisconsin Archaeologist*
devoted an entire issue to rock art research in that state. Some states are
lacking serious research altogether, and most reports are concerned with sin-
gle sites. The *Newsletter of the Arkansas Archaeological Society* noted in 1987
that "there is NO ONE doing concerted research on this topic in our state!"
(Davis 1987:3). Since then, Hilliard (1992, 1993, personal communication
1993) has been working on a survey of Arkansas rock art. The general lack
of research focused on rock art affects many other states as well, although
interest is increasing.

PREVIOUS ROCK ART RESEARCH IN MISSOURI

Grant (1981:137) states that "the only large concentration of rock drawings
in the Eastern Woodlands is in Missouri near the junction of the Mississippi
and Missouri Rivers." He repeats this statement in his later edition and it is
emphasized by his distribution map of North America (1981:17). Fundaburk
and Foreman (1957:93) also credit Missouri as being "the center of a Middle
West petroglyph area." In fact, Missouri contains more recorded petroglyph
and pictograph sites than any other state in the Eastern Woodlands. With an
eastern concentration of sites, particularly in the Mississippi River valley, one
would expect similar rock art activity in adjacent Illinois, but at present only
about fifty sites are known in the state (Mark Wagner, personal communica-

tion, January 1999). Arkansas to the south has approximately 116 sites, mostly in the northwestern two-fifths of the state (Jerry Hilliard 1993:3, personal communication 1998). These appear to center around the Petit Jean Mountain and along the northern Arkansas River valleys with most occurring on rock shelter or cave walls or ceilings. Iowa rock art appears to be sparse with a current total of seventeen sites (William Green, personal communication, March 1993; Tim Weitzel, personal communication, 1998). Although rock art sites seem to diminish as one moves westward across Missouri (except in the southwest around Springfield), several sites have been identified in Kansas with the largest concentration in the north-central area within the Smokey Hills region. There is also a scattering in south-central and south-eastern Kansas (O'Neill 1988:5). For the most part, rock art sites in Kansas bear little resemblance stylistically to those of Missouri.

In 1942, Diesing and Magre reported a total of forty-one sites for Missouri. Grant's map (1981:17) indicated fifty-seven such sites. When the comprehensive Missouri project began, Magre (personal communication, March 1987) reported that he had notes on about seventy-five sites, but that not all had been investigated. At the close of the official fieldwork for this study in 1991 we had identified an additional fifty-five sites, bringing the number to 132. In the autumn of 1992 and early 1993, two more significant sites were documented for a total of 134. A few others have been identified since then. At several rock art sites, parts of motif-carved, low-lying rock outcrops were observed to have the potential of extending beneath encroaching sod. In fact, at two sites, edges of the sod could be lifted like a carpet to reveal continuing motifs. There is no doubt that new sites in remote areas, under sediment, or on private property will continue to be discovered as work proceeds.

Earliest records of regional rock art date to 1673 with the river expedition of Fr. Jacques Marquette, a French Jesuit priest, and Louis Joliet, a French-Canadian explorer. It was Marquette who, in his journal, reported seeing the Piasa pictograph on an Alton bluff near the confluence of the Mississippi and Missouri rivers. McAdams (1887) also noted the Alton rock art. Although this site is not in Missouri, and the pictographs were removed or destroyed and later replaced by a painted mural,[1] we believe that it bears mention on three counts: it is within the immediate area, the Piasa (water/underwater spirit) is an important motif in the mythology of the area's early Native Americans, and there are parallels to this beast in several of Missouri's petroglyphs and pictographs.

Marquette described the original pictograph in his journal as follows:

> Two painted monsters which at first made us afraid, an[d] upon which the boldest savage dare not long rest their eyes. They are as large as a calf; they have horns on their head like those of a deer, a horrible look, red eyes, a beard like

a tiger's face somewhat like a man's, a body covered in scales, and so long a tail
that it winds all around the body, passing above the head and going back be-
tween the legs, ending in a fish's tail. Green, red, and black are the three colors
composing the pictures. (Thwaites 1901:139–41)

Although Marquette's original sketch has disappeared, Jacobson (1991) se-
cured from the French Naval Archives in Vincennes, France, a copy of a
segment of a 1678 map by Jean Baptiste Louis Franquelin that includes a
small drawing, in the vicinity of the Alton location, of a creature that resem-
bles Marquette's description of the Piasa. As Jacobson noted, it is not certain
whether this drawing was copied from Marquette's notes or simply executed
from Marquette's description. Catlin (1844:plate 310) showed in a Chippewa
birch bark drawing (a song guide) a possible illustration of the Piasa or
horned water spirit.

The next earliest reports of Missouri rock art of which we are aware are
those made by William Clark on his journey with Meriwether Lewis up the
Missouri River in their quest for the Northwest Passage, an economically
feasible route to the Pacific Ocean. In his journal, Clark noted two graphics
in the Missouri region. On May 23, 1804, he wrote:

We passed a large Cave on the Lbd. Side (called by the french Tavern) about
120 feet wide 40 feet Deep & 20 feet high many different immages are Painted
on the Rock at this place. The Inds. & French pay omage. Many nams are
wrote on the rock. (Moulton 1986:248)

A trip to this site revealed a much-used shelter with the walls covered with
graffiti and carbon from fires. Although there may be remnants of the above-
mentioned pictographs visible with infrared lighting, none were noted with
the available natural lighting.

The second group of pictographs, which the expedition passed on June 7,
1804, Clark noted and described as follows:

S 88° W. 2 Miles to a pt. on Lbd. Side, high bluff on Stbd. Side, Monitou
Creek is 30 yds. Wide at the mouth, passed a painted part of a Projecting rock
we found ther a Den of rattle Snakes, Killed 3 proceeded on passed . . . (Moul-
ton 1986:283–84)

In another section of his journal he wrote:

Set out early passed the head of the Island opposit which we Camped last
night, and brackfast at the Mouth of a large Creek on the S. S. of 30 yds wide

Called big Monetou, from the pt. of the Isd. or Course of last night to the mouth of this Creek, is N. 61° W 4 ½ ms. a Short distance above the mouth of this Creek, is Several Courious Paintings and Carveing in the project-ing rock of Limestone inlade with white red & blue flint, of a verry good quallity, the Indians have taken of this flint great quantities. We landed at this Inscription and found it a Den of rattle Snakes, we had not landed 3 minutes before three verry large Snakes wer observed on the Crevises of the rocks & Killed . . . (Moulton 1986:284–85)

Clark's references noted the site as 3.5 miles northwest (upriver) of the entrance of the Manitou Creek; there is a rock art site near Manitou Creek at Torbett Spring, but it is below Manitou Creek. (The word *Manitou* is spelled several ways; some of the variations are *Moniteau, Maniteau, Monetou, Monitou,* and *Moniture.*) Furthermore, Clark's illustrations (Figure 2.1*a* and *b*) do not resemble the pictographs we saw at the Torbett Spring–Rocheport site (Figure 2.3), leading us to believe that there may have been, or may be, two distinct pictograph sites. In this area on April 11, 1833, Prince Maximilian of Wied also recorded pictographs and wrote:

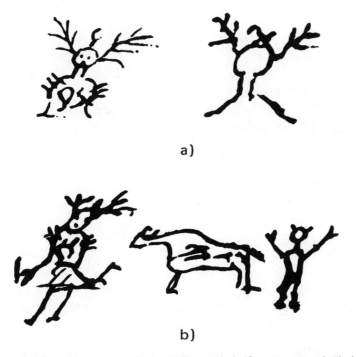

a)

b)

Figure 2.1. Big Manitou pictographs by William Clark (from Lewis and Clark Journals, June 5–7, 1804).

On the rocks, which are divided by ravines into broad rounded shapes, like towers, the Virginia red cedar grows, and falcons build their nests. We see here on the rocky walls red spots, strokes and figures, remaining from the times when the Indians dwelt here. . . . Just before dinner we reached Rockport, a village founded two years ago, on the Manito River, six miles up which river Columbia is situated. Near this place there are again many red figures on the rocky walls, among others that of a man with uplifted arms; not thirty years have elapsed since this whole country was in the possession of the Indians. (Thwaites 1906:243–44)

In 1882, these pictographs were examined and an account entitled "Indian Pictographs in Missouri" was prepared by Charles Teubner and published in the *Kansas City Review of Science and Industry* (Teubner 1882). In the same year, mention of these graphics was made in the History of Boone County (Teubner 1882:976–78), and later the *Stevens Centennial History of Missouri, 1820–1921* (Stevens 1921:1, 566–67) described "the pictured rocks." In the 1930s, Professors Jesse Wrench, Brewton Berry, Carl Chapman, and Richard S. Brownlee visited the site. Brownlee (1956:49–54) eventually described the site and gave a summary of the early accounts of the pictographs along these bluffs. He redrew Teubner's illustrations with a certain amount of artistic license.

The only early account that appears to pertain to the pictograph site we saw is Stephen Long's of July 6, 1819, in which he noted:

The rocks advance boldly to the brink of the river, exhibiting a perpendicular front, variegated with several colours arranged in bold stripes. Here is a very fine spring of water gushing out of the base of the precipice; over it are several rude paintings executed by the Indians. These cliffs are called the Big Manito rocks, and appear to have been objects of peculiar veneration with the aborigines, and have accordingly received the name of their Great Spirit. (Thwaites 1904–1907:vol. 14, 147)

The spring that we saw does issue from the base of the bluff, but there is also another spring about three miles northwest of Torbett Spring whose waters flow from the *side* of the bluff. Confusion remains regarding this site, which we refer to as the Torbett Spring–Rocheport site, and the Big Moniteau site in the Torbett Spring area, which has never been relocated. Fowke (1910:92) also quoted Thwaites's edition of Lewis and Clark:

A Short distance above the mouth of this Creek [i.e., Big Moniteau, on the south side, between Boonville and Jefferson City], is Several Courious paint-

ings and carving on the projecting rock of Limestone inlade with white red & blue flint, of a verry good quality, the Indians have taken of this flint great quantities. (Owen 1882)

There seems to have been a number of pictographs on the bluffs in this region along the Missouri River, particularly in the vicinity of Torbett Spring near the city of Rocheport. A graduate student in the Anthropology Department at the University of Missouri related that he thought the original site was destroyed during blasting and construction activities along the base of the bluffs for the Katy Railroad and the MKT tunnel. We made a trip to the area in 1991 and found a group of pictographs remaining high on the bluff (Figure 2.3). Both Moulton (1986) and Brownlee (1956) described these bluffs but with some contradiction. It is possible that some of the original rock art array here was destroyed by weathering: the remaining graphics at Torbett Spring are quite faint.

Following the early exploration diaries, the next published report of which we are aware pertains to a petroglyph site that was removed from the St. Louis riverfront in 1818–1819. It is a double footprint accompanied by an abstract freeform groove (Figure 2.2a and b). A most interesting controversy surrounded this petroglyph, now in the backyard of the Rapp-MacClure House in New Harmony, Indiana. Arndt (1975) alluded to the controversy and reviewed some of the correspondence concerning this petroglyph, which he excerpted from Lockwood (1905:614):

> The legend is that Father Rapp told his people that these were imprints of the feet of the Angel Gabriel, who had alighted upon earth to convey to the Society a message from heaven.

Other observers at the turn of the century believed that the footprints were made in "soft stone" and then petrified at some later date. The first account in *The Aborigines of America* (Oldschool 1816:8) read:

> About one-fourth of a mile below St. Louis, there is a distinguished impression in a rock of a man's foot. The gentleman who informed me of this remarked, that the people in the neighbourhood will not allow that this was done by Europeans.

In *American Antiquities and Discoveries in the West,* Josiah Priest (1834:152–53) quoted Schoolcraft, further sustaining the confusion surrounding this site. *The American Journal of Science and Arts* (Owen 1882) contains a correspon-

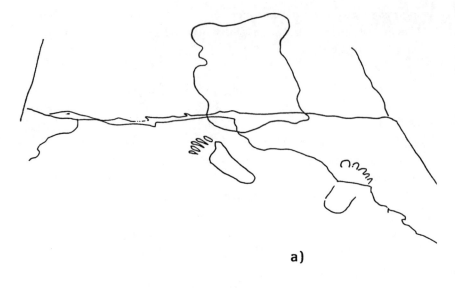

a)

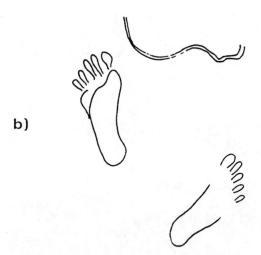

b)

Figure 2.2. Footprints (St. Louis Riverfront); *a,* From slide by Dennis Au; *b,* From photograph by Fred E. Coy, Jr.

dence in lengthy letters between Henry Schoolcraft and Thomas Hart Benton. Selections from these letters follow.

Remarks on the Prints of Human Feet, observed in the secondary limestone of the Mississippi valley.

Sir,

I now send you a drawing of two curious prints of the human foot in limestone rock, observed by me last summer, in a detached slab of secondary formation, at Harmony, on the Wabash; together with a letter of Col. Thos. H. Benton, a senator in Congress from Missouri, on the same subject. The slab of stone containing these impressions, was originally quarried on the west bank of the Mississippi river, at St. Louis, and belongs to the elder flietz range of limestone . . .

These prints appear to have been noticed by the French soon after they penetrated into that country from the Canadas, and during the progress of settlement at St. Louis were frequently resorted to as a phenomenon in the works of nature. But no person appears to have entertained the idea of raising them from the quarry with a view to preservation, until Mr. Rappe visited that place five or six years ago . . . His followers, it was said, were to regard these prints as the sacred impress of the feet of our Savior. . . . Mr. Rappe contracted with a stone mason to cut out the block with the impressions, paying him . . . a liberal price for his labour, and ordered it to be transported by water to his residence in Posy county, Indiana . . . The slab . . . forms a parallelogram of eight feet in length, by three and a half in breadth, and has a thickness of eight inches, which appears to be the natural thickness of the stratum of limestone rock . . .

The prints are those of a man standing erect, with his heels drawn in, and his toes turned outward, which is the most natural position. . . . The prints are strikingly natural, exhibiting every muscular impression, and swell of the heel and toes, with a precision and faithfulness to nature, which I have not been able to copy, with perfect exactness, in the present drawing . . .

Every appearance will warrant the conclusion that these impressions were made at a time when the rock was soft enough to receive them by pressure, and that the marks of feet are natural and genuine. Such was the opinion of Gov. Cass and myself . . . Col. Benton entertains a different opinion, and supposes them to be the result of human labour, at the same period of time when those enigmatical mounds, upon the American Bottom, and above the town of St. Louis were constructed. The reasons which have induced him to reject the opinion of their being organic impressions are these:

1. The hardness of the rock

2. The want of tracks leading to and from them.

3. The difficulty of supposing a change so instantaneous and apropos, as must have taken place in the formation of the rock, if impressed when soft enough to receive such deep and distinct tracks.

A similar review was offered by Broadhead (1880).

In 1913, David I. Bushnell, Jr., in an article in the *American Anthropologist,* quoted Edwin James on the same site as follows:

> The horizontal strata of limestone which underlay the town of Saint Louis and the surrounding country, have strongly attracted the attention of the curious, on account of having been found in one or two instances, to contain distinct impressions of the human foot. There is now in the possession of Mr. Rapp, of the Society of the Harmonites, a stone, which has upon its surface, marks that appear to have been formed by the naked feet of some human being, who was standing upon it while in a plastic state; also an irregular line, apparently traced by a stick or wand, held in the hand of the same person. This stone was taken from the slope of the immediate bank of the Mississippi below the range of the periodical floods. (Bushnell 1913:8–15)

This is just a small portion of the many papers written on this petroglyph site that captured the curiosity of some of St. Louis's earliest historic inhabitants. Unfortunately, this, the only known rock art site in the city of St. Louis, has been moved, as previously mentioned, to New Harmony, Indiana. Other sites are noted to have been removed from their original locations. One foot petroglyph, discussed further along, is in the collection of the Missouri Historical Society accompanied by a wealth of records on others.

In the Missouri Historical Society's "Indian Collections Notes" from meeting minutes dated April 21, 1881, the following was recorded:

> On the face of a perpendicular rock on the shore of the Osage—but whether the right or the left bank ascending I do not know—a few miles above the Pacific Railway bridge were once some paintings representing, it is said, men and animals. A gentleman who came down the river on a steamer whilst I was in Jefferson City (March 1881) informed me at the time that the paintings are so far obliterated that the only distinct image then to be seen was that of an animal, but of what species he could not determine.

This vague reference was mentioned with additional information later by Fowke. In 1910, Fowke (1910:81) reported on this same site, Painted Rock, stating that "among the numerous paintings on rocks and cliffs in the Missouri valley is one on the right bank of Osage river, 25 miles above its mouth and 16 miles south of Jefferson City." He also noted that the figures "are now faint" and listed the figures as a "so-called 'buffalo,' a design resembling a man with upraised arms, and several others too nearly obliterated to venture a guess as to their meaning. Lower, where the river occasionally covers them, are a zigzag line, probably intended for a serpent, and two or three 'turkey tracks.'" In the following paragraph he expressed his belief that the picto-

graphs were unlikely "of considerable antiquity" because they would have
been more worn being out in the open. Although he discussed various other
locations containing rock art, this is the only site to which he referred in his
1910 publication.

A passage from the Missouri Historical Society's meeting minutes dated
September 18, 1883, contains the following interestingly worded information:

> Mr. Wm. McAdams, of Alton, read the following paper relating to certain
> carvings and paintings on rocks in Missouri and elsewhere.
>
> Mr. President. It is probable that the Mound Builders and other aborigines
> of this region made many attempts at recording some of the more momentous
> events in their history; also, that they had no written language, but made use
> of pictures and perhaps symbols to convey their meaning. Some of the figures
> used by them are widely distributed over the United States, though more com-
> monly found in the Valley of the Mississippi.
>
> A number of these figures are to be seen in a cavern on the banks of the
> Saline, in St. Genevieve County, Missouri, carved on its sloping limestone
> walls to depth of half an inch, to an inch and a half. The figures are arranged
> in a continuous line, and consist of circles, human foot tracks, bird tracks,
> birds with outstretched wings, representations of the sun (apparently) &
> moon, circles with, and circles without rectangular cross lines within O.
>
> The circles vary from 6 to 12 in. in diameter. The bird represented in an
> upright position with extended wings measures 13 inches from the Eagle shaped
> beak to the tip of the tail, and 12 inches from tip to tip, across the wings. The
> bird tracks are similar to those that would be left by a large turkey walking on
> soft sand.
>
> The human tracks are correctly reproduced. One, the chubby foot of a
> child, is 4-½ inches long; the other, of a giant, is 13 inches in length, and 6
> inches across at the base of the toe.
>
> The "sun" is represented with rays, and the moon in crescent form.
>
> The circles enclosing each a cross are several in number, and of great interest.
>
> That these carvings were executed at a distant period of time appearances
> indicate. Some of them are covered with stalygmitic deposits, which in some
> places is so thick as almost entirely to conceal the lines. (Missouri Historical
> Society 1883:231–32)

Bushnell later reported on this site, which has received almost as much
attention as the St. Louis Riverfront site, which was also called "St. Gabriel's
Footprints." The site is referred to here as Bushnell Ceremonial Cave and as
the former reporter noted is in Ste. Genevieve County.

Bushnell reported and illustrated thirteen petroglyphs. He also mentioned
a Mr. Ephraim Squier, who read extracts from the *Ste. Genevieve County*

Plaindealer at a meeting of the American Ethnological Society in 1861 and noted the flat area outside the cave, which contained "round holes, similar to mortars, about the size of a tin cup. These places were no doubt made by the ancients, as a place to pound with stones their corn into hominy or meal." Such holes have been found at other sites in Missouri as well as in other states and were perhaps used for pounding nuts, for making acorn flour, or possibly for other purposes totally unrelated to food processing, as will be discussed later.

Bushnell continued to describe the site and referred to carvings he located, including some that have since been cut out and removed: a hand, a small foot, and possibly one of the birds. Our findings are somewhat different from his. One reason for the difference may be the missing data, that is, the removed carvings. There is certainly a section cut from the southeast area near the entrance to the cave. The owner of the property told us that it was removed in the 1800s and sent to "a museum in Chicago." Calls to the registrar's office at the Field Museum of Natural History in Chicago (and the Smithsonian, the Peabody Museum, and the Missouri Historical Society Museum at St. Louis) failed to turn up any of the petroglyphs removed from this site.

Fowke (1922:57–81) referred to the Miller's Cave site: "Three miles northeast of Big Piney is a cavern which from its position, formation, and surroundings is particularly adapted to the requirements of primitive people in search of a permanent shelter." He discussed the cave and its artifacts and illustrated three of the carvings on the boulders in front of Miller's Cave: "On the flat surface of two of these are about 25 figures pecked into the stone apparently with a pointed flint implement."

Beginning in the late 1930s, recording Missouri's rock art became popular mainly among the state's avocational archaeologists, who were occasionally joined by professionals. Reports from this period include that of Adams and Magre (1939), who described their findings from a surface survey of Jefferson County. They reported only two petroglyph sites (Hidden Valley Shelter and Herrell), although the area is rich in rock art. Adams, Magre, and Munger reported a follow-up trip to Bushnell Ceremonial Cave and noted that in this visit twenty-seven years after Bushnell's investigation only eight of the thirteen originally reported petroglyphs were still evident (Adams, Magre, and Munger 1941:13).

Diesing and Magre (1942) reported on the Washington State Park petroglyphs in Washington County and the Paydown Deer pictograph in Maries County. The Washington State Park petroglyph sites, at three distinct locations (A, B, and C), are among the better-known sites and A and B are open to the public. The Paydown Deer site, which was originally reported to con-

tain a number of other pictographs, is now said to have either exfoliated or been vandalized within the past several years. Eichenberger (1944) and members of the Marion-Ralls Archaeological Society investigated the Rocky Hollow (Holliday) and Mitchell sites in northeast Missouri. These early projects that describe rock art sites in the counties of Jefferson, St. Louis, Monroe, Randolph, and Ste. Genevieve are precious records attributable to the work of avocational archaeologists.

A few scattered reports also appeared some years later (Brewer 1949; Erickson 1951; McKinley 1950). Brownlee (1956) discussed the Torbett Spring and Big Moniteau sites in Boone County. He reported that only two remain of the ten pictographs originally reported at the Torbett Spring location. We photographed these with a telephoto lens, and in the resulting slides found parts of four others (Figure 2.3). Wyatt (1959) covered the Washington State Park and Maddin Creek petroglyphs in Washington County. McMillan (1964) completed a survey project on the archaeological resources in the Bourbeuse River Valley and the Lower Meramec Valley of the Meramec Basin and reported two rock art sites in Crawford and Franklin counties. In 1965 his survey of the Gasconade River Valley was published; it included information on sites in Pulaski (Miller's Cave), Phelps (Gourd Creek Cave), Maries (Paydown Deer), and Texas (White Rock Bluff) counties. Ellis (1969:52–58), while he was a Benedictine monk at the St. Pius X Monastery, described the Bushburg-Meissner petroglyph site on the Mississippi River in Jefferson County. The petroglyphs on the boulders at this latter site are now seriously worn.

In the early 1970s, the Mound City Archaeological Society produced a few isolated reports in its newsletters, including Magre's reports on the Salt River site (1971a), the Fort Hill site (1971b), and the Lost Creek site (1971c). Ellis (1971) reported on the Maddin Creek site in the September issue and Schuldt and Magre (1974) again on the Fort Hill site in March 1974. The *Missouri*

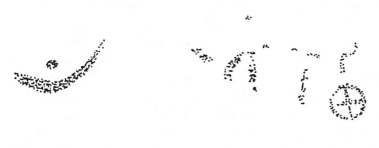

(in part)

Figure 2.3. Panel (Torbett Spring–Rocheport).

Archaeological Society Quarterly also contains some information: Lubensky (1985) gave a report on the Brown and Kelso Farm/Timber Hill sites in Vernon County, and Varney (1990) updated information on the Miller's Cave site in Pulaski County. Other small articles and references are also a part of these records.

Although the above articles mention authors of various rock art reports, the greatest amount of survey work in the state was done by Frank Magre between the mid-1930s and mid-1970s. He not only kept a photographic record in later years of the sites he visited, but he also, when he first became interested in rock art, and before he owned a camera, drew the panels and motifs. Thus, many of the earlier recorded sites, no longer in existence, are represented only by his line drawings. Much of Magre's early work was carried out under a WPA project with Robert McCormick Adams (Adams and Magre 1939; Adams, Magre, and Munger 1941), but he continued investigating new and previously reported sites throughout the ensuing forty years. For a review of Magre's contributions, see Appendix B.

In general, the early reports summarized above comprise a remarkable contribution to the preservation of Missouri's rock art records by the avocational archaeological community.

OBJECTIVES AND HYPOTHESES OF THE PRESENT WORK

Because relatively little in-depth research and analysis has been published on rock art sites in the state, a considerable amount of original survey and re-survey, recording, and photography was required before any analytical work could be done. Research and fieldwork were carried out periodically from 1987 through 1993. We found that the petroglyphs and pictographs are quite diverse and vary from circles, concentric circles, quartered and/or rayed circles, squares, and rectangles to feet, hands, arms, and anthropomorphic figures in a number of activities and attitudes. The animals vary from birds, elk/wapiti, and deer to turtles, fish, and snakes. Birds, in particular, are depicted in a large number of shapes and sizes. Other animals may be represented, such as the beaver, otter, and opossum. A number of designs considered to represent fertility symbols (Snow 1977:47; Wellmann 1979a:154) are plentiful. Many abstract designs are included as well as unidentifiable complex forms and basic design elements such as dots and lines. These motifs are not unlike those from rock art sites in other parts of North America and the world, but, as with each locality, they have their own styles, themes, and structures. These are discussed in Chapter 5.

During the original fieldwork, we noted differences between some of the

early drawings that had been done and the actual petroglyphs and pictographs that we observed in the field. Two cases in particular are discussed and illustrated in Chapter 4. Several other cases are noted elsewhere. In Diaz-Granados's dissertation, both new and original illustrations were represented (Diaz-Granados 1993:appendix D). In some cases this was done because of the discrepancy between them; in other cases it was done because a site was so seriously weathered only portions of it could still be recorded.

The objectives of our work have included the generation of a statewide inventory by documenting all known and identifiable petroglyph and pictograph sites in Missouri. This includes sites from those already with site numbers and ample information to those referenced vaguely in the literature regarding early exploration in Missouri. It includes known historic petroglyphs and pictographs. It also includes reports by local informants who "remember seeing a picture on a bluff" that was blasted off in construction, faded away, or was otherwise destroyed. The reasoning for including all known sites is that the oral information is gradually being lost just as are the petroglyphs and pictographs. Loss of a site does not negate its importance to the archaeological record. Simply knowing that a site once existed at a location is useful. Learning more about that site (content, media, colors) from those who witnessed and remember it is sometimes possible and can result in the recovery of important information that would otherwise be lost.

Our strategy for retrieval of site information is explained fully in Chapter 4. With all the groundwork accomplished in the field, library, and laboratory, Diaz-Granados (1993) was able to assemble a data base, or inventory, of 134 sites. The number of known sites is currently 140. The form that a rock art inventory usually takes consists of site locations (hand-mapped or plotted with a Geographic Information System program), illustrations, and a motif inventory. The 1993 study generated approximately 700 drawings. With the original graphic data base of 134 sites, Diaz-Granados tentatively defined the stylistic areas and boundaries, as illustrated in Chapter 5, Figure 5.11. It should be noted that this was not a simple task, nor do we consider the resulting stylistic areas as final. Rather, they represent a trial solution to the problem of data organization. The data were approached from a number of perspectives. The process of selection is further discussed in Chapter 5. Each style along with the basis for its definition and placement within a particular area is also explained there.

Structure and Graphic Styles Data

Structure here denotes how the motifs are arranged, with special attention to those that occur in association with others. The graphic styles and their structures are a major consideration and the core of this analysis. Structural

analysis is used to identify and categorize sites. The motifs and elements (these terms are defined in Appendix A, Glossary), their arrangement, and their manner of rendering are also used as a basis to define the styles. At sites in which the panels are structurally complex, the combination of motifs can produce "themes." Some sites with only one or two motifs may also be considered thematic. The assessment of styles is one of the most complex and varied processes in archaeological analysis. This is discussed in detail in the first part of Chapter 5. To evaluate a large number of sites of greatly varying content is in itself difficult. Considering the wide variation among sites, and the fact that comprehensive categorization had not been attempted, the material was approached with an unconfined strategy.

Approaches used in areas with long histories of rock art research and analyses were reviewed and components that worked for Missouri were adapted. However, nowhere were methods found that could be clearly or readily applied to the graphic data involved. Many of the works to which we refer were interesting but vague in actually defining methods of analysis. We have addressed that need in this study and hope that the explicit blueprint available here for working with rock art and ordering rock art inventories will be of value to others.

Contextual Data

The context of a site is important: this is discussed in Chapter 4 and elaborated upon in Chapter 5. What might be considered variables for the graphic styles data inventory are the environmental, geological, or other physical data that also include proximity to a water resource (major and/or minor) and, possibly, elevation above sea level. Along with the above basic factors of context, other "*micro*-contexts" should also be considered. These include rock outcrop or formation on which the graphics are located, location in regard to actual placement, general direction the major portion of the rock art faces, and related fauna and flora within the area. In other words, each rock art site is considered within its particular specialized surroundings, and this information is weighed together with the content of the designs (i.e., the motifs and recognizable symbols and structure) to reach a determination of its possible function.

Hypothetical Considerations

Our hypothesis is that the distribution of Missouri rock art styles—including individual motifs, their groupings, content, and structure—will reveal patterning that correlates with particular environmental regions and/or territories conducive to habitation by early groups. Data from this approach should have the potential of assisting in the refinement of knowledge about

the prehistoric inhabitants of Missouri by providing clues to the distribution of prehistoric, protohistoric, and historic human groups and thus provide findings to assist in strengthening the early cultural chronology for the state.

Areas of human activity are evidenced by the mere presence of rock art on bluff, shelter, and cave walls and on outcrops either inland or along river banks. These graphics sometimes contain motifs comparable to those found on diagnostic artifacts. In addition, some may correspond to themes found in the oral traditions of linguistically similar historic groups. The importance of areas as communication centers or interaction spheres has sometimes been found to depend upon a limited number of characteristics of the physical setting (Howard 1968; Witthoft 1949; among others). For example, ceremonial areas for the busk or Green Corn ceremonies are customarily located near running water.

Historic tribes that inhabited Missouri, such as the Osage and the Missouri,[2] lived and hunted within fairly specific boundaries according to Chapman (1980) and O'Brien (1994). Other groups such as the Sauk, Fox, Miami, Shawnee, Piankashaw, Quapaw, Michagamea, Illinois, and Kaskaskia hunted, traded, and traversed the state along relatively well-known routes (Chapman 1974; Edmunds 1976; Horr 1974; Houck 1908). Through this analysis we have found preliminary evidence of spatial patterning in regard to motifs (i.e., content and possible function), context, and styles. Locations of at least a portion of the sites correspond with known areas of activity and/or travel routes of early populations. In addition, we have made an effort in this study to correlate the rock art data with belief systems—oral traditions and mythologies—of linguistically related groups.

The Major Questions

With use of the graphic data from 134 sites, Diaz-Granados (1993) defined stylistic areas and tentative boundaries, as shown in the style map (Figure 5.11). Each style with the basis for its development and placement within a particular area is explained in Chapter 5. Using this information, we address the following questions:

1. Can distinctive styles be identified in Missouri rock art?
2. Is there evidence of a connection between placement of sites and environmental features?
3. Is there evidence of distributional patterning of specific styles (themes, motifs, or elements)?
4. Can the motifs contained within the carvings and paintings be correlated with diagnostic artifacts to obtain chronological information?
5. Can this rock art, through its motifs, content, and various styles, be

related to Native American groups, of shared linguistic stock and oral traditions, known to have inhabited the state or surrounding areas during protohistoric and/or historic periods?

Once the preliminary field work and research were completed, the database was developed, and a map was assembled representing the general placement of petroglyphs and pictographs (Figure 4.8*a*), as well as a map showing the density of rock art sites per county (Figure 4.8*b*). Then maps illustrating the distribution of the major motifs were generated (Figures 5.22–5.38). Finally, a style map was developed showing the major, or "Primary" styles, and a selection of the "Limited" and "Quasi" styles (Figure 5.11). The spatial patterning of styles and motifs, correlated with the environmental data, can be combined with data on hunting areas, game trails, and trade routes of early groups found in the archaeological record and in the ethnographic and ethnohistoric literature (Edmunds 1976; Fowke 1910, 1922; Horr 1974) to work toward a clearer picture of early activity in these areas.

Faunal data were compared to the animals represented in the motifs of selected sites, as has been done in previous reports (Diaz-Granados 1983; Lambert 1983; Grant 1981; among others). While it is customary to associate animal depictions with those animals that were regarded as food resources, the possibility of their representing clan totems and characters in oral traditions or mythologies of associated groups is also considered.

By reviewing data from the early reports and looking at areas of site concentration, context, and content, stylistic similarities (and dissimilarities) were identified. It was at this point that we began to organize an initial chronological sequence for a selection of the sites, based primarily on their diagnostic motifs. Along with style distribution maps, a preliminary rock art chronology for the eastern portion of the state was created using Chapman (1980:1) as a basic framework. We modified this framework for Missouri rock art by borrowing from Hall (1991:10) and Kelly (1991). Further development of the chronology came from the relative placement of styles in Phillips and Brown (1978, 1984). As this study progressed, new information, coupled with the developing rock art picture of the whole state, and the introduction of AMS dates on pigments from a site, allowed us to generate Missouri's first rock art chronology. And, after all, it is the development of a rock art chronology that is most sought after in conjunction with these rock art investigations.

3 The Natural Environment

The natural environment, particularly physiography, geology, and fauna, must be considered in developing a thorough understanding of the appearance of prehistoric rock art. These factors have been considered in several works (Fritz and Ray 1982; Goldstein 1987; Lambert 1983; Swauger 1984; Vastokas and Vastokas 1973; among others). Molyneaux (1977), strongly advocates that studies of rock art should not omit consideration of the physical (and cultural) contexts. In regard to the overall Missouri environment as context, Chapman and Chapman (1983 [1964]:11) state, "Missouri, due to its geographical location, has an exceptionally favored position in regard to the cultural areas in North America . . . there is access to the area from the north, east, south and west by the largest streams in all of North America. Water-traveling Indians had routes to and from Missouri in any direction."

The state's largest portion of known sites is located south of the Missouri River with the majority occurring in the natural division that encompasses the Ozarks and Ozark Border (Nelson 1985:3). The distribution map (Figure 4.8*b*) will give the reader an idea of the density of known sites. A comparatively small number is located north of the Missouri River within the Glaciated Plains division. Because of supportive geography, including major rivers, particularly the Mississippi and Missouri, with their tributaries and associated streams and creeks, it is easy to see why this region, environmentally favorable to human occupation, drew early populations. It is also easily understandable that an area with plentiful resources, abundant geological "canvasses," and thriving populations would manifest a wealth of rock art.

Another factor that probably contributed to the relative abundance of sites in the state is the profusion of dolomites and limestones. Dolomites and limestones weather into karst landforms. These result in an ample number of caves, rock shelters, and overhangs that provide both protection from harsh weather for humans and animals and a measure of safety for the rock art— particularly the fragile pictographs. With more than 5,000 caves reported, Missouri is one of the leading cave states. Approximately thirty-three percent of the known rock art sites are located on the inner or outer walls of caves and rock shelters (Figure 4.4). This percentage, comprising mostly rock paint-

ings, gives some idea of the possible number of pictographs in unprotected contexts that have been lost to weathering.

A look at the basic geology and physiography of Missouri provides a partial answer to the state's rock art distribution pattern. The southern half of the state was unglaciated and has abundant rock exposures, whereas the area north of the Missouri River was glaciated. In the northern section, roughly eighty percent of the land is covered with unconsolidated, glacial deposits offering little bedrock exposure. This is where there is a sparsity of sites. Only five sites are currently known: one each in Marion, Monroe, and Ralls counties and two in Adair County. These sites are petroglyph sites and all but the Gil Branch site in Adair County are complex sites. No rock art has been found, or at least reported, in the northwest quadrant.

GEOLOGY AND NATURAL AREAS

The southeast quadrant of the state, which contains most of Missouri's recorded rock art sites, consists of a core of Precambrian igneous rocks (St. Francois Mountains) surrounded by outwardly inclined (dipping) strata. U.S. Geological Survey maps (Branson 1944; Hunt 1974) show Lower Paleozoic formations (Cambrian and Ordovician, two of the oldest geologic periods represented in the state) and Pennsylvanian formations (Upper Paleozoic). An initial attempt to correlate rock art sites with rock types failed partly because the available geological maps are far too general for identifying materials at specific outcrops and partly because of the problems encountered in collection efforts. However, the outcrops on which the major sites are located were identified and are discussed below.

The majority of the state's petroglyphs occur on dolomites. We began early in this project to search out data on the locations of the various sandstone formations because it was thought that these correlated with the occurrence of rock art sites. It was discovered that, unfortunately, little exists on either sandstone or dolomite (the correct identification) and there is no state geologic map that specifically shows these formations, layers, and outcrops in detail. Anderson's general map (1979) lumps sandstone, dolomite, and limestone together in some areas, making it impossible to distinguish them by use of the map alone. We were informed by a geologist that geologic maps normally lump lithologies because they vary at scales too small to show in detail. Nevertheless, we refer to this general geologic map for definition of the area that contains the highest number of petroglyphs and pictographs.

The abundance of dolomites in southeast Missouri could be, at least partially, responsible for the high incidence of rock art sites. Anderson's map indicates that Washington County consists primarily of Derby-Doerun dolo-

mites surrounded by Potosi and Eminence dolomites. The map also shows large areas of Gasconade dolomite to the northwest and southwest central portions of the county. Adjacent Jefferson County, on the other hand, shows in its southern region the Southville formation, Powell dolomites, Cotter dolomites, and Jefferson City dolomites. These appear to border Decorah and Plattin formations along the eastern Missouri state line extending north from Ste. Genevieve County up through Jefferson County, then crossing that county toward the north to northwest. These formations are, in turn, bordered by St. Peter sandstones and the Everton formation to the south and Joachim dolomite and the Dutchtown formation to the north.

The major rock type on which the graphics were carved was identified as arenaceous or sandy dolomite from the Derby-Doerun formation by Professor Harold Levin, Department of Earth and Planetary Sciences, Washington University (personal communication, May 1992). This identification was confirmed by Jerry Vineyard, Deputy State Geologist (retired in 1997) (personal communication, August 1992). Both specialists made their determination from a sample of exfoliated rock from a boulder at Washington State Park. Dolomite is a semitransparent sedimentary crystalline mineral consisting of double carbonates of calcium and magnesium (Nelson 1985:181). It is a buff color, almost pale yellow in some areas, but most outcrops, being exposed to the elements, have developed a dark grey cortex or patina through oxidation and possibly from pollution. The petroglyphs of the primary Missouri rock art group, five sites called the "Big Five,"[1] all appear to be on this same dolomite in dolomite glades and within the area of dry-mesic limestone/dolomite forests, according to Nelson (1985:104), who compiled information on the terrestrial natural communities in Missouri. Thus, the context of the glade environment held some significance in regard to the placement of these rock art sites that comprise the Big Five grouping.

Within this area, Nelson (1985:107) also shows a distribution of sandstone glades. His dolomite glade distribution map shows the densest occurrence in the southeast quadrant of the state (excluding the bootheel). He counts Missouri as a region with "significant glade areas" with the major glade landscapes in the "White River Section, St. Francois Mountains Section, and Ozark Border Natural Division. Total glade area in Missouri exceeds 400,000 acres" (Nelson 1985:99).

Because the glade setting was frequently chosen for rock art activity, it is important to give at least a brief description of this type of environmental context. Glades are open areas surrounded by woods. They consist of rocky barrens located on moderate to steep slopes in deeply dissected drainages or hilly to mountainous terrain. Their presence is attributed to bedrock type, previous geologic events, past climatic changes, and other natural forces. Ac-

cording to Nelson, "Glades have very diverse floras, related to the diversity of substrates and soils. Some plants prefer limestone or dolomite while acid-loving plants occupy sandstone, chert, igneous rocks, and shale. Principal influences that maintain glades include drought, animal activity, fire, topography, and weathering" (Nelson 1985:99).

Several of these glade sites bear the remnants of a geological phenomenon more obvious at some than at others. These natural formations are called tinajitas (solution pits) and are an interesting feature of this Derby-Doerun dolomite. These curious formations are produced because of the dolomite's friability when it weathers. Tinajitas are circular pits with radiating grooves and are fairly typical surface karst features evident at all five of the major petroglyph sites as well as on boulders elsewhere in the vicinity of these dolomites.

The mode of formation for these solution pits or pans is, according to Vineyard, quite evident: "Water tends to stand longer in shallow depressions on the outcrop. If water stands long enough for algae to grow, organic acids hasten the solution process, and the depressions widen and deepen." He adds that tinajitas are more typical on granite but that those on granite "do not have the peculiar radiating ridges that seem to be typical of such features that form in carbonate rocks" (Jerry Vineyard, personal communication, September 1992). It is the tinajitas on the dolomites in this area, the ones associated with rock art sites, that were often enhanced by carving.

Modification usually appears along each of the radiating ridges produced during tinajita formation. It may have been these very formations that attracted the initial petroglyph activity. The radiating ridges were at times enhanced to create what are locally referred to as, and that appear to be, "tadpole forms swimming, in a radiating circle, out of the pit" (Frank Magre, personal communication, 1987). The bottoms of some of these embellished cavities are perfectly flat, but Vineyard insists that this, too, occurs naturally. When these unusual forms were first noted, there was a question regarding their origin. However, the features that distinguish the unmodified tinajitas from the enhanced type are the ground circles evident at the tops of each of the radiating lines.

Other sites in the state rock art inventory are located on a variety of different rocks. Most, if not all, of the pictographs are painted onto sandstone or limestone walls. One site consists of a St. Peter sandstone cave over a partially collapsed limestone cave. The inner sandstone walls contain the paintings. Many other pictographs are located on sandstone cliff or bluff walls. There are a number of pictographs along the Bourbeuse River in east-central Missouri. Dr. R. Bruce McMillan, Director, Illinois State Museum, who surveyed this area in the mid-1960s, reports, "there are a great number of both

petroglyphs and pictographs on the Bourbeuse River. The pictographs are probably present because the sandstones along the Bourbeuse may hold the pigments better than the dolomites exposed along the Meramec" (personal communication, June 1988).

FAUNAL OR ZOOMORPHIC ENVIRONMENT

Included in the motifs of Missouri rock art are animals that lived in and roamed the areas in which the depictions are located. Such representations are also abundant throughout the major rock art regions of the United States, the carvings and paintings changing as the fauna changes. Researchers have been somewhat successful in comparing present-day fauna to those portrayed in the rock art (e.g., Grant 1983; Lambert 1983; Sundstrom 1989). In addition to there being a possible connection with hunting activities, some animals are probably associated with supernatural powers. Although one generally thinks of the animals most widely illustrated as those that are feared or revered—bear, mountain lion, jaguar, snake, birds of prey—most animals represented in Missouri rock art may be connected with matters of subsistence. On the other hand, they could also refer to clan symbols, totems, mythological characters, or figures associated with creation beliefs and other oral traditions.

The major quadrupeds depicted include the wapiti (commonly referred to as the elk, or North American elk), which before European contact probably ranged the entire area of what is now Missouri. These large animals weighed 500 to 900 pounds and were prized for food and hides, but "by 1830 elk were becoming scarce" (Schwartz and Schwartz 1959:332). The deer or white-tailed deer that also ranged the state were much smaller. These are probably depicted at the Thousand Hills State Park site (Figure 5.12b and c). Other sites depicting four-legged quadrupeds may also portray deer, but there is insufficient detail to make a determination.

We propose that the antlered animals depicted at the Rocky Hollow (Figure 3.1a) and Willenberg Shelter sites (Figure 3.1b) represent wapiti rather than deer because their antlers are shown in a backward configuration whereas deer antlers grow up and forward. The animal at the Paydown Deer site (Figure 3.2) may represent a deer. Both deer and wapiti have cleft hooves (even-toed), which can be seen on the quadrupeds at the Thousand Hills State Park and Willenberg Shelter sites. Therefore, it would not be a criterion for making a distinction between them, although this does support the identification of *either* wapiti or deer, both ungulates of the Cervidae family.

The variety of other quadrupeds possibly illustrated include the bison (western Missouri), black bear (southern Missouri), fox, otter, raccoon, rabbit, and opossum. The long-tailed animal at the Thousand Hills State Park

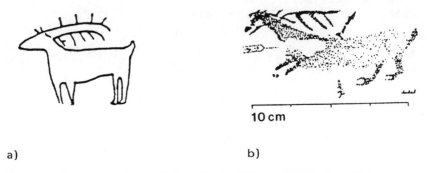

a) b)

Figure 3.1. Depictions of wapiti/elk: *a*, Rocky Hollow; *b*, Willenberg Shelter.

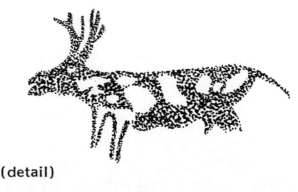

(detail)

Figure 3.2. Depiction of wapiti/elk/deer (Paydown Deer) (based on drawing by Eugene Diesing/Frank P. Magre).

site (Figure 3.3, *a* and *b*) is identified on the site's interpretive boards as an opossum. Although the opossum has a broad range that includes the Thousand Hills State Park area, the animal depicted has some unique characteristics. What may be represented is the underwater spirit with its typically long tail. Hamell (1998) discusses the importance of this figure in northeastern oral tradition, ritual, and material culture.

Another quadruped, of the rodent family, possibly represented both on foot and in pelt form, is the beaver. There is also a historic horse pictograph at the Lost Creek site. This is the only equestrian rock art presently known in the state and it does not appear with a mounted figure, as is frequently seen west of Missouri. The absence of horses in Missouri's petroglyphs and pictographs probably indicates that this rock art predates the introduction of horses in the region.

Birds are the most abundant animal form represented. For example, they total nine at the Rocky Hollow site and twenty-three at the Mitchell site,

10 cm _____. 10 cm _____.

a) b)

Figure 3.3. Long-tailed animals/opossum/underwater spirit: *a* and *b*, Thousand Hills State Park.

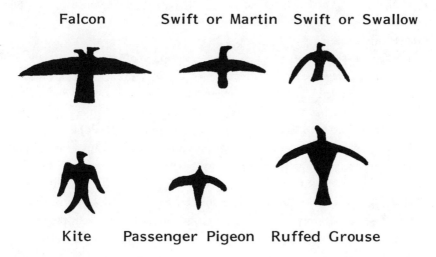

Figure 3.4. Bird petroglyphs (Rocky Hollow), tentatively identified (based on A. Eichenberger 1944:53).

with the largest one carved at Washington State Park Site A. James D. Wilson, ornithologist with the Missouri Department of Conservation, believes that it is possible to identify carved bird forms, at least tentatively, provided there is a distinct silhouette. He identified a selection of the birds at Rocky Hollow Site #1 (Figure 3.4) as including a falcon, swift, martin, swallow, kite, passenger pigeon, and ruffed grouse (James D. Wilson, personal communication, April 1983).

Identification of the birds at the Washington State Park Site A, Thousand

Hills State Park site, Maddin Creek site, Mitchell site, and Three Hills Creek site plus the many other sites that include bird forms has not yet been attempted. These are generally believed to represent raptors and appear to be hawks, falcons, and other birds of prey. Some of the bird forms with bifurcated tail feathers are thought to represent "birdmen," which opens up another topic, addressed in Chapter 6. An owl may be depicted in the upper figure at the Willenberg Shelter site (Figure 5.51*b*).

Although fish are rare in Missouri rock art, they are known at two sites, the Lost Creek site in Jefferson County, a historic pictograph, and Rocky Hollow Site #2 (Figure 5.40). John Wylie, Director of the Natural History Division (now retired) at the Missouri Department of Conservation, believes that the fish species are slightly more difficult to determine than the birds. However, he made the effort, commenting that the fish to the lower right in Figure 5.40 bears a line that juts from its lower jaw, which could indicate a type of catfish. The black bullhead, one of the Prairie Region fish, has this among other characteristics as well as a tail that is slightly notched (Diaz-Granados 1983:12).

Reptiles in the form of snakes are the second most frequently depicted animal forms. Depictions of snakes are plentiful in Missouri's rock art record. We feel safe in referring to most meandering forms as snakes or serpents because many have a head indicated or even the open-mouth configuration. The most obvious is the coiled snake at Washington State Park Site A (Figure 3.5). Furthermore, there remains a connection between the serpent motif and water, as well as between the serpent and the earth and/or underground. The coiled snake is believed to be a reference to a water source. It would be difficult to identify snakes in regard to species. At the Rattlesnake Bluff site, however, there is a very obvious, and reasonably well-preserved, pictograph of a rattlesnake (timber rattlesnake?) with two faded versions directly above it (Figure 3.6).

Turtles are less common but are present at the Dry Fork Creek Shelter

Figure 3.5. Coiled snake (Washington State Park) (drawing by Frank P. Magre).

Figure 3.6. Snake (Rattlesnake Bluff).

10 cm

Figure 3.7. Turtle (Dry Fork Creek Shelter).

(Figure 3.7), the Maddin Creek site, and Rocky Hollow Site #1. Some other reptile motifs that may be represented include skinks or lizards. A possible lizard appears at the Sharpsburg site, at the Thousand Hills State Park site, and possibly in two panels at the Washington State Park Site A. Insects, depicted in occasional rock art of the southwestern United States, appear to be absent in Missouri, unless they are represented within some of the unidentifiable forms, such as the motif in Figure 5.10, D-8.

Wobst (1977:320) notes that early populations used their capacity to symbolize as a means of coping with environmental stress. The fauna depicted in the petroglyphs and pictographs probably exemplify the animals that were hunted, were feared, or had ceremonial and symbolic significance. As in many early Native American groups, animals came to symbolize not only clans but also deities or other abstract concepts: snakes symbolized the earth or underworld, birds symbolized the sky, and lightning, "the heavens" or de-

ceased ancestors. Through ethnographic writings it is generally accepted that many of the early historic groups in Missouri used the clan system and identified themselves with a variety of animals and sometimes parts of animals.

FLORAL OR PLANT ENVIRONMENT

When the survey for this study was completed, illustrations finished, and motifs and theme panels ready for analysis, we were surprised to find that little in the iconography appeared to refer to anything in the plant world. Only three motifs are designated in the charts (Figure 5.3), although another may portray a seed pod (Figure 5.10, A-8). Unlike the Southwest where graphics can be seen that portray maize sprouts, plants, and occasionally trees, Missouri presents an obvious lack of such motifs. Because a major portion of subsistence consisted of plants, either gathered or cultivated, this may seem strange. One possible explanation is that the petroglyphs and pictographs may not have been connected with subsistence, at least subsistence from plants. Another suggestion is that plant representations may be translated to unfamiliar and unrecognizable motifs or abstractions, or that depictions focused on associated mythological characters (Corn Mother) rather than on the plants themselves.

THE SKY ENVIRONMENT

Considered along with the terrestrial communities and their environments is the celestial environment or "sky environment." We believe that celestial phenomena are depicted in Missouri rock art, as has been suspected and reported elsewhere (e.g., Brandt 1977; Brandt and Williamson 1977, 1979; Grant 1981; Miller 1955a, 1955b; Schaafsma 1980; Sherrod 1984; Sherrod and Rolingson 1987; Swauger 1974). The necessity to record the passage of time and to predict celestial events was present early in human history. It is not difficult to imagine prehistoric people watching the movement of the stars in the sky, observing the rise and fall of the moon, and marveling at comets and the warmth and brilliance of the sun.

Prehistoric groups, even prior to the adoption of agriculture, must have been concerned with the changing of the seasons, long-term and short-term fluctuations in the weather, and the movements of the sun and other celestial bodies. The activities of the cosmos could be observed, calculated, and predicted with considerable reliability. Knowledge of the solstices, equinoxes, and the solar and lunar cycles was of paramount importance. The shaman or priest who accumulated knowledge of natural phenomena and astronomical

calculations became very powerful. He or she communicated with the heavens and the gods.

Probably long before early peoples thought to record historical events, they began keeping track of celestial ones. In China, Mesoamerica, and the Southwest, records remain that attest to the importance of cosmic activity in daily life. Historical events often came to be associated with a major comet, a conjunction of planets, or other cosmic phenomena. Unfortunately, much of this information was part of an oral tradition now lost. Some such records do remain, however, from the early Chinese, Mayans, and Anasazi. Native Americans were acutely aware of nature, both terrestrial and celestial. Williamson (1981, 1989) recounts the interaction between early populations and sky phenomena, their dependence on knowledge of the sky environment, and how this knowledge was utilized for guidance with regard to planting and harvesting. Recorded data are plentiful among the Navajo, Pawnee, Chumash, and others. The Bighorn Medicine Wheel in Wyoming, the Sun Watch Village (Incinerator site) in Ohio, and Cahokia Mounds in Illinois are a few sites with features expressing prehistoric and protohistoric astronomical awareness.

At Cahokia Mounds, a short distance from several of the rock art sites in eastern Missouri, prehistoric features are possibly aligned to measure the sunrise of the winter solstice and the sunset of the summer solstice. Woodhenge, a basically circular arrangement of a varying number of cedar posts with one in the center, constructed and reconstructed possibly four or five times between A.D. 1000 and 1150, is believed to have served as a solar observatory. For example, at the spring or vernal equinox, as the sun rises, it aligns with the "vernal equinox post," the center post, and the edge of Monks Mound. It is believed that the inhabitants of Cahokia worshiped the sun as did many other early cultures (see Wittry 1961, 1964, 1969; also Cover and Moore 1986; Jones 1986; Marshack 1985; and Rafter 1986; among others). Celestial phenomena are further discussed in Chapter 6.

The plentiful outcrops of sandy dolomite in the southeastern quadrant of the state, the presence of numerous glades, and the sandstones of the northeastern quadrant provided ready-made canvases for the production of rock art by Woodland and Mississippian communities. The numerous sandstone shelters on both sides of the Missouri River also provided protected surfaces for pictographs. Although many factors were undoubtedly in play, not the least of which were the ample water and food resources available, it was surely the area's generally "user-friendly" environment that attracted the people responsible for the abundant rock art activity that took place in prehistoric Missouri.

4 Methods

DATA RECOVERY

The first goal was to compile a site inventory. A relatively small number of sites had been officially reported for Missouri, and no comprehensive state survey had ever been carried out. The plan was to combine previously reported sites and archival records of sites with information obtained via the following:

1. Questionnaires distributed to a twenty percent random sampling of approximately 600 statewide members of the Missouri Archaeological Society;
2. Inquiries to the Society's affiliate chapters throughout the state;
3. Inquiries to professionals who work (or have worked) in the state;
4. Information from the state's caving organizations (Diaz-Granados joined two of these, gave slide presentations at their annual meetings, and placed written requests for information in their newsletters);
5. Calls to the superintendent and/or archaeologist at each state park in Missouri;
6. Attendance at county fairs and festivals and farm shows at which we provided an information booth with posters, hand-outs, return questionnaires, and other items on "Indian rock art."

A number of sites were also added through original survey. While several sites were identified through the six methods noted above, and probably were sites that would otherwise have remained unreported, the overall time expenditure for the methods might be considered out of proportion for the return. However, many contacts were made and the research goals of the project were well-publicized, making many people aware of such sites and the need to preserve them. Occasional reports continue to trickle in as a result of this public outreach.

Three trips were made to the files of the state's repository for archaeological site numbers at the Archaeological Survey of Missouri (ASM) in Columbia. Greg Fox, the office manager and person in charge of these files at the

time, did a computer check by county (114 total) to determine which sites were coded with "4," the number that indicates a petroglyph or pictograph site in the ASM file system. Unfortunately, many sites were either incorrectly coded over the years or not coded at all. In several cases we were aware of rock art sites that existed but were not encoded. Some multiple-component sites were coded as "village sites" that included rock art. In other words, either the person turning in the report or the office recorder at the time encoded only one component for each site. The other source of state records, sites on microfiche at the Missouri Department of Natural Resources, Jefferson City, was also checked. It was at this latter office that we discovered in the records multiple numbers assigned to a few sites. This problem is briefly discussed below.

Once the initial list was compiled, the locations of as many sites as possible with clear provenience were plotted on a state map. The general areas of other site localities were noted to provide some indication regarding where sites and concentrations might occur. This map was prepared in the hopes of combining site visits. The plan was successful in cases in which two or three very small sites (i.e., one to three motifs each) clustered. It was less useful at complex rock art locales, despite their close proximity, because two to five days were required to investigate and photograph these larger sites.

FIELDWORK

In 1981 the American Committee to Advance the Study of Petroglyphs and Pictographs (ACASPP) established documentation standards for rock art sites in an effort to help protect and increase awareness of this endangered resource (Swartz 1981). Others have also offered recording standards (Bain 1975; Clewlow and Wheeling 1978; Lee 1982; Sanger and Meighan 1990; Stuart 1978; and others), and opinions and methods continue to be discussed in the professional journals and in the rock art organization newsletters, such as *La Pintura,* the newsletter of the American Rock Art Research Association (ARARA), and the *E.S.R.A.R.A. Newsletter* of the Eastern States Rock Art Research Association (ESRARA). In 1992, Jean Clottes, president of Comité International d'Art Rupestre, published the first *International Newsletter on Rock Art* (*INORA*), which also contains occasional articles on recording.

Fieldwork was carried out over a four-year period. Previously reported sites that we judged to be important because of their size, complexity, or content were visited and revisited. In addition, a sampling of some of the more modest, single-motif sites was investigated. We continued throughout the project to receive occasional calls or letters regarding new sites. Some we pursued personally, while for others, scaled photographs or drawings from the infor-

mants were obtained. Visiting a minor site required a minimum of three hours plus travel time. The large or more complex sites took at least four to eight hours and often required return visits just to complete the basic recording. The greatest distance for any trip was the approximately 400 miles required for the round trip to the Kirksville area. It became apparent at the beginning of the fieldwork that except in a very few cases, detailed mapping of each site, as we did at Rocky Hollow in 1983, was not possible within the time frame of the project. However, we were able to photograph each site in color slides, and usually in black and white as well, and to make acetate tracings and/or drawings at several of the more complex sites. On one occasion, a second trip to an area was required for our informant simply to locate the site. Some of these sites had not been visited for three to four decades and new highways, roads, and other construction made it difficult for informants, relying solely on memory, to relocate them. A few remained elusive.

At each site, a general survey of the immediate area was conducted to determine the presence of any satellite sites. Often, in the case of both petroglyphs and pictographs, additional graphics were located and recorded. In conversations with other rock art researchers, we found this phenomenon to be relatively common. In fact, on occasion we have returned to a complex site thought to be completely covered only to find a graphic that had been overlooked.

After we had more fully developed our recording techniques, a few of the larger sites were revisited and rephotographed. On some of the return trips, the objective was to obtain photographs from directly above using a ladder, because this enabled a much better perspective of complex sites such as those typical of the Big River area. In the case of the Three Hills Creek site, attempts were made to arrange for aerial photography. Although we were able to schedule two dates, both had to be aborted because of inclement weather. Further complications in making arrangements and the costs forced us to abandon this approach for the time being. Government aerial photographs are presently being sought. A few other sites that were difficult to assimilate because of their exceptional intricacy were revisited for additional photographs, acetate tracings, and general information. These sites took precedence over single-motif sites because of their greater informational potential.

Forms for several of the previously reported sites were updated when new information was uncovered. In three cases, we felt compelled to update by placing the sites under two separate state numbers. In the case of the First Creek site, a single site number had been assigned for two separate shelters. We also divided the Rocky Hollow site because the major panels are located on two distinct and opposing rock walls separated by fifty meters and a perennial stream. The third site, Bushberg-Meissner, was renumbered as two sites because the major portion of the site is a series of exposed boulders

at the water's edge, while the other portion is a panel on the wall inside a small fissure cave approximately twenty-five meters up the steep bank. This is not to say they were not used in conjunction, only that they are two distinct sites in two very different contexts: river bank and cave. Graphics at the former are in basically horizontal positions on boulders, whereas at the latter site they are on a vertical wall of a fissure cave and include some pigments.

The most complex site encountered, the Three Hills Creek site, was examined five times. With each visit, we became more familiar with its motifs and intricacies and were able to see more and find more. In fact, we found additional motifs or markings at several of the previously reported sites. This is not in any way meant to demean the recording skills of the informants, but rather to emphasize the important roles that the time of year, day, condition of the rock surface (clear, covered with lichen, moss, mold, wet, dry), and—most critical—the *lighting*, play in recording efficiency. Because of this recurring problem of undernumeration, we decided not to try to "quantify" these exceptionally complex sites, although this was the original intent. We take comfort in a passage from Bahn and Vertut (1988:39) in which they came to the same decision: "[I]t is difficult to quantify the drawings: this is because of superimpositions, deterioration and above all, a lack of consensus about how to count 'signs'—should a series of dots be considered separately or as a unit? And how can one quantify a mass of meandering finger marks? Consequently, different authors often have widely divergent totals of figures for the same cave."

Needless to say, the more complex sites required more time to assimilate. To aid in assembling panoramic photographs in the laboratory, printed number cards were made, approximately fifteen by fifteen centimeters, to be placed on the panels at complex sites. Positioning these numbers sequentially on the panels and/or sections of long, intricately carved boulders helped to later reconstruct the site with photographs or drawings. At the two largest sites, Washington State Park and Three Hills Creek, numbers and also letters were employed so that the sequence of several panels of graphics on a boulder four to five meters in length could be identified in the photographs.

In carrying out this project, we have learned a great deal about the subject matter; not just about recording the graphics but also about "translating" them to paper. By "translate," we mean a simple reading or deciphering of the visual graphic—and not interpretation of its meaning. We find that these graphics are misinterpreted, or misread, frequently enough to bear mention. This results in a portion of the records at some sites being incomplete or inaccurate. In fact, some of the most enigmatic sketches, upon investigation of the originals, turned out to be renderings of simple, recognizable forms. Two examples are shown in Figures 4.1 and 4.2.

In the time-consuming process of personally documenting seventy-four

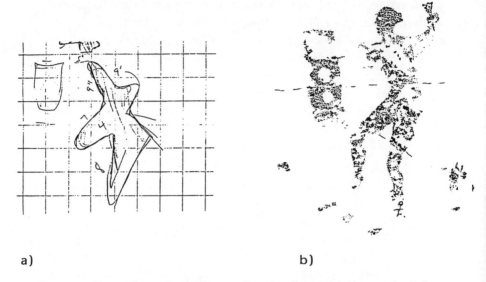

a) b)

Figure 4.1. Comparison of recordings: *a*, Drawing from original report by Robert Elgin; *b*, Pictograph drawn from projected slide taken at site (Rattlesnake Bluff).

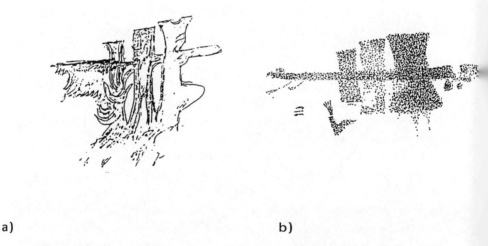

a) b)

Figure 4.2. Comparison of recordings: *a*, Drawing from original report by Frank P. Magre; *b*, Pictograph drawn from projected slide taken at site (White Rock Bluff).

sites (some revisited up to five times) and investigating and recording the remainder of the petroglyphs and pictographs in this inventory, we found this phenomenon of early misinterpretation to cause an occasional delay in field operations. We would sometimes spend time looking for motifs that did not exist. Time was also spent in looking for sites and motifs that had been van-

dalized or removed. The remainder of the sites, those not personally recorded, fell into one or more of the following categories: destroyed, buried, single-motif sites, or single-motif/late-reported sites a considerable distance away from our St. Louis base. In most of these cases, the informants supplied scaled or unscaled photographs and/or drawings.

All rock art researchers know that many outside factors can not only affect, but often sabotage, recording efforts. These include varieties of inclement weather, changes in lighting, shadows from tree branches, inability to gain access to a site, difficulty in locating a site, and realization that the site is no longer there because it has become a major highway, rock quarry, subdivision, fast food restaurant, section of a stone fireplace in someone's home, coveted collector's treasure, or door stop. Our work situation was not unique in the realm of rock art research, but we noted that the recording of rock art was, and is, certainly different from traditional archaeological fieldwork.

Chalking Reconsidered

Before any photographic work could begin at some of the petroglyph sites, it was necessary to enhance them in some way so that they would show up better photographically. As intent as we were on not chalking—or even touching—the petroglyphs, we became resigned to the fact that in order to get a usable slide or photograph during daylight hours, light chalking would have to be done. Most of the sites including all of the major sites had been chalked on numerous occasions for more than four decades. Furthermore, some Missouri petroglyphs had also been painted white or completely filled in with chalk in past years by those wishing spectacular photographs. Thus, remnants of the calcium carbonate from the chalk would already have been absorbed into the stone, interfering with any possible trace analysis or other chemical testing. Other methods such as those using aluminum foil, powder, paint, and night photography[1] were all impractical under the circumstances.

The mission to end chalking of petroglyphs, led by members of the American Rock Art Research Association (ARARA) in California, was originally based on two original and major objections. First, the "school chalk" that is invariably used is composed almost entirely of calcium carbonate. This chalk is hard and can be very abrasive to weathering sandstone or dolomite. The other reason is the possible contamination of the rock patina by the chalk substance. With regard to avoiding the abrasiveness of "school chalk," we were able to locate a specially formulated artist's chalk, composed of sixty percent zinc oxide powder and only forty percent calcium carbonate, with an organic binding agent of gum tragacanth. This pastel, zinc chalk is extremely soft and comparable to the pressed powder used for women's makeup; it was produced by artist Carl Stone for his work in rendering pastel drawings. The

recipe for this and other soft zinc chalks can be found in Mayer's *The Artist's Handbook of Materials and Techniques* (1991).

Although chalking has received severe criticism in the past, some rock art researchers are finding it necessary to occasionally return to this method of bringing out faint carvings for more effective photographic results. On one of our first field trips we photographed the Maddin Creek site without chalking. When the slides were returned, we realized that a return visit to the site would be necessary. What you see in person may not always be what you get on film. The soft zinc chalk was a compromise on those occasions when chalking was necessary. Nevertheless, we do not condone chalking and recommend against it in the majority of recording cases.

ARARA past president John Crawley, offering his views on chalking more than a decade ago, claimed that in spite of objections there were instances when "chalking may be of value and it is possible that the areas that you are attempting to photograph would only be visible to the camera after they have been chalked" (Crawley 1981:13).

Eugene Diesing, an amateur archaeologist and early recorder of Missouri rock art, filled in all petroglyphs with paint, chalk, or whitewash before he photographed them. We have some of his photographs that clearly show this, and his use of this technique was also related to us by one of his frequent field partners, Frank Magre. A representative from the Missouri Department of Natural Resources, while chalking the Washington State Park petroglyphs in 1994 in preparation for taking interpretive photographs, filled in each design completely with either chalk or paint for the purpose of achieving photographs of high contrast. The results are visually impressive, but very dubious from the standpoint of conservation. This practice should be stopped, because complete chalking on friable stone obliterates any possible lines or details within the design field and may completely contaminate the rock for future chemical or dating analysis.

Another complaint of those opposed to chalking is that it can lead to a biased drawing. That is, the researcher can introduce his or her own preferences in regard to how lines should continue. Two points should be made here: first, in chalking petroglyphs, if a line appears to stop, one should not chalk it as though it were continuing. Second, at some point, particularly if the petroglyph is difficult to record with any kind of normal or enhanced photographic measures, the graphic will have to be translated to line art, so that sooner or later that same bias may be introduced. Some researchers enlarge their field photographs and *then* draw in what they sense are the carved lines. To our thinking, this is more problematical. With petroglyphs, particularly in the wooded contexts where most of those in the state are found, one runs the risk of interpreting a shadow as a carved line. That is to say, pro-

jected on a two-dimensional screen, a dark carved line can blend into the dark shadow of an overhead branch or twig. However, after studying hundreds of petroglyphs (thousands of motifs), one can, with keen observation and by touch, recognize most of them and can determine even the faintest original and existing lines.

LABORATORY WORK

Photography

Photographs are an essential component of a rock art inventory (Salzer 1986:61). Color slides and black-and-white photographs were crucial to this project. Both were taken with and without scale. Slides were taken with a 35 mm Nikon N2000 camera purchased through Diaz-Granados's National Science Foundation grant. A 50 mm lens was used for most shots, although a 24 mm wide-angle lens was employed where necessary to obtain panoramic views and capture the general setting at each site. A 60-300 mm Tokina SZ-X telephoto lens was used at a few sites where it was impossible to get a reasonably close shot. Natural lighting was used wherever possible. Film types included Kodak Ektachrome (speeds 100, 200, 400), Kodachrome (speeds 64, 100, 200), and Kodak Plus-X Pan and Tri-X black-and-white film.

Infrared photography was not part of the proposal nor were funds allotted for that purpose, although it has been used with a measure of success at some other sites (Salzer 1986). Experiments were done using color filters in the field as well as color enhancement through processing and copying procedures in the laboratory. The latter procedures were effective in bringing out pigment colors in the slides taken at certain pictograph sites. Technicians at Commercial 35 in Maplewood, Missouri, experimented with color filters in processing to get, for example, variations in the intensity of the color in the red wapiti pictograph at the Willenberg Shelter while trying to subdue the surrounding green of the invading lichen. The experiments were successful to a degree, but more work needs to be done.

As a backup to the photographic work, in certain instances, acetate tracings were made. This process may be the least intrusive method of direct recording. In the 1960s, researchers Dewdney and Kidd (1967:9) remarked on their method of using artist's rice paper and, later, Saran Wrap plastic film. We were fortunate to have, some thirty years later, Mylar acetate available to us. Acetate tracing was accomplished by placing a sheet of forty-eight-inch-wide, three-millimeter-thick acetate over a basically horizontal boulder or grouping of boulders with petroglyphs. There was no unnecessary pressure applied to the petroglyphs. The acetate was lightly held in place and the

graphics then traced with a black felt-tipped marker pen (pointed tip). The overlay translates the motifs in their exact sizes without the unavoidable angles and distortion often seen in photographic perspective shots.

Orientation and any brief explanatory notes were written directly on the acetate. Although the three-millimeter-thick acetate was sufficiently sturdy, another equally sturdy material from the 3M Company, Hartoray 4 mm polyester film, can also be used. It is more flexible than the Mylar acetate and will wrap around boulders that contain carvings on both tops and sides. It has the one drawback of transferring ink from one surface to another when it is rolled up. However, this can be overcome by sandwiching it with paper or tissue before rolling (Iloilo M. Jones, personal communication, October 1990). There was no need to acetate-trace vertical petroglyphs because they were invariably in better condition and easier to photograph.

We would like to have traced a few of the pictographs but because of their fragility decided against it. In our opinion it is less problematical to discern the forms of colored pigments than to detect those of worn carvings. Of course, this depends on whether later graphics have been superimposed. The use of a Munsell Soil Color Chart for identifying colors of pigments in the pictographs was rejected because of numerous complications such as variations of color within a field; the natural mixing of colors between worn, faint pigment and the abraded, exposed sandstone grains to which it adheres; absence of some of the colors on the chart; and bias caused by variation in lighting. The basic differences observed in shades were noted (e.g., orange-red, brown-red).

Drawings

More than 700 line drawings were generated from the hundreds of slides, photographs, and sketches produced as a result of the fieldwork or were obtained as original drawings from informants. A few points must be addressed here. As a basic caution, it should be remembered that, while as accurate as possible, the drawings are taken from three-dimensional rock surfaces that have been "translated" into two-dimensional renderings. Wherever possible, the outline of the boulder or boulder section on which the carving was located was delineated in the original rendering. A dotted or dashed line was used to indicate a vague line noted either at the site or on the slide. Every effort was taken to put down what is actually there, to minimize distortion (except in angle shots), and, in most cases, to try to give a sense of the whole context. Most drawings are shown with scale.

If a drawing was made from a photograph that was taken unavoidably at an angle, the drawing reflects this. In many cases, a straight-on view was made of motif details, but it was frequently impossible to get a straight-on shot of an entire outcrop with standard photographic techniques. Also, if a

form appeared to be unfinished, it was left as is. No attempt was made to "complete" motifs or panels. In addition, a number of the drawings, approximately ninety, were done by informants. These sketches are included for comparison and sometimes used simply because the site is no longer in existence and those drawings, often rough sketches without scale, are the only records remaining of a site.

Producing drawings for this study was a painstaking and time-consuming process. To begin the procedure, Diaz-Granados reviewed the slides for a particular site—as many as sixty to a hundred—and selected those to be used for the drawings. The criteria for selection included clarity, composition, and angle or lack thereof. Because the number of motifs per site in our data base varied from one to as many as several hundred, the time required per site also varied greatly. As many slides as were necessary to cover all panels and motifs at each site were identified. The slides were then projected, one by one, onto a sheet of drawing paper (acid-free) taped to the wall. The ink used was a solid black and pen point diameters varied from 0.003 to 0.007 millimeters with 0.005 millimeters the most frequently used.

When work with the illustrations was begun, Diaz-Granados first penciled them in and then later inked them in. However, after experience with the first several sites, it became possible to ink the illustrations directly onto paper from the projected slide. This allowed a more exact reproduction from the slides, particularly with the pictograph drawings, because with those reproduction was a matter of working with varying shades. In the case of major sites, such as Washington State Park Site A, three or more slides were projected onto consecutive sheets of paper that were then pieced together in a panorama of the complex panel, resulting in composite drawings sixty to ninety centimeters in length. It was then necessary to reduce these drawings to manuscript size.

In reproducing pictographs, a method of filling color fields with dots (pointillism) was employed. This was not intended to give the traditional "stippling" effect. The desired end result was to reflect the relative intensity of pigment in each area of the pictograph. In situations in which two or more colors were evident, red pigment was done in dots and the black interpreted in finely hatched lines. This plan worked well for most of the pictographs in our data base. However, in the case of a few, including Picture Caves #1 and #2 and Mike's Shelter, we encountered many lines within the pictographs rather than fields or filled areas. In those circumstances, the lines were simply drawn in. Also, in the complex renderings of Picture Cave Site #1, some of the smaller figures were filled in solid. In most of these cases, colors were indicated by letter designation: r for red; b for black. One of the drawings for Picture Cave was taken from a small snapshot and solid areas within this small visual field were likewise completely filled in.

A CONTEXTUAL APPROACH

Most of the literature on rock art from the early 1900s and into the early 1980s is primarily descriptive. We believe the reason for this is twofold: first, it has been and still is an acceptable way to report petroglyph and pictograph sites. Second, it is a safe method of reporting (i.e., no one will call you a lunatic or idiosyncratic if you merely *describe* a rock art site), and it does add to the archaeological data base. Although descriptive reports are limited in what they contribute to our knowledge of the past, they preserve the basic data and provide material for subsequent comparative surveys and analyses. With rock art interest, research, and interpretive studies by professional archaeologists on the increase, however, it has become more acceptable, even expected, to move beyond the limits of pure description. The appealing feature of the contextual approach is that it brings together a variety of data.

Just as the informational potential of the soil matrix surrounding buried artifacts was ignored for many decades, so too was the physical context of rock art sites. As Butzer (1980:418) states, "The basic ingredients of archaeology are artifacts and their context—ranging from food residues to sediment and landscape matrix." Butzer then begins a discussion on "environmental" archaeology, and it is within this area that we focus the primary meaning of "context" in this study. Hodder, too, advocates "contextual archaeology" because it "encapsulates the environmental context (how the object functions in its social and physical environment)" (Hodder 1987a:1). Butzer (1980:418) remarks at the beginning of his study, "'Context' means many things to many people." We have found this to be a valid assertion in the readings so far encountered, and we detail below how the concept is applied in this study.

In prehistoric times, placement of petroglyphs and pictographs was dependent on available and appropriate geological resources. This context and the physical environment in which the rock art is located and was first created must be examined. As Butzer (1980:418) says, "Our ultimate goal is the interrelationship between culture and environment." In a sense, the context is viewed as an integral part of the artifact and this creates one of the few situations in archaeology in which the artifact and data remain *in situ*. A contextual approach to the study of rock art is also advocated by Goldstein (1987), Hudson and Lee (1984), Reichel-Dolmatoff (1967), Schaafsma (1980, 1985), Sundstrom (1989, 1990), Ucko and Rosenfeld (1967), and Vastokas and Vastokas (1973) and is becoming increasingly regarded by rock art scholars as a serious component of these studies.

Sundstrom (1989, 1990) stresses context for support in interpreting the functions of rock art sites: "Once the carvings and paintings have thus been placed within a chronological and spatial framework, we can proceed to con-

sider them, where possible, within the contexts of the physical environment, their own internal structures, and specific cultural developments." In general agreement with her objectives, we also hope to demonstrate here that rock art is "directly related to other aspects of culture and that as static remnants of extinct cultures . . . [the] data can be directly applied to the central concerns of archaeology, whether they be historical, processual, or ideological in nature" (Sundstrom 1989:5). The "contextual" approach can have many facets.

A Consideration of Place: Sacred Places

As part of the contextual approach, we are also investigating what has generally been referred to as "place" or "the power of place." This is the context that is, in large part, the "situ" of rock art sites; that is to say, it is the place into which the rock art was originally introduced and used for an indeterminate number of days, years, or centuries. "Place," in a sense, is thus viewed as an integral part of the artifact. In fact, the "place" itself is sometimes referred to as an artifact (Godden and Malnic 1982:31). This "place" assuredly possessed a sacredness and was chosen with great care in order to be appropriate to the function the graphics were meant to serve for their intended audience, whether a group or an individual.

Turpin (1992:275) raises the important question of whether the site was deemed sacred and thus embellished with rock art or the graphics were created and thus the site became sacred. It is impossible to know whether the mere selection rendered it sacred or whether its sacredness was the result of an event that took place at that precise spot. Young (1982:179) also raised the question, writing, "It is, perhaps, impossible to separate place and image in this manner with respect to power, distinguishing one or the other as being prior or prime, since rock art characteristically brings together both the power of place and the power of imagery, juxtaposing the natural world with the human creative world." The location may have been selected because of a death, mystical experience, or rite of passage that occurred. Such a place could have been selected because it related to an activity inherent in a group's life-style, belief system, or oral tradition, or for its proximity to a nearby village site, or for some combination of the above.

Vastokas and Vastokas (1973) studied the physical setting of the Peterborough petroglyphs in order to understand their "shamanic function and symbolic significance" (Schaafsma 1985:261). Schaafsma refers to the relevance of the physical setting in the term *spatial iconography* and notes that this factor can provide clues regarding the function and interpretation of the associated rock art. Wellmann (1979b) compares rock art to graffiti and uses the term *exotic space* to convey a place chosen to be special by virtue of its remote or special location and/or its graphics. Schaafsma (1985:262) cites sacred loca-

tions where petroglyphs and pictographs occur in the Southwest and notes that "the paintings and petroglyphs in all cases serve both to identify and maintain important locations, honor the supernaturals, and in this way, as with the Chumash, tie the Navajo and Zuni to their mythic beginnings." Levy-Bruhl (1983:92) cites the connection between totems and context: "Like most other observers, as for example Radcliffe-Brown, Elkin, Ursula McConnel, Ralph and Marjorie Piddington, Raymond Firth and many more, Spencer and Gillen emphasize the close association of any tribal group and its totem with some particular site or local centre." We take this, for the purpose of our argument, to support the hypothesis that rock art may, in some cases, function as portrayals of clan names or totems. Levy-Bruhl quotes Spencer and Gillen (1927:74–75) here: "At each of these spots—and they are all well known to the old men, who pass the knowledge on from generation to generation . . . [were kept the] 'churingas' [souls, spirits] . . . stored in Pertalchera, or sacred storehouses, that usually had the form of small caves and fissures in the rocks."

At contact, the Osage resided in several villages in Vernon County on the south side of the Osage River and in Benton County, according to Chapman and Chapman (1983:102), the most important late-period site being the Brown site. O'Brien and Wood (1998:357) leave the possibility open, in support of the Chapmans' theory, that the Osage originated in the Central Mississippi River Valley. It is conceivable that the abundant rock art found in the southeast quadrant of the state was produced by a proto-Osage group—a group that carried on a variety of activities in this region, utilizing its glades, and probably the many caves and rock shelters, as sacred places.

In another reference to sacred places, Godden and Malnic (1982:20), writing about Australian aboriginal rock art, report the following:

> In the special learning process of initiation, boys are taken to sacred places which are often also secret places. Their sacredness is sometimes marked by art of one form or another, whether portable objects, stone or earth arrangements or rock pictures. This is used to illustrate the knowledge the boys are acquiring, but it is often the direct visual representation of the religious figure or power in whose service the knowledge is carried, and so all the correct attitudes, behaviour and ritual approaches must be taught at the same time.

The essence of the above quote can be compared to that of "vision quest" scenarios in which a young person goes to a designated location and through fasting and hardship discovers his guardian animal spirit. The vision quest of the Sioux, along with their purification rites, is such a ritual. Joseph Brown (1989:44), quoting Black Elk, a Sioux, discusses the importance of "lament-

ing" for a vision. In short, after the sacred spot is chosen, the "lamenter's" helpers set up the site with five poles in the configuration of a cross (+), the center pole representing "Wakan-Tanka," or the Great Spirit. This cross is "a symbol with much power in it" (Joseph Brown 1989:59). The "lamenter" performs rituals around these poles and then "raises his pipe to the heavens asking the wingeds and all things to help him, and then pointing the pipe stem to the Earth, he asks aid from all that grows upon our Mother" (Joseph Brown 1989:57–78).

According to Lowie (1956:241), folktales of the Crow, a Siouan-speaking group, "bristle with unsolicited apparitions that opportunely rescue a hero from the brink of disaster." During the vision quests, the person involved may carve or paint a motif on a wall at his sacred place depicting his guardian spirit/animal. This has been suggested by Steinbring and Granzberg (1986:207), among others, in regard to rights of passage in general, including those associated with puberty. Furthermore, although references to vision quests are mainly associated with the Plains groups, the same type of ritual may have been practiced by Siouan groups in the Missouri region. If such paintings and carvings were indeed executed in conjunction with vision quest rituals, it could account for a number of the smaller sites depicting singular animals or other motifs. Of course, these could also be attributed to clan markings. In these cases, and probably in many of the others, the intended audience is a prime consideration for understanding the content and its placement.

A reference to sacred rocks is found in *Crow Dog* (Crow Dog and Erdoes 1996:23–24), which discusses four generations of Sioux medicine men. It mentions "the holy Medicine Rocks" and notes that these rocks "are covered with designs scratched into them—figures of men, horses, and buffalo." These rocks/boulders were in sacred places where the people gathered for prayer. The stones were believed "sacred because the spirits dwell in them" (Crow Dog and Erdoes 1996:115–17, 123).

Schaafsma (1985:263) states that several scholars support the argument that Great Basin petroglyphs were made by hunters or "hunt shamans" and used in association with hunting rituals or "magic." The petroglyphs have been found to occur apart from habitation or camp sites. They are instead placed along game trails or in proximity to other places particularly convenient for taking game. Blakeslee and Blasing (1988) also discuss Indian trails partly in association with petroglyphs. While we have not yet ascertained whether the placement of rock art sites in Missouri conforms to the location of early game trails, it is probable that an association exists.

Houck (1908:vol. 1, 226) shows in his map of "Aboriginal Trails and War-paths" that this could well be the case for some of the sites, because game

trails often precede later trails (followed by roads, followed by major trans-
portation highways). A review of the locations of sites in regard to Houck's
map revealed quite a few clusters and single sites on or close to these trails.
The map in Horr (1974:fig. 49) of Osage trails also shows some correlations,
but we are not prepared to make any bold statements at this time. Olsen
(1985), in an example of a contrasting possibility, relates the rock art at the
Hovenweep site to agricultural adaptive functions. Understandably, each situ-
ation is viewed with regard to its cultural context, if known, and interpreted
differently in light of identifiable graphic content. A number of other contex-
tual situations are postulated by researchers.

The Shaman–Rock Art Connection

According to Schaafsma (1985:260) and others, many North American
petroglyphs and pictographs are believed to have shamanic origins (Garvin
1978; Hedges 1970, 1975, 1976; Heizer and Baumhoff 1962; Keyser 1977, 1979;
Kirkland and Newcomb 1967; Schaafsma 1980; Snow 1976; Vastokas and
Vastokas 1973). A great deal of the evidence for the shamanic origins of rock
art, however, derives from the internal or pictorial evidence within the im-
agery itself, as opposed to outside criteria (Hedges 1976:127; Wellmann 1975,
1976a). This includes a tendency toward abstraction and the presence of
birds, snakes, skeletal and X-ray motifs, solar imagery, horned and other
elaborate headgear, boats, fertility symbolism, and so forth. All of these ele-
ments commonly have shamanic associations in many parts of the world
(Vastokas and Vastokas 1973). Anthropomorphs with arms/hands in particu-
lar raised positions are also considered shamanic. Hedges (1976, 1983) pre-
sents an overview of shamanic imagery throughout North American rock art
and in southern California specifically.

The basic responsibilities of the high priest or shaman, according to the
ethnographic literature, are renewing the world (or sacred fires); divining the
future; controlling the weather; maintaining the fertility of crops, animals,
and people; healing the sick; solving problems; and guiding the dead into the
afterlife. Shamanism has long been accepted as an integral part of some rock
art activity. The reason for this could be the abundance of the so-called "sha-
man figures." Shaman figures are considered to be anthropomorphs with
both arms/hands (and sometimes a single hand) raised, according to Garvin
(1978), Hedges (1983), Hilliard (1992), Snow (1977), and many others. Such
figures are frequently seen in Missouri, other parts of the United States, and
around the world. In Missouri, as elsewhere, there are figures with a single
raised hand. Vastokas and Vastokas give a shamanistic interpretation of the
Peterborough petroglyphs in their 1973 work and include figures whose arms

are not necessarily in a raised position (Vastokas and Vastokas 1973:plate 15, figs. 12, 13, and others).

With regard to shamans, it is generally known and widely documented that contemporary shamans have used and still use hallucinogens as an aid in communicating with the supernatural. Peyote was used in the Southwest, southern Plains, and Mexico, and species of datura have been used in some southwestern and southeastern areas. Reichel-Dolmatoff's often-cited work on the Tukano Indians details this group's use of narcotics and the designs probably produced as a result of the phosphene activity associated with these drugs. In his words, "It would not be difficult to find parallels to phosphene-derived design motifs in prehistoric artifacts, such as the decoration of ceramics, or petroglyphs and pictographs" (Reichel-Dolmatoff 1978a). Phosphenes and other entoptic phenomena are further discussed in Chapter 6.

Although context has been addressed in regard to analysis of rock art, we would like to put into graphic form the essence of the complexity of contextual considerations. Context can be considered on a broad or a very specific basis. To begin with, of course, there is the *major* context, that is, the *macro*-environment, the broad picture in which *landscape* is considered: landform and water resources. Also considered within this landscape are the fauna and flora. Next, there is the *micro*-environment, which includes the outcrop, cave, or shelter in or on which the graphics are placed and anything peculiar to that locality. Then there is the *general cultural* context that controls, to an unknown degree, the purpose or function of the graphics and possibly their placement and structure. Finally, there is the *ideological* context that results from the cultural activity and belief system, which may or may not be known (Figure 4.3).

Physical Context of Sites

It is highly probable that in many cases the choice for placing rock art at one location as opposed to another was because of the believed or assigned importance or "sacredness" of the place: in a sense, place can be considered as "icon." It is even conceivable that the place might have served an oracular role, because one of the major functions of any shaman is communication with the deities and supernatural powers. The sacred location traditionally chosen by a group's religious leader, high priest, or shaman to carry out ritual activity could account for the grouping of locational categories (see below). For example, Dewdney and Kidd (1967:16) state that "the sites themselves show a bewildering variety of locations" in his area of the Great Lakes and there is a preference for "a vertical rock face close to water." Although not referring to shamanic connections, Hilliard (1992:8) notes that of 116 known

Figure 4.3. Contextual layers of a rock art site.

sites in Arkansas, 103 are on shelter walls or ceilings, six are in caves, and eight are on sandstone rocks, slabs, or boulders.

Schaafsma, a proponent of the importance of site location as a means of identifying the possible function of rock art, suggests a number of associated site functions (Schaafsma 1985:261–62). Primarily, she discusses sites as "shrines," referring to the work of a number of researchers (Hudson and Lee 1984; Reichel-Dolmatoff 1967; Vastokas and Vastokas 1973; among others). Schaafsma (1985:262) states, "In the Southwest, a number of locations where rock art is present were or still are part of the spiritual geography of the Pueblo and Navajo people." She also discusses the importance of these rock art locations in regard to the "mythic beginnings" of these groups, stating that the rock art serves to "identify and maintain important locations," as discussed later in the section on oral traditions.

For Missouri, the four major areas of placement are as follows:

1. Caves and rock shelters (Figure 4.4)
2. Land outcrops in glades and other open or wooded expanses (Figure 4.5)
3. River- and creek-associated sites (Figure 4.6)
4. Spring-associated sites (Figure 4.7)

In conversations with others, we were surprised to find that there is ample disagreement, and thus confusion, on what defines some of the above areas. Most disagreement was on the term *glade*. A short definition—an open space

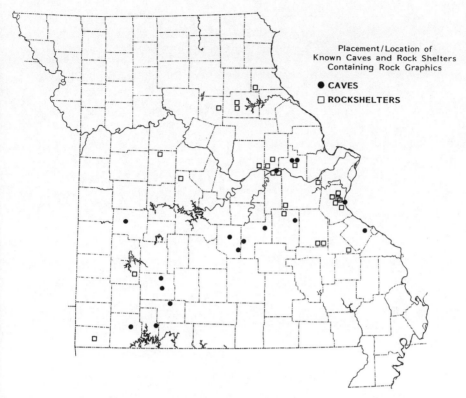

Figure 4.4. Sites in caves and rock shelters.

surrounded by woods—could apply to a large portion of the Missouri land-scape and leaves the definition vague. A noteworthy characteristic of many of the Missouri glades is the presence of cedar trees. This factor coupled with a presence of substantial dolomite outcrops and tinajitas possibly produced a "sacredness" of place that attracted those who produced the rock art. All the sites in the state's major grouping are located in glades with cedar trees.

La Flesche, in his *Osage Dictionary* (1932:381), points out that the red cedar and the "female cedar" (cypress?) are life symbols. According to Lopinot (1991:49), "Redcedar wood has been commonly recognized among carbonized and uncarbonized wood samples both from Cahokia and from other Mississippian mound centers in the American Bottom." Norrish (1978a) reported that at the Cahokia site in Collinsville, Illinois, the posts at Woodhenge were cedars (possibly imported from other areas) and used for this ceremonial season marker. The cedar tree was also used as sacred medicine by the Osage according to La Flesche (1932:399).

There is some disagreement in regard to caves and rock shelters. The

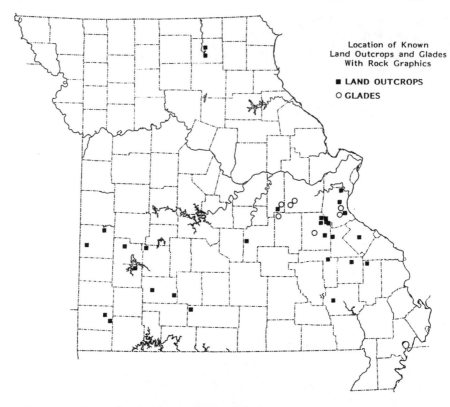

Figure 4.5. Sites on land outcrops and in glades.

reader should be aware that some so-called "caves" are merely rock shelters and some rock shelters are actually caves that have collapsed or that silted in during the distant past and never reopened. Weaver (in Weaver and Johnson 1980:15) states that "a precise definition for shelter caves or rock shelters has not been sufficiently written. The margins between a true cave and a shelter cave can be vague." He gives the definition of a "cave" as follows: "Caves are ordinarily defined as natural openings in the surface of the earth large enough for a person to explore beyond the reach of daylight." He says that one would thus expect all caves to be extensive, but this is not the case: "There are, for instance, recorded caves in Missouri less than 50 feet long consisting of one room or a single body-sized passage, tube or crevice. A few quick bends in a tunnel are all that is required to prevent light penetration."

Missouri has more than 5,000 documented caves, primarily limestone but including several sandstone caves. In general, most recorded caves in the state exceed fifty feet and a large percentage surpass one hundred feet. Caves exceeding 1,000 feet in length are fairly common in cavernous counties. Some of the state's caves have been extensively excavated by professional archaeolo-

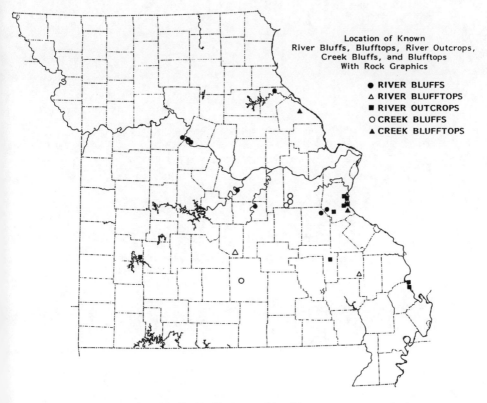

Figure 4.6. Sites on river bluffs, bluff tops, and boulders.

gists (e.g., Arnold Research Cave, Graham Cave, Tick Creek Cave) and have yielded evidence of long occupation dating back at least 10,000 years. While more than thirty percent of the sites in our data base are attributable to caves and rock shelters, it puzzles us why with more than 5,000 caves recorded there is not more evidence of rock art activity. One of the reasons could be that graphics may not preserve well (or be preserved at all) in some wet caves, and many Missouri caves are wet. Another simple explanation was suggested by a local speleologist, Joseph Walsh: most cavers are not looking for rock art. In any case, this particular category needs special attention and additional survey work.

Returning to the subject of division, the four categories can be further separated by placement at a specific site. The category of caves and rock shelters can be divided as follows (Tables 4.1 and 4.2):

1. Inside entrance wall(s)
2. Outside entrance wall(s)
3. Entrance ceiling/floor

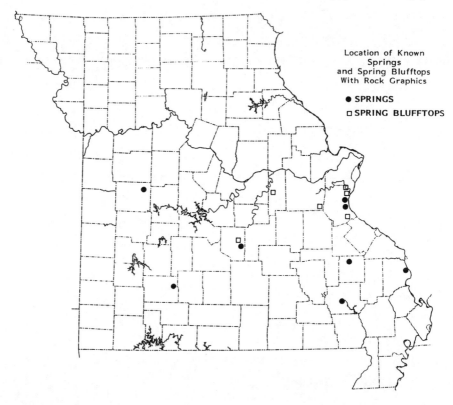

Figure 4.7. Sites at springs.

 4. Interior wall/ceiling/floor or stalactite/stalagmite
 5. Fall rock
 6. Combination

Spring-associated sites can all be included within the following divisions (Tables 4.3 and 4.4):

 1. Spring outcrop
 2. Spring bluff wall
 3. Spring bluff top
 4. Cave spring

A few times, when a site type seemed to defy categorization, it turned out to be associated with a spring.

 River-, stream-, or creek-associated sites include the following (Tables 4.3 and 4.8):

Table 4.1. Sites Associated with Caves (on outer or inner surfaces or on outcrops)

Site Name	County
Blacksmith Cave	Barry
Bushberg-Meissner Cave	Jefferson
Bushnell Ceremonial Cave	Ste. Genevieve
Crystal Cave	Greene
Devil's Slide Cave	Greene
Gourd Creek Cave	Phelps
Lookout Point	Pulaski
Miller's Cave	Pulaski
Monegaw	St. Claire
Old Spanish Cave	Stone
Picture Cave #1	Warren
Picture Cave #2	Warren
Reed Cave	Phelps
Reeves Cave	Crawford
Salt Peter Cave	Gasconade
Smallwell Cave	Christian

Table 4.2. Sites Associated with Rock Shelters (on outer or inner surfaces, on outcrops)

Site Name	County
Deer Run Shelter	Madison/St. Francois
Dry Fork Creek Shelter	Warren
First Creek Shelter #1	Gasconade
First Creek Shelter #2	Gasconade
Fort Hill Shelter	Jefferson
Grindstone Hill	Jefferson
Haw Creek Turtle	Morgan
Hidden Valley Shelter	Jefferson
Jarvis Shelter	Jefferson
Katy Trail	Callaway
Lambert	Jefferson
Lost Creek	Washington
Lost Creek Shelter	Washington
Loutre River	Montgomery
Maze Creek Shelter #3	Dade
Mike's Shelter	Montgomery
Mitchell	Randolph
Rocky Hollow #1	Monroe
Sharpsburgh	Marion
Steinbach Shelter	Jefferson

table continued on next page

table continued

Steusse Shelter	Franklin
Sugar Creek	McDonald
Tavern Rock Shelter	Franklin
Tobin-Reed	Saline
Tonkey West Shelter #1	Crawford
Willenberg Shelter	Franklin

Table 4.3. Sites Located around Springs and on Spring Bluff Walls

Site Name	County
Govel Spring	Madison
Kimmswick Footprint	Jefferson
Miller's Spring	Pulaski
Moccasin Spring	Cape Girardeau
Pigeon Hollow	Henry
Ring Creek	Wayne
Sulphur Springs	Jefferson
Whitelock School	Greene

Table 4.4. Sites Located on Spring Blufftops

Site Name	County
Ditch Creek	Franklin
Donnell	Jefferson
Herrell	Jefferson
Riviera Ledge	Jefferson
Schneider	Gasconade
Shanghai Springs	Pulaski

1. River/stream/creek outcrops (these can be either along a bank or within the path of running water)
2. River/creek bluff wall
3. River/creek bluff top

Land outcrops (i.e., terrestrial as opposed to outcrops in or near bodies of water) include the largest variety of possible locations, and land outcrops appear also in a variety of sizes, configurations, and elevations. The basic situations, however, are usually these (Tables 4.9 and 4.10):

1. Low, horizontal outcrops
2. Glade outcrops
3. Ridge outcrops

Table 4.5. Sites Located by Rivers (on banks)

Site Name	County
Bushberg-Meissner	Jefferson
Commerce Eagle	Scott
Thebes Rock Ledge	Scott

Table 4.6. Sites Located on River Bluffs/Blufftops

Site Name	County
Anheuser	Jefferson
Arrow Rock	Saline
Big Moniteau	Cooper
Frumet	Jefferson
Herculaneum Footprints	Jefferson
Herculaneum Landing	Jefferson
Katy Trail	Calloway
Kimmswick Footprint	Jefferson
Lohraff	Phelps
Loutre River	Montgomery
Miller Cave	Pulaski
Mineral Fork Bluff	Washington
Painted Rock	Osage
Paydown Deer	Maries
Salt River	Ralls
Shot Tower Bluff Footprint	Jefferson
Tesson Ferry	Jefferson
Torbett Spring-Rochporte	Boone

Table 4.7. Sites Located on Creek Bluffs

Site Name	County
Champion Eagle	Franklin
Crawford Staff	Crawford
Rattlesnake Bluff	Franklin
Rocky Hollow #2	Monroe
White Rock Bluff	Texas

Table 4.8. Sites Located on Creek Blufftops

Site Name	County
Noix Creek	Pike
Plattin Creek	Jefferson

Table 4.9. Sites on Land Outcrops

Site Name	County
Brown	Vernon
Caplinger Mills	Cedar
Chamber's Glyph	Pulaski
Church	Jefferson
Corisande Beach	Jefferson
Doe Run	Iron
Dogwood	Douglas
Elephant Rocks	Iron
Farris Farm	Gasconade
Gil Branch	Adair
Kelso Farm	Vernon
Maddin Creek	Washington
Maddin Creek Ridge	Washington
Matthews Creek	Madison
Mount Zion Church	Jefferson
Mutton Creek	Dade
Scaggs	Bollinger
Shoal Creek #1	Barry
Shoal Creek #2	Newton
Shumate	Greene
Tesson Ferry	Jefferson
Thousand Hills State Park	Adair
Three Hills Creek	St. Francois
Tuskie Station	Wayne
Waddell School	Greene
Wallen Creek	Washington
Washington State Park Site A	Washington
Washington State Park Site B	Washington
Washington State Park Site C	Washington
Wilson's Creek	Greene

Table 4.10. Sites Located on Glade Outcrops

Site Name	County
Indian Foot Lake	Jefferson
Jake's Prairie	Crawford
Peene-Murat	Gasconade
Persimmon Hill Glade	Jefferson
Reifer	Gasconade
Shirley	Washington
Winkle	Franklin

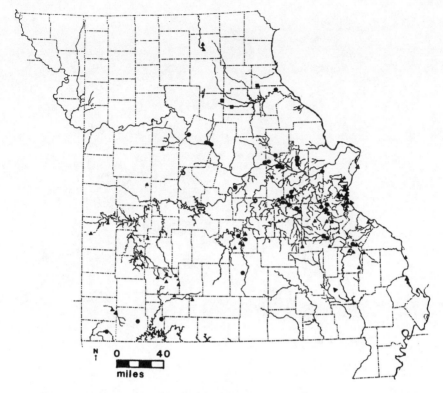

Figure 4.8. *a*, Distribution of Missouri petroglyph and pictograph sites.

4. Valley/canyon boulders
5. Isolated boulders

The land outcrops can probably be divided into the most variations since the first type, low, horizontal outcrops, can occur at any height above sea level. They have been found on hilltops, in valleys, and in virtually every context in between. The same holds true for glade outcrops and isolated boulders.

Hilliard (1992:9) tested the elevation of the 116 known rock art sites in Arkansas, mostly located in caves and shelters, against one hundred of the state's other reported archaeological sites located in shelters but not containing rock art. Two results emerged: at least for Arkansas, surfaces suitable for graphics "are more likely to occur on high capstone geological formations" and "sandstone outcrops are higher in elevation than limestone surfaces throughout the Ozarks." Hilliard (1992:10) adds that current evidence indicates the choice of execution for rock art was that of "a high setting."

Of course, the above divisions can become cumbersome when applied to

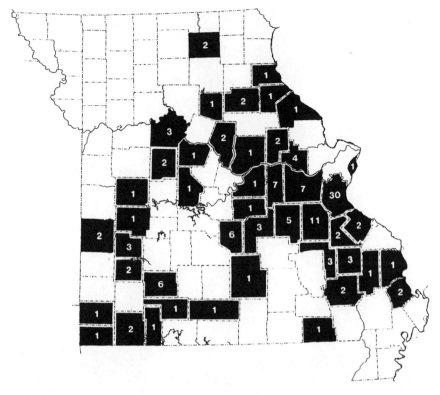

Figure 4.8. *b*, Density distribution of rock art sites by county.

a large data base of sites (Figure 4.8*a*), so we have tried to organize the categories into comprehensive units. These locations and general physical contexts are significant, we believe, and were surely not chosen at random. Furthermore, the fact that the five major sites, in addition to having a similarity of content, are all located within thirty miles of each other, on the same sandy dolomite formation, and on outcrops approximately the same height off the ground, and that all five contain tinajita formations, we believe is meaningful (see discussions in Chapters 6 and 7).

Another level of context is the surficial field or "frame" in which the graphics were executed. Understandably, there was no traditional border within which the carver or painter worked. The background or field was essentially "free-form." Whether the creator of the graphics, shaman, artisan, carver, or painter, worked within an imaginary field confined by the entire space of a boulder, whether this person *visualized* a restricting outline dictated by subject matter, shape, or some other reason, or whether the controlling factor was the surface contours we may never know. It is a fact, however, that at a num-

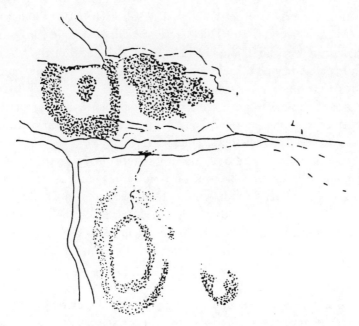

Figure 4.9. Concentric circles (Frumet) (from slide by Frank P. Magre).

ber of sites the graphics were placed on an "unlikely" rougher surface while adjacent to it there was a smoother surface. This implies that what we would take to be an ideal surface for painting or carving is not necessarily what the aboriginal person was looking for, and that other unknown factors are obviously involved.

Contextual Associations of Motifs

Of the few associations that can solidly be made between particular motifs and locations, one that stands out is that of concentric circles in association with water. Examples of this connection include the Anheuser site (river), Bushberg-Meissner site (river), Bushnell Ceremonial Cave (spring), Frumet site (river) (Figure 4.9), Plattin Creek site (river), Schneider site (spring), and Tobin-Reed site (spring). Examples may also be found at the Reifer, Three Hills Creek, Washington State Park, White Rock Bluff, and Winkle sites, among others, but the concentric circles are not as prominent as in the previously listed sites.

Conversely, a search for a specific correlation to the frequently observed avian or "thunderbird" motif (usually defined by broad wings, fanned tail, profiled head and beak) was not successful. Birds appear in the context of a cave (Bushnell), on shelter walls (Mitchell, Sharpsburg), on breakdown boul-

ders within shelters (Groeper and Hidden Valley Shelter), on outcrops in glades (Maddin Creek, Three Hills Creek, Washington State Park south of the Missouri River, and Thousand Hills State Park north of the Missouri), on a bluff wall (Champion Eagle, Rocky Hollow), and on a boulder on a river bank that is at times under water (the Commerce Eagle). The apparent repeated use of this avian motif speaks of its importance as a symbol to the Native American groups of the Missouri area, which is emphasized by its use in almost every conceivable physical context.

The possible influence of unusual features in the natural setting, in regard to attracting prehistoric people to a location, can be cited in the occurrence of rock art in glades on dolomite outcrops that display the tinajita formations discussed earlier. There is no doubt that these formations held a special significance for the carvers of petroglyphs (see Chapter 3). Also included among the possible attractions to particular sites are other natural formations such as fissures in both vertical and horizontal rock surfaces, fissure caves, and solution holes of varying sizes. This phenomenon of the possible "sacredness" of a place as the result of natural features or unusual rock formations seems to characterize rock art activity in many other regions as well.

Although there are basic norms and methods for rock art recording, actual field techniques may differ somewhat from region to region and site to site. Nevertheless, the basis for any survey project is the data recovery. Any ensuing analyses begin with that data recovery, so methods should be designed to address the questions being asked. In our case, the data-gathering task was demanding because of a myriad of obstacles around which we were required to work. However, the sites were eventually recorded and placed into a data base in part to produce a site distribution map (Figure 4.8a) and a site density map (Figure 4.8b). These maps give the viewer a good idea of the expanse of rock art in the state, yet protect the privacy of the landowners. Possibly the most important factor in assembling and recording these sites was the need for a sensitivity to the physical contexts in which each site was placed. We became quickly aware of the importance of context. In carrying out the project, we found that it was the matter of context that enriched each site's integrity and helped to make it unique.

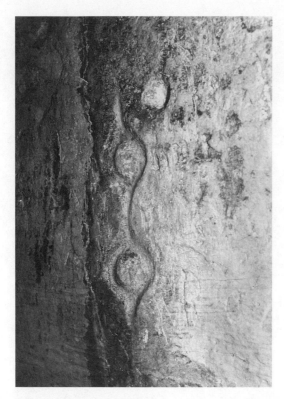

Plate 1. Bushberg-Meissner

Plate 2. Bushnell Ceremonial Cave, Pit and groove and cup holes outside cave entrance

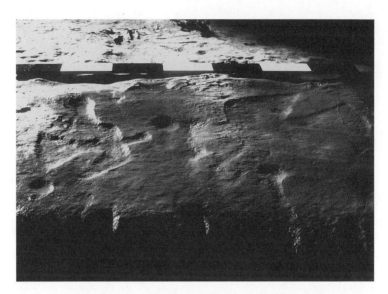

Plate 3. Bushnell Ceremonial Cave, Birds

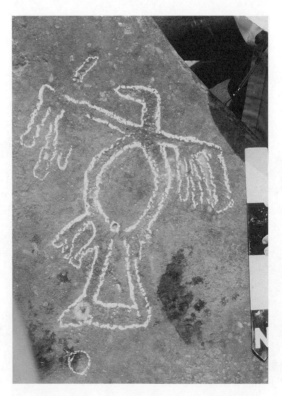

Plate 4. Commerce Eagle (chalking and slide by
Frank P. Magre)

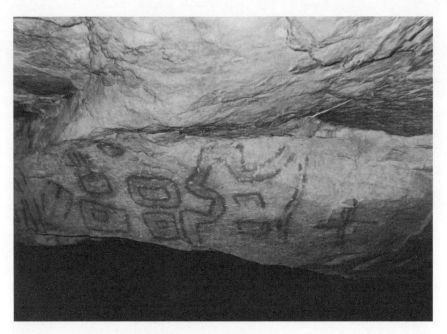

Plate 5. First Creek (photograph by Donald Zykan)

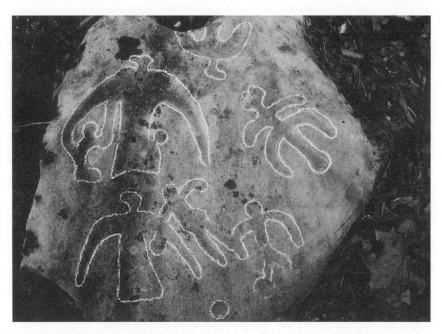

Plate 6. Maddin Creek "Bird rock" (chalking and slide by Frank P. Magre, petroglyph removed from site)

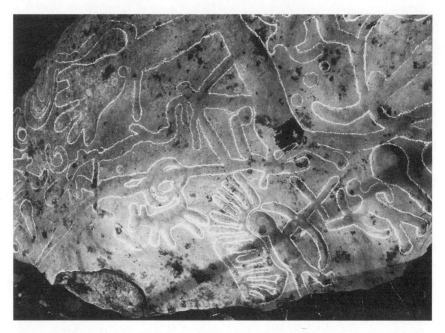

Plate 7. Maddin Creek, Archers in combat and arm (chalking and slide by Frank P. Magre)

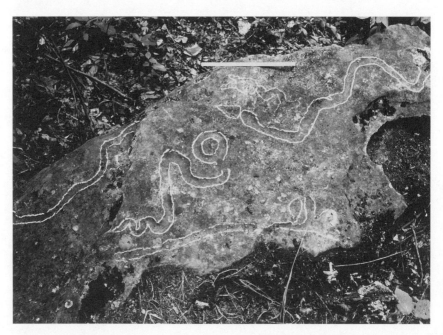

Plate 8. Maddin Creek, Serpents around concentric circle (chalking and slide by Frank P. Magre)

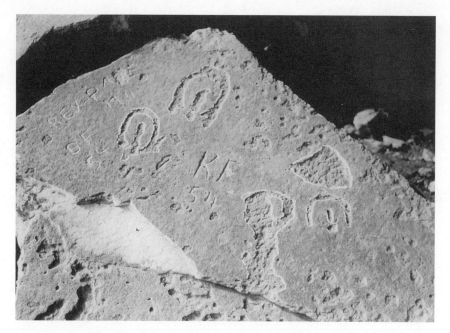

Plate 9. Miller's Cave, Vulvar motifs (slide by Robert Elgin)

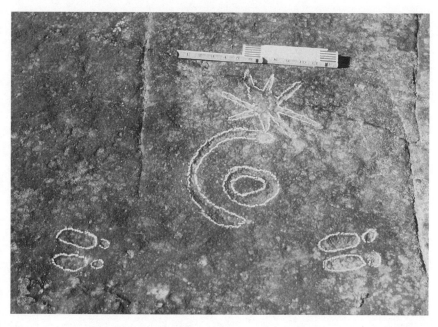

Plate 10. Peene-Murat, Crescent and star/supernova and rabbit tracks (photograph by Robert Elgin)

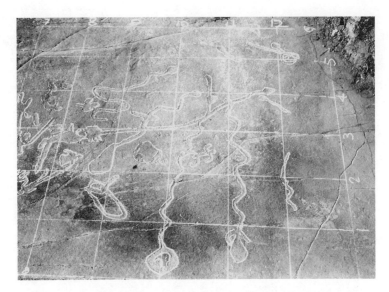

Plate 11. Peene-Murat, Meandering connected forms (chalking and slide by Robert Elgin)

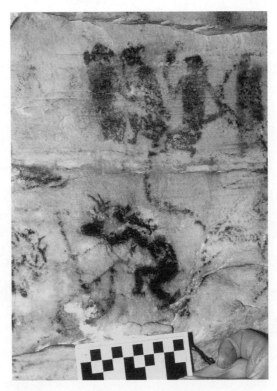

Plate 12. Picture Cave, Group of three

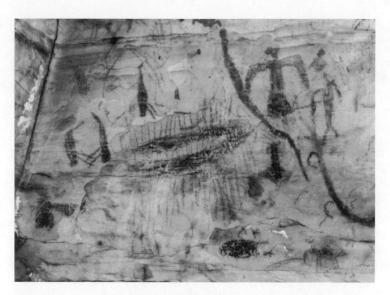

Plate 13. Picture Cave, Wall of turkey/bird motifs and serpents

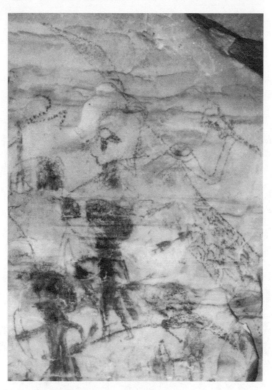

Plate 14. Picture Cave, Kilted figure (photograph
by Philip Newell)

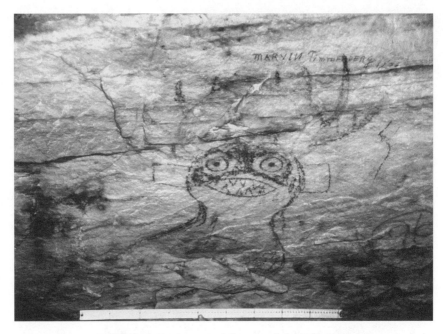

Plate 15. Picture Cave, Underwater spirit (photograph by Sally J. Kula)

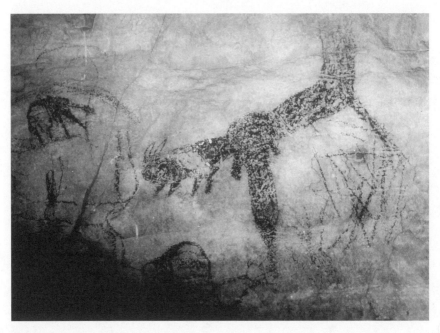

Plate 16. Picture Cave, Bent arm

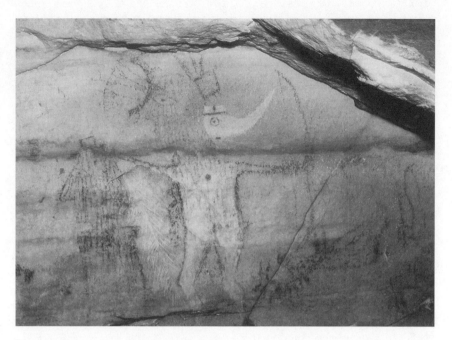

Plate 17. Picture Cave, Maskette panel

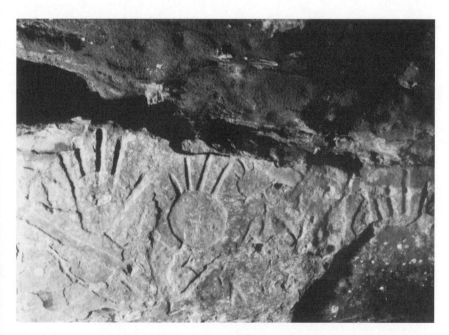

Plate 18. Rocky Hollow, Hands panel (photograph by Richard C. Smith, courtesy of L-A-D Foundation)

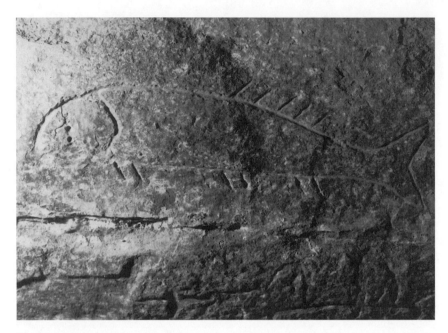

Plate 19. Rocky Hollow, Fish detail (photograph by Richard C. Smith, courtesy of L-A-D Foundation)

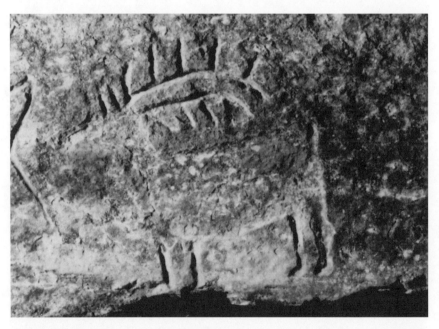

Plate 20. Rocky Hollow, Deer detail (photograph by Richard C. Smith, courtesy of L-A-D Foundation)

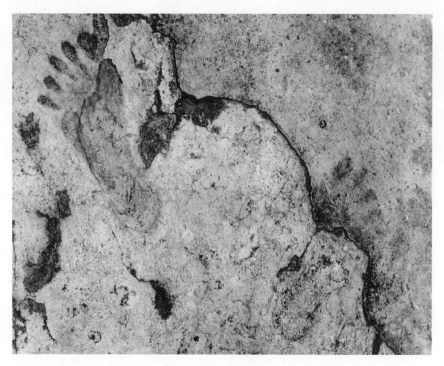

Plate 21. St. Louis Riverfront, St. Gabriel's Footprints, removed 1818–1819 (photograph by Fred E. Coy, Jr.)

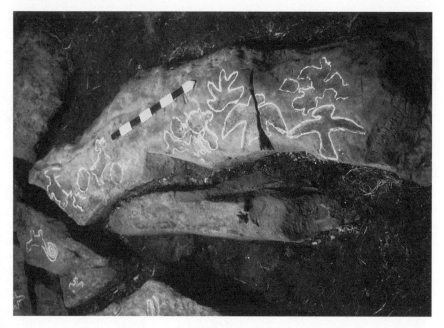

Plate 22. Thousand Hills State Park, Split bird rock (chalking by Frank P. Magre)

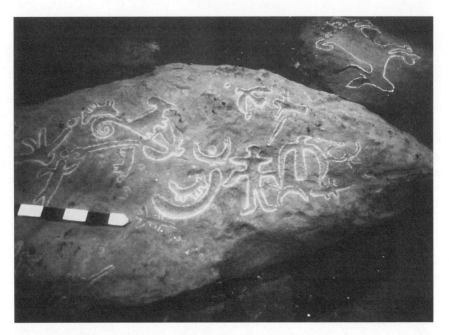

Plate 23. Thousand Hills State Park, Large group with birds and crescent (chalking by Frank P. Magre)

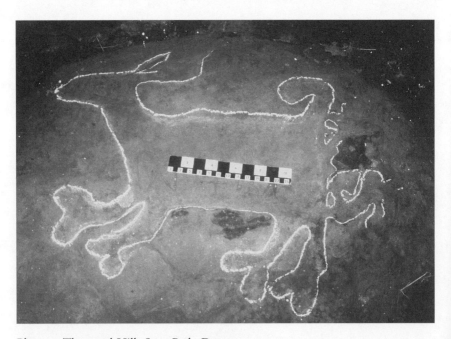

Plate 24. Thousand Hills State Park, Deer

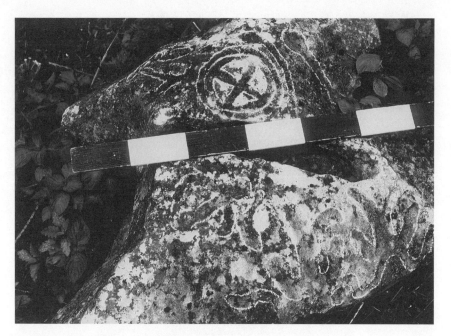

Plate 25. Three Hills Creek, Cross in circle

Plate 26. Three Hills Creek, Tinajita formation (photograph by Benedict Ellis)

Plate 27. Washington State Park A, Big Bird

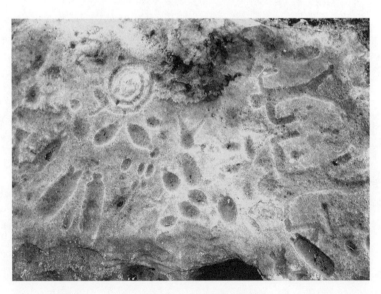

Plate 28. Washington State Park A, Harvest group

Plate 29. Washington State Park B, Mace (photograph by Frank P. Magre)

Plate 30. Willenberg, Crescent and star/supernova

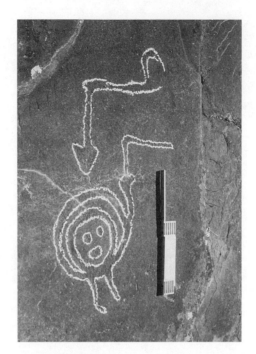

Plate 31. Winkle (chalking and photograph by Robert Elgin)

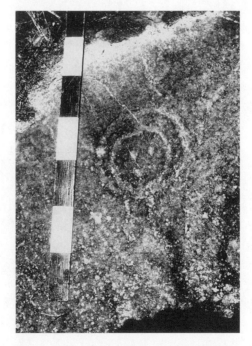

Plate 32. Winkle (unchalked version)

5 Analyses of Missouri's Rock Art

CONCEPT OF STYLE

It is neither crucial nor germane to the fundamental objectives of this study to engage in an extended discourse on the work of each researcher who has addressed "style" in an archaeological context. The amount is ever increasing. The reader is referred to Conkey (1990) and Davis (1990), who give excellent overviews of the history, theories, and uses of style in archaeology, and to Phillips and Brown (1978). Phillips and Brown offer a detailed discussion of a trial-and-error process of ordering the styles found on shell engravings from the Spiro site. They discuss how they developed their "Hypothesis D" (after working through A, B, and C). They refer to their Hypothesis D as "a working model." "A working model" also describes the results of this analysis. The complexity of the data demands it. However, some preliminary discussion is in order to familiarize the reader with a variety of approaches to and thoughts on style analysis; a few issues must be clarified, or at least considered.

Below, we define style as the word is used for this analysis of Missouri rock art. For the purpose of this study, we have tried to make it as much a visual recipe as possible: one that can easily be duplicated, adapted, or dissected. We first emphasize that defining *style* is no easier than defining the term *art*, yet some basic issues must be addressed. For example, style is not static but an ever-changing phenomenon, as evidenced in our own society. This fact, coupled with the complexity of the interaction of early groups, plus the problem of dating these unstratified artifacts, creates a difficult puzzle and one that should be approached from a variety of angles. The complexity of the task is indicated by the current number of approaches coupled with the diversity of rock art in the Missouri data base.

There is almost as much disagreement on what constitutes style as there is on what is and is not art. Davis (1990:19) plainly states, "Style is not 'in' the material, the matter of artifacts or works of art. Style must be discovered and written up by someone." Of course, any style analysis begins with description and ordering of the materials in question. Because no one has gone into any detail considering rock art styles in the Eastern Woodlands (Schaafsma 1985:252), there is little basis for comparison.

We do not believe it is necessary to create a single theory of style but think it better to reach some agreement on what constitutes style in rock art. Some believe that in order to understand style, one must understand the processes that generate style. This is neither practical nor possible to accomplish within regions that lack a continuity of native groups, such as Missouri. That is, there are no remnant populations in the state of surviving native groups who can be queried, observed, and studied. This is possibly one of the reasons this area of research has been avoided by professionals in the state. The Missouri historically merged with the Oto and relocated to the west, and the Osage, while retaining a portion of their tribal identity, were removed in the 1820s, eventually to territory in Oklahoma. Therefore the luxury of being able to employ the "direct historical approach," as can be done in the American Southwest and other parts of the world, is denied us. Ethnographically, it may be possible to develop methods to differentiate whether a style was produced through personal intent, as a result of group tradition, or with influence from others. Such studies have been carried out, most notably those of Friedrich (1970) and Roe (1982). Because this is not possible for Missouri, we must approach style on a visual, comparative, and theoretical basis.

Stylistic analysis has been used for many decades by both archaeologists and art historians to describe the style, or range of styles, of artifactual materials within a given culture or period. It has also been used with these materials when the culture and period are unknown. Even within the fundamental constraints of stylistic analysis, methods can vary widely along with modifications specific to the materials being analyzed. The term *style,* defined for the purpose of this discussion, involves the distinctive media, form, content, complexity, technique, and manner of depiction inherent in rock art. Style *analysis,* here, is taken most simply to mean the ordering of the graphic data. Thus, the core of stylistic analysis as employed here is to describe the style and its distinctive qualities, including considerations of content (motifs and themes), structure, placement, and medium. Determination of the cause for the presence or absence of the variations in the group of styles is yet another consideration.

In order to clarify style analysis as relevant to our research data, we began by investigating some of the various facets of this concept as they have been applied to other nontransportable rock carvings and paintings. We adapted methods that we felt worked best with the data available on Missouri petroglyphs and pictographs. That the concept of style is an indispensable tool in petroglyph research is an opinion expressed by Wellmann (1979a:16) and Schaafsma (1971, 1980, 1985), among others. As Amsden (1936:2) states, "While color and form are (except in their subtler manifestations) beyond dispute, design is very easy to disagree upon." This statement is true of ce-

ramic analysis but also readily applicable to research with petroglyphs and pictographs. Yet style analysis is only one of the tools that offers insight into the use of rock art (other tools include contextual analysis and ethnographic analysis, as two examples).

Schaafsma (1980:6) states, "The recognition of rock art styles is basic to the ordering of data concerning rock art. That 'human behavior is not capricious but is patterned' (Martin and Plog 1973:24) is a fundamental premise, of course, that has always underlain systematic investigations of human activity, and it has been well demonstrated that the art of any cultural group conforms to the confines of a style or a limited range of styles." Schaafsma (1980:7) continues by stating that among the major components of style in regard to rock art is the motif[1] inventory. Although local styles are generally not expected to vary as much as regional styles, minor differences in motifs and the ways in which they and any possible elements are positioned and executed can indicate different uses (functions) of a site, work of a particular carver, or the presence of different carvers.

Schaafsma (1980:8) defines rock art as "an artifactual or material record of the ideological component of a prehistoric social system." She notes that a "shared repertoire of rock art elements, figure types, figure complexes, and aesthetic modes—hence style—thus signifies participation in a given ideographic system and, in turn, in a given communication network." Schaafsma (1985:247) emphasizes that the usefulness of the identification of styles, "which in turn constitute visual systems, needs to be stressed." In short, the plan is usually to first categorize the styles and then, second, provide support for the choices.

Schapiro (1953:287) states that for the archaeologist, style is most often studied as a "symptomatic trait, like the nonaesthetic features of an artifact." It is used as a diagnostic means rather than as an important constituent of culture. He further states that style is a system through which "the personality of the artist and the broad outlook of a group are visible. It is also a vehicle of expression within the group, communicating and fixing certain values of religious, social and moral life through the emotional suggestiveness of forms. . . . The style reflects or projects the inner form of collective thinking and feeling." While we heartily agree with his assessment, we would be hesitant to emphasize "collective" simply because this does not take into account individual variation.

Franz Boas (1927), Ruth Bunzel (1938), and Gene Weltfish (1953) considered styles as primarily determined by the constraints imposed by the physical environment. The potential impact of environment on the creation of rock art is discussed in Chapter 3. In brief, we believe that environment may relate to content more than to style. The influence of environment seems

clear in the creation of rock carvings and paintings. For the creation of petro-
glyphs and pictographs to take place, there must be suitable rock surfaces.
Therefore, geological features in one of the four categories noted above (land
outcrops, river bluffs, caves/shelters, and spring outcrops) must be accessible.
The hardness of the rock would control, to some extent, the handling of the
medium. The available fauna would likely be reflected in the content of the
rock art as would indications of the ideology of the local groups.

Binford (1973, 1984a, 1984b, 1986), Dunnell (1978), Sackett (1977, 1982,
1985, 1986a, 1986b), Shanks and Tilley (1988), and Wiessner (1983, 1984, 1985)
have debated whether style can be analyzed autonomously or whether it must
always be considered within its functional context. In other words, to what
extent, if any, does function control style? Shanks and Tilley (1988:87) point
out that "the interpretive basis of the meaning of material culture provided
by traditional archaeology was undermined. Instead, material culture was
granted a fresh significance which became grafted in terms of the opposition
between two dichotomous terms: style and function." They further point out
that much of the debate in the past fifteen years "hinges on the definition
and use of these terms and whether primacy can (or should) be granted to
one or the other in an understanding of the past." It would probably be wise
to sort out the varying levels of the inseparability between function and style
based on the particular materials under consideration. Function is a very im-
portant consideration in the study of all artifacts, including petroglyphs and
pictographs. However, because rock art is created, utilized, and remains *in
situ,* we believe it must first be considered from that perspective. Function is
discussed in Chapters 6 and 7.

STYLE ANALYSES OF CULTURAL MATERIALS
AND THE ANALYSIS OF ROCK ART

Working with nontransportable artifactual material presents a dimension
of style analysis that contrasts notably with the analysis of designs on trans-
portable artifacts like pottery, lithics, and textiles. Analysis of prehistoric pot-
tery designs undertaken by Cronin (1962), Deetz (1965), Hill (1966, 1968,
1970, 1977), Longacre (1964, 1970), and others focused on social information
as reflected in design elements and their frequencies (see also Plog 1976, 1978;
Watson 1977).

Early concern with style analysis was followed by investigations of the
art subsystems, and sometimes the individual artisans of specific groups, pri-
marily historic. These studies included those of Arnold (1983), Bunzel (1972
[1929]), Hardin-Friedrich (1970), Muller (1977), Roe (1982), and Washburn
(1977). Arnold worked with the design structures in a sampling of 172 vessels

of the Shipibo-Conibo Indians of Peru. He examined the relationship of these structures to the community's main social and cultural patterns. Bunzel examined the creation of pottery in the Southwest by delving into the similarities of form and manufacture and then looking at the variations of decoration and their causes. Hardin-Friedrich worked with living artisans to determine their use of form and field and the effects of interrelational influences.

In trying to adapt methods of stylistic analysis of pottery (always confined to a specific number of forms and a variety of specific fields within those forms) to that of rock art (varying forms, fields, and surfaces, at least in Missouri), one is bound to encounter obstacles. Apparently, for this area, no rigid standards dictated the structure of most of the rock art, at least from what is observable in those pictographs and petroglyphs that have survived. In areas of the Southwest, as well as in Africa, Australia, and Venezuela, where many pictographic records have endured a less destructive climate and population, there are series of rock paintings that lend themselves better to a comparative analysis. Because this is not the situation in Missouri, where the majority of petroglyphs and pictographs differ markedly from one another, the application of style analysis is much more challenging.

In most cases, archaeologists do not have access to complete information about the manufacture of the materials that they analyze. Complete knowledge would include documentation of the maker, the maker's social group, that group's standards for artifact production, and possibly the origin of the material and the actual tools and techniques used in manufacture. In the absence of this information, we are left with the task of organizing the observable and measurable data in order to analyze it. It is acceptable to do this in more than one way, and in fact a variety of approaches have been used to analyze the same body of data. This is part of the problem that has caused confusion in analyzing rock art data. Another problem, that of the use of different words for the same attributes, is partially addressed in Appendix A, Glossary.

It is unfortunate that no analytical work of the above type has been done in Missouri as a component of any of the earlier rock art reports. Along with the cultural continuity issue, another obstacle is that artifacts from Missouri, pottery in particular, are not richly ornamented until later in the prehistoric record. Fewer than an estimated twenty percent of funerary wares are painted, judging from several of the major collections and the literature. Missouri archaeologists must rely primarily on pottery fabrication, temper, decoration, and form as bases for their analyses. There are occasional plant, animal, or human representations; some simple decorative elements (punctates, grooves, chevrons, etc.); and more infrequently motifs (quartered circle, ap-

pended circle, spiral, step motif, and equilateral cross). A small sampling of more complex graphics is available, however, in other transportable objects such as engraved catlinite tablets, bauxite figurines, hammered copper ornaments, and shell gorgets. A few of these latter items have connections to some of the state's rock art as discussed in Chapter 6.

A possible motif/content-oriented dilemma is that of determining whether the carvers or painters were male or female. Although it is generally accepted that lithic tool manufacture was a male-dominated craft and pottery a female-dominated craft, it is not known, at least in Missouri, which segment was responsible for rock art production. It could be postulated that the abundance of female motifs at a large portion of the sites indicates a female-dominated activity, and sites that contain the "pit and groove" elements, hence, could be male-produced. Conversely, the opposite can also be speculated. If the graphics were the result of shamanistic activity, it again would be difficult to ascertain whether the carver or painter was a male or female shaman. The fact that women are intricately woven into the present-day ceremonial activities of living Native American groups (Howard 1968) suggests that the creation of rock art may have been a task that was carried out by both men and women depending on the content and function of the site. Unfortunately, we cannot unequivocally link particular motifs to male or female ownership.

Returning to motifs in general, we find it puzzling that frequently used motifs such as the nested semicircles and the step design on Mississippian pottery found in our general area are almost nonexistent in the known volume of Missouri rock art. Both motifs and artifacts are generally believed to have been produced during about the same period (Carl H. Chapman, personal communication, 1985; James B. Griffin, personal communication, 1990). During the Woodland and Mississippian periods, certain design motifs enter the picture (e.g., concentric circles, interlocking circles, nested chevrons, the ogee, the spinning cross [commonly called a swastika], and the hand), and while there are some correlations with these motifs to those that appear in the state's rock art record, they are sparse, except for concentric circles.

There are, however, a substantial number of recognizable motifs, and some of the objects depicted in petroglyphs and pictographs do have their well-known and dated artifactual counterparts. The mace, the bannerstone, and the bilobed arrow seen in Missouri's petroglyphs and pictographs have their equivalent in artifacts from our region (see Chapter 6). Unfortunately, relatively few of these motifs appear on the state's ceramics, and it is the ceramic inventory in many areas that offers the best source for relative dating and for comparison of diagnostic motifs and symbols. In place of this missing cul-

tural resource, we have had to rely on materials from associated areas, such as the shell engravings found at Oklahoma sites.

Although there are methods in the design analysis of ceramics to discern social interaction between households, there is no widely recognized means of measuring the amount of interaction between groups creating rock art. Theoretically, one could, as is done for decorated ceramics, compare the motifs or elements used and assess the similarity of content and/or compare the placement and organization of the graphics in the panel, that is, the structure. Hodder (1987b:41), however, reminds us that "design structure may have different meanings in different cultural contexts." While design structure can be described, assigning meaning to variations in structure is problematical (see Fischer 1971 for a thought-provoking attempt).

Similarity in the basic structure of graphic communications in two different areas could reflect interaction. In regard to ceramic variability, Plog (1976:9) proposes that "the amount of design transmission between individuals will be directly proportional to the amount of interaction between them." Although his work was in reference to ceramics, the same principle could be applied to petroglyphs and pictographs.

Wiessner (1985) has a somewhat different viewpoint that is more appropriate to the analysis of rock art. She describes style creation not solely as a functional phenomenon but rather as part of a complex sociopolitical process. She states, "In this process, people compare their ways of making and decorating artifacts with those of others and then imitate, differentiate, ignore, or in some way comment on how aspects of the maker or bearer related to their own social and personal identities. Style is thus not acquired and developed through routine duplication of certain standard types, but through dynamic comparison of artifacts and corresponding social attributes of their makers" (Wiessner 1985:161).

This concept of a dynamic process in style creation seems to fit the realm of rock art, because in this case, function is more likely to control content with style as a secondary variable. Stylistic variation can also be attributable to other factors, such as expertise and/or personal preference of carver or painter, symbol systems characterizing a group and/or time period, and possible style templates in vogue. It is important to note that whereas the classification of ceramics often results in large quantities of specific types, every rock art site in Missouri is unique, even when there are similar motifs between sites. For example, if we observe a pecked style, most likely the technique of pecking was used because of the hardness of the base stone (i.e., control of the medium over the carver). Imagine, however, the complexity of one factor. If the carver prefers, despite the hardness of the rock surface, to

incise the surface even if it takes three times as long, is the medium still controlling the outcome and the style? Alternatively, one carver may find ease in incising extremely hard stone because of a personal preference and years of experience, whereas another pecks the stone because of lack of experience or lack of time. These are unknown factors that could be consequential in the creation of a style.

STYLE AND COMMUNICATION OR INFORMATION EXCHANGE

A very general but much quoted statement by Schapiro (1953:304) seems to take a position in sympathy with our view that rock art, in regard to style, is most fundamentally a means of communication:

> Style, then, is the means of communication, a language not only as a system of devices for conveying a precise message by representing or symbolizing objects and actions but also as a qualitative whole that is capable of suggesting the diffuse connotations as well and intensifying the associated intrinsic effects. By an effort of imagination based on experience of his medium, the artist discovers the elements and formal relationships that will express the values of the content and look right artistically. Of all the attempts made in this direction, the most successful will be repeated and developed as a norm.

This statement is often used by those undertaking style analyses of cultural materials, including rock art, and while it has only a general implication to our approach, we include it for its reference to "communication" and the last sentence about creation of a "norm." The concept is possibly better explained by Wiessner (above). We agree, however, with the notion of the existence or development of norms and the question of whether variability is a result of cultural templates or of normative behavior. However, this broaches another issue: did the norm develop from intentional repetition, or because of preference, or as a result of some other unknown controlling factors? This is where individual preferences enter the picture and provide, in the analyses of ceramic and lithic materials, a viable avenue of inquiry and information (Hill and Gunn 1977).

Using style analysis to isolate the individual artist would appear to be much more complex in the arena of rock art than it is in the manufacture of pottery or shell ornaments. The difference is that with pottery, for example, there are depositional patterns that can be correlated to types. Without that horizontal/vertical spatial factor, a rock art site is essentially isolated in both time and space. Furthermore, because a number of pictograph sites have

weathered away, we are left with a predominance of petroglyphs and a some-
what biased data base. The identification of the individual carver or painter
was not a research question of this project. We mention it, however, because
it is an issue that often arises in the analysis of transportable artifacts.

If the carver or painter is controlled by the limitations of the media, as was
suggested by Boas (1927:78–79), then part of the resultant style will be de-
pendent on those media. In other words, there are limitations placed upon
the craftsperson according to the type of stone, the tool kit, and the carver's
or painter's ability and expertise in working with a particular medium, as
discussed above. The most obvious difference among the media is that of
the field or panel into which the motifs are carved or onto which they are
painted. The form itself is not humanly made, as with ceramic vessel manu-
facture, but provided by nature. The carver or painter is not working with a
personally created shape or form but with an essentially asymmetrical canvas
in the form of an *in situ* boulder, bluff, or cave wall. Media are discussed in
more detail below.

It is known for some areas of rock art activity, for example in Australia
and Africa, that because of a location's ceremonial importance, successive
generations continue to paint or carve at that particular site. Godden and
Malnic (1982:20) comment that the Australian aboriginal people believe that
the spirit powers originally *painted themselves* on the rock a long time ago:
"men merely renew the images." This is also evident in the Southwest where
there are variations in the repatination of rock surfaces indicating continued
or long-term activity. The reason for this could have been a change in the
symbols, adoption of a neighboring group's oral tradition or ritual, or sim-
ply additions to reflect current events. Therefore, it would hardly be possible
to isolate the carvings of an individual craftsperson. Moreover, in Missouri,
weathering often renders the outdoor graphics unidentifiable regarding tech-
nique of execution. Brush strokes in pictographs would be undiscernible, and
fine demarcations in the carving of petroglyphs would be obliterated by vari-
ous types of weathering such as water runoff and by biological encroach-
ment, exfoliation, and vandalism.

One of the most pragmatic and influential approaches and explanations
regarding the relation of style to communication or information exchange is
the 1977 paper by Wobst, in which he discusses the many factors that can
influence the message function of an artifact's style and the variables involved
in an artifact's audience. Wobst points out that "stylistic messaging" can stem
from a variety of behavioral sources. In some cases the Missouri petroglyphs
and pictographs appear to have been executed for the purpose of information
exchange (i.e., information on local fauna and hunting methods, ceremony,
identification of a site or area per resources or clan ownership, relaying a nar-

rative or group oral tradition). Accordingly, style, insofar as it constitutes a portion of the content (e.g., naturalistic=zoomorphic=hunting information), may be said to have a bearing on function.

In some cases the graphics are believed to suggest fertility and human procreation, such as the so-called multiple birth scenes at the Maddin Creek site (Wellmann 1970a) and the frequently observed depictions of what appear to be male and female genitalia. In other cases, the designs are abstract, geometric motifs, and thus can be analyzed only through their variations in form, placement, and associations. Forge (1973:xviii) considers the possibility that such graphics are "self-contained systems of communication acting directly on the beholder" and not meant to be verbally translated. In other words, they are encoded with symbolism, meaning, and/or power.

STYLE ANALYSIS AND MISSOURI ROCK ART

As pointed out by Schaafsma (1985:252), no detailed stylistic analysis of any rock art region in the Eastern Woodlands has ever been carried out, although there are a number of descriptive reports. The best known report, that of Swauger (1984), and the more recent work of Coy et al. (1997) do not address style analysis at all. In short, we are breaking new ground. While this is an exciting task, it is also very difficult because comparative material is almost entirely lacking. There is such disparity in style analyses of rock art in general that it appears each researcher redefines style, or at least how he or she will apply it to a body of data.

Grant, who published the first major synthesis of North American rock art in 1967 (Grant 1981), refers to a style group that is concentrated in eastern Missouri, southern Illinois, a portion of northern Arkansas, and the western part of the Tennessee River Valley. He calls this group "Mississippi Stylized" (Grant 1981:144) and lists the attributes for this style as "batons, bi-lobed arrows, various abstract forms." Unfortunately, both petroglyph photographs in his illustrations (Grant 1981:138) are erroneously labeled as being "northeastern" in the state when they are actually from southeastern Missouri sites. This appears to have somewhat skewed his style map (Grant 1981:22). His assessment of the major sites in eastern Missouri, moreover, is necessarily very generalized because he is describing the entire North American continent.

Wellmann (1979a:156), the only other scholar who discusses Missouri rock art style in any detail, does not seem to challenge Grant's "Mississippi Stylized" as the prevailing style. He maintains that the rock art in Missouri and southern Illinois belongs to the Late Woodland period of A.D. 400 to 900 or to the subsequent Mississippian period. He discusses, and places emphasis on, many of the graphics in regard to motifs recognizable in the Southeast-

ern Ceremonial Complex. He does not, however, try to distinguish separate groups within this major category. Like Grant's work, Wellmann's is a general overview, although he offers much more detail and commentary than does Grant.

Previously determined diagnostic motifs that could assist in dating the graphics are generally lacking, but there are a few at a selected number of sites, most notably the Mississippian motifs at the Lost Creek, Washington State Park A and B, Three Hills Creek, and Wallen Creek sites. Motifs seen in the rock art do not often correlate well with those found on the transportable artifacts such as pottery and carved bone, although we have a wealth of motifs as depicted in such collections as the shell engravings from Spiro, Oklahoma. In fact, each medium may utilize very different motifs simply because of differences in how those artifacts were used. We cannot be certain of the reason, but there are some motifs specific to each of the two rock art media, carving and painting (e.g., "turkey tracks" or "tridents" frequently seen in petroglyphs are lacking representation in the state's known pictographs). This is discussed in detail below in the section on media. It is difficult to assess a motif's level of schematization. Another consideration is that motifs in Missouri rock art are primarily naturalistic and representational. Abstract motifs constitute a definite minority, if one does not include (as some researchers do) the basic elements of dots and certain geometrics.

METHOD OF STYLE ANALYSIS
FOR MISSOURI ROCK ART

The basic assumption that we use in this study is that graphic expressions were executed to communicate or transmit information. Dondis (1974:104), in discussing visual techniques and communication strategies, explains that

> The end result of all visual experience, in nature but primarily in design, lies in the interaction of duplex polarities: first, the forces of content (message and meaning) and form (design, medium, and arrangement); and second, the effect on each other of the articulator (designer, artist, craftsman) and the receiver (audience). In either case, one cannot be separated from the other. Form is affected by content; content is affected by form. The message is cast by the creator and modified by the observer.

In this sense, function can be viewed as an integral part of style on the premise that form follows function. The expressions could include many varieties of information from complex to simple: from a story composition in multiple layers to the signature of a single person. Thus, we are consider-

ing petroglyphs and pictographs in their functional capacity. Encapsulated within this functional capacity are the selective principles, adapted from Levine (1957:954–55), that are used by the producer of the graphics. These include the following:

1. Motifs: subject matter or content, which might produce a theme singly or in combination with other motifs,

2. Structure[2]: placement and arrangement of motifs within the entire field (or a motif's juxtaposition to other motifs), and

3. Manner[3] of depiction, form, or presentation (referred to by Schapiro [1953:287] as "expression").

While the first category has been discussed in the previous section, the second and third require additional explanation. Manner indicates the distinction, for example, between simply carving an outline of a motif or carving intaglio fashion (which requires more time). Another example would be that of roughly scratching in a design as opposed to carefully incising or painting it and filling the fields with a pattern or solid color. A further distinction would be the level of mastery the carver or painter had over both the media and the renderings. Are the graphics painted or carved with an obvious show of expertise, or are they simply roughed in? In regard to an analysis of structure, we illustrate the variations in Missouri rock art by the use of graphics and refer the reader to Figure 5.1.

Two important variables that must accompany the above defining categories of structural placement are media and location. Although the former is considered by several scholars to control style to some extent, we prefer to keep it as a variable in style development. We are not certain why a particular carver, shaman, vision quester, or other communicator chose one rock wall over another or one shelter over a dozen others in a particular canyon.

Whether a site was deemed a "sacred place" because of an important planned or unplanned event that occurred at that spot or because the rock art *made* it sacred we cannot know. Why the person chose to carve rather than paint the motifs is another unknown. This could have been associated with the purpose or function of the graphic panel, but then again it could have simply been a matter of availability of pigments or personal preference. Location and the possible sacredness of these sites were looked at in Chapter 4 under the discussion of context.

Because of the large quantity of graphic material in our data base we found it necessary to sample the rock art for the stylistic analysis. All petroglyphs and pictographs, however, were translated to line drawings (Diaz-Granados 1993:appendix D). A sampling of fifty-eight frequently occurring motifs and elements (Figures 5.2 through 5.10) was assembled for the purpose

Figure 5.1. Structural variations in Missouri rock art.

of comparison, discussion, and investigation. Although only about half of the sites were used for the detailed analysis, many of the others are referenced throughout. This semiformalistic approach takes into account the naturalistic, stylized, representational, and abstract motifs and elements and considers their associations, patterning, and the possible influence of the environment on their production and use. Styles are offered as tentative categories in order to allow flexibility and expansion as additional sites are located.

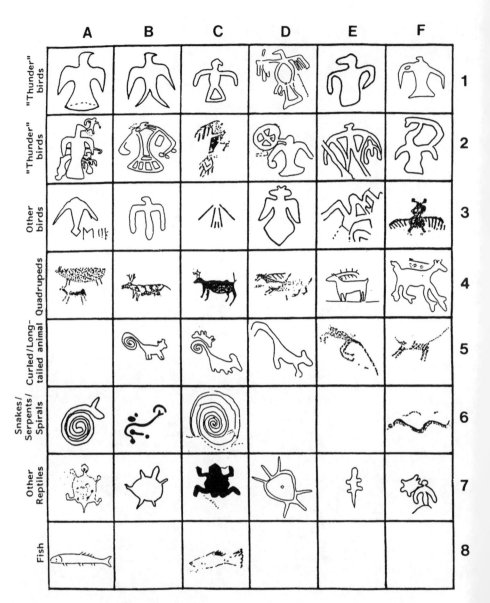

Figure 5.2. Bird and animal motifs.

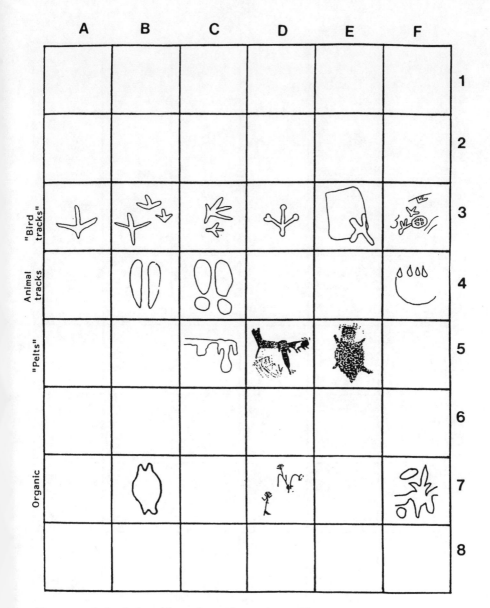

Figure 5.3. Animals (cont'd), tracks, and organic motifs.

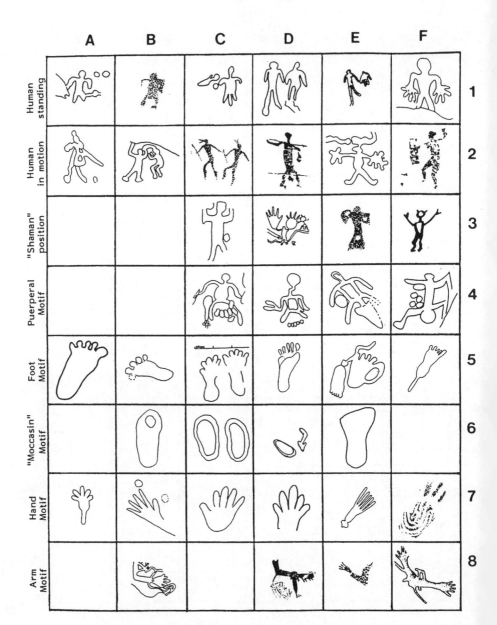

Figure 5.4. Anthropomorphic motifs.

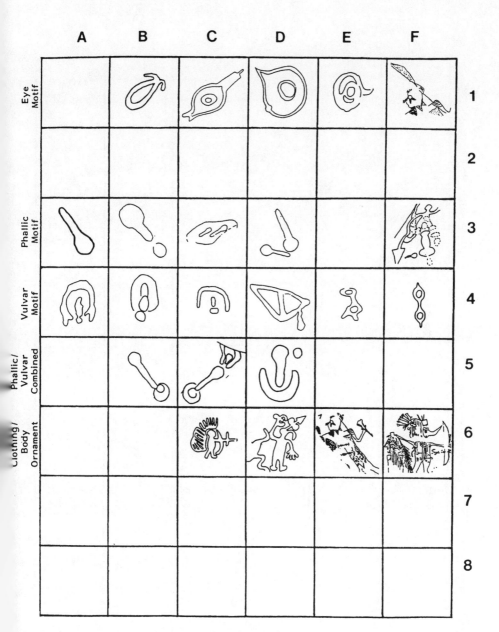

Figure 5.5. Anthropomorphic (cont'd) and related motifs.

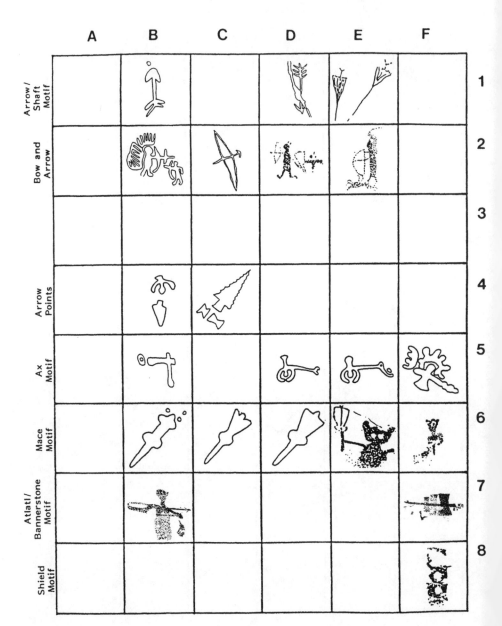

Figure 5.6. Weapons and related motifs.

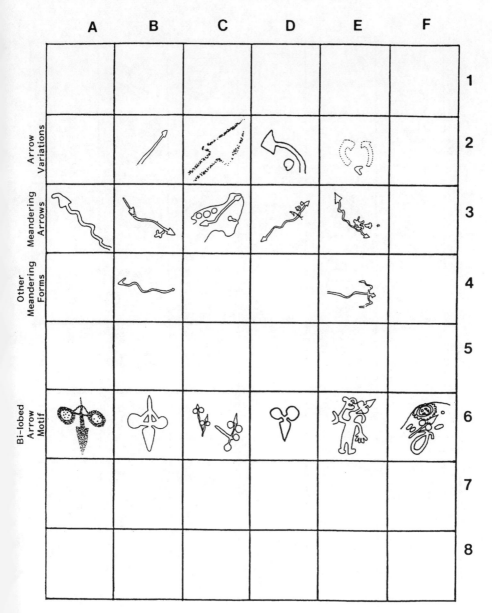

Figure 5.7. Arrows and related motifs.

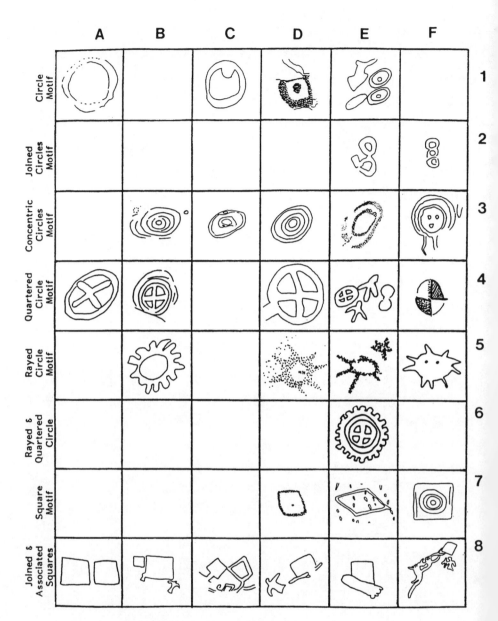

Figure 5.8. Geometric and abstract motifs.

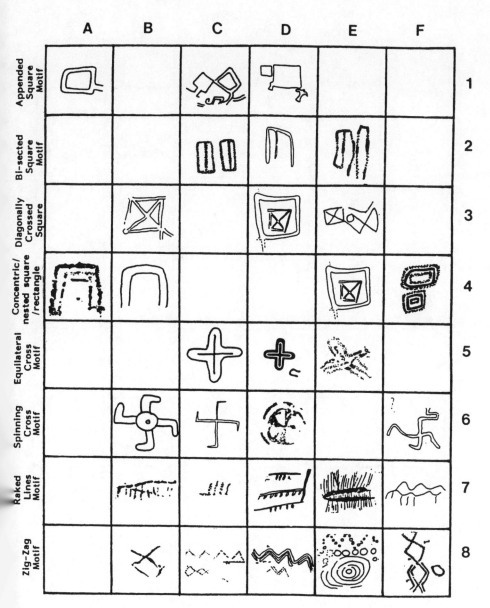

Figure 5.9. Geometric and abstract motifs (cont'd).

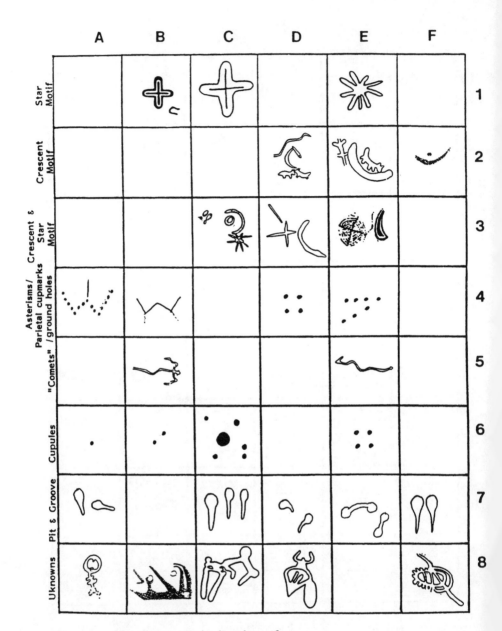

Figure 5.10. Miscellaneous and celestial motifs.

Media: Petroglyphs versus Pictographs, Rendering Techniques, and Pigments

In discussing media as they relate to rock art, we are addressing a more objective category than when working with motifs and the content or subject matter of the rock art. Not only are considerations of media more objective, but also they can lend themselves to more rigorous scientific investigation. Pigments can be removed (or not removed) and chemically analyzed and, of course, pictographs can be subjected to ultraviolet or infrared photography to bring out faded areas or to distinguish paints with varying compositions. Work with pigment analysis has been carried out by Clottes (Wilford 1990a), Lorblanchet (1991), and Russ, Hyman, and Rowe (1992), among others.

In regard to petroglyphs, the investigative possibilities are not as great. The primary approach is to examine the manner of carving, incising, or abrading. If the rendering remains clear and has escaped the devastation of weathering and vandalism, these techniques can be analyzed for line width, length, and depth and repetition of particular elements or motifs.

The Petroglyphs

Petroglyphs can be carved, incised, pecked, abraded, ground, or scratched and are the most durable of the media used in rock art renderings. While more plentiful in Missouri than pictographs, they seem to be more enigmatic. We can fathom paints mixed from minerals and organic substances being used to produce the pictographs and applied with a variety of implements (e.g., plant or animal fibers, a stick, fingers, bone pipe). However, while it is obvious that a hard rock implement must have been used to create the petroglyphs, the actual tools employed are basically unknown. It is speculated by Magre (personal communication, 1989) that quartzite (#7 on the Mohs hardness scale) was used when available, because it is plentiful at the Washington State Park and Three Hills Creek sites as well as at other sites in the southeastern part of the state. Both large and small pieces lie on the ground surrounding the carved outcrops. Dick Wichern of the Marion-Ralls Archaeological Society believed a tool found below the Rocky Hollow Site #1 when his group made casts in the late 1930s was used to produce the carvings at that location. The tool is a worked chert flake, 5.5 × 9.5 centimeters, and resembles the shape of a comma. It is illustrated in Diaz-Granados (1983:23).

In 1983, during the Rocky Hollow project, we conducted an experiment to determine how much time would have been required to create a bird motif typical of those carved into the sandstone at Rocky Hollow #1 (similar experiments have been carried out by Bard and Busby [1974] and Busby et al.

[1978]). Using fragments of chert of varying sizes, we incised a small bird, approximately 12 × 8 centimeters, into the vertical section of a boulder of Warrensburg sandstone that was situated a half mile east of the site. Working steadily, we found that the outlining, incising, and abrading of the body area, intaglio style, required only twenty-two minutes. The experiment provided an estimate of the amount of time required to incise and carve, intaglio fashion, an average-sized motif in the style of motifs executed at the nearby Rocky Hollow site. The motifs carved exclusively in outline style would have required only an estimated ten minutes. Working on some limestones, granite, or any of the harder rocks would have required additional time and probably a pecking technique rather than incising and abrading. Working in sandstone to produce a considerable-sized panel of motifs, however, would not have required an inordinate amount of time.

Ninety-six petroglyph sites were reported in the original study (Diaz-Granados 1993). The majority of the petroglyphs are worn. Many have been vandalized to varying degrees with small boulders completely removed or sections cut out. Those that fall into the "worn" category are impossible to "read" in regard to rendering techniques. The word *worn* can be quite subjective, but one need only observe the extensive petroglyph grouping at Site B in Washington State Park to see the condition of severely worn carvings.

The Site A petroglyph grouping was considered valuable enough in the 1960s by the state park division to merit building an open-sided shelter and boardwalk over them. Below the translucent roof the boardwalk extends on a central axis along, and a few feet over, the two major rows of low-lying, carved outcrops. This structure has been reasonably effective in keeping the general public from walking on the petroglyphs. People who see them today, however, are surprised at how faint they are: some are nearly invisible. This is because, in the 1960s, the petroglyphs were regularly "cleaned"—actually scrubbed with a wire brush by the site caretaker, resulting in the removal of much of the dark patina still evident on boulders surrounding the shelter. More recently, it was noted that the petroglyphs were being swept in the fall to remove the leaves for better visitor viewing. These actions have resulted in the removal of much of the cortex along with many of the once sharp and well-defined lines evident in early photographs. Surface grains, along with any graphic details, have been removed down to the natural yellow-buff color of the Derby-Doerun formation and only the barest outlines remain on many of the carvings.

The group of petroglyphs at Washington State Park Site B are quite worn from natural weathering but mostly from people walking on them. The same applies to Site C, which we discovered across Highway 21 from the major

grouping. It was no doubt a part of the original site before the highway construction came through. Local residents tell us that many carved boulders were destroyed when Highway 21 was constructed.

The above discussion is just one example, by no means rare, meant to emphasize the fact that most of Missouri's petroglyphs are in poor condition. If the petroglyphs are in an area of modern human activity, they will certainly be adversely affected. If they are in extremely remote locations, they may be in a somewhat better situation, but not necessarily so. The Maddin Creek petroglyphs in Washington County are in a relatively inaccessible location; yet, they are excessively worn from human activity as well as from biological encroachment.

There are a few petroglyphs on less friable rock than the arenaceous dolomites and sandstones on which the major sites are located. Most notable is the Commerce Eagle. Despite being accessible and periodically under water, it has endured to the point that one can still see the peck marks. Almost all other petroglyphs in Missouri are seriously worn. Some of those that are either within a sheltered natural environment or on an angled vertical wall that slants back at its base may remain in stable condition. These include the Bushberg-Meissner Cave, Mitchell, Sharpsburg, and Tobin-Reed sites. Poor site management and outright vandalism, coupled with natural weathering processes to which the sites are exposed, mean not only is it difficult to impossible to assess rendering techniques, but also that very few sites are expected to endure beyond the next few decades.

The Pictographs

Pictographs or rock paintings, as they are often termed (Bahn and Vertut [1988] say "coloured drawings"), are a medium very different from that of petroglyphs. Here we are dealing with an "additive" procedure in which pigments are usually ground, mixed with a binder, and then applied by brush, stick, finger(s), feather, or bone. Lewis-Williams (1983:24) describes the use by Bushmen of fine hollowed bones filled with paint. He also suggests that early creators of these graphics sought out porous stone knowing its high absorption qualities (Lewis-Williams 1983:25). While the carving, incising, or abrading involved in petroglyph manufacture was found not to require an exorbitant amount of time, the paintings may have required even less in some cases (not taking into account the grinding and mixing of pigments and securing of the materials). As Bahn and Vertut (1988:105) comment, they were "undoubtedly quick and easy things to do" for a person of experience. For example, Michel Lorblanchet (1991) reproduced the "Frise Noire" of Pech Merle (twenty-five animals measuring 7 × 2.5 meters) on another cave wall "lit by

a lamp in his left hand. Each figure took an average of 1–4 minutes . . . the whole frieze required about an hour, including initial sketching with a stick." Of course, each painted graphic, depending on its intricacy, size, amount of fill, and so on, would require considerably varying amounts of time to complete, and this does not allow for the conception and planning.

There are forty-four pictograph sites reported in this study, less than half the number of petroglyph sites recorded for the state. The discrepancy can most likely be credited to the destruction of sites by weathering rather than to any other factor. We are not discounting the possibility that there could be cultural factors, in light of the high density of pictograph sites in places such as Petit Jean Mountain in Arkansas (Fritz and Ray 1982:252) and numerous sites in the Southwest. While the petroglyphs have survived and are, for the most part, still identifiable (at least many of the motifs can be discerned), the pictographs, unless protected within a cave, shelter, or under a cap rock, are very faint or have disappeared except for a few scattered remnants of color. This situation may create a bias, but it should not halt research.

It is not unusual for an exposed pictograph site to contain together with a few identifiable motifs many more that have faded beyond recognition. The only two exceptions to this generalization are the Lost Creek site, which contains a still visible bilobed arrow and "sun symbol," and possibly the Painted Rock site. The Torbett Spring–Rocheport site pictographs that were reported by the Lewis and Clark expedition, among others (see Chapter 2), are on an exposed bluff and although they are seriously faded, portions of the reported motifs remain visible. The White Rock Bluff pictographs likewise are very faint. Perhaps these sites are preserved because the pigments were absorbed by the sandstone surface under optimal conditions for the chemical process to occur that binds them to the stone.

Pigments

A separate research project is needed to investigate the various pigments and to determine their composition. It is likely, however, that Missouri pigments are comparable to those used by Native Americans in surrounding regions, because the state has comparable animal and mineral resources. The most common colors used in Missouri's pictographs are shades of red, including dark red, brownish-red, rust-red, orange-red, and pink-red; blacks include shades of blue-black and grey-black. The minerals from which the red pigments were created include hematite, iron oxides, red ochres, and possibly limonite. Yellow ochres, when heated beyond 250 degrees Centigrade, pass through different shades of red as they oxidize into hematite (Bahn and Vertut 1988:100). Trubitt (1996:192–94) discusses the possibility that some of

the exotic raw minerals found in the Cahokia area, including hematite, came from the Missouri region.

The use of red ocher pigments in the southeastern United States was significant during the protohistoric and surely the prehistoric periods. Hudson (1976) discusses the importance of the use of red ocher pigment with regard to the southeastern Indians. He notes that according to John Swanton's informants, Creek hunters carried red ocher pigment in their buckskin pouches. They used the ocher to mark their eyes with the probable forked-eye design, allegedly to improve their vision and attract game and/or members of the opposite sex (Hudson 1976:129, 168). A plummet made from red ocher could be used for divining a lost person or object (Hudson 1976:354). Red ochre was also apparently used to fill the engraved designs on stone discs (Hudson 1976:392, 295).

Lewis-Williams (1983:25), in reference to Australian pictographs, mentions it was revealed in an ethnographic account that hematite was sometimes mixed with the blood of a sacrificed animal. Black pigments were probably derived from mixtures composed primarily of charcoal/carbon, although iron/manganese oxides are another possibility. In the one known case of white pigment at Picture Cave #1, possibly burnt bone, kaolinite, or crushed shell was used, but no chemical analysis has yet been performed.

Hamell (1992:455), who writes on color symbolism of the Iroquois and other northeastern groups, views white as the most important color: "Light (sources), bright (reflective), and white things are tangible metaphors for abstractions of greatest cultural value: for life itself, and for positive states of physical, social, and spiritual well-being. . . . Within ritual contexts, these concepts of well-being have traditionally constelled about white shell." He later emphasizes that white shell "functions as a metaphor for light, and thus for life itself" (Hamell 1992:457). This statement brings to mind the important figure buried in Mound 72 at Cahokia Mounds on a blanket of more than 20,000 marine shell disc beads.

The other predominant colors are red and black, the major colors in Missouri's pictographs. Hamell summarizes these three colors as potentially organizing "ritual states-of-being" with "white social states-of-being, black asocial states-of-being, and red anti-social states-of-being" (Hamell 1992:456). The symbolic significance of the colors within the state's pictographs is not readily obvious, so it is difficult to assign meaning such as red equals day and black equals night, or red is life and black is death, and so on. However, we believe that the colors, as well as the compositions, of the pigments used were meaningful to the painter and his or her group.

Wilford (1990a:B9) notes that "some styles of painting persist 1,000 or 2,000 years, but we see more changes in the paint recipes," adding that the

main variation in the recipes was the substance used for the extender. He reports that to analyze the paintings scientists used electron microscopes with x-ray attachments and mass spectrometers designed to separate and identify individual chemical elements in samples "no larger than the tip of a needle." Although no analysis of pigment composition has yet been attempted for the Missouri pictographs, from the variety of shades, both red and black, we would judge that there were many different "recipes." Some of the differentiation in colors may also be attributable to the sandstone matrix or binder used. Nevertheless, there is a great range of colors, particularly within the red spectrum. At extensive sites in which there is series of pictographs, such as those seen at the Deer Run Shelter or the White Rock Bluff sites, several different shades are found at each site.

Whether varying shades of red at a singular site are the result of different "batches" of pigments mixed at different times or whether there is any significance in the shade itself cannot be determined with the present state of knowledge. Wilford asks whether the differences in pigment recipes were expressions of cultural values. He relates that French scientists ponder "if each prehistoric artist or group of artists had its own hallmark paint recipes just as did the studios of Renaissance Italy." Another speculation is that "women might have used one recipe and men another, or . . . different paints might be concocted for artistic expressions associated with spring or autumn ceremonies" (Wilford 1990a:B5). He notes in his article that Clottes, in analyzing the different pigments, indicates that chronology was responsible for at least part of the explanation.

The majority of Missouri's surviving pictographs contain a predominance of red pigments, as discussed above. This is evident, for example, at the Frumet, Katy Trail, Lost Creek, Lost Creek Shelter, Salt River, Torbett Spring–Rocheport, White Rock Bluff, and Willenberg Shelter sites, and in fact at most of the major sites. The panels at Picture Caves #1 and #2 are rendered in mostly black pigments. Singularly depicted animals are almost invariably portrayed in red pigment. These include, for example, those at the Frumet, Loutre River, Painted Rock, and Paydown Deer sites. Interestingly, the rattlesnake at the Rattlesnake Bluff site is executed in black, whereas the adjacent "dancing warrior" is done completely in red pigment. Other faded areas of pigment surrounding the human figure are also red, sometimes varying in shade. The most unusual site is at First Creek Shelter #1, where some motifs consist of lines painted in alternating red and black pigments.

MISSOURI ROCK ART STYLES

Missouri's rock art sites, many being extremely complex, required considerable time to sort. The complexity may be due, in part, to the fact that an

entire state was being considered, whereas most surveys cover smaller homo-geneous areas of rock art clusters. A wide range of sites was found within the 69,000-square-mile region. Along with the greater expanse of sites in a vari-ety of diverse physiographic and ecological regions, another factor colors the picture. It is generally believed that the state was not only home to the Mis-souri and Osage groups but also that other groups claimed land during cer-tain periods or seasons and had their bases or used the trails/game trails in various parts of the state. This factor of diversity is discussed throughout and particularly in Chapter 7.

Rendering techniques for rock art in some states are clearly evident, such as those in the Glen Canyon region of Utah (Schaafsma 1971), but this is not the case in our area. Originally, we had intended to include a major section on analysis of the rendering techniques observed at each site. Unfortunately, because most of the graphics are so seriously worn, as discussed earlier, ac-tual rendering techniques, other than the most basic divisions (i.e., incised, ground, painted), are rarely discernible, and thus there is no inventory-wide basis for comparison. In the few cases in which rendering technique is appar-ent, it has been noted. Lundy (1974:259–60) did not find rendering tech-niques particularly significant in making style distinctions among the rock art of the Northwest Coast.

Without the advantage of obvious rendering techniques, the problem of identifying rock art styles was to define those areas in which the graphics were similar and around which specific groupings could be defined. In order to measure similarities we needed to sort out the attributes that distinguished each style. In other words, we had to select attributes comparable among sites and group them into a descriptive style, while isolating those sites with at-tributes singularly distinct from all others. This step was difficult, partly be-cause of the paucity of similar work in the eastern United States and partly because we had to rely on work done in the Southwest and other parts of the world where the sites are quite different. While there are several approaches from which to choose, few fit the data found in Missouri.

Washburn (1977:5) states in her landmark work on design analysis through symmetry classification that

> In an effort to move forward with the business of analysis, archaeologists have developed a variety of classificatory schemes without first inquiring into the nature of the process of classification, the nature of the data being classified and the nature of the questions being asked of the data. Archaeologists have borrowed a classification system—taxonomy—without understanding that it is unsuitable for the analysis of certain aspects of the human cultural system. With the shift in research emphasis toward investigations of one specific facet of a culture, classifications that illuminate only the broad outlines of the his-

torical sequence of events in a culture have become methodologically inappropriate.

She proposes choosing attributes for their relevance to one's specific problem. Similarly, Watson, LeBlanc, and Redman (1984:210) state, "One's choice of attributes should never be arbitrary but should depend on one's purpose."

With more than 140 sites scattered over three-fourths of the state, we decided to begin by focusing on the attributes of the *major* concentrations. We have also included large or complex single sites that appear significant because of their content (e.g., a single, complex site or one that contains a major Mississippian motif or motifs). Thus, the selection of formal attributes that we apply here to identify rock art styles is basic to ordering data on rock art. Our approach could be called "semiformal." We can appreciate the formal approach of Gardin (1980:68) in which he makes his selections on either intrinsic or extrinsic attributes that are involved. In short, the "intrinsic" attributes include "the 'physics' of objects" relating to techniques of fabrication or decoration; "the 'geometry' of objects," that is shapes, dimensions, profiles, and so on; and "the 'semiotics' of objects," that is ornament, iconographical representations, and so on. Extrinsic attributes include "chronological indications of all kinds," locational considerations, and function of an item/items. To each one of these attributes Gardin assigns a code letter, such as *T* for time. These codes are combined in an elaborate formula for analysis of archaeological constructions (Gardin 1980:9, fig. 3).

We have laid out our "semiformal" system differently and in a manner more specific to the problems of analyzing Missouri's rock art. Nevertheless, because of its structuring there is no reason this system cannot be applied to the graphics of any locality. For the purpose of this study, Missouri rock art sites are separated into three major style categories that we have tentatively labeled *Primary styles, Limited styles,* and *Quasi-styles;* a fourth category, *Substyle,* is used for small sites that can be included under one of the other three headings. The substyle deviates on one or more attributes, but the similarities outweigh the deviations and are not sufficient to command a separate style category at this time. In turn, style groupings are given designations that are associated to their major style site as well as assigned a general locational term (e.g., Big Five [Southeastern] Primary style).

Primary styles are those composed of multiple groupings with similar content, theme, structure, and manner (see Appendix A, Glossary, for definitions of these terms). There are two clusters of petroglyph sites included under this label: a southeast grouping of five sites (plus satellite sites) and a northeast grouping of four sites (with one satellite site). These two groups of sites are obviously connected, as discussed below. With 140 sites, it may seem odd that only two major styles have been identified. There are other groupings in-

cluded under the other style categories. Nevertheless, certainty that a major style category can be identified is currently confined to a distinct northern and distinct southern grouping.

On the other hand, we have taken several major sites, mostly pictographs, and labeled them Limited styles. These are singular sites that are obviously significant in regard to their size, complexity, and content, but for which there are no known related sites in the state. According to the Schaafsmas, "One site can certainly represent a style" (Curtis Schaafsma, personal communication, January 1993). Polly Schaafsma adds that "if you have one site and only one in a distinct style, you can undoubtedly expect that more will turn up, since style is a cultural phenomenon" (personal communication, February 3, 1993). These distinct sites are usually complex in structure. Other sites may be discovered that correlate with these sites, including rock art in bordering states, and that may modify the style description. For example, Picture Cave #1 is a Limited style site, but one with similarities to the graphics at the Gottschall site in southwestern Wisconsin.

The third style category, that of *Quasi-styles,* includes sites that repeat a motif or group of motifs, and usually a general technique, but that are not large or complex enough to enable detailed comparisons with other sites. While two major groups contain graphics that are observably homogeneous (the Primary styles), most other sites are unique. After much soul-searching, we came to the conclusion that it would be inappropriate to lump into mega-categories styles that are not truly analogous. It is often a matter of judgment whether to place these sites under the Quasi-style heading or simply to include them as a substyle. Within the Quasi-style category are small, single-motif sites, such as those along the Mississippi River that exhibit single footprints (Anheuser, St. Louis Riverfront, Herrell sites). While there are some commonalities among a selection of these sites, they are not sufficient to merit a full-scale style category; hence the Quasi-style label.

In relation to this, in reasonably close physical proximity but with totally different placement, motifs, and structure are still other groups of sites. There are sites in southwestern Illinois, northern Arkansas—even Wisconsin—that more closely parallel some of the Missouri sites than do other sites within the state. As more surveys are completed, sites in these conterminous states may eventually tie in to Missouri's Limited style sites. For now we remain essentially within the political boundaries of Missouri in the discussion of styles (with the exception of the Piasa site in Illinois and the Gottschall site in Wisconsin).

We have identified two Primary petroglyph styles, six Limited petroglyph styles, and two Quasi petroglyph styles (see Table 5.1). Within the pictograph category, there presently appear to be no Primary styles, but six Limited and four Quasi styles. As mentioned elsewhere, the comparative scarcity of pic-

Table 5.1. Missouri Rock Art Styles (a preliminary grouping)

Petroglyph Styles

1. Big Five (Southeastern) Primary style
2. Salt River (Northeastern) Primary style

3. Thousand Hills State Park (North) Limited style
4. Central East Limited style (Peene-Murat)
5. Central-A Limited style (Miller's Cave)
6. Central-B Limited style (Lohraff)
7. West Central Limited style (Tobin-Reed)
8. Western Limited style (Pigeon Hollow)

9. Mississippi River (Eastern Riverine-A) Quasi-style
10. Mississippi River Bluffs (Eastern Riverine-B) Quasi-style

Pictograph Styles

1. Picture Cave (Eastern) Limited style
2. First Creek (East Central) Limited style
3. Salt River (Northeastern) Limited style
4. White Rock Bluff (South) Limited style
5. Deer Run Shelter (Southeast) Limited style
6. Willenburg Shelter (Central-A) Limited style

7. Lost Creek (Southeast-Central) Quasi-style
8. Missouri River (Central-B) Quasi-style
9. Piney River (Central-C) Quasi-style
10. Paydown/Painted (West Central) Quasi-style

tograph sites makes the division of styles within that category more tenuous and challenging. Our criteria for the above divisions include five major variables: (1) media, (2) location, (3) motifs (that may in combination produce a theme), (4) manner of execution (outline, intaglio), and (5) structure (layout, arrangement and orientation of motifs within the panel/field). The motifs category is divided into primary and secondary motifs. This simply means that primary motifs are those that dominate the site by shear number and/or size. Secondary motifs are those that appear occasionally, although there may be only one at a site.

There are two *combination styles/site types* included in the inventory that are listed loosely by medium and rendering techniques. They are (1) painted petroglyphs and (2) a combination of petroglyphs and pictographs at a single site. There are seven such sites presently known. Three major sites fit the first category: Rocky Hollow, Mitchell, and Sharpsburg. We have placed these

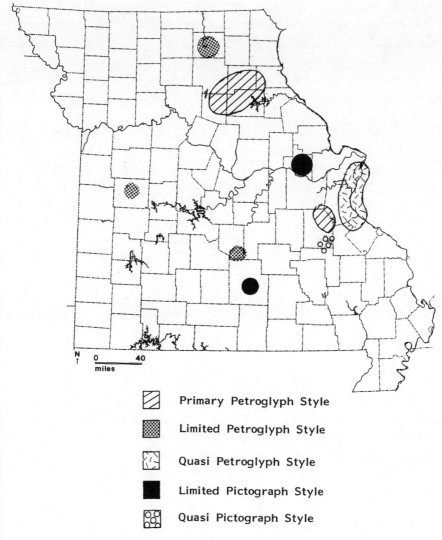

Primary Petroglyph Style

Limited Petroglyph Style

Quasi Petroglyph Style

Limited Pictograph Style

Quasi Pictograph Style

Figure 5.11. Assessment of a selection of Missouri's rock art styles.

sites under the listing of petroglyphs because we do not know how many petroglyphs originally contained pigments. That is to say, other petroglyphs may have been painted and the paint has since faded. The three sites that are included in the second mixed style are the Dry Fork Creek Shelter, Deer Run Shelter, and Groeper Shelter. They are listed under *both* categories.

With the above information at hand, a style map was produced (Figure 5.11) that locates the two Primary petroglyph style areas. The Primary petroglyph style south of the Missouri River is the Big Five in the Big River region that we have tentatively termed the Southeastern style. A group of three sites

in northern Missouri in the Salt river region are termed the Northeastern style sites and comprise the other Primary petroglyph style. The map contains the Limited styles that include the pictograph sites that have been described. The style map also includes a selection of the Quasi-styles. This map was generated partly for the purpose of comparisons with future sites and styles as they are discovered in the state and adjacent regions.

The Quasi-style petroglyphs of the Eastern group include numerous sites along the Mississippi River, located primarily south of its confluence with the Missouri River. These Eastern group petroglyphs are usually located on horizontal bluff tops adjacent to the Mississippi River or a major tributary. The majority of the sites contain either a singular motif of a bird, a foot, or concentric circles or a combination of these motifs in a small grouping, except for Bushberg-Meissner, which is an extended grouping or line of boulders.

As previously noted, Missouri petroglyphs and pictographs are very diverse. When we began looking at the many sites in the data base, we were surprised and, at first, distressed that they did not easily cluster into conspicuous groupings. In any case, as Huchet (1991) comments, "Some authors rely on dubious concepts, most notably that only one style can exist at a given place and time." Missouri's rock art may help to prove that this is not the case. This matter is addressed further in Chapter 6.

The following listing of styles is, of course, tentative. We are at a stage of describing and preliminarily identifying styles rather than refining them. The style groupings that we feel most secure about are the Big Five/Southeastern and the Northeastern groups. Within each of these two Primary style groupings there are genuine connections. When one compares the sites in each group, several similarities are noted in content, motif, structure, and manner; hence, they comprise (or exhibit) a common style. These two groups, therefore, are discussed in detail. The major Limited styles are also discussed, and all of the tentative style classifications are delineated "cookbook fashion." These may be somewhat revised over the next decade by us and others. At least the matter of ordering Missouri's rock art sites for classification, study, and comparison has begun.

THE PETROGLYPH STYLES

1. Big Five (Southeastern) Primary Style

Media: Petroglyphs
Location: Low dolomite outcrops in glade areas
Motifs:
 Primary motifs: Anthropomorphs in action, birds, serpents, anthropomorph with "cleft" head

Secondary motifs: Phallic/vulvar, meandering arrows, feet, hands/skeletal hand, bird tracks, squares
Manner: Intaglio, incised
Structure: Mostly random complex
Theme: Ceremony, games/sport, myths/oral tradition, fertility, narrative
Sites:
Washington State Park A/C
Washington State Park B
Maddin Creek (Maddin Creek Ridge)
Three Hills Creek
Wallen Creek
Substyles:
Riviera Ledge (location and size of site differ)
Cedar Hollow Ledge (location and size of site differ)

Of all the known sites in Missouri, this grouping is the most homogeneous. The carver(s) of the Big Five style petroglyphs chose low-lying dolomite outcrops in glade areas along the Big River and its tributaries on which to place their motifs and panels. These sites contain intricate, often elaborate, compositions of motifs, elements, modified natural features such as tinajita formations, potlid fractures, and solution holes, and occasional ground pits or cupules (or cup marks) of varying sizes. The carver seems to have been primarily concerned with the content of the graphics and communicating information (discussed in Chapter 6). The content of the first four sites displays the largest number of motifs utilized in any petroglyph complex and includes birds, bird tracks, other animals, animal tracks, serpents, hands, feet, arrows, phallic and vulvar motifs, anthropomorphic motifs, symbolic motifs including the bilobed arrow, and geometric motifs such as the circle, joined circles, quartered circles, and squares, as well as abstract motifs and elements. Some variation occurs, but the major motifs are present at the sites as is the random complex structure (see Figure 5.1).

The structure of the motifs gives the impression of a random and complex placement, although this was probably not the case. That is, they were probably placed with purpose, in a manner logical to the carver, but that knowledge is not available to us. The term *random complex* is meant to convey, however, that it is often impossible to determine the orientation of a panel when it is located on a horizontal surface. In addition, all motifs and elements fall within a specific size range with rarely any exceeding several centimeters in dimension. The two petroglyph sites that contain exceptions to this rule are Washington State Park A (the big bird, Figure 5.12*a*) and Thousand Hills State Park (the two deer, Figure 5.12, *b* and *c*). A singular pictograph site, Rattlesnake Bluff (Figure 5.13), portrays a dancing warrior motif that is one

a)

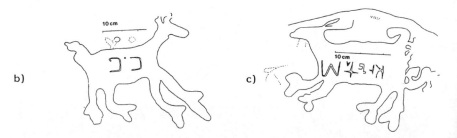

b)

c)

Figure 5.12. Large bird and deer: *a,* Washington State Park; *b* and *c,* Thousand Hills State Park.

meter high; the serpent at the Groeper Shelter is about 70 centimeters long; and a few of the depictions at Picture Cave #1 fall into that same range.

Structurally, most of the panels in the Big Five sites are complex. The viewpoint originally intended by the carver is, of course, unknown. In other words, it is often difficult to tell which parts were intended as top, bottom, and so on. In one panel at Maddin Creek (Figure 5.14) the matter of whether the larger figure or the two smaller figures are upright is problematic. This unique petroglyph site is discussed in more detail in Chapter 6 under the section on using oral traditions for interpretation. It is the oral tradition that offers insightful clues on the possible viewpoint intended by the carver.

Along this same line, motifs are frequently "crowded" as if the carver was trying to get as many as possible into a limited panel area. For example, at Washington State Park A (Figure 5.15), if one views the entire field of motifs, it bears a horizontal rectangular band orientation, yet the motifs, particularly

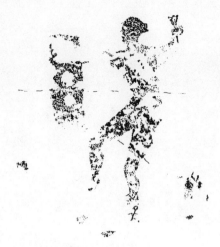

Figure 5.13. Dancing warrior (Rattlesnake Bluff).

Figure 5.14. Complex figure panel (Maddin Creek) (from tracing by Frank P. Magre).

the two central anthropomorphs, are placed more or less centrally at an angle. A number of motifs "float" around these figures and only to the right is there any continuity of form in the series of seven ovals. This same style of tightly grouping motifs is present at the Maddin Creek and Three Hills Creek sites. Another feature is the occasional connecting elements (also seen at the Peene-

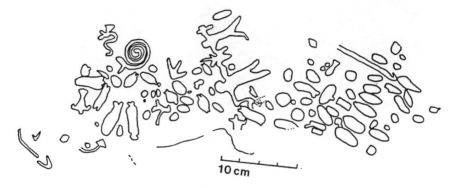

Figure 5.15. "Crowded" panel (Washington State Park).

Murat site to the west). The connecting components are typically undulating lines that may indicate serpents, but could also imply roads, passage of time, running water, or clan lineages.

Anthropomorphs are rendered in an essentially flat manner, outlined or intaglio. Some of the anthropomorphic motifs demonstrate examples of both techniques within a single figure; for example, one body is incised in outline whereas the lower appendages are intaglio. Most anthropomorphic and bird figures are intaglio.

Any facial detail has long been worn or weathered off, although the figures at Wallen Creek contain remnants of what might have been diagnostic ritual clothing components. Two have a circle type design on their torsos and the third figure has what may be a society sash extending down between his legs. One figure has an unusually shaped head that could suggest a mask or ear ornaments. Many of the anthropomorphic figures are static simple forms while others are in definite action postures. The action figures are usually larger and often associated with a stick and "ball(s)" such as at Washington State Park B (Figure 5.16*a*). There is also a "stickball" player at the Mitchell site (Figure 5.16*b*). An example of the creative use of space can be seen in one of the smaller sites (Wallen Creek, Figure 5.17) in which action figures (suggested by the leg configurations) sport around (possibly enhanced) natural solution holes—a probable focal point of the grouping. Another figure has its legs apart, arms outstretched to the side, a circular disc, and below that a disproportionately large phalluslike motif positioned between the legs (see Figure 5.17, top left, and a close-up in Figure 5.47*c*). On the adjacent boulder is a similar figure in similar stance with its hands exaggerated and opposing, serpentlike figures attached to the top of its head.

Another major component of this group is the emphasis on fertility motifs and puerperal acts. Both phallic and vulvar motifs, common to rock art (as

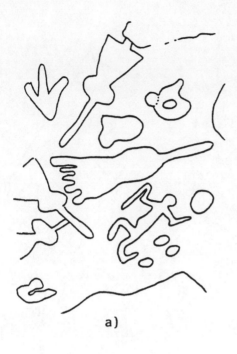

a)

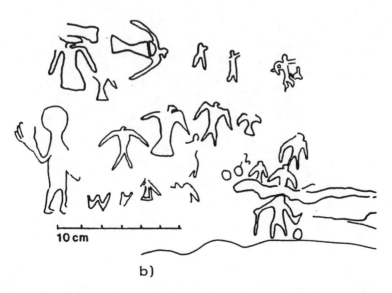

10 cm

b)

Figure 5.16. Anthropomorphs with sticks: *a*, Washington State Park B (chalking and slide by Frank P. Magre); *b*, Mitchell.

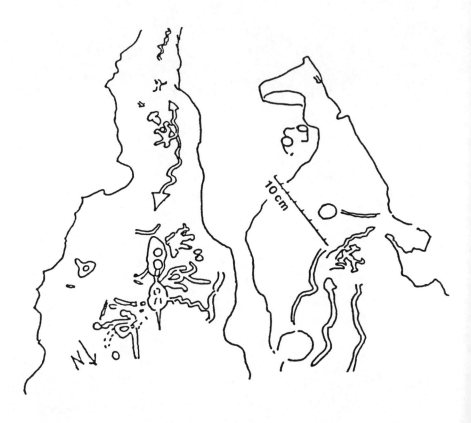

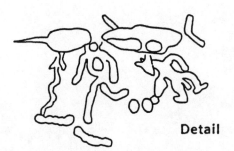

Detail

Figure 5.17. Use of space (Wallen Creek).

identified in most areas with rock art activity), are present at all the Big Five sites. Only Wallen Creek does not have an obvious vulvar motif. Perhaps the most unusual and distinctive anthropomorphic figures are those in puerperal attitude (Figure 5.44*a* and *b*), which is discussed at length by Wellmann (1970a). These include figures with legs apart or bowed and a number of circles or ovals associated just below and/or in the immediate vicinity. There are some variations to the manner in which they are depicted, but the essence may be birth, fertility, or possibly "rebirth," as discussed in Chapter 6 under the section on oral traditions and mythology.

2. Salt River (Northeastern) Primary Style

Media: Petroglyphs
Location: Rock shelter facades and alcove walls
Motifs:
 Primary motifs: Birds, animals
 Secondary motifs: Anthropomorphs (action), celestial phenomena (Rocky Hollow #1)
Manner: Incised, intaglio, painted petroglyphs
Structure: Linear random
Theme: Narrative, oral tradition
Sites:
 Rocky Hollow #1
 Rocky Hollow #2
 Mitchell
 Sharpsburg

The carver(s) of the Northeastern style chose basically vertical river/creek shelters in and on which to carve their motifs. The walls of the first three sites are roughly vertical whereas the fourth is slanted back at the base. The petroglyphs at these sites are believed to have been painted with red and/or black pigments, and some of the original pigment can still be seen at the Sharpsburg site (Rocky Hollow #1 was repainted in the 1940s; Dick Wichern, personal communication, 1987). The primary concern of the carver, as with the Southeastern style group, appears to have been communication through motif content. Rocky Hollow #1, Mitchell, and Sharpsburg display a predominance of birds and bird tracks, particularly the first two sites. Rocky Hollow #2 portrays two to three fish, the only certain prehistoric fish depictions presently known in the state (Figure 5.40). There are differences at these sites, but the bird and animal forms, coupled with their placement on vertical walls, tie them together. All three sites lack obvious phallic and vulvar motifs, although a series of pit-and-groove motifs are present at the Sharpsburg site

along with two circles attached by a bar (referred to by some as a "female motif").

Anthropomorphs are not emphasized, except at Rocky Hollow #1 where there is a figure with raised hands (Figure 6.5). It is the most unusual of the "shaman" figures presently known in Missouri because both hands are raised and the left hand is "obliterated" by a circular disk. Two small figures at Rocky Hollow #2 appear to be on their knees probably shooting with bow and arrow. One figure at the Mitchell site, the largest (Figure 5.16b, at left), is depicted with a raised hand. It is larger than the panel's approximately half dozen other anthropomorphic figures, all of which are small (6 to 7 centimeters) in comparison. The anthropomorphs at Sharpsburg are even less emphasized with only one or two, possibly three, small figures present. The structure at these four sites is relatively similar. The panel is essentially sequential with only a slight irregularity. That is, occasional motifs are placed above or below the main horizontal panel of motifs.

3. Thousand Hills State Park (North) Limited Style
Media: Petroglyphs
Location: Medium low-lying outcrops, horizontal surface/some edges
Motifs:
 Primary motifs: Quadrupeds, birds, animals with tails curled into a spiral
 Secondary motifs: Anthropomorphs, abstract symbols, serpents
Manner: Intaglio
Structure: Random complex
Site:
 Thousand Hills State Park
Substyle:
 Gil Branch (motifs: animals [quadrupeds])

The Thousand Hills State Park site in northern Missouri could almost be placed as a substyle of the Big Five. The motifs are located on low-lying, basically horizontal outcrops. However, the outcrops are flatter than those in the southeastern group. As with the Big Five sites, the Thousand Hills State Park site includes at least one large dominant animal. The structure, however, is quite different in that the northern motifs seem "sprinkled" over the rocks rather than carved into the crowded groupings seen at the major southeastern sites. The carver(s) at this site, once again, used content and motifs to convey information. The Thousand Hills State Park site portrays two very large deer (70 × 44 centimeters and 75 × 58 centimeters) on singular boulders. Each deer motif almost fills its boulder's space. Other animals, especially the figure with the long, curled tail, are also featured on single rocks.

A few of these curled-tail animals are present at the southeastern sites, but not with the emphasis seen at Thousand Hills State Park. Serpents, plentiful at the Big Five sites, are in the minority at the northern sites, except for Rocky Hollow #1. Anthropomorphs are also de-emphasized, with only two present.

4. Central East Limited Style

Media: Petroglyphs
Location: Very low-lying horizontal outcrops
Motifs:
 Primary motifs: Serpents, undulating lines
 Secondary motifs: Arms/hands, birds, anthropomorphs, celestial phenom-
 ena, ogee
Manner: Outline, pecked
Structure: Random complex, some areas with singular motifs
Site:
 Peene-Murat
Substyle 1:
 Schneider (on bluff top)
Substyle 2:
 Winkle
 Jake's Prairie

There are notable similarities between the Peene-Murat site and the sites of the Big Five. These include the meandering serpents, hands, birds, and small anthropomorphs, but other features separate the two. The motifs are pecked into a hard, low-lying outcrop. While this is the major grouping, the focus appears to be a meandering line from which others extend, bordered on one end by a complex group of motifs. There are several motifs that are peripheral and isolated. Another distinguishing feature is the possible portrayal of celestial phenomena in one of the peripheral groups.

5. Central-A Limited Style: Combination Stylized-Abstract

Media: Petroglyphs
Location: Two breakdown boulders at cave entrance, facing Big Piney River
Motifs:
 Primary motifs: Vulvar motifs
 Secondary motifs: Bird/anthropomorph (removed)
Manner: Outline, pecked
Structure: Linear random
Site: Miller's Cave

6. Central-B Limited Style: Combination
Naturalistic and Representational

Media: Petroglyphs
Location: Very high outcrop over river
Motifs:
 Primary motifs: Shaman, bird, vulvaforms
 Secondary motifs: Bird tracks
Manner: Outline, pecked
Structure: Singular, small group
Site: Lohraff

7. West Central Limited Style: Representational-Abstract

Media: Petroglyphs
Location: Two inner walls at entrance of small rock shelter
Motifs:
 Primary motifs: Ground holes in patterns, circle
 Secondary motifs: W, fish(?), foot
Manner: Mixed: ground holes, incised, intaglio
Structure: Basically linear-random
Site:
 Tobin-Reed

8. Western Limited Style: Representational

Media: Petroglyphs
Location: Wall in small canyon
Motifs:
 Primary motifs: Anthropomorphs, animals
Manner: Incised stick figures with horned headdresses?/rabbit ears?
Structure: Part linear random/part linear sequential
Site:
 Pigeon Hollow

9. Mississippi River (Eastern Riverine-A) Quasi-Style

This style is based on the fact that the structures are not all linear sequential although the motifs are comparable.
Media: Petroglyphs
Location: River bank/creek outcrops
Motifs:
 Primary motifs: Pit and groove, snakes, concentric circles, cross
 Secondary motifs: Feet, geometric/abstract, anthropomorphs, vulvaform
Manner: Incised

Structure: Basically random complex with some small groups
Site:

Bushberg-Meissner (river outcrop, multiple boulders on bank)

Substyle 1:

Bushnell Ceremonial Cave (Structure: Petroglyphs are more or less placed on mixed horizontal and angled vertical surfaces; Bushnell motifs are placed within a water-related cave rather than on a river bank. They are connected, however, in that major portions of both sites consist of pit-and-groove carvings.)

Substyle 2:

Bushberg-Meissner Cave

Sulphur Springs Bluff

Although there are a number of motifs at this site similar to those of the Big Five, and in spite of the fact that it is not far from the Big Five grouping, we have separated it stylistically on two major counts: (1) locations and (2) structures. The Bushberg-Meissner site is located on the bank of a major river (Mississippi) on more rounded limestone boulders and not on the low-lying dolomite outcrops typical of the Big Five. The similar motifs are the snakes/serpents, circles, and two anthropomorphs, but this site also contains a major section of the classic pits and pit-and-groove elements that are evident at the Bushnell Ceremonial Cave but scarce at the Big Five sites. The structure differs in that the motifs are more evenly spaced and rarely connecting, that is, less complex. Bushberg-Meissner also contains the concentric equilateral cross and the "spinning cross," which are not evident in the Big Five grouping. An interesting feature of this site is the association of the concentric cross with the pit-and-groove pattern, both of which have been considered possible references to celestial phenomena.

10. Mississippi River Bluffs (Eastern Riverine-B) Quasi-Style

Media: Petroglyphs

Location: On river or stream bluff tops

Motifs:

Primary motifs: Feet

Secondary motifs: The few vary and include mace, concentric circle, and others

Manner: Incised, intaglio

Structure: Singular

Sites:

Anheuser

Ellis Footprint

Herrell Footprints

Donnell

St. Louis Riverfront

Kimmswick Footprint (removed)

Anheuser contains two foot petroglyphs in one section and a concentric circle in another.

THE PICTOGRAPH STYLES

1. Picture Cave (Eastern) Limited Style

Media: Painted, polychrome (red, black, and white)

Location: Walls and ceiling of cave

Motifs:

Primary motifs: Anthropomorphs (with clothing, hair, weapon details), animals

Secondary motifs: Arrows, weapons, serpents, circle

Manner: Outline and fill

Structure: Mostly linear random, some complex areas

Site:

Picture Cave #1

Substyle 1:

Picture Cave #2 (Manner: black/red, sequential)

Substyle 2:

Groeper Shelter

The Picture Cave style is unique in Missouri in that it is the only known site that contains abundant detail in body, hair, and accoutrements and in its depictions of possible myths or story-telling scenes. The pictographs extend for about twenty-two meters along the walls of the cave. The pigments include shades of red and black, and in one panel white is used. The manner of expression varies widely in that the graphics run the gamut from finely executed to roughly drawn. The complexity of the superimpositions has not been investigated in detail and will require a considerable amount of time to decipher. We should mention that the cave also has its share of historic graffiti.

The structure is linear random and in areas complex; that is, the graphics have been done in a "spiral," with other motifs and symbols appearing seemingly at random above and below the panel. In addition, there is evidence of reuse of this site, and fainter earlier graphics can be seen in areas below the later more vivid ones. It was suggested that superimposition may indicate "chapters" in a story as done by Australian Bushmen (James Brown, personal communication, April 1993).

Motifs include most impressively the anthropomorphs with hair, hair or-

nament, and body-painting/tattooing detail. The head ornament may be an attempt to portray a type of disc/ogee as is seen on the forehead of the "Big Boy" pipe from the Great Mortuary at the Craig mound at Spiro. Robert J. Salzer suggests a comparison to "Braden A" (personal communication, 1990), whereas we suggest comparison to a general "Braden" style (as discussed in James Brown 1989 and Phillips and Brown 1978, 1984). The arrows at Picture Cave are diagnostic, also, in that they portray the nock in a Y configuration extending from the end of the arrow as do several on the Utz tablets.

The characteristics that strongly connect Picture Cave to the Gottschall site in southwestern Wisconsin are those of the anthropomorphs. Attributes include thin arms and legs that taper and fade. Hands are not executed in detail. Also present at both sites are distinctive oval eyes, body stripes, concentric circles on the shoulder, patterned loincloth (concentric semicircles in vertical position), and forelock ornament. Vertical striping is evident on the bodies and faces of two Picture Cave figures (Figure 6.6) and concentric circles are on the shoulder of another figure as well as on a figure at the Gottschall Shelter. One of the outstanding features of the panel to the far right is the long-nosed god maskette (see Chapter 6) at the side of the face of the upper striped figure—presumably attached as an ear ornament. Other identifiable motifs include quadrupeds, birds/turkeys, serpent, bows, arrows, maces, and possible vegetation. There are also abstract motifs that include the concentric circle, wavy lines, bisected rectangles, and elements that consist of a series of dots and stripes.

The other feature at this site that bears special mention is the figure that probably depicts an "underwater" spirit or monster (Figure 5.18). It contains the classic attributes of antlers, fangs, large eyes, raccoon face (Knight 1989:206), and ear spools. Its body, however, is serpentlike, extending to the left of the large round head. Although there are no other known, two-dimensional graphic counterparts to this unusual face in Missouri, there are two in Tennessee, one at Devil Step Hollow associated with the Mississippian period (Faulkner 1988:239) and another at Officer Cave (Willey, Crothers, and Faulkner 1988:55). According to Faulkner, these depictions are associated with burial caves (Faulkner 1988; Charles Faulkner, personal communication, April 1993). It is on record that a burial was removed from Picture Cave in 1992 by representatives of the Unmarked Human Burial Committee of the Missouri Department of Natural Resources. Another remarkably similar "basic monster face" (round head/face, round eyes, wide, open mouth showing teeth) can be seen in Corner (1968:107). It is a pictograph at Shuswap Lake #3 in the interior of British Columbia.

Of possible relation to this motif, although difficult to compare because the site has been destroyed, is the bluff above Alton, Illinois, often discussed

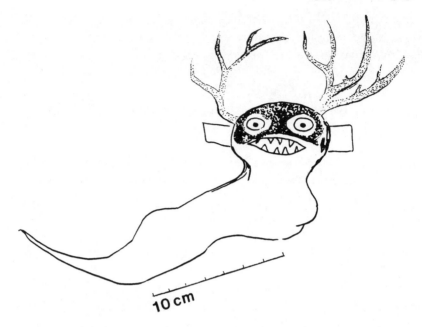

Figure 5.18. Underwater spirit (Picture Cave).

in reference to its Piasa (water/underwater spirit) depiction. A line of graph-
ics is illustrated in McAdams (1887:22) that bears a remarkable resemblance
to a selection of the pictographs at Picture Cave #1. These include fighting
turkeys and other birds that are similar in form to those illustrated in
McAdams. His panel also includes the concentric circles motif and a large-
winged bird somewhat like the one at Picture Cave, particularly in the con-
figuration of the wings. This could all be coincidence or attributable to the
depiction of comparable mythological figures. If the latter is the case, then it
is all the more curious because both sites contained a portrayal of the under-
water spirit/monster/serpent, "uktena" (unkténi), or Piasa.

One of the most unusual motifs is the dotted pattern over the entryway
to Picture Cave #2. It appears to be an outline of a few mountains or hills
(not illustrated). An interesting depiction in Cave #2, also evident but ex-
tremely faded in Cave #1, is what appears to be "drying racks" (Figure 5.19).
Joseph Brown (1989:76) refers to the drying racks used by the Oglala Sioux
as a symbol of "heaven."

2. First Creek (East Central) Limited Style
Media: Painted, bichrome-mixed (reds and blacks)
Location: Back wall of low shelter

Figure 5.19. Drying racks (Picture Cave).

Motifs:
 Primary motifs: Geometric, abstract, both rectilinear and curvilinear
 motifs
Manner: Multicolored lines and areas, bold concentrics
Structure: Linear sequential and some linear random
Site:
 First Creek Shelter

3. Salt River (Northeastern) Limited Style (Running Men)
Media: Painted, red pigments[4]
Location: River bluff
Motifs: Anthropomorphs (in motion)
Manner: Activity and naturalistic portrayal with anthropomorphs executed
showing exaggerated calves
Structure: Linear sequential
Site:
 Salt River

4. White Rock Bluff (South) Limited Style
Media: Painted, polychrome (red and black with hints of yellow [and some
say lavender])
Location: Bluff wall
Motifs:
 Primary motifs: Anthropomorphs
 Secondary motifs: Animals, circles, weapons, symbols
Manner: Mostly solid figures
Structure: Linear sequential and some linear random

Site:

 White Rock Bluff

5. Deer Run Shelter (Southeast) Limited Style

Media: Painted, bichrome (red and black)

Location: Shelter wall

Motifs:

 Primary motifs: Abstract, symbols

 Secondary motifs: Animals

Manner: Outline and fill

Structure: Linear sequential and some linear random

Site:

 Deer Run Shelter

6. Willenberg Shelter (Central-A) Limited Style

Media: Painted, bichrome (red and black)

Location: Walls and ceiling of shelter

Motifs:

 Primary motifs: Animal/bird/owl

 Secondary motifs: Wapiti, celestial (crescent with circle design)

Manner: Outline, fill, sketch

Structure: Linear random, some singular

Site:

 Willenberg Shelter

7. Lost Creek (Southeast-Central) Quasi-Style

Media: Painted, red pigments

Location: Creek bluff

Motifs:

 Primary motifs: Symbols, concentric circles, sun symbol, bilobed arrow

 Secondary motifs: Quadruped/bird?

Manner: Outline and fill

Structure: Singular, small group

Sites:

 Lost Creek

 Frumet

8. Missouri River (Central-B) Quasi-Style

Media: Painted, red pigments

Location: Spring/river/creek bluff

Motifs:
 Primary motifs: Anthropomorphs, circle, quartered circle, Oneota/Osage
 crescent with oval
Manner: Selected group of several motifs
Structure: Linear sequential
Sites:
 Torbett Spring–Rocheport
 Big Moniteau Creek
Although represented by a small remaining number of sites, the picto-
graphs appearing on bluffs centrally located in the state along the Missouri
River contain red pigment motifs placed in linear sequential or linear random
groupings. They do not appear to convey stories or scenes but rather individ-
ual symbols. They are usually very high on the bluffs and in difficult-to-reach
locations.

9. Piney River (Central-C) Quasi-Style

Media: Painted, red pigments
Location: Bluff face above river or creek
Motifs:
 Primary motifs: Animal or anthropomorphs
 Secondary motifs: Arrow, staff
Manner: One or two motifs in outline and fill
Structure: Singular, small group
Sites:
 Champion Eagle
 Crawford Staff
Substyle 1:
 Rattlesnake Bluff
This pictograph contains motifs in both red and black pigments. It is a
relatively small site but one of the most rare in the state because it portrays
a "dancing" warrior, holding a shield in one hand, with a mace raised in the
other. It is reminiscent of some of the figures in the shell cups and gor-
gets pictured in Phillips and Brown (1978, 1984). The figure was painted en-
tirely in red pigment whereas the rattlesnake to the right was painted entirely
in black. Two faded versions of the same can be discerned just above the more
vivid one.

10. Paydown/Painted (West Central) Quasi-Style

Media: Painted, red
Location: Walls of outcrops on river

Motifs:
 Primary motifs: Quadrupeds
 Secondary motifs: Other animals
Structure: Singular, small group
Sites:
 Paydown Deer
 Painted Rock

FURTHER DISCUSSION OF
PETROGLYPH AND PICTOGRAPH STYLES

Additional explanation regarding the designation of styles is in order. The sites listed under the heading of substyles, Riviera Ledge and Cedar Hollow, are, first of all, examples of sites that bear similarities but are smaller in size and removed from the general location type of the major grouping. Riviera Ledge contains many of the motifs seen at the Washington State Park A and B sites: birds, squares, appended squares, feet, phalluses, and four small pits in a quadrant. However, the location of the site—both horizontally and vertically—is very different: it is on a creek bluff ledge. In addition, the site is contained in the area of the ledge itself, which is small in relation to the expanse of the Big Five sites, the structure is different, and the motifs are more widely spaced. The Cedar Hollow site also contains similar motifs and a complex structure.

The Peene-Murat site, two counties to the west, is situated in a glade on a low-lying sandy dolomite outcrop. It also contains some similarities to the Big Five, such as the undulating serpentine motifs (Figure 5.20a). These motifs, however, branch from a central serpentine configuration and it is this motif that dominates the major grouping. Serpentine figures are present in the Big Five but none compare in size to the one at Peene-Murat. In addition, an ogee, barred oval, and other motifs appear at Peene-Murat that are not present in the Big Five. The manner of execution, structure, and outcrop are different and thus the site, although similar in some respects, merits its own category.

The next major style grouping of petroglyphs that merits further discussion is that of the Northeastern style.[5] This style includes three sites: Rocky Hollow, Mitchell, and Sharpsburg. Here we see incised and intaglio birds, serpents, an occasional anthropomorph, and carvings that were placed more or less sequentially on a vertical shelter wall. Remotely connected to the Northeastern petroglyph group is the site found at Thousand Hills State Park. It contains some of the same motifs (random complex structure) but in a different context. The graphics are situated on a group of boulders and are

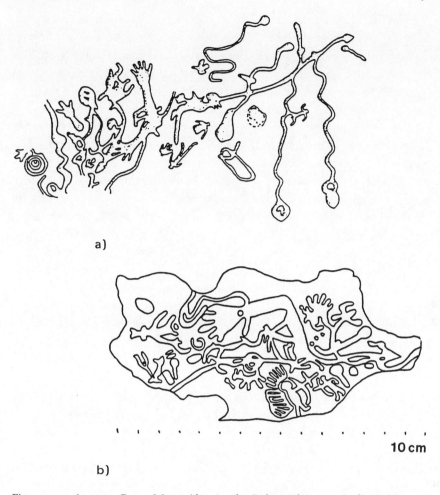

a)

b)

10 cm

Figure 5.20. Arms: *a,* Peene-Murat (drawing by Robert Elgin, 1958); *b,* Maddin Creek (drawing by Benedict Ellis).

placed in a random manner (or so it appears). Thus, this physical context and structure prevent the Thousand Hills State Park carvings from being part of the Northeastern style, although select motifs might seem to link them together. The other feature of this style that bears mention is the presence of the two very large deer carvings, discussed above. They are the largest depictions known in the northern part of the state (averaging 80 centimeters long).

Limited Styles: Pictographs

The pictographs that compelled us to name the "limited" style were those at Picture Caves #1 and #2, possibly the sites with the most informational

potential in the state. Picture Cave #1 contains complex panels (sometimes in layers) of anthropomorphs with shoulder and face tattooing or painting, clothing details, weapon details, action postures, animals, the mythical "underwater spirits," concentric circles, and many unknowns. The motifs as well as the scenic panoramas are in multiple layers, which are difficult in places to separate except where distinct levels of fading are evident.

The pictographs in Picture Cave #2 illustrate several anthropomorphs with basically simple, silhouette forms and linear, sequential structure (unlike Picture Cave #1), although a few motifs appear occasionally outside the sequential groupings. Characters are portrayed in a variety of activities that may include the stick and ball game, shooting the bow and arrow, and using an atlatl and spear. Quadrupeds are present as well as geometric, abstract motifs such as the bisected rectangle and zigzag. There is a nested rectangle, open at one end ⊓, similar to ones at Maddin Creek. As with the petroglyph sites within the Big Five, these two pictograph sites are so complex, particularly Cave #1, that it is extremely difficult to assimilate all that is going on in the panels.

Only two major pictograph sites have been reported in the general southeast quadrant, although surely others exist or existed. The two sites are Lost Creek (bilobed arrow and sun symbol) and Frumet (large red concentric circles). A possible quadruped and bird are also on the capped bluff at Frumet and adjacent to the circles, but these are difficult to identify. That a strong connection exists among these sites there can be little doubt, despite the variation in media. The Lost Creek bilobed arrow is well represented at Maddin Creek and also seen at Three Hills Creek and Washington State Park. The concentric circles motif at Frumet is, of course, prevalent at many of the sites in Missouri and particularly well represented at the riverine locations.

Quasi-Styles

As previously mentioned, we are using the term *Quasi-style* to denote a petroglyph or pictograph site that has a motif or motifs similar to those at other sites, but is not sufficiently complex or diagnostic to call it a "style" (i.e., a Primary style). The most notable sites that we place under the Quasi-style category are those petroglyphs found along the Mississippi River and its tributaries that contain portrayals of feet and\or concentric circles. One cannot be certain whether the repetition is the result of a single group's activities or simply a shared symbolism in these two motifs. The most obvious of these sites include the Anheuser site, the St. Louis Riverfront site, and the Herrell site. Other Quasi-style groupings could be included on the basis of similarity of motifs or subject matter.

One of the most intriguing aspects of the typically, structurally complex Big Five is that this cluster of sites appears to confirm Fischer's hypothesis (1971) about hierarchical as opposed to egalitarian social structure as reflected in a group's graphic expressions. If the group or groups who produced the rock art in this area of the Mississippi Valley were agriculturists and were hierarchical in their societal structure—as seems to be the case to judge from the Mississippian symbolism included in the site's motif repertoires—then according to Fischer's hypothesis, these graphics should be (1) asymmetrical, (2) contain designs that are varied and complex, (3) contain designs that are crowded, and (4) contain many closed figures. All five sites meet all four criteria.

MOTIFS

In this study, we use motifs as one of the primary means of trying to understand the functional aspects of these sites, not an uncommon technique. The term *motif* can be defined as a broadly recurring and identifiable depiction of a person, animal, object, geometric, or other shape. The repetition of a particular motif is probably significant and gives importance to it. Layton (1978:29) considers repetition or "redundancy" a "key concept in communication theory." Boas (1927) also discusses "decorative redundancy." Motif recognition not only is the most obvious way to identify a site (by visual contents of the graphics) but also provides a readily available means for comparing sites. Schaafsma (1980:7) believes that "among the major components of style in regard to rock art are the element inventory and the specific figure types making up this inventory."

We have selected fifty-eight motifs and elements (see Appendix A, Glossary, for definitions) that dominate, essentially by repetitive use, the rock art of Missouri. These motif and element categories can be considered in a variety of ways: singly, in association with other motifs, and in association with their physical setting and/or matrix. They can also be analyzed categorically in a range from naturalistic (realistic or representational) to abstract or geometric. While it is easier for rock art researchers to deal with naturalistic motifs, the abstract carries a measure of mystery and intrigue. The first sentence of Olsen's 1985 work is, "Abstraction is the key word." She refers to abstraction as a form of expression and communication, the process of abstraction, and how graphic images become symbols.

The abstract forms are most often considered to be "sacred." This belief is discussed at length by Vastokas and Vastokas (1973), Schaafsma (1985), and others. Schaafsma (1985:255) explains: "The ambiguity in the meaning of a

symbol may have a corresponding visual ambiguity. Such ambiguity or abstraction functions to increase the power of an element by contributing to its esoteric nature. Dondis (1974:22) states, "The meaning inherent in abstract expression is intense; it short-circuits the intellect, making contact directly with the emotions and feelings, encapsulating the essential meaning, cutting through the conscious to the unconscious." The abstract undoubtedly serves an encoded, metaphorical mission, which is cross-cultural in scope.

Giedion[6] (1962:241), with reference to European rock art, also discusses the mystique of abstraction of the "grandes signes," citing the location of the most abstract motifs and designs as usually being "hidden away in the most inaccessible parts of the caverns." Such does not seem to be the case in Missouri. However, there have not been any reports of nor systematic searches for rock art in the deep recesses of Missouri caves. The only instances of segregated abstractions of which we are aware are at the Bushberg-Meissner Cave site in Jefferson County and the First Creek site in Gasconade County. Otherwise, abstract motifs are in close, or relatively close, association with other motifs. The Bushnell Ceremonial Cave contains the quartered circle motif. On the ledge fronting the cave is an array of pit-and-groove motifs. Feest (1992:34) states that the oldest styles of Great Basin rock art "are thought to have been the simple 'pit and groove' and a late curvilinear abstract style." He suggests, as a general trend, that graphics progressed from abstract to representational. This might imply that the realm of ritual and ceremony became more available and less of an elite domain controlled by the few. That is, more individuals could train to become shamans, or medicine men and women, as societies became more complex.

While some of the general motifs listed below occur in isolation, most are seen in association with a variety of other motifs. This co-occurrence is discussed throughout the inventory as well as in Chapter 6. Among the many motifs contained in Missouri's petroglyphs and pictographs, as well as on portable artifacts, are those representing a regional expression of what has long been referred to as the Southeastern Ceremonial Cult or Complex (Muller 1989:12–14; Phillips and Brown 1978:169; Waring and Holder 1945:30; Williams 1977:16). However, the basis for this complex (maize agriculture, earthen mounds and associated plazas, and a Mesoamerican influence) is now considered "largely obsolete" and some think that the complex was neither a "cult" nor "ceremonial" (Watson 1990a:44). It is believed that the complex "reflects exchange and interaction networks created by Big Men and Chiefs (at least some of whom were also priestly personnel) in indigenously developing, socially stratified, Mississippian societies (Griffin [1952:363–64] pioneered this general view)" (Watson 1990a:44). Griffin (1952:363) also states

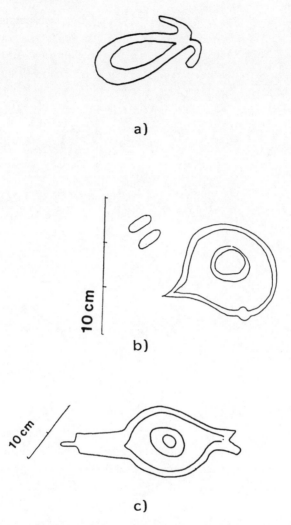

Figure 5.21. Ogee motifs: *a,* Maddin Creek; *b,* Peene-Murat; *c,* Commerce Eagle.

that "most of the elaborate art forms so often figured in southeastern archae-
ology have come from a relatively few major centers. . . . This is an indication
of the ceremonial importance of these objects to tribal units."

It is the motifs associated with this complex that are of concern here. They
include the cross, the quartered circle, the concentric circles, the bilobed ar-
row, the ogee, hands, and the "forked eye." The forked eye motif is found on
a figure at Picture Cave #1, and an isolated variation of the motif is at the
Maddin Creek site (Figure 5.21*a*). An ogee motif is at Peene-Murat (Figure
5.21*b*), and what could be considered still another variation of the eye motif

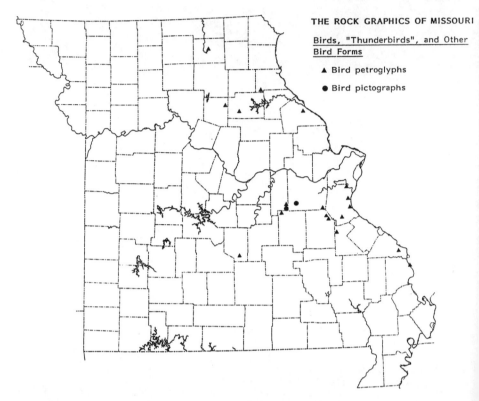

Figure 5.22. Distribution of bird motifs in Missouri rock art.

is found at the Commerce Eagle site (Figure 5.21*c*). One other diagnostic motif is included under the category "skull/bones." This one could also be considered present in Missouri in the portrayals of a skeletal hand and severed arms at Maddin Creek, Washington State Park A, and White Rock Bluff. We have not identified any skulls or obvious long bones as pictured in category VIII by Waring and Holder (1945:30) nor the barred oval of category VI (except for a possible variation at the Peene-Murat site), although we do have barred rectangles at Picture Cave, and Mutton Creek, and First Creek.

The major motifs in this study's inventory are placed in charts as well as described. The selection of major motifs, of course, relates to Missouri's known rock art sites. Discovery of new sites could add to or alter the current listing. Categories numbered fifty-five to fifty-eight are elements that are seen either as isolates or in conjunction with identifiable motifs. These elements could be classified as abstract motifs. The inventory of motifs is illustrated in Figures 5.2 through 5.10; the maps in Figures 5.22 through 5.38 show the distribution of each motif category; Appendix C lists the distribution of motifs by site.

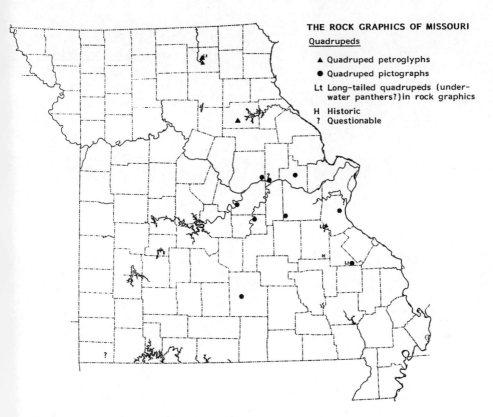

THE ROCK GRAPHICS OF MISSOURI

Quadrupeds

▲ Quadruped petroglyphs
● Quadruped pictographs
Lt Long-tailed quadrupeds (under-
 water panthers?)in rock graphics

H Historic
? Questionable

Figure 5.23. Distribution of quadruped motifs in Missouri rock art.

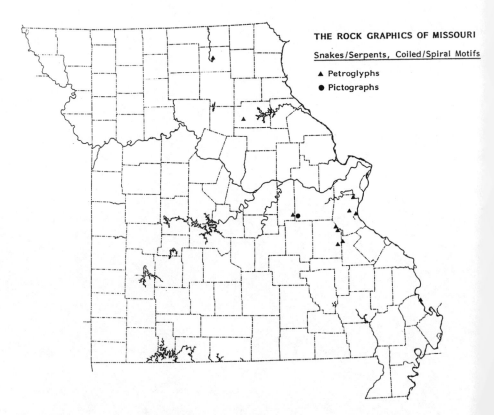

THE ROCK GRAPHICS OF MISSOURI

Snakes/Serpents, Coiled/Spiral Motifs

▲ Petroglyphs
● Pictographs

Figure 5.24. Distribution of snake/serpent motifs in Missouri rock art.

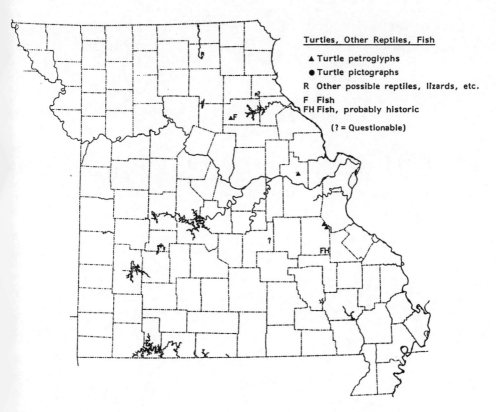

Figure 5.25. Distribution of turtle and other reptile motifs in Missouri rock art.

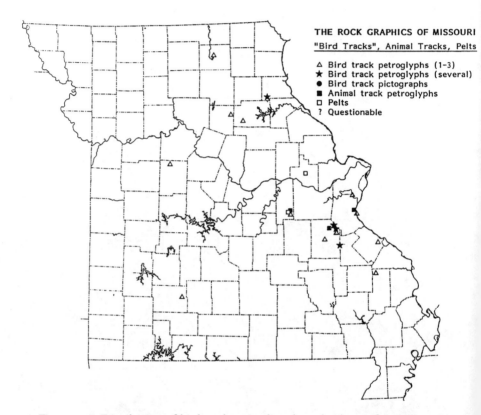

THE ROCK GRAPHICS OF MISSOURI

"Bird Tracks", Animal Tracks, Pelts

△ Bird track petroglyphs (1-3)
★ Bird track petroglyphs (several)
● Bird track pictographs
■ Animal track petroglyphs
□ Pelts
? Questionable

Figure 5.26. Distribution of bird track, animal track, and pelt motifs in Missouri rock art.

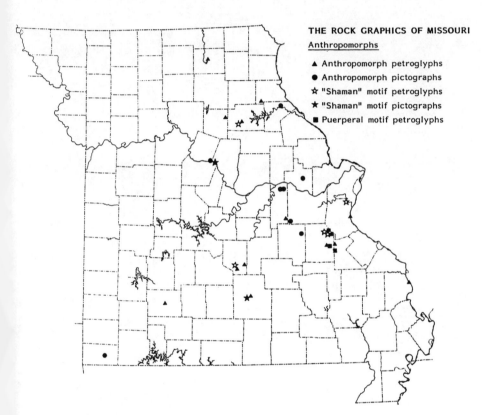

THE ROCK GRAPHICS OF MISSOURI

Anthropomorphs

▲ Anthropomorph petroglyphs
● Anthropomorph pictographs
☆ "Shaman" motif petroglyphs
★ "Shaman" motif pictographs
■ Puerperal motif petroglyphs

Figure 5.27. Distribution of anthropomorph motifs in Missouri rock art.

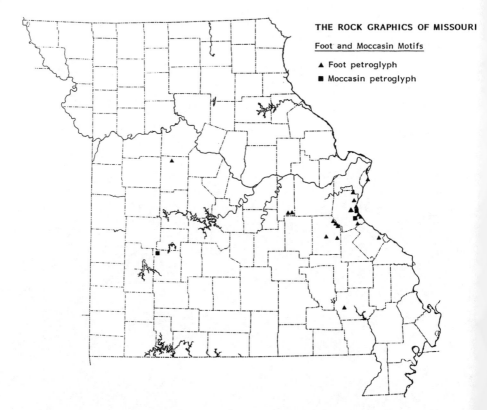

Figure 5.28. Distribution of foot and moccasin motifs in Missouri rock art.

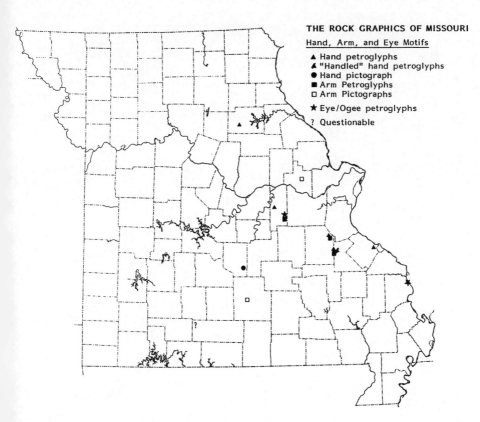

Figure 5.29. Distribution of hand, arm, and eye (ogee) motifs in Missouri rock art.

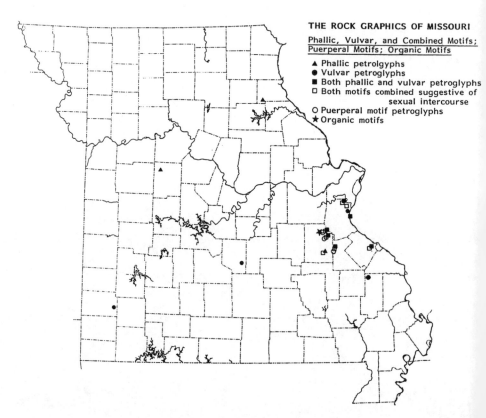

Figure 5.30. Distribution of phallic, vulvar, combination, and birth scene motifs in Missouri rock art.

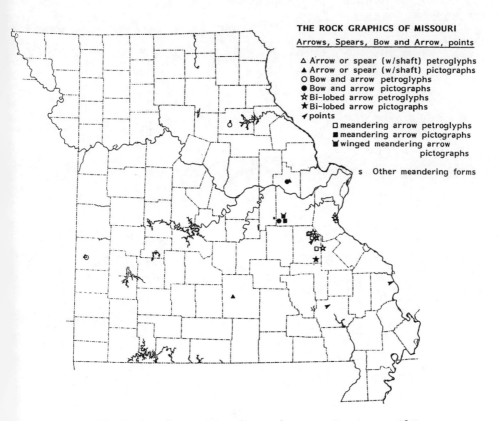

THE ROCK GRAPHICS OF MISSOURI

Arrows, Spears, Bow and Arrow, points

△ Arrow or spear (w/shaft) petroglyphs
▲ Arrow or spear (w/shaft) pictographs
O Bow and arrow petroglyphs
● Bow and arrow pictographs
☆ Bi-lobed arrow petroglyphs
★ Bi-lobed arrow pictographs
↗ points
□ meandering arrow petroglyphs
■ meandering arrow pictographs
⛟ winged meandering arrow
 pictographs

s Other meandering forms

Figure 5.31. Distribution of arrow, spear, bow and arrow, point, etc., motifs in Missouri rock art.

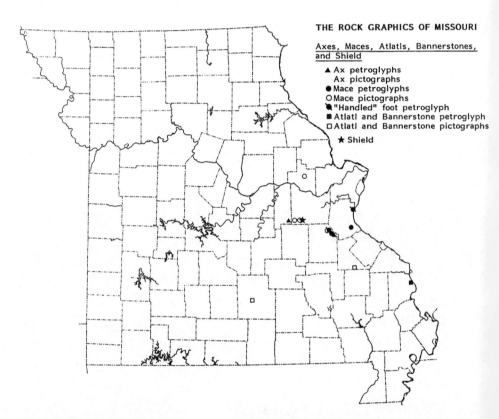

Figure 5.32. Distribution of ax, mace, atlatl, bannerstone, and shield motifs in Missouri rock art.

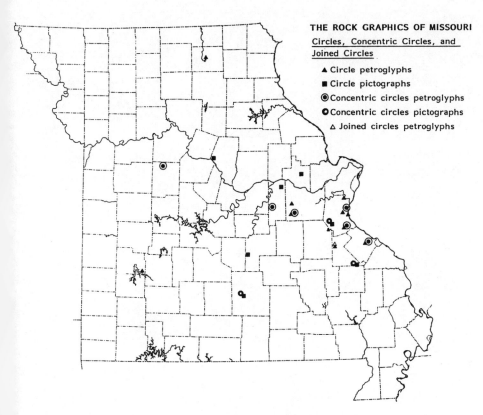

Figure 5.33. Distribution of circles, concentric circles, joined circles, etc., motifs in Missouri rock art.

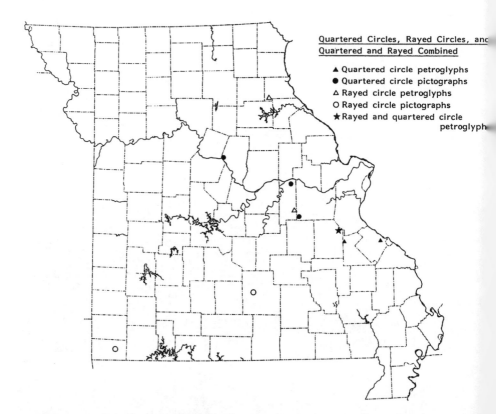

Figure 5.34. Distribution of quartered circles, rayed, quartered circle, and rayed combined motifs in Missouri rock art.

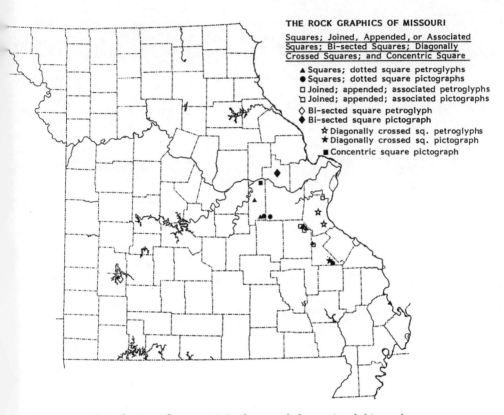

Figure 5.35. Distribution of squares: joined, appended, associated, bisected, diagonally crossed, and concentric square motifs in Missouri rock art.

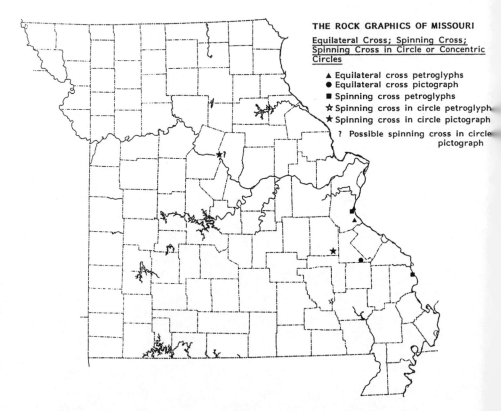

Figure 5.36. Distribution of equilateral cross, spinning cross, etc., motifs in Missouri rock art.

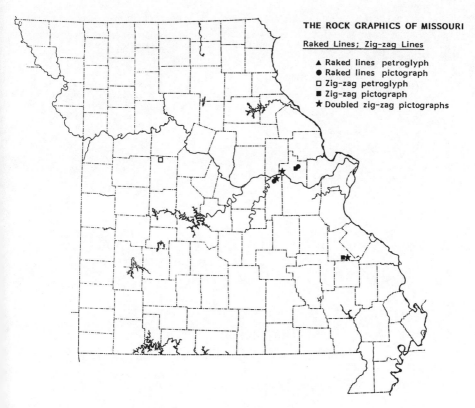

THE ROCK GRAPHICS OF MISSOURI

Raked Lines; Zig-zag Lines

▲ Raked lines petroglyph
● Raked lines pictograph
□ Zig-zag petroglyph
■ Zig-zag pictograph
★ Doubled zig-zag pictographs

Figure 5.37. Distribution of raked and zigzag line motifs in Missouri rock art.

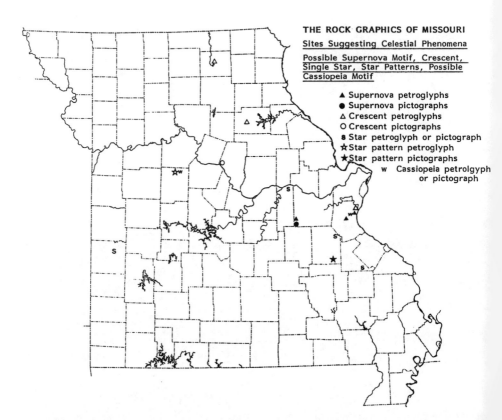

THE ROCK GRAPHICS OF MISSOURI

Sites Suggesting Celestial Phenomena

Possible Supernova Motif, Crescent, Single Star, Star Patterns, Possible Cassiopeia Motif

▲ Supernova petroglyphs
● Supernova pictographs
△ Crescent petroglyphs
O Crescent pictographs
8 Star petroglyph or pictograph
☆ Star pattern petroglyph
★ Star pattern pictographs
 w Cassiopeia petrolgyph or pictograph

Figure 5.38. Distribution of celestial motifs in Missouri rock art.

Flora and Fauna

1. Birds and Animal Motifs (Figure 5.2)

The motif that seems to be most often carved or painted on rocks in Missouri is the bird. Grant (1981:137) notes that at the confluence of the Missouri and Mississippi rivers "the thunderbird is the dominant design element." He also sees this avian motif as being related to the Algonkian bird designs of Pennsylvania. "Many examples of the typical Algonkian thunderbird occur at sites in the Mississippi Valley . . . the only other occurrence of this distinctive symbol in the Eastern Woodland is at Safe Harbor, Pennsylvania" (Grant 1981:141). The bird carvings and paintings often display distinctive tail shapes (expanding, contracting, bifurcated, etc.). In most cases, these birds are in silhouette or outline and can be tentatively identified with regard to genus.

2. Quadrupeds (Figure 5.2)

There are a large number of quadrupeds. Some are identifiable, but most are even more difficult to identify than the birds. When a quadruped has antlers we can be fairly safe in assuming it is a cervid, either a deer or a wapiti. In the literature, animals with antlers are usually referred to as deer, but as noted in the Rocky Hollow site report (Diaz-Granados 1983:15), there is a clear distinction between the configuration of deer and wapiti antlers. Given that powerful and controlling animal spirits are often venerated, one suspects that the massive wapiti may often be depicted. Wapiti were plentiful in most areas of Missouri prior to 1800. Other quadrupeds possibly represented are the bear, bison, beaver, raccoon, rabbit, and canids, among others. There is a horse pictograph—presumably historic—at the Lost Creek site where prehistoric pictographs are also present. A quadruped that appears with relative frequency in Missouri rock art is the one with the long, extended, or long and curled tail. Because of its frequency, we believe it deserves a distinct motif category.

3. Curled-Tailed or Long-Tailed Animal (Figure 5.2)

This creature has been and could be labeled an opossum. The opossum figures prominently in Mesoamerican mythology, but is not a major character in Native North American oral tradition. Although Muller (1986:62) labels a depiction at Mud Glyph Cave "a probable opossum" the figure is unfortunately not pictured. It is rather unlikely, but not impossible, that the opossum, a slow, land-crawling, nocturnal, and common arboreal creature in the eastern United States would be so highly regarded as to merit portrayal. However, Hudson (1976:139) notes that the southeastern Indians often sin-

gled out anomalous animals for special symbolic values. Ronald C. Wilson, a zooarchaeologist, refers to opossum *tracks* at Jaguar Cave, Tennessee (Faulkner 1986).

It has been suggested that these four-legged animals with extremely long tails, either straight or curled into a spiral, may instead be representations of the previously mentioned mythical creature known as the Piasa, uktena, "underwater spirit," or "water spirit." This creature was painted by Native Americans on the bluffs at Alton, Illinois, across the Mississippi River from St. Louis (see discussion in Chapter 2) and was also depicted at other locations in the Eastern Woodlands. The Omaha referred to it as the spirit of all animals, an animal that dwelt at the bottom of a great lake. It is illustrated in Fletcher and La Flesche (1992 [1911]:515), and effigy mounds in Wisconsin (Radin 1990:47) are believed to represent "various clan animals of the Winnebago, including the long-tailed 'water-spirit.'" It is also referred to by the Oto, Crow, and other Siouan-speaking groups.

This creature, often cited in modern literature as the "Piasa," was an object of fear and respect for centuries among early Native American groups and has been a fascinating research figure for archaeologists, historians, and folklorists for many decades (Catlin 1844; Jacobson 1991; Iloilo M. Jones 1990; and others). Hamell (1998) discusses the underwater panther as the animal depicted in long-tailed representations in northeastern North America. Hamell (1998:259–61) mentions the extensive range of this feline throughout the New World until recent historic times. He also discusses the association of the panther/long-tail in myths (Huron-Wyandot and Seneca) with the "primal man-being" and mentions that within these groups the "long-tail" is linked to the meteor/comet. In another reference, Burland (1985:58) shows a beadwork and wool yarn bag woven by the Sauk and Fox (early Prairie-Peninsula inhabitants) about 1880 that depicts this same motif.

This creature with all of its diagnostic features exhibits horns, four clawed feet, scales, an extremely long tail (sometimes curled over its head), beard, fangs, raccoon mask, and wings; sometimes it has ear spools and a snakelike body without feet. Although there have been no previous references to this mythical creature in the literature on Missouri rock art, there may be such a depiction at Picture Cave #1 (Figure 5.18). It is shown with its face in a frontal position. Its open oval mouth is lined with opposing pointed teeth. Its eyes are concentric circles and there are square forms at the sides of its head to probably indicate ear spools. Delicately drawn antlers project from the top of its head and are so faded as to suggest they were rendered earlier and the face and/or head possibly redrawn. Extending to the left is its body, simply rendered by two wide, undulating lines that taper and fade. A similar body is on the Piasa petroglyph discovered by Iloilo M. Jones in Illinois (1990).

4. Snakes/Serpents/Spirals (Figure 5.2)

Snakes or serpents are second only to birds in frequency of occurrence in Missouri petroglyphs and pictographs. They usually are portrayed in one of two forms: meandering or coiled. Coiled snakes are quite consistent in form; the only variation is the mouth, which is depicted either open or closed. Meandering snakes are plentiful and vary considerably. Modifications include having the mouth open or closed, being shown crossing another form or person, being held in the beak of a bird, or having a protrusion (feather, horn, or crest) angling back from the head (seen at Rocky Hollow Site #1, Figure 5.7, B-4, and at the Groeper Shelter, Figure 5.39). The latter version is presumed to depict the horned or feathered serpent.

Because the alcove at Rocky Hollow also contains a crescent moon motif, we should mention a passage by Marshack (1985a:142) in which he states, "The metaphorical serpent is used to represent astronomical and meteorological processes of the sky and of the earth as an extension of cosmological processes." Other possible serpent motifs have heads that look like arrow points (Figure 5.7). These two latter types are illustrated in Vastokas and Vastokas (1973:figs. 30 and 33) with regard to the Peterborough petroglyphs, which contain a large number of serpents.

5. Other Reptiles and Amphibians (Figure 5.2)

Turtles and lizards, salamanders or skinks, are seen occasionally in petroglyphs. It is often difficult to identify these if they are badly weathered or faded. The turtle, although an important symbol in oral traditions, is seen at just a few sites, and there is only one obvious (and one possible) frog motif. However, there are many motifs that have been interpreted as representing "tadpoles."

6. Fish and Amphibians (Figure 5.2)

Fish do not appear often in Missouri rock art, but in one case in which they do (Rocky Hollow #2), they are carved with considerable detail. The

10 cm

Figure 5.39. Horned serpent (Groeper).

two distinct fish at Rocky Hollow are carved with dorsal, caudal, and anal fins (Figure 5.40) and were tentatively identified by John Wylie, former director of the Natural History Division, Missouri Department of Conservation, as possibly representing the catfish or black bullhead, found in the area's streams and rivers (John Wylie, personal communication, May 1983). It is curious that there are not more portrayals of fish because they provide such a plentiful food source in the state. A fish painted at the Lost Creek site is historic.

7. "Bird Tracks" (Figure 5.3)

The most noted and well-known "tracks" are those referred to as "bird tracks." These are found in great number in Missouri and also in many other parts of the world. Their variety, for such a simple trident design, is notable. The motif can be in the form of a simple bisected V, others show a rounded form at the base of the V, or it can be executed in great detail such as one at Washington State Park Site B. Another variation is with the central line extending a distance below the point: Υ. It is unclear whether all of these motifs are indeed "bird tracks" or even bird-related.

They may be encoded abstractions, simple trident marks, or in some cases vulvar motifs, or with the bisecting line extended downward longer than the Υ, this motif might portray a forked wooden stick, an important item in ritual activity in Native American groups as well as elsewhere (Marshack

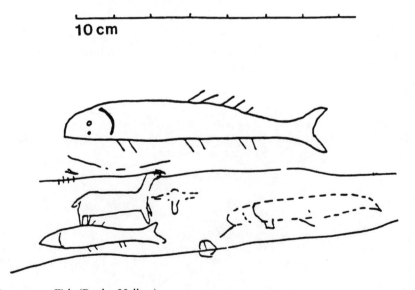

Figure 5.40. Fish (Rocky Hollow).

1985a:143). Snow (1977:47) refers to these motifs as female genitalia and notes that "their frequent identification as bird tracks has tended to obscure their real meaning. Most birds, particularly the birds of prey that most interested North American shamans, have rear toes that leave tracks quite different."

These "bird tracks," while they are often encountered isolated on boulders, are sometimes portrayed in association with another motif such as the quartered circle (Figure 5.3, F-3). They can also be found within large complex sites such as those at Washington State Park. There they seem to complement more intricate and involved themes and were obviously an important and widely used motif. Interestingly, this motif, abundant in petroglyph form, is rarely seen in pictographs in Missouri.

8. "Animal Tracks" (Figure 5.3)

While prominent in the American Southwest, animal tracks are less frequently found in Missouri. However, a few examples of obvious animal tracks carved into rock are present at several sites. They probably represent deer and rabbit. Perhaps they refer to the animal itself or to clan marks. The most unique tracks yet found in Missouri are the bear paws on the ceiling of the Hidden Valley Shelter in Jefferson County (Figure 5.3, F-4).[7]

9. "Pelts" (Figure 5.3)

At least one site contains a representation of what appears to be an animal pelt or animal-skin medicine bag hung over a human arm (Figure 5.41). This could be significant if the identification is correct. Otter-skin medicine bags

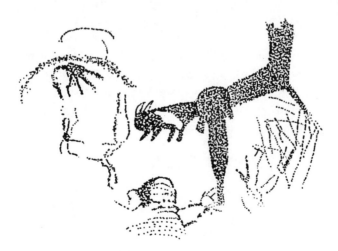

Figure 5.41. Arm with animal pelt/medicine bag (Picture Cave).

were used by many of the upper and middle Mississippi Valley groups. One other site has a pictograph of what the informant believes to be a pelt, most probably a stretched pelt. Other depictions of animals that appear to be "flattened" may also represent pelts or animal skins.

10. Organic (Figure 5.3)

Obvious plant representations are rare in Missouri's petroglyphs and pictographs. The most notable are the possible "corn sprouts" (Wellmann 1979a:157) at Washington State Park (Figures 5.3, B-7 and 5.15). As mentioned elsewhere, there is a possibility that these motifs originally had gridlike striations within the oval areas suggesting ears of corn. Diesing (unpublished map notes) shows a "tree" design at the Peene-Murat site that appears to us to represent meandering serpentine motifs. Enigmatic graphics at a few sites, for example, the Thousand Hills State Park site, may represent a seed pod or nut and sprout.

Anthropomorphs

In identifying the anthropomorphic motifs, we found it necessary to separate them by general activity. We settled on four basic attitudes: standing, in general motion (running/dancing/at sport/in conflict), in the "shaman" position (with both hands or a single hand raised), and in puerperal acts. It is difficult to impossible to make a determination on the gender of most anthropomorphs, particularly in regard to the petroglyphs. Even the figures in what appears to be suggested puerperal activity are without any obvious female characteristics. In addition, the role of shaman can be filled by either men or women in many societies. In the rock art of other areas, especially the pictographs in the American Southwest, it is often possible to determine gender through hair arrangement and clothing details, but not here. These features are absent in Missouri except for the figures at Picture Cave #1 and possibly a very few in the anthropomorphs at Wallen Creek, described below. Thus, no attempt is made to assign gender to most anthropomorphs depicted in the state's petroglyphs and pictographs.

11. Standing Anthropomorphs (Figure 5.4)

Those anthropomorphs (human beings) that appear to be standing are included here. Posture is essentially straight and even, legs are straight or slightly spread, and arms are at the sides in a generally vertical position. In some instances the figure is holding an object or is adjacent to a motif. In almost all cases we are dealing with petroglyphs and do not see the detail of clothing and accoutrements (except at Picture Cave #1, Rattlesnake Bluff,

and very few others) that is evident in the numerous pictographs of the Southwest.

However, we must address one detail we believe has been misinterpreted by both Wellmann (1970a, 1979a) and Magre (1965) concerning the standing human being with an appendage between the legs (mentioned earlier). While in some instances this could represent a male figure with phallus, as they suggest, we believe that at least some of these figures depict the person in native clothing with his warrior society sash, usually an animal skin or skins. The Siouan warrior society sash was traditionally worn around the neck and draped down the back. It hung very low, sometimes to the ground, along the back of the legs. These society sashes set apart the individual as a valiant warrior and were worn only in battle and during important ceremonies. A society sash is portrayed on the copper hawk man in Howard (1968:41).

Sashes are also depicted in the Spiro region where figures are portrayed frontally on cups showing "back aprons" (because they are shown behind the figure) and referred to as a "Craig C specialty" by Phillips and Brown (1978:101). Several of the early illustrations of Native Americans show such sashes (e.g., Bodmer 1970 [1832–1834]; Catlin 1844:plates 235 and 236; Hunt and Gallagher 1984:298; Mails 1973:plate of Pehriska-Ruhpa, 48, 62, 329). The Catlin illustrations display two Sioux figures in their ball player attire; feathers and/or cloth is shown hanging from the waist but descending centrally between the legs. Of course, in all cases, the placement of the sash would be more obvious if the figures in the above-mentioned drawings were all pictured frontally in a formalistic manner as are most of the petroglyphs.

Fundaburk and Foreman (1957:61, 84, 87) illustrate figures from shell gorgets and other items manufactured from shell. Several portray male figures with sashes hanging down essentially between the legs (and *not* extending to the ground). Another frontal illustration that we are aware of is on the New Albin tablet (Bray 1963:34) in which a possible society sash is depicted between the figure's legs. The practice of wearing society sashes has continued to the present day and can be seen in traditional clothing worn at Native Americans ceremonies. Almost all the dancers on the Osage Reservation wear these same style sashes as part of their traditional clothing for the Ilonshka, the ceremonial dances.

12. Anthropomorphs in General Motion
(Running, Dancing, at Sport) (Figure 5.4)

Although Wellmann (1979a:157) claims that action scenes "are rare" in North American rock art, many of Missouri's graphics portray human beings in motion, including running or dancing (Salt River site, Figure 5.42), throw-

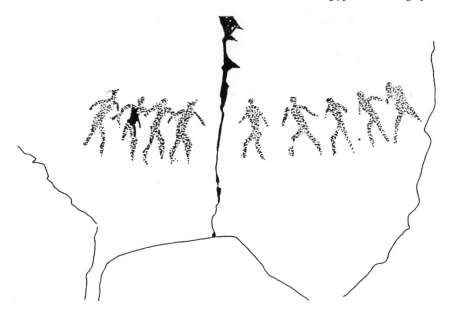

Figure 5.42. Running men (Salt River) (from Donald P. Heldman slide).

ing an atlatl dart or spear (White Rock Bluff site, Figure 5.43*a*), fighting or shooting the bow and arrow (Maddin Creek site, Figure 5.43*b*), "dancing" (war-dancing?) (Rattlesnake Bluff site, Figure 5.13), and playing at sport (stickball or chunkee?: Wallen Creek site, Figure 5.17, lower left). At the Washington State Park site a figure appears to be playing a type of stickball with a single stick (Figure 5.16*a*).

13. Anthropomorphs in the "Shaman" Position (Figure 5.4)

The so-called shaman position has been described and discussed by Garvin (1978), Grant (1981), Snow (1977), Schaafsma (1980), and Wellmann (1979a) as well as herein. Vastokas and Vastokas (1973:70) state, "Although handprints commonly occur in rock art sites the world over from Palaeolithic times onward, the rendering of the raised arm and the emphasis on gesturing hands carry a specific meaning in Algonkian pictography: the gesture is always associated with shamans, represented either as full-figured bodies or signified simply by the pictograph of an arm. . . . All denote gestures of reverence, supplication, or communication with the sky and more specifically to the Great Spirit." The figure with raised hands is represented in Missouri rock art at the Mitchell, Rocky Hollow, White Rock Bluff, and Three Hills Creek sites, and the arm motif is addressed below. The Clark notebook illustrates one from the Big Moniteau site on the Missouri River bluffs. Further discussion on shamanism and rock art is included in Chapter 6.

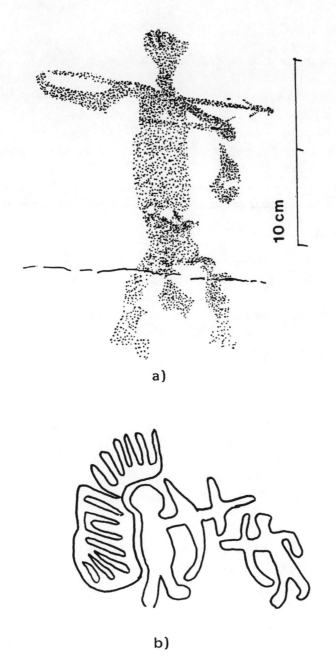

10 cm

a)

b)

Figure 5.43. *a*, Spearthrower (White Rock Bluff); *b*, Archers in combat (Maddin Creek) (drawing from chalking and slide by Frank P. Magre).

14. Anthropomorphs in Puerperal Activity (Figure 5.4)

One of the most controversial motifs in Missouri is that of the puerperal or "birth" scenes evident at the Maddin Creek (Figure 5.44, *a* and *b*) and Three Hills Creek sites. The ones at Maddin Creek are believed to be a record of a multiple birth event (Magre, personal communication, 1989; Wellmann 1970a). While we agree that it most probably denotes a "birth" motif, and also agree that the face value impression of a *multiple* birth is plausible, we disagree that the explanation is that simple. It may very well represent births, although not necessarily an actual delivery, but rather the number of off-spring of an important mythical character (discussed in Chapter 6).

15. Foot Motif (Figure 5.4)

An extremely common motif is that of the foot or feet. Foot motifs appear in almost all the major rock art regions and are one of the most frequently reported graphics. Bushnell (1913) reports on the distribution of this motif throughout the United States and notes that "numerous examples . . . were formerly to be met with along the bluffs of Jefferson County, Missouri, and northward on the river bank near and within the city of St. Louis." He cites examples in Missouri, including one along the Gasconade and one from the bluffs at Kimmswick, which were both cut out and sent to the Peabody Museum. We were able to secure a scaled slide of the Kimmswick footprint but the museum reported no record of the one from Gasconade.

Petroglyph footprints in Missouri vary widely from single and double prints (the St. Louis Riverfront site had two prints), to the multiple "walking" prints at Indian Foot Lake, to prints with varying numbers of toes (Ellis Footprint, four toes), and prints that are either associated with other motifs (Riviera Ledge, foot and square) or made into other symbols such as the one that displays a "handle" appended where the ankle would be (Anheuser and Washington State Park B, Figure 5.4, F-5). These motifs are frequently situated along major or minor waterways. The numerous foot carvings along the southeastern bluffs of the Mississippi River comprise the eastern small Quasi-style sites. Carter Revard (1987:460), of Osage heritage, mentions the allegorical connection between footsteps and prayers among the Osage peoples. Interestingly, footprints are rare in Tennessee and Wisconsin (Charles Faulkner, David Lowe, personal communications, April 1993).

16. "Moccasin" Motif (Figure 5.4)

We have read and heard of more "moccasin" petroglyphs than we have actually seen. It seems that natural depressions are frequently mistaken for moc-

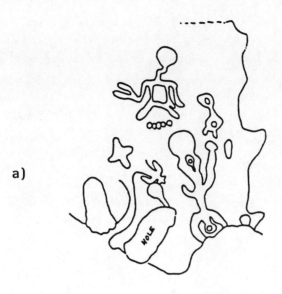

a)

b)

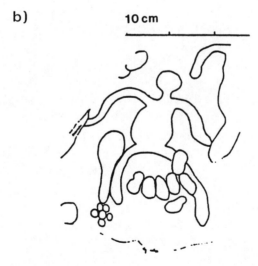

10 cm

Figure 5.44. *a* and *b*, Birth scenes (Maddin Creek) (recording and drawing by Benedict Ellis).

casin prints. However, some may indeed portray the covered foot. They are referenced in Cedar, Jefferson, and Crawford counties and one may be evident on a piece of sandstone supposedly cut from a bluff along the Gasconade and now in the collection of the Missouri Historical Society in St. Louis. One possible moccasin petroglyph may also be present at the Plattin Creek site. Other than these, we have not found any additional evidence of "moccasin print" petroglyphs, and no pictographs with this motif have been reported.

17. Hand Motif (Figure 5.4)

The hand motif is much more limited in quantity and distribution than the foot motif. Hand depictions vary from prints (Schneider site, Figure 5.45*a*), to skeletal hands (Washington State Park site, Figure 5.45*b*; and one at Three Hills Creek (Figure 5.45*c*), to enlarged or abnormally "fat" hands (Bushberg-Meissner, Rocky Hollow, and Mitchell). There is also a hand at the Three Hills Creek site that is treated in the same manner as the feet at the Anheuser site: a "handle" is attached to where the wrist would be. In both instances, this makes the hand or foot take on the appearance of a club or mace. Another distinctive rendering of the hand is one seen at the Deer Run Shelter site (Figure 5.4, F-7). Interestingly, this treatment of the palm with concentric ovals is seen in the rock art of the Southwest. One such example is illustrated by Feest (1992:54), who says that this figure on an Arapaho Ghost Dance dress shows hands styled as "protective designs."

18. Arm Motif (Figure 5.4)

A number of arms are depicted both in petroglyphs (Peene-Murat, Figure 5.20*a*; and Maddin Creek, Figure 5.20*b*) and at two pictograph sites (Picture Cave, Figure 5.41; White Rock Bluff, Figure 4.2*b*). They are very naturalistic and four of the five are associated with other motifs, such as another arm or a pelt or medicine bag. The arm at the White Rock Bluff site is just below what appears to be an atlatl with bannerstones attached. Isolated, detached arms are widespread in the rock art of other areas and have been associated with the power of shamans. Revard suggests that the repeated bent-arm motif might signify a message in Native American sign language (Carter Revard, personal communication, October 27, 1993). A preliminary literature search did not disclose any clues, but we agree that this repeated motif was probably intended to carry a message either to the viewer or to the powers above.

19. Eye Motif (Figure 5.5)

Although eye motifs are rare in Missouri, there is an outstanding eye or "ogee" motif at the Peene-Murat site, as previously mentioned (Figure 5.21*b*).

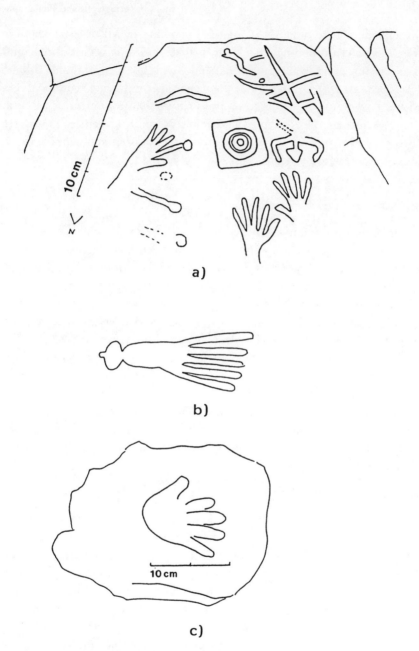

Figure 5.45. Hands: *a,* pointing to concentric circles in a square (Schneider); *b,* skeletal (Washington State Park) (from slide by Frank P. Magre); *c,* single (Three Hills Creek).

We include it here because the motif is common in Mississippian pottery from this and surrounding areas. Muller (1986:78) lists it as part of the Spiro style and notes that while present at Mud Glyph Cave in Tennessee (Muller 1986:60, plate 12), the motif does not have the oval center common elsewhere. A variation of the ogee motif is carved into a boulder at a site in Illinois across the Mississippi River from and south of the St. Louis area (Fortier 1995). An atypical eye or ogee is on the rock outcrop with the Commerce Eagle (Figure 5.21c) and may be considered an ogee variation or unusual "weeping eye" form.

20. Phallic Motif (Figure 5.5)

Motifs in this group, widely accepted as denoting the male sexual organ, are also often referred to as "pit and groove" elements. They are found in association with natural or artificially produced (i.e., ground) pits. These are prevalent at many sites and sometimes found in conjunction with other motifs, including what are widely accepted as vulvar motifs. They are most frequently found in multiples. Campbell Grant (1981) refers to these "pit and groove" motifs as being possibly the oldest in North America.

Plains sun dancers, while undergoing self-torture in the form of incisions through the skin, stared at rawhide cutouts of the male in profile portrayed with an exaggerated phallus. "In this way the dancer hoped to increase his fertility and thus ensure the growth of the tribe" (Bancroft-Hunt and Forman 1992). Just four sites are presently known that contain only phallic motifs, while sites with phallic and vulvar motifs placed singularly or in combination total thirteen.

21. Vulvar Motif (Figure 5.5)

The vulvar motif has been discussed in the literature probably more than any other graphic motif. According to Giedion (1962:89) vulvar motifs occur in rock art from the early Aurignacian in Europe to the historic period in the United States. Stoliar (1977a:40–41; 1977b:13) illustrates a variety of Aurignacian motifs that do not differ markedly from many of those found in Missouri's petroglyphs. Like some of the other common motifs, it is present at almost every site in the world where rock art activity has occurred. The most typical is the U-shaped motif. Although somewhat similar in appearance it is not to be confused with the horseshoe motif seen in the American Southwest where rock art activity extended into and past the time of Spanish contact and the introduction of the horse.

Other portrayals of this motif include the circle, small concentric circles with or without a vertical line placed centrally at the bottom, the joined circle

a) b) c) d)

Figure 5.46. Vulvar motif: *a*, Bushberg-Meissner; *b*, Miller's Cave; *c*, Washington State Park; *d*, Sharpsburg.

motif, and any number of variations on the above. In regard to the meaning of the vulvar motif, it is generally thought to denote human fertility, although it could imply fertility of crops or animal resources. In some cases it might have been carved to symbolize an important female deity. Vulvar motifs are associated with game trails in the Great Basin according to Thomas (1976).

Sundstrom (1989:417) states that in the Northwestern Plains, the vulvar and phallic motifs do not appear in the rock art records until the latter portion of the late prehistoric period and possibly not until the protohistoric period "at which time they become a dominant motif." She further notes that their appearance "seems to coincide with the movement of Siouan and Algonkian speakers into the area from the east and northeast." We can use this information to move back in time from her "late prehistoric" into possibly middle prehistoric for its appearance in the Missouri area. Sundstrom adds that depictions of vulvas and phalluses "can best be thought of as representative of a Pan-Plains art tradition which may ultimately have roots in the Eastern and/or Northern Woodlands" (Sundstrom 1989:418).

At the Bushberg-Meissner Cave, a carved motif that has been referred to as a type of "female symbol" (Figure 5.46*a*) appears on the wall just inside the narrow entrance to this small fissure cave. It may have been placed there to emphasize the similarity of the crevicelike opening to female genitalia. In the western United States, McGowan (1978:21) notes natural as well as enhanced rock formations that resemble female genitalia and that are known to have served a ceremonial function. The motif is evident at the major petroglyph sites in the southeast quadrant of the state. Notable are those on the fall rocks at Miller's Cave (Figure 5.46*b*) where more than a dozen vulvar motifs were pecked into two adjacent boulders. The boulders have been markedly vandalized. Vastokas and Vastokas (1973:82, fig. 21) discuss the vul-

var motif and illustrate a number of them with oval to triangular forms and locations ranging from California, Washington, British Columbia, and Mexico to Siberia, Norway, and France, as well as Missouri.

Shapes other than the horseshoe-shaped motifs are also suspected to represent the vulva. In addition to the figure in 5.46a is a variation that resembles an "oar-shaped motif" (Figure 5.46d). Nevertheless, the naturalistic and U-shaped motifs predominate among the Missouri petroglyphs. None have yet been identified in the state's pictographs.

22. Phallic-Vulvar Motifs in Association (Figure 5.5)

In at least three petroglyphs, including Three Hills Creek (Figure 5.47a and b) and Wallen Creek (Figure 5.47c), there are depictions that could be interpreted as motifs suggesting sexual intercourse. Sometimes the depiction is that of a phallic motif pointing toward or "entering" an ovoid or circular one (Figure 5.47b). Vastokas and Vastokas (1973:86, fig. 24) illustrate motifs

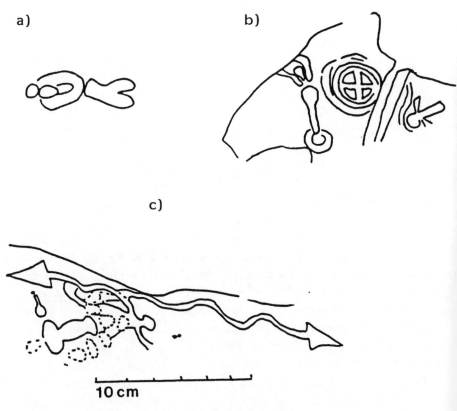

Figure 5.47. Motifs suggesting copulation: a and b, Three Hills Creek; c, Wallen Creek (from chalking and slide by Frank P. Magre).

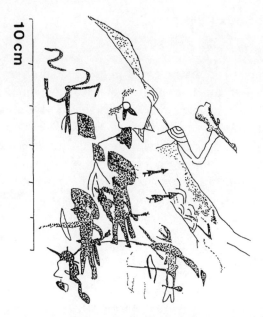

10 cm

Figure 5.48. Anthropomorph with clothing details and body decoration (Picture Cave).

found in the Peterborough petroglyphs that also suggest copulation. Reichel-Dolmatoff (1971:51, 129), in regard to the Desana of Colombia, discusses the strong correlation between fertility and shamanism.

23. Clothing/Body Ornament (Figure 5.5)

There are very few examples of clothing detail in Missouri rock art, although there are many anthropomorphs. The reason for this is that little of the pictographs remains except for light traces, and the petroglyphs are too weathered to have retained any possible detail from when they were first executed. The pictograph site at Picture Cave #1, preserved because of its remote location, is an exception. It retains a considerable amount of clothing detail including loin cloth, hair details and ornaments, shoulder tattoo, and facial tattoo or painting (Figure 5.48). A few petroglyph sites show "protrusions" in silhouette that might indicate clothing or ritual paraphernalia. Among the few definite examples are the Thousand Hills State Park site, where one anthropomorphic figure has an adornment at the waist, and the Wallen Creek site, which has action figures with possible society sash, "apron," and head or hair ornamentation (Figure 5.17, note detail). As with clothing, however, very little evidence of body ornamentation is available in the more than one hundred sites in Missouri.

Weapons and Related Items

24. Arrow Point and Shaft Motif (Figure 5.6)

The arrow point and shaft motif is in itself not all that prominent, but when it does appear in petroglyphs it is quite true to form. It is more likely to be seen, however, in association with the bow and is also seen at times protruding from animals such as those at Picture Cave #1 and the wapiti at the Willenberg Shelter (Figure 3.1*b*). Its most unique depiction is at Picture Cave #1, where it is shown with a horizontal Y-shaped element extending from the nock end of the arrow shaft. This same Y-shaped element is illustrated in at least two of the Stiles tablets, numbers 2 and 6 (Bray 1963:20, 26) from near Cherokee, Iowa. As Oneota style motifs they are compared by Bray to those from the Utz site in Saline County, Missouri (Bray 1963:17).

25. Arrow Motif Variations (Figure 5.7)

A few motifs that appear to be portions of arrows or spears are present in Missouri rock art. They are illustrated with straight or curving shafts (Figure 5.49).

26. Bow and Arrow Motif (Figure 5.6)

The bow and arrow motif is seen in the state's rock art sites more frequently than the singular straight arrow shaft. In fact, it is seen in several parts of the state, from Vernon County in western Missouri to Washington County in the southeastern part of the state. Most notable is the carving at Maddin Creek that depicts two opposing figures each with a raised bow and arrow (Figure 5.43).

27. Arrow Point Motif (Figure 5.6)

There are two known petroglyphs that portray motifs in the shape of arrow or spear points. One is at the Moccasin Spring site and the other, which is ambiguous, is at the Washington State Park site.

Figure 5.49. Meandering arrow (Washington State Park) (from chalking and slide by Robert Elgin).

28. Ax Motif (Figure 5.6)

Several axes (Figure 5.50, *a* and *b*) are present at the Maddin Creek site. Some are of unusual design. One is quite elaborate with its petaloid form (Figure 5.50*b*), and a third, at the Reifer site, appears to be in the form of a simple monolithic stone ax (Figure 5.50*c*).

29. Mace Motif (Figure 5.6)

The mace motif is one of the more frequently encountered designs. It is prominent at the Washington State Park B site, and at least three differently styled maces can be seen there (Figure 5.16*a*). A mace similar to one at Washington State Park can be seen in a pictograph at the Rattlesnake Bluff site held in the figure's raised hand (Figure 5.13). Another style is present in the pictograph at the Willenberg Shelter site (Figure 5.51). This mace is bisected by a vertical line and is reminiscent of those portrayed in the shell engravings at Spiro and the copper plates at Etowah. The bifurcated mace is also portrayed on the wall at Mud Glyph Cave in Tennessee. Muller (1986) considers the mace one of the motifs limited to the late thirteenth century and associated with the Southeastern Ceremonial Complex.

30. Atlatl/Bannerstone Motif (Figure 5.6)

Only two sites contain graphics that may depict bannerstones. The Deer Run Shelter has a weathered but discernible pictograph that resembles a butterfly-style bannerstone surrounded by dots. The White Rock Bluff site also has a possible atlatl onto which are attached three bow tie bannerstones of graduated sizes and color intensities (Figure 4.2*b*). White Rock Bluff may have one of the most unusual depictions, unrecognized when the site was first reported in the 1950s: an anthropomorphic figure about to launch what appears to be an atlatl and spear (Figure 5.43*a*). Sundstrom (1989:353) reports portrayals of atlatls in the rock art of the southern Black Hills, and they have been reported in a variety of other regions.

31. Shield Motif (Figure 5.6)

Although there is only one certain shield motif in the state, we felt it deserved its own category because of its frequent appearance in other areas to the west. This one is vertically rectangular and may have a series of three circles between the top and bottom border. It is held by the dancing warrior at the Rattlesnake Bluff site (Figure 5.13).

32. Meandering Arrow Motif (Figure 5.7)

One of the most curious motifs, that of the meandering arrow, is not uncommon in other parts of the United States. It would be easy to assume

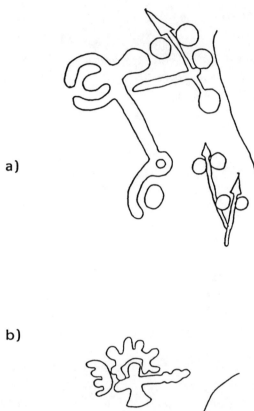

a)

b)

c)

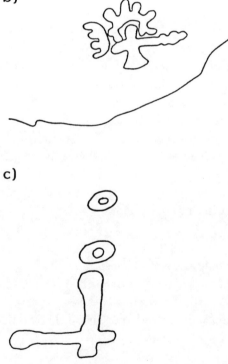

Figure 5.50. Ax motifs: *a* and *b*, Maddin Creek (from drawings by Benedict Ellis); *c*, Reifer (from photograph by Robert Elgin).

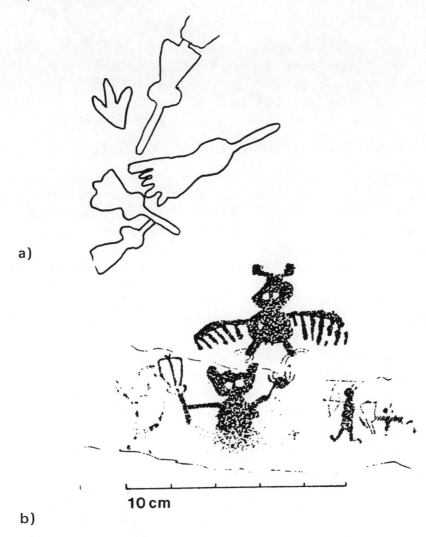

a)

b)

10 cm

Figure 5.51. Maces: *a*, Washington State Park (from chalking and slide by Frank P. Magre); *b*, Willenberg Shelter.

that the form indicated a serpent were it not for the distinct arrow point (head?) at one end. In the story of Red Horn, his arrows turn to serpents when he sets his quiver down at the end of each day (Radin 1954:24). This is not to say that this oral tradition is necessarily implicated, but there may be a similar mythological background or metaphor suggested. The meandering arrow is seen also with multiple arrow points, often with one at each end of the shaft. Varieties of this motif can be seen at the Wallen Creek (Figure 5.17) and Washington State Park sites. There is also a variation at the Peene-Murat site (Figure 5.20*a*).

33. Other Meandering Form Motifs (Figure 5.7)

These motifs appear as meandering or undulating lines usually without "heads" or "points" at one or both ends, although they sometimes terminate in some other unknown form. There is at least one each at the Wallen Creek, Washington State Park C, Thousand Hills State Park, and Rocky Hollow sites. This latter example is located adjacent to a crescent moon.

34. Bilobed Arrow Motif (Figure 5.7)

More common than the arrow and shaft or the bow and arrow motif is the bilobed arrow motif. It is seen with frequency at several of the major sites on the eastern side of the state. Examples of this motif are included at the Lost Creek, Three Hills Creek, Maddin Creek, and Washington State Park sites. A classic example illustrated by Henson (1986:104) closely matches a motif in Missouri rock art. Muller (1986:62) considers the bilobed arrow the most distinctive horizon marker for the later thirteenth-century horizon.

Geometric, Abstract, and Related Motifs

35. Circle Motif (Figure 5.8)

There are many sites in Missouri that contain circle motifs, and these come in a variety of configurations and associations. Some have an attachment or appendage, and some have a dot in the center. Because there are so many different circle motifs, we have sorted them into the following categories: joined, concentric, quartered (cross-in-circle), rayed, and rayed and quartered.

36. Joined Circles Motif (Figure 5.8)

Five sites are known to contain the joined circles motif: Bushberg-Meissner, Bushnell Ceremonial Cave, Cedar Hollow Ledge, Three Hills Creek, and Washington State Park A. This motif, seemingly rare in Missouri's rock art inventory, is featured more often in pottery design and clothing detail.

37. Concentric Circles Motif (Figure 5.8)

The concentric circles motif comes in a variety of forms, including both two and three circles and a dot within a single circle (dot-in-circle), which may be considered as concentric (as illustrated in Fundaburk and Foreman 1957:plate 52, top row). Concentric circles are widespread and may, along with quartered circles, comprise the majority of circular motifs in the state. They are seen in both petroglyph and pictograph form and at a variety of sites primarily in the eastern half of the state. As noted above, concentric circles are frequently observed in association with water resources and are sometimes thought to represent the expanding circles that result when a pebble

is thrown into the water. The concentric circles motif, sometimes called the "target motif" (if a third circle is present), is often considered to be a sun symbol and has been portrayed on shields, buffalo robes, and pottery. An excellent example is illustrated in Williamson (1989:171) from Chaco Canyon and has the addition of horns. Bancroft-Hunt and Forman (1992:124) refers to it as a "symbol of harmony." This motif was obviously tattooed on the shoulders of certain men (Burland 1985:114; Lorant 1946:plate "An Indian Chief") and is listed in the glossary of motifs (shown on shoulders) in Phillips and Brown (1978:149). Concentric semicircles are also represented on cloth fragments of rabbit hair mantles (Hamilton 1952:plate 148) and the motif is "one of the most common forms at Mud Glyph Cave" (Muller 1986:76).

38. Quartered Circle (Cross-in-Circle) Motif (Figure 5.8)

One of the most common motifs, and one that is also widespread through-out the United States, is the quartered circle. It has been identified in the rock art by numerous scholars in many locations (Fritz and Ray 1982:272, Arkansas; Heizer and Baumhoff 1962, Nevada and eastern California; Heizer and Clewlow 1973, California; Swauger 1984, Ohio; Wagner et al. 1990, Illinois; among others). It is seen in a variety of forms: simple, simple with an appendage, surrounded by concentric circles and/or rayed lines, and in association with bird tracks or a bird. The cross configuration was used as a sacred symbol within a circle (Joseph Brown 1989:89) for the Sun Dance ceremony and the busk or Green Corn ceremony (Howard 1968). It was used by the Omaha and Kansa for the central design of the ball game field (Fletcher and La Flesche 1992:197) and was the configuration of the Shell society's "fireplace and four sticks" (Fletcher and La Flesche 1992:figs. 123 and 124).[8]

The quartered circle motif, depicted on cooking/boiling vessels, is also evident on shell cups in association with what has been referred to as the "black drink" (Emerson 1989:66, 72–73). It is depicted on the backs of spiders on at least two shell gorgets from Missouri (Howard 1968:58, fig. 18*B*) and Illinois (Phillips and Brown 1978:175). This motif was used in tattoos on the backs of the hands of Osage women. The quartered circle is also seen on prehistoric pottery from Missouri and other states including Tennessee, Arkansas, and Mississippi and is present elsewhere in ancient Mesoamerican rock art (Aveni, Hartung, and Buckingham 1978), in European rock art (Kuhn 1956), and in China (Kwang-chih Chang 1986:150). Kuhn mentions the appearance of this motif on pottery as early as 3000 B.C. in Susa (Kuhn 1956:180). In all actuality, it is probably evident worldwide.

39. Rayed Circle Motif (Figure 5.8)

The rayed circle is usually thought to be a sun symbol or perhaps a bright star. It is a rather common motif in many areas, but there are only four

presently known in Missouri and each one is distinct. At the Peene-Murat site the carving resembles a stylized sun, whereas the pictograph at the White Rock Bluff site is more delicate (and faded) and its rays are pointed. The Sharpsburg petroglyph (Figure 5.52*a*) also has pointed rays that radiate around its ovoid shape, and it appears to have two "eyes" (Figure 5.52*b*). This portrayal, if indeed a face is intended, is unique in Missouri; however, faces within rayed circles are common in the Southwest (Zeilik 1984).

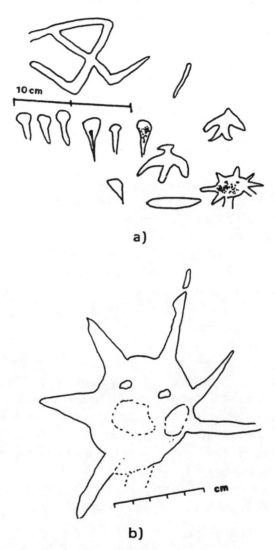

a)

b)

Figure 5.52. *a,* Panel with rayed circle; *b,* Detail of rayed circle.

40. Rayed and Quartered Circle Motif (Figure 5.8)

The rayed and quartered circle is, of course, a combination of the preceding two motifs. Because it is frequently seen at many sites in the American Southwest we have included it here, although only one example is presently known in Missouri (Maddin Creek; Figure 5.8, E-6).

41. Square Motif (Figure 5.8)

The square, while a simple geometric motif, seems to carry a tremendous amount of symbolism because it is used quite frequently and in different associations. There are many references throughout the literature to the square: it is used for the layout of the ceremonial ground for the Green Corn (or busk) ceremony and other similar harvest ceremonies, and as the shape for ceremonial corn cakes and the shape of woven wood armor that protects against piercing arrows. It is also considered a house structure and the motif shape for the house of a female deity (Bowers 1965:339). The square motif is particularly prevalent in the rock art of the Southwest and includes such meanings as "shrine, farm land, and ceremonial enclosures" (Olsen 1985:19).

42. Joined and Associated Squares Motif (Figure 5.8)

A few of the squares appear to be attached to other squares or to other geometric shapes. They are also frequently seen with appendages that have been translated as entrances or exits, as with the appendage on the quartered circle from the Cahokia beaker ("Tippett bean pot"). Two examples are those at Three Hills Creek (Figure 5.8, C-8) and Washington State Park A (Figure 5.8, B-8; and 5.9, A-1).

43. Appended Square Motif (Figure 5.9)

The appended square category refers to the motifs consisting of a square or rectangle with an intrusion, usually placed at a corner, which may be a serpent, foot, line/path, or bird. These are seen in the graphics of the Big Five including Three Hills Creek and Washington State Park, as well as at the Riviera Ledge site (in both 5.8, row 8, and 5.9, row 1).

44. Bisected Rectangle/Square Motif (Figure 5.9)

Bisected rectangles/squares occur at three sites from the Joplin area in far western Missouri to east-central Missouri: the Picture Cave, Mutton Creek, and the First Creek sites (Figure 5.9, C-2, D-2, and E-2, respectively). Muller (1986:76) includes the "Barred Rectangle" in his listing of Spiro style motifs.

45. Diagonally Crossed Square Motif (Figure 5.9)

One of the more unusual motifs is the diagonally crossed square. There are at least three examples in the state, and this motif is also present in southeast Nebraska (Indian Cave State Park; Bill Pfantz, personal communication 1991), as well as in the American Southwest, in the Great Lakes area (Dewdney and Kidd 1967:68 and 115), and elsewhere in the United States. Sundstrom (1989:406) notes the use of "X-form humans" in Northern Plains rock art. They are also present in the rock art of Texas, Oklahoma, and Kansas. Sundstrom writes that the motif seems to have diffused to the Northwestern Plains from the Great Lakes–Canadian Shield region. This motif is seen in ethnographic art attributed to the Mandan and Blackfoot (Ewers 1945), and in rock art attributed to the Blackfoot and Cree (Conner 1984; Keyser 1979). The Fort Hill site in southeast Missouri has more or less concentric squares in which the inner square borders an X. Faulkner and Simek (1996:780, fig. 6d) illustrate a related motif from a Tennessee cave. This motif also appears on engraved shell artifacts from sites in the Southeast. The meaning is unknown, but some of the possible associations include a connection to either the square ceremonial ground or archaeoastronomy. Olsen (1985:23) lists it as "Mouth," "Sun Shield," or "Turkey Feathers" for the southwestern United States. It may also in certain cases represent an abstract human or bird form.

46. Concentric or Nested Squares Motif (Figure 5.9)

One pictograph site, First Creek, exhibits three concentric squares as a motif. What makes the motif even more unusual is that it is bichromatic with alternating dark red ochre and black pigments used to complete the three squares. Two very similar partial (open ended), concentric rectangles, one a petroglyph and the other a pictograph, appear at First Creek (A-4) and Maddin Creek (B-4), respectively. One other square in this motif category, located at the Schneider site, comprises a single square that encloses, rather than another square, concentric circles (Figure 5.45*a*).

47. Equilateral Cross/Concentric Cross Motif (Figure 5.9)

The equilateral cross/concentric cross motif refers to either the equilateral cross motif or its outlined form. There are three known examples of this latter type of motif in Missouri. Although its meaning is unknown, it must have been of symbolic significance because it is evident in the rock art of many areas of North America including Arkansas (Fritz and Ray 1982:264), Tennessee and Alabama (Henson 1986:99), Illinois, and Nevada (pictured in Heizer and Baumhoff 1962:fig. 45, and possibly Olsen 1985:22). It is also apparent on artifactual materials from sites in Arkansas and Cahokia Mounds

in Collinsville, Illinois, on Archaic bone artifacts at Indian Knoll and other Green River, Kentucky, sites, as well as on ceramic materials from Missouri and other locations in the Mississippi River Valley region.

The concentric or outlined cross is also seen in other parts of the Southwest and places such as Hidalgo, El Tecomate, and Tula, Mexico (Patterson 1992:191). It was recently observed, in concentric form, on the ceiling of a rock shelter at Bonnaire, Netherlands Antilles. The site interpreter there called it a "glyphic emblem" of the star-watcher who kept track of time, births, and birth dates of each clan. Furthermore, the interpreter was told that a "star-watcher" was reportedly found at the cave at the turn of the century still carrying on the tradition (Michael Fuller, personal communication, January 1993).

48. Spinning Cross Motif (Figure 5.9)

A widely used motif both in rock art and on pottery is the spinning cross (also erroneously referred to as a swastika). As with the quartered circle, it has been regarded as a world motif, and sometimes as symbolizing the sacred fire or "sun on earth." This motif is widespread and has been used in Crete, in ancient Rome, in India (as one of the body marks on the Buddha), and in China. In twentieth-century Germany it became the symbol of the Nazi party. Although it is sometimes said that the Nazi version "spun" in one direction and the Native American design in the other, both directions have been observed in the rock art record and in other prehistoric media (Fundaburk and Foreman 1957). Excellent examples in artifact form are the Etowah copper ornaments from graves in Mound C, illustrated in Byers (1962:210 and 214). The spinning cross motif, both singularly and with a circle or concentric circle, is present at three Missouri sites.

49. Raked Lines Motif (Figure 5.9)

The raked lines motif, popular elsewhere but very scarce in Missouri, is commonly considered in the American Southwest to represent "rain." The scarcity of rain in some regions of the Southwest may account for the abundance of this symbol there. Evidently it was not as important in our area, which ordinarily receives an abundance of rain, because there are only a few examples.

50. Zigzag Motif (Figure 5.9)

Another of the motifs seen with more frequency in other parts of the country is the zigzag motif, which is present at a minimum of six sites. This almost always consists of one to three horizontal lines that move up and down at slight and equal angles like a series of attached Vs. The true zigzag

of angular and horizontal form is the most prevalent (Figure 5.53*a*), but we do have a related vertical arrangement ("diamond chain") (Figure 5.53*b*), which is more commonly seen in the Southwest. Patterson (1992:83) refers to the "diamond chain," mentioning it as a stylized representation of the snake and as having a possible connection to the puberty rites of young girls. The zigzag motif can be traced back to at least 3500 B.C. and is widespread as a symbol for water or a waterway: river, stream, or creek. Marshack (1985a:140–43) gives a brief but excellent review of the occurrence of this motif throughout the world and cites the double example as the Egyptian sign for water and the multiple zigzag as the "image" of water (Marshack 1985a:141).

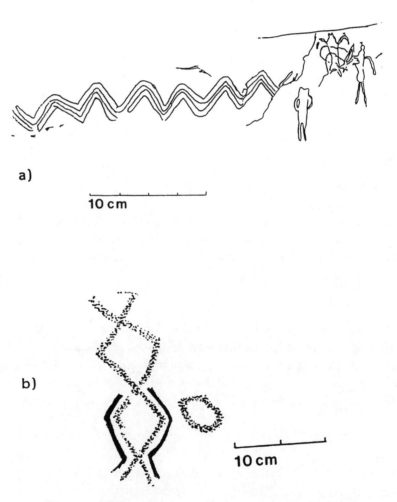

a)

10 cm

b)

10 cm

Figure 5.53. Zigzag and diamond chain motifs: *a,* Picture Cave; *b,* First Creek.

51. "Star" Motif (Figure 5.10)

The five-pointed star, seen in the American Southwest, does not appear in its popular form in Missouri's rock art. There are four-, five-, and six-pointed star motifs; however, the points are more spokelike, giving the appearance of a "starburst" rather than a classic five-pointed star. Examples of such motifs are found at the Brown site, Deer Run Shelter, First Creek Shelter, Mount Zion Church, and others.

52. Crescent Motif (Figure 5.10)

The crescent is another common motif found in North American rock art throughout the United States, as well as in other countries. It is seen in association with animals, human beings, and animal tracks and in a horizontal position (cusps up) in association with a centrally positioned, circular motif. It is present on the catlinite tablets of the Oneota culture (Bray 1963). The horizontal (cusps up) version can be seen in the pictograph at the Torbett Spring–Rocheport site (Figure 2.3) and as a similar face paint design on an Osage Indian (La Flesche 1925:plate 12).

53. Crescent and Star Combined Motif (Figure 5.10)

The crescent and star combination is not atypical in Missouri and has also been reported in the American Southwest (Brandt and Williamson 1979; Miller 1955a, 1955b; Williamson 1981), Arkansas (Sherrod 1984), and Illinois (Iloilo M. Jones, personal communication, 1996), as well as in China (Clark and Stephenson 1979) and elsewhere (Aveni 1977). Although there is always the possibility that a crescent and star could portray the planet Venus in close proximity to a crescent moon, most reports attribute it to a more spectacular celestial event. Recorded in various parts of the world was the supernova explosion of A.D. 1054. It was seen throughout the northern hemisphere (see Chapter 6) and resulted in the Crab Nebula, still visible in the constellation Taurus.

In 1990, an article appeared in *The New York Times* (Wilford 1990b:B9) discussing and portraying a Mimbres pot depicting a crescent-shaped rabbit with a starburst on its hind foot. This design was attributed to a depiction of the A.D. 1054 supernova. Dr. R. Robert Robbins, an astronomer at the University of Texas at Austin, said that this motif is "the most certain record of the supernova that has ever been discovered outside China and Japan." The Mimbres people connected a rabbit with the moon rather than seeing a "man in the moon." The star and crescent petroglyph at the Peene-Murat site has what appears to be two rabbit tracks carved in close association with the

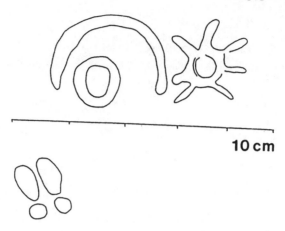

Figure 5.54. Crescent and star petroglyph motif (Peene-Murat).

Figure 5.55. Crescent and star pictograph motif (Willenberg Shelter) (from slide by Robert Elgin).

crescent and star (Figure 5.54). Another intriguing example is at the Willenberg Shelter (Figure 5.55), and there are at least three others.

54. "Unknown" or Complex Form Motifs (Figure 5.10)

A variety of complex and enigmatic forms have been encountered in Missouri's petroglyphs and pictographs. These do not seem to bear any connection to natural or otherwise recognizable forms. The four examples we show are from sites that are, in general, composed of complex designs; one of these unusual motifs is at Thousand Hills State Park and one at Three Hills Creek.

Elements and Features

55. Parietal Asterisms/Cup Marks/Ground Holes (Figure 5.10)

At three sites, ground holes or painted dots that do not fit the pit-and-groove category (see below) appear on the wall or ceiling of a shelter. At the Deer Run Shelter, the dots are placed in a zigzag pattern. At the Lost Creek site, red ochre dots are placed on the shelter ceiling in three distinct areas. All three panels recall star patterns and are discussed in detail in Chapter 6 in the section entitled Interpretation through Celestial Phenomena. The ground holes on the walls at the Tobin-Reed Shelter are a third variation. They are used in two contexts: on the wall facing the shelter opening (Figure 5.56c) and on the right wall (Figure 5.56a, right, detail d). One can only guess at their meaning. However, another detail (Figure 5.56b) shows a distinct W that could signify the constellation Cassiopeia.

Additional motifs in the form of "dots," either carved as cup marks or painted, may be asterisms (star patterns). One was recognized as Pleiades (the Osage, who trace their origins to the sky, have a Pleiades clan) and others as Cassiopeia, the corona, and other asterisms. These records provide weighty evidence regarding the observation of celestial phenomena by the Native Americans who inhabited Missouri.

56. Cupules or Pits (Figure 5.10)

At almost every major petroglyph site, there are circular pecked and ground depressions, cupules, or cup marks. At some these are few and seemingly scattered at random, such as at the Anheuser, Brown, Commerce Eagle, Jake's Prairie, and Persimmon Hill Glade sites. On the other hand, boulders have been noted that contain nothing but these cup marks. The most significant of this type is at the entrance to Bushnell Ceremonial Cave. Because this array also contains a few grooves, it is included in the pit-and-groove category. Such arrangements of cup marks could portray constellations or star patterns as noted in Giedion (1962:144). Giedion (1962:147–49, 294) also believes that cupules date as far back as the Mousterian and Late Neolithic, if not earlier.

57. Pit and Groove (Figure 5.10)

Sites containing both pits and grooves are found throughout the rock art regions of the United States (Grant 1981:140). However, the pit-and-groove motif is associated in Missouri as well as in Georgia with the outlined equilateral cross, a motif representative of the late prehistoric period (A.D. 1400–1700). Missouri examples, such as those at the Bushnell Ceremonial Cave and

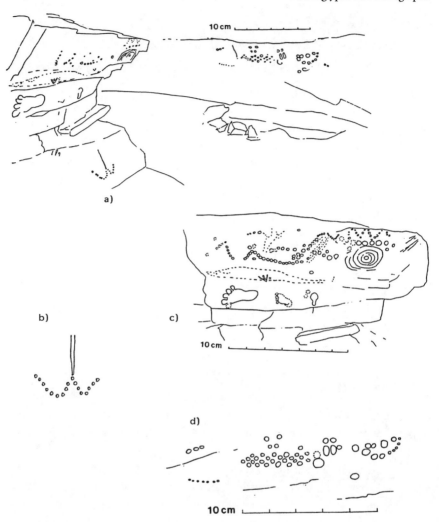

Figure 5.56. Dots and dot patterns (Tobin-Reed): *a,* View of both walls; *b,* Detail; *c,* Main wall; *d,* Close-up grouping in right wall.

the Bushberg-Meissner sites, may be both patterned and symbolically signifi-cant as indicated by the association of pits and grooves with other motifs such as the serpent, the cross and spinning cross, and a female motif.

58. "Tadpole Circle"/Tinajitas Formation (Figure 5.57)

While the recurring "tadpole circle" motif is partly a natural phenomenon, it is also a uniquely carved one. As discussed in detail in Chapter 3 under the section on geology, it appears that a natural geological formation, the solution

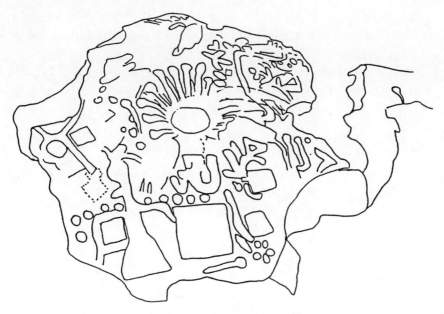

Figure 5.57. Tinajita (Three Hills Creek) (from chalking and slide by Benedict Ellis).

holes called tinajitas, attracted prehistoric peoples to enhance these circular depressions. Examples of this motif abound in the Big River area. They are prominent at the Maddin Creek, Three Hills Creek (Figure 5.57), Wallen Creek, and Washington State Park A sites. Wellmann (1979a:158) discusses them, quoting Magre (1965) as saying that "they could have been used for the preparation of food, incense, medicine, or paint, or possibly even for bloodier rites," and he relates that "Caddoan, Kansa, and Natchez Indians in the lower Mississippi Valley were known to practice some form of human sacrifice." He then refers the reader to Fundaburk and Foreman (1957:59), who describe human sacrifice by the Natchez.

In summary, one of the results expected from mapping motif distributions was the appearance of patterns. These indeed did appear as evidenced in the motif distribution maps (Figures 5.22 through 5.38). For example, bird motifs (Figure 5.22) appear to group in a northeast and east-central pattern, whereas quadrupeds (Figure 5.23) are spread out over much of eastern Missouri. The foot motifs (Figure 5.28) are found in the east/southeast central region. The heaviest concentration of foot motifs is seen in east-central Missouri in a band along the Mississippi River. The hand motif seems to be more prevalent south of the Missouri River, and vulvar/phallic motifs (Figure 5.30) are defi-

nitely concentrated in the southeast central area with only a few depicted north of the river. Interestingly, the vulvar, serpent, and bird motifs cluster in more or less similar patterns. One of the most striking patterns is that of concentric circles (Figure 5.33). While a number are found along the Mississippi River, there is a distinct trajectory of five such motifs extending from Ste. Genevieve County to Pettis County.

6 Interpretation

Our purpose with regard to interpretation is to examine the rock art sites on an individual basis as well as to view them as a general and expansive phenomenon. In doing so, we identify and explain the rock art motifs when they are executed in realistic or representational style, we describe and compare those motifs and elements portrayed in abstract style, and we explain the possible reason for their presence and use in relation to their physical context. We also discuss and attempt to explain the possible function of the rock art within its ideological context. Assigning a probable time period to the rock art is a part of the task of archaeological interpretation. We have done this with a selection of the sites using diagnostic motifs and, at one particular site, dating by accelerator mass spectrometry (AMS) of the pigments.

There are obvious limitations to interpretation, and we are aware of the caveats. While identification of motifs is difficult enough, working with abstract elements presents an even more tenuous area of interpretation, because similar signs can have different meanings for different cultural groups. This could also apply to recognizable motifs. Korn's (1978:162) statement on the problems encountered in the formal analysis of visual systems, directed to present-day Abelam paintings of Papua New Guinea, bears quoting in part: "Ritual art is a matter of secrecy, and the anthropologist is justifiably excluded from knowing its meaning. . . . Moreover, where meanings are divulged, there is no guarantee that they are accurate; they may be intentionally or unintentionally wrong." In addition, it is well known that motifs or symbols can change meaning (and possibly graphic form) through time even within a single group. Thus we see here some idea of the problems that confront us when working with the distant past that are not necessarily alleviated when working with living cultures.

Along with the inherent limitations, there are several possible levels of "interpretation" in the study of rock art. These include, beginning with the most obvious, interpretation of the *content* of the panel and its individual *motifs*. This is followed by interpretation of the *structure* (arrangement of the motifs) and possible inferences suggested by that structure and its motif associations and, finally, by the interpretation of *context* (i.e., both the general and the most immediate locale in which the graphics were carved or painted).

All of the above in any combination have been addressed in the increasing body of available publications, with the interpretation of actual content a forerunner despite the danger of misinterpretation. Context is growing in popularity as an approach to interpretation and should always be addressed.

Interpretation of motifs portrayed in petroglyphs and pictographs is nevertheless frequently attempted in professional rock art studies (e.g., Faulkner 1988; Grant 1981; Hudson and Lee 1984; Keyser 1987; Lambert 1983; Parsons 1987; Turpin 1986; Vastokas and Vastokas 1973), as it is in the present study. Marshack (1985a) cautions that there is a danger in comparing images on the basis of their visual similarity. Meighan (1981:83) states that "all site reports should make an effort to go beyond mere description" to offer some ideas of what the rock art might mean. There are many instances in which motifs, in general, have been interpreted through the investigations of ethnographic accounts, primarily in the American Southwest (Schaafsma 1971, 1975, 1980, 1985) and the Eastern Woodlands (Hall 1977, 1991). Wellmann (1979a), in his general survey of North American rock art, also discusses interpretation of motifs. The use of ethnographic and historic records has lessened the apprehension of offering interpretations of petroglyphs and pictographs and may be a factor in the increasingly detailed attempts at interpretation in rock art research.

Ucko and Rosenfeld (1967:239), considering interpretation, express the belief that Paleolithic cave art is the result of many different interests and was probably executed for different reasons or functions and under varying circumstances. This could very well be said for all types of graphic communication. However, in instances of abstraction—that is to say, use of geometric or free-form motifs rather than obviously naturalistic or representational scenes—we cannot decipher function per se without ethnographic support, and that is not available in Missouri as it is in the American Southwest, Australia, and other parts of the world. In Missouri, because of Euro-Colonial interference, the Native American groups in the state were forced westward, disseminated, and/or eliminated. Thus, without that cultural continuity interpretations must be based largely on the *content* of the graphics and as much information as possible that can be extracted using archaeological records and the available ethnographic documents and related resources from surrounding areas.

In reference to interpretation, several factors must be considered, including an investigation of the oral tradition and belief systems of early groups that inhabited, hunted in, or traversed areas where rock art and other sites are located. This has been done and there is a substantial amount of literature on the subject, but mainly from sources outside the Missouri region. This line of interpretation is more prevalent in areas such as the Great Plains and

Southwest where descendants of early cultures are still resident—where there are consanguineous ties to past cultures. However, there is sufficient evidence of early historic groups, their linguistic orientation, and associated general mythological beliefs on which to base a broad comparison.

COGNITIVE APPROACH

Even without the ties to living, resident cultures, and although interpretation is unavoidably speculative, one should make the attempt to preliminarily interpret the data. We find support in the following statement: "If archaeological material is recognizably primarily and deliberately symbolic—as many grave goods are, for example—then interpretations of past belief systems are possible. . . . Materials that are most probably symbolic thus provide the best data for inferring past belief systems" (Watson, LeBlanc, and Redman 1984:274).

In regard to rock art and the cognitive approach, Hudson and Lee (1984) state, "If this neglected segment of the archaeological record is ever to contribute to a much larger aspect of anthropological inquiry into past human behavior, it will require the development of a method and theory for coping with the cognitive content of rock art, one which focuses upon the linkages between art and culture, style and social group, context and function, and ultimately symbol and meaning."

In agreement with the above statements, and in the absence of direct historical data, we have explored the available oral traditions of associated groups, at least those that inhabited, hunted in, or traversed areas where the rock art is located or were associated through language to the groups encountered in Missouri at contact (Figure 6.1). Stories and oral traditions appear to be connected to a range of motifs we are seeing at Missouri's rock art sites, especially within the content of the Big Five group in Washington and Jefferson counties and at Picture Cave #1 in Warren County. These particular groups are explored in detail. The other avenue for interpretation that we investigate is the connection of certain graphics depicting diagnostic artifacts. We will address this matter first.

INTERPRETATION THROUGH COMPARISON WITH ARTIFACTS DEPICTED IN THE ROCK ART

Awareness of regional cultural materials from archaeological sites has aided in the interpretation of certain motifs and sites. The diagnostic artifacts/motifs about to be described are from sites in Missouri and adjacent areas. The comparable motifs seen both in artifacts and in petroglyphs and

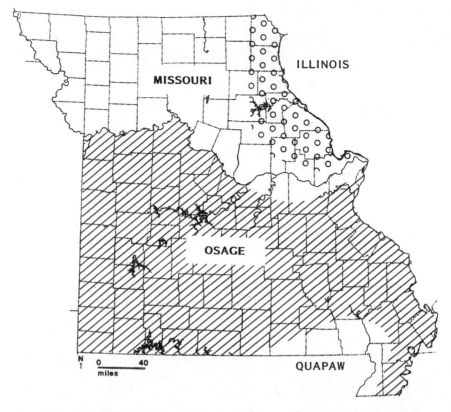

Figure 6.1. Areas of habitation, activity, and influence of major Native American groups in Missouri at contact (Bray 1978; Bushnell 1914a, 1914b; Chapman 1974; Diaz-Granados 1993).

pictographs include the mace, the hafted celt or ax, the quartered circle, the bilobed arrow, the atlatl, the bannerstone, and the long-nosed god maskette.

The mace (Figure 5.6) is seen in petroglyphs at Washington State Park Site B, Three Hills Creek, and the Donnell site and in pictographs at Picture Cave #1, Rattlesnake Bluff, and Willenberg Shelter, among others. The mace is portrayed either alone as a symbol or held in a raised hand. The axes at the Maddin Creek and Reifer sites show a considerable variety and include at least four types (see Chapter 5).

The quartered circle, a diagnostic motif of the Emergent/Developmental Mississippian and later periods, is widespread throughout the Southeastern Woodlands. It is considered one of the typical symbols of the Southeastern Ceremonial Complex (Williams 1977:11) and extends into the Plains (most notably on the Spiro cups and shell gorgets as pictured in Phillips and Brown

1978, 1984) as well as into the Southwest. The quartered circle motif is a symbol of importance either representing the world (four corners) or perhaps the sacred fire that is ritually lit during the ethnographically documented busk[1] or Green Corn ceremony. At the busk a circle was cleared in the middle of the sacred ceremonial square ground and logs were placed in this circle to form an equilateral cross that would eventually be lit. In this case, the fire represents the manifestation of the sun on earth (Howard 1968; Witthoft 1949). This quartered circle motif is seen on pottery including long-necked water bottles, on a beaker from Cahokia ("Tippett bean pot") in which the quartered circle exhibits an appendage similar to those seen in a sampling of the quartered circle petroglyphs in Missouri, on Walls Engraved pottery, and on the shell gorgets from the Craig mound at Spiro, Oklahoma (Hamilton 1952; Phillips and Brown 1978, 1984).

The quartered circle is represented in Missouri's petroglyphs, including within the Big Five group. It is also in the same general area in a pictograph at Lost Creek (Figure 6.2a, "spinning"), and the spinning cross (sans circle) is present at Bushberg-Meissner (Figure 6.2b). Another quartered circle petroglyph is present at Bushnell Ceremonial Cave to the south. An associated motif is the equilateral cross (sans circle). These may bear no symbolic connection, but we include them because they are configured in both static and "spinning" (or swastika) form, as are the equilateral crosses within the circle.

The bilobed arrow, portrayed in pictographs at Lost Creek (Figure 6.2c) and Groeper, among others, and in petroglyphs at the Maddin Creek (Figure 6.2d) and Three Hills Creek sites, is reflected on both hammered copper plates and shell gorgets from the Southeast. Hall (1989:241) compares the bilobed arrow motif to that of the long-nosed god maskette.

Depictions of atlatls and bannerstones have not been previously identified in the literature, but these are exactly what appear to be illustrated at a minimum of two sites. The most notable is the White Rock Bluff site, at which there are two portrayals. One (Figure 5.43a) shows an anthropomorph with arm raised holding what appears to be a spear in launching position as when used with an atlatl. To the left of this figure is another illustration that clearly depicts what appears to be an atlatl with three bow tie bannerstones of graduated sizes (Figure 4.2b). While this depiction is probably symbolic in character, and includes a very small flexed arm just below it, there is little doubt as to the content of this illustration. It constitutes an argument for a possible early date for this pictograph site, although the atlatl and bannerstones, considered typical of the Archaic period, were also utilized in subsequent periods. Another example of the bow tie bannerstone is perhaps depicted at the Deer Run Shelter.

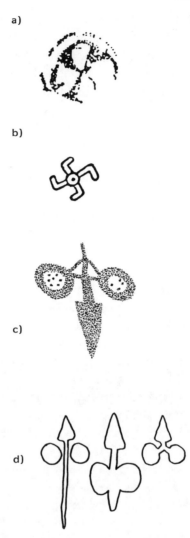

Figure 6.2. Spinning cross: *a*, Lost Creek; *b*, Bushberg-Meissner. Bilobed arrow: *c*, Lost Creek; *d*, Maddin Creek.

TOTEMISM AND ANIMISM

Scholars have discussed totemism and animism in primitive groups (e.g., Levi-Strauss 1966; Levy-Bruhl 1983 [1935]; Marshack 1972). These are somewhat difficult concepts to separate. Briefly, totemism is a belief in a relation or kinship between an individual or group and an animal or plant. Animism is the attribution of life, spirit, and consciousness to objects in nature or even

to inanimate objects. Some belief systems can even attribute a spirit to an abstract entity such as a celestial phenomenon, weather, or a color. Some totems take the form of therianthropic creatures. Because we cannot know the nature of totemism in communities far removed in time, it would be impossible to do more than generalize regarding the possible connection between totemism and Missouri's prehistoric human groups. However, it is entirely possible, in view of the ethnographic records coupled with the abundance of recognizable animal motifs in the state, that some form of totemism was in play.

Animals as "motifs" are seen in a large number of Missouri petroglyphs and pictographs and they no doubt served a variety of functions. These could include animal deities, clan symbols, motifs symbolizing available fauna or hunting activities, hunting magic, and vision quest animal spirits. As mentioned elsewhere, it is impossible to know for certain the meaning of each motif, but a classification that considers the structure and context of each use could bring us closer to understanding their possible functions. Each zoomorphic motif is depicted singularly (e.g., Figure 6.3, *a* and *b*), in association with another motif (e.g., Figure 6.3*c*), or as part of a complex grouping of motifs (e.g., Figure 6.3*d*). The most frequently observed zoomorphic motifs are the bird and the serpent or snake.

Marshack (1972:281–340) discusses traditional theories about feminism and totemism in Paleolithic graphics and the roles of the "Woman-Mother" and animals as totemic ancestors of clans. He quotes Abramova in a passage we believe is significant enough that it bears repeating:

> During this stage of development while man was creating his amazing art of primitive realism, the cult of animals undoubtedly carried within itself some totemic concepts, the essence of which consisted of ideas about animal ancestors. The universality of these notions and their presence among the very primitive tribes of today enables us to consider totemism as the elementary form of religion, and in general, as having been the religion of the emerging clan society . . .
>
> The magical subjects of Palaeolithic art reflect a desire not only to kill animals, and gain mastery over them, but there is also another aspect . . . the idea of fertility. This idea was inseparably linked with the cult of animals and the cult of the Woman-Mother which passes over into concepts of the zoomorphic totemic ancestor. . . . The cult of animals was not only concerned with their killing, but with their resurrection as well, a fact which can be found in ethnographic data dealing with rites of propitiation and expiation. (Abramova 1967:86)

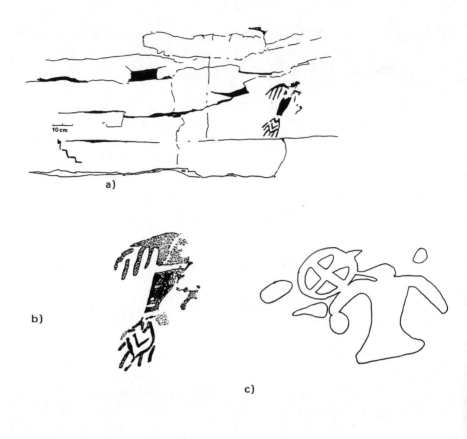

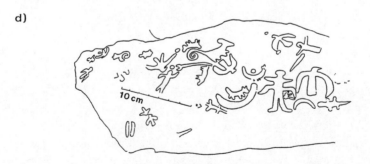

Figure 6.3. Birds in a variety of arrangements: *a*, depicted singly on bluff wall, and *b*, detail (both Champion Eagle) (from R. Bruce McMillan slide, 1965); *c*, with quartered circle in beak (Three Hills Creek); *d*, in complex panel (Thousand Hills State Park).

Marshack (1972:340) disagrees with these ideas, however, viewing totemism as not necessarily "universal," stating, "nor, where present, is it specifically related to the *major* animals or the *major* gods or goddesses." Clan totems from the Omaha demonstrate this (e.g., First, Head of Deer, reddish excrement of the newly born calf, eyes flashing [Fletcher and La Flesche 1992:134–98]). It is difficult if not impossible to determine when viewing rock art whether an animal is depicting a clan totem, hunting prey, a guiding spirit, or a feared animal.

Marshack (1985a, 1986) discusses iconography of what may or may not be serpent depictions in a series of papers, criticisms, and responses to Mundkur's 1976 and 1978 papers and 1983 book on serpent symbolism and iconography. Mundkur takes the "biological materialist" approach, according to Marshack, because of his reference to "ophidian fear" as a basis for depicting the serpent graphically. Marshack maintains that this is an inadequate explanation particularly because many of the zigzag forms to which Mundkur refers have no "heads." He refers to these as symbolizing "water." Marshack asserts that the symbolism of the serpent cannot be generalized because the meaning and significance would naturally, as with most motifs, be culture-specific (personal communication, April 1993).

The "thunderbird" is readily identifiable as a bird, although there is often the question as to whether these forms are birds, bird deities, ancestral spirits, or birdmen, particularly in those examples with bifurcated tail feathers. These bird depictions could also represent shamans: "A basic trance characteristic is the sensation of flight . . . by which the shaman travels to the spirit world" (Van Tilburg 1983:47). There is a great variety in this category. The birds are seen in naturalistic forms, at times with ornately carved or painted tails (Figure 6.3b). Sometimes they are anthropomorphized with humanlike legs or are holding objects, "speaking," or possibly even playing chunkee, as some have a small circle carved by one wing, or stickball when associated with a ball and a stick. Occasionally they are shown in association with other creatures such as snakes or anthropomorphs or with symbols such as the square or quartered circle.

Two avian-related designs, frequently seen in ceramic decoration, are evident in at least a couple of the motifs in Missouri rock art. These are the nested chevron and the nested semicircle motif. The former is visible in the tail of the Champion Eagle pictograph (Figure 6.3b), and the latter is seen in the clothing on the figure at Picture Cave (Figure 5.48). As previously mentioned, a "rabbit hair garment" with this same design (Hamilton 1952:271, plate 147) was found at Spiro. The nested semicircles are also reminiscent of the design on the Ranch Incised pottery sherds from the Campbell site in Missouri (Chapman and Anderson 1955:37, 43) and from sites in Arkansas,

Kentucky, and Tennessee. The copper Wulfing plates from Dunklin County portray hawks with the nested semicircle tails and the adjacent semicircle wing motif (although not nested in the copper). The frequent use of this design suggests the probable widespread use of this and other avian symbolism. Ethnographic information about Dhegihan-speaking groups confirms that they employed animals, including birds, as clan names. For the Winnebago (Ho-Chunk), as with the Osage, "descent was reckoned in the paternal line. But these appellations refer to the animals after whom the clans are named, the term *wangeregi* covering the birds, the term *manegi,* land and water animals" (Radin 1990 [1923]:137).

Radin (1990:138) also states that "among the Winnebago, a number of other Siouan, and Central Algonquian tribes, there was a fivefold classification; earth animals, sky animals, empyrean animals, aquatic animals, and subaquatic animals." The empyrean classification would include the "thunderbird" or any avian depictions, the earth would include the bear and wolf, and so on. On the other hand, the Mandan clan was "nontotemic" (Meyer 1977:72). Little is known of the Missouri on this matter; however, for clan names, the Osage (whose oral tradition speaks of their people as originating from the stars) were known to use animals, animal parts (tails, wings), plants/trees, and a number of phrases that include a variety of items and concepts such as "Star-that-came-to-earth," "Little-sacred-one," and "Those-who-do-not-touch-blood" (Chapman 1974:51–54, after La Flesche 1921).

Further explanation regarding the position of totemism among ancient groups can be found in Radin (1957). In his book on primitive religions, Radin explains that for the Winnebago, a Siouan group,

> There were at least four different explanations given for the relationship of a man to his totem animal: he was descended from that animal; he had been changed from an animal into a human being when the clan first originated; his totemic clan name was derived from the animal without descent being claimed at all; or, finally, he derived his totem name from the fact that his ancestors had imitated the actions of certain animals. There were, likewise, two different conceptions of the original clan animal. According to one he was a real animal; according to the other he was a generalized spirit-animal who took on a real and specific animal form when he appeared on earth. According to this latter theory, when a man of the deer or buffalo clan, for instance, killed a deer or buffalo, he was not killing his totem animal at all. (Radin 1957:205)

While totems are often thought of as animals, Radin also points out that a group's totem can be practically any object, organic or inorganic, natural or artificial. It can even be the sun, moon, stars, and so on. However, in the

overwhelming majority of cases the totem is an animal or plant (Radin 1990:202–5).

The possibility of animals representing the guiding spirit revealed through a person's vision quest is also a potential rationale for the animals in Missouri's petroglyphs and pictographs, especially those that are singular and isolated. Examples of these include the Champion Eagle site (Figure 6.3*b*) and the Paydown Deer site (Figure 3.2). Lowie cites several guardian spirits in the forms of animals; for example, "a man surviving a snake bite regarded the snake as his patron" (Lowie 1918:63, 1956).

THE BIG FIVE

In regard to iconographic material for interpretation, one could not hope for a finer group of sites than the Big Five. There is little doubt that this range of apparently related major rock art sites was left by peoples with a rich oral tradition. Chapman and Chapman (1964:79, 1983:87), in reference to the Washington State Park petroglyphs, suggest that these graphics may have served as mnemonic devices.

> [This site] was probably the junction of game trails and war trails, and was possibly a consecrated spot where young men were initiated into secret society rites and were taught the mythology associated with the initiation. The rock carvings may have been memory aids for songs and rites that were part of the ceremony. The symbols probably had magical as well as religious meaning, and participation in the ceremonies at the sacred spot could have been the means of imparting the powers of the symbols to those participants. (Chapman and Chapman 1983:87)

Although this statement was made extremely early, perhaps even prematurely, in the state's rock art research and the Chapmans had not taken into consideration the other related sites in the Big Five group, the statement agrees with our assessment in part. We would not, however, have limited the site's use to the initiation of young men. Similarities in content among the Big Five sites, as well as context, abound. Possibly the most notable are the sport or action "scenes," which may depict stories of mythic heros playing either stickball (some are portrayed holding a single stick) or the Mississippian game of chunkee (a few are positioned with discs by their feet). Storms-as-he-walks (often depicted in the form of a bird) is a supernatural thunder-being in Winnebago oral tradition; he is the mythological companion of He-who-wears-human-heads-as-earrings. Both are described in the ethnographic literature as playing the stickball game with "the giants." Petroglyphs

of birds associated with a circle, perhaps a game ball or chunkee stone, at the tip of or under a wing may also relate to this story. That the Siouan groups played stickball is well documented in Culin (1992), Catlin (1844), and Schoolcraft (1825). Additional discussion of this appears below in the section on oral traditions and mythology.

INTERPRETATION THROUGH CELESTIAL PHENOMENA

As discussed in Chapter 3, Native Americans were undoubtedly tuned in to celestial phenomena or were dependent on a shaman or other important figure who specialized in this area of knowledge. Relevant motifs are present in both portable artifacts and parietal graphics. Objects depicted include clouds, lightning, thunder, the rainbow, and, of course, the more distant celestial phenomena of stars, Venus as the morning star, asterisms, meteors, the moon (both full and in crescent form), and the Crab nebula. This is not unique to Missouri. In the Southwest, the step design, ⌐⌐⌐, is representative of clouds. Thunder as a celestial phenomenon has often been assigned to the bird motif and widely termed the "thunderbird" at sites from the west to the east coast.

In Southwest rock art the depiction of stars, as well as the sun and moon, has been frequently observed (Williamson 1981:191). Williamson also states that depictions of celestial phenomena are not confined to the American Southwest and that "many Plains Indians (Sioux, Pawnee, Crow, Blackfoot, Kiowa, and Cheyenne) often decorated their lodges and tipis with stars, the sun, and the moon." A classic example is the Skidi Pawnee star chart exhibited at the Field Museum in Chicago. Williamson (1981:193) adds that "although they have not been particularly well studied to date for their astronomical content," enough examples of celestial motifs occur in graphic expressions "across the continent, including the Midwest and East," to demonstrate that the sun, moon, stars, and comets were of considerable importance and interest to Native Americans.

Grant (1978:230) cites the use of star patterns from the early to mid-1800s in the Navajo area. He relates that the traditional Navajo are extremely reluctant to talk about the star panels to Anglo-Americans because "they are considered special places." Schaafsma (1980:322–24) discusses a sampling of such sites including those that include star patterns on shelter ceilings reminiscent of the one in Missouri at Lost Creek Shelter. A drawing of the three panels from this latter site was given to Richard Heuermann, astronomer in the Department of Earth and Planetary Sciences at Washington University. He studied them and discovered obvious star patterns. Most notably he pointed

out that the central panel contains the configuration of asterisms at the winter solstice, December 21, 4:45 P.M., and at the summer solstice, June 21, 4:45 A.M. Furthermore, he recognized asterisms in the two adjacent panels that include the Corona and the Pleiades (personal communication, October 1991). Of course, additional research must be carried out, but present evidence is very promising. Another possibility is recognizing the recording of spectacular celestial events, such as the supernova explosion of A.D. 1054.

It was in the Southwest that the first possible North American records of the A.D. 1054 supernova were recognized and reported (Miller 1955a, 1955b). These are of a crescent motif adjacent or attached to a star or circle. While this configuration could have various meanings, including the portrayal of a crescent moon in concert with the planet Venus, there is strong evidence that depictions in several parts of the country may portray the A.D. 1054 supernova, which occurred on July 4–5, 1054, when the moon was in a crescent phase and in a visual line with the supernova that appeared about six times the brightness of Venus. The supernova was so bright that it could be seen even during daylight hours.

This event, visible throughout the northern hemisphere, is believed to be recorded in rock art at other sites, including Chaco Canyon in northwest New Mexico, White Mesa in northern Arizona, and Fern Cave in northern California (Aveni 1975). Sherrod (1984:158–62) reports such sites in Arkansas. Swauger discusses an entire panel at the Dunn Farm Petroglyphs site that has the appearance of a sky map. The panel includes numerous dots and grouped dots, which are possible asterisms, and there are four crescents including one with a "star" figure at its cusp—a possible representation of the supernova that created the Crab nebula (Swauger 1974:plate 67, graphics 4 and 5).

"The Crab nebula, a striking formation of rapidly expanding, glowing gas in the constellation Taurus, may be the most thoroughly investigated object of modern astrophysical science" (Maran 1982:84). This statement echoes a similar one by Clark (in Clark and Stephenson 1979:140). The A.D. 1054 supernova was described in detail by astronomers in China, Japan, Arabia, and possibly Italy (Maran 1982:89). It would have appeared at a twenty-one-degree declination above the equator at latitude thirty-eight degrees north, giving it a seventy-three-degree position over the horizon at the highest point, and thus was visible in Missouri (Dr. Michael Friedlander, Physics Department, Washington University, personal communication 1991). It originally appeared two degrees to the right of a crescent moon and was visible for twenty-three days during daylight hours and for almost two years at night. This latter fact may be significant in its possible identification within the rock art record and other cultural materials.

Brandt and Williamson (1979) report that of all the supernova sites they

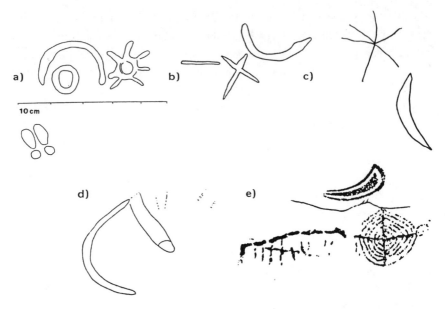

Figure 6.4. Crescent and star motifs: *a*, Peene-Murat; *b*, Mount Zion; *c*, First Creek; *d*, Rocky Hollow; *e*, Willenberg Shelter.

located in the Southwest, approximately fifteen, all but two are consistent archaeologically with the 1054 date. At the state archaeological meeting in May 1990, Diaz-Granados reported on rock art sites in eastern Missouri that may depict this A.D. 1054 event. There are at least five such sites presently known: Peene-Murat, Mount Zion Church, First Creek, Rocky Hollow, and Willenberg Shelter (Figure 6.4, *a* through *e*) (Diaz-Granados 1990).

On June 19, 1990, Wilford reported in *The New York Times* regarding a painting in the center of a Mimbres ceramic bowl excavated near Silver City, New Mexico: "radiocarbon dating and other analysis" showed the bowl was apparently produced about the time of the 1054 supernova. The painting depicts, in black and white, a rabbit (Mimbres symbol for the moon) curled into a crescent shape with a small sunburst at the tip of one foot. The sunburst is surrounded by twenty-three rays—the number of days that the celestial event was visible. Wilford states, "And so the Indians of the Southwestern United States left what archaeologists and astronomers call the most unambiguous evidence ever found that people in the Western Hemisphere observed with awe and some sophistication the exploding star, or supernova, that created the Crab nebula" (Wilford 1990b:B9).

Other conceivable astronomical records, including possible star motifs, sun motifs, asterisms (sky patterns), and solstice markers, are recorded at a mini-

mum of ten Missouri sites. Bisected Ys that have been referred to as "turkey tracks" might have astronomical significance as solstice markers when evident on a vertical wall, as might the X or X in a square. These records also include the W, a possible Cassiopeia motif, and evenly spaced ground holes (calendar marks?) at the Tobin-Reed site (Figure 5.56); the W motif carved at the Fort Hill site; the cup mark patterns in front of the opening at Bushnell Ceremonial Cave; and the probable asterisms in red pigment on the ceiling of the Lost Creek Shelter, as previously mentioned. It is not inconceivable that such asterisms were carved or painted by early groups, because the Osage, for example, had sky clans (nine Sky People clans and fifteen Earth People clans; Wilson 1988:14) that included such names as Pleiades Clan, Star-people Clan, and Carriers-of-the-sun-and-moon Clan (Chapman 1974:52–54). The Hidden Valley Shelter site contained two bear paw/claw carvings (Figure 5.3, F-4), a larger and a smaller one, which are considered by Wegmann (1980:18) to represent Ursa Major and Ursa Minor. He cites documentation of the bear constellation by other early Native American groups as reported in Hall (1977) and Eddy (1977). Wegmann also discusses what he terms an "astronomical shelter" at the Jarvis site (which is in close proximity to the Mount Zion site and might have had some connection in prehistoric times); he describes several abraded, straight lines that he thinks align with mounds in the area. He also briefly examines the diagonally crossed quadrant graphic at the Fort Hill site, which he claims is in alignment with the summer and winter solstices.

At the Rocky Hollow site, the only anthropomorphic figure on the west wall is depicted with both hands raised in the "shaman" position. The left hand is open and upright, but the palm is obliterated by a perfect circle in intaglio. It was suggested by Wichern, who worked on the original site report with Eichenberger (1944) in the late 1930s, that the round hand represented an eclipse being "perpetrated" or a sun "being stopped" by a priest or shaman (Dick Wichern, personal communication 1983). According to Tooker (1964) an eclipse is unlucky. The Huron, Iroquoian speakers but neighbors of the Algonkian, associated the eclipse with the turtle, and, in fact, a turtle is also depicted with this figure, immediately above and almost touching the "hand/eclipse" (Figure 6.5). "The Huron believed that the eclipse of the sun occurred when the great turtle who upheld the earth changed his position and brought his shell before the sun" (Tooker 1964:79). Another possibility that has been suggested for this unusual intaglio circle on the raised hand is that it might have been inset with mica to reflect the sun at the solstice (the panel faces east).

Still another possible correlation to celestial phenomena is derived from

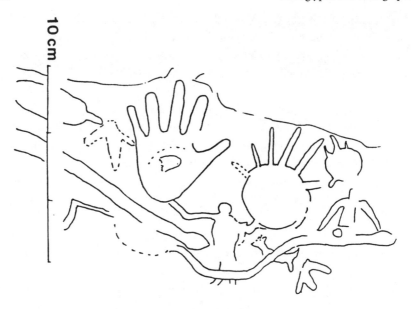

Figure 6.5. Large, exaggerated hands (Rocky Hollow).

designs also located within the alcove at the Rocky Hollow site (Figures 5.10, B-5 and E-5) and at the Groeper Shelter site, that have been referred to as possible metaphors for a comet or shooting star (Figure 5.39). Because many rock carvings and paintings created throughout the prehistory and history of humankind are thought to represent records of important events, it is within reason that some of these carvings may have served as mnemonic devices tied to the recounting of celestial occurrences as they were associated with births, deaths, major conflicts, and so on. A substantial number of rock art sites left by the Anasazi between A.D. 800 and 1300 are believed to have been used for calendrical purposes (Schaafsma 1985:265).

Marshack (1985b:28), in his paper on a North American calendar stick, discusses a complex system of astronomical and calendric references. He addresses the presence of a "generalized lunar 'calendar' consisting of named moons or months" among North American Indian groups that was noted by nineteenth-century ethnologists. He also states, "Ethnologists who lived with particular tribes and learned the language reported a surprising sequential complexity in the ritual and practical calendar of farming peoples such as the Zuni (Cushing 1941) and Hopi (Stephen 1936) in which both non-arithmetical lunar and solar observation played a part." Marshack (1985b:29) says that a few of these wooden calendar sticks have survived, including one each from the "Osage and Winnebago of the Siouan language family."

ENTOPTIC PHENOMENA CONSIDERED: PHOSPHENES

Some interesting work has been done in regard to the possible relation between entoptic phenomena and particular motifs evident in the graphics or arts of prehistoric populations as well as aboriginal groups in Australia, Africa (Lewis-Williams 1983), Colombia (Reichel-Dolmatoff 1978a), the American Southwest (Hedges 1982), and elsewhere. The term *entoptic* denotes visual phenomena that have their seat *within* the eye. Entoptic phenomena produce what is referred to as *phosphenes:* the patterns and colors seen when one closes one's eyes and presses or rubs on the eyelids, as reported on by Oster in *Scientific American* (1970). Phosphenes can also occur during sensory deprivation or from ingestion of hallucinogenic drugs.

Reichel-Dolmatoff (1978a:300), as part of his study on the Tukano Indians, demonstrated a correlation between Tukano designs and phosphene motifs induced by hallucinogenic substances. Van Tilburg (1983:56–58) claims that "a similar correlation has been pointed out between phosphenes and Chumash rock art motifs." Patterns seen in the initial stages of drug-induced trance states are phosphenes. The typical drug-induced trance state begins with flashes of color and geometric figures (phosphenes), followed by familiar scenes and faces and unfamiliar or fantastic scenes, faces, and objects. Van Tilburg (1983:59) goes on to say that "Chumash rock art is particularly rich in phosphene imagery. . . . In some instances Chumash designs are outlined with white dots that duplicate a characteristic of datura visions." She also notes that "as the discussion by Reichel-Dolmatoff clearly shows, phosphenes represent the initial stages of the hallucinatory experience, and the two phenomena cannot be separated" (Hedges 1983; Van Tilburg 1983:58–59).

There is only one site in Missouri that shows some of this vibrant use of colors and patterns: the First Creek Shelter. The graphics at this site are geometric and abstract, and they differ in composition from all other graphics presently known in the state. Mention of this site in no way confirms its association to entoptics; however, there is always that possibility. We do not know what, if any, hallucinogenic substances were used by the Native American groups in Missouri during prehistoric times or the early contact period. It should be noted that any of the other methods, fasting, chanting, exertion, or sensory deprivation, might have been in play.

While studies can be conducted ethnographically, such as those of Reichel-Dolmatoff (1978a, 1978b), it is more difficult to prove a connection between hallucinogenic drugs, entoptic activity, and the geometric and abstract motifs in prehistoric rock art. Our reason for saying this is founded on the possibility of "norms of graphic response." That is to say, certain graphics created

by a carver or painter, in particular those that include basic geometrics, can be attributed to normative responses from stored perceptions. Whether as a result of purely expressive or communicative efforts, the resulting geometrics could easily stem from basic designs to which every human being is exposed. These include the circle, the semicircle, the oval, the square, the harlequin or diamond shape, and the wavy line—forms comparable to those seen in nature. Some of these are pictured by Knoll in Oster (1970:87).

TEMPORAL CONSIDERATIONS

When this project was initiated, there was no working chronology for Missouri's rock art record. Chapman (1980:1) generated a chronology for Missouri archaeology. He referred to the rock art within the context of the Mississippian period when citing the Washington State Park petroglyphs, primarily because of the abundance of Mississippian motifs (in Chapman and Chapman 1983:87). The lack of dates for the majority of rock art sites results in part from the fact that no associated scientific excavations or dating of pigments has been performed. The scope of the present project, as originally conceived, included neither excavations of possible adjacent or nearby sites nor the procurement of dates on pigment samples, so dating was strictly relative. A recently funded research project (1996–1998) to date a selection of the pigments, however, has provided direct dating information that is discussed below.

In attempting to assign a time frame to rock art without direct dating, we are confronted with two limiting factors: first, the lack of a stratigraphic sequence that aids in the dating of transportable artifacts and, second, the general belief that correlations between rock art and adjacent excavations are difficult, if not impossible, to establish. The problem is that there is no solid evidence that rock art and adjacent cultural deposits were placed there at the same time unless there are linking diagnostic artifacts or pigments. These are present at some of the rock art sites of the Southwest and intricately woven into the ceremonies and rituals of groups still living in that area. Graphic portrayals of diagnostic artifacts in Missouri are discussed below. Mark Hedden (1996:7–24) has developed a system of relative dating in which he correlates petroglyphs on Maine beaches with glacial deposits. Still, there remains a paucity of other known means for dating rock art.

Although we do not have the much discussed "desert varnish" that occurs on rock art in the American Southwest, there is a form of patination in Missouri. It results from the action of bacteria depositing iron (and manganese) oxides on the stone. It does not produce the same effect, however, as in the arid Southwest and for that reason it cannot be used in the same way. Well-

mann (1979a:156) explains the situation as follows: "Dating is difficult in the Eastern Woodland since all carvings tend to repatinate rapidly in the humid climate of the region." Grant (1981:44) indicates that excess moisture removes or inhibits the patina. In other words, the rate of repatination is dependent on local conditions, and therefore detailed research would have to be carried out just to arrive at a basic time frame for each physiographic region and microregion in Missouri.

Nor is photochromatography, used to date the amino acids that were part of the binders used in the manufacture of the paint, particularly reliable. Furthermore, cation-ratio dating, as experimented with on southwestern rock art by Dorn (1994) and Dorn and Whitley (1984), is a method yet to be perfected and of doubtful use at sites in the Mississippi River Valley. These authors admit that "some of these cation-ratio dates have substantial uncertainties" (Dorn and Whitley 1984:308), although methods are in the process of being refined.

The National Wildlife Federation (1982) reports that the rainfall in the eastern half of the United States is now ten to one hundred times more acid than normal; the effects of this on eastern rock art have not been investigated. Moreover, some of the discoloration on outcrops in certain areas may be attributed to pollutants in the air from at least two of Missouri's major power plants that emit sulfur and nitrous oxides. The Ontario Ministry of the Environment (1982) produced an illustration that shows emissions of sulphur dioxide (SO_2) in the east central portion of Missouri, a location of rock art activity.

Although we presently lack the ability to date through layering of naturally deposited mineral coatings, there are a few instances of obviously superimposed carvings or paintings that might allow for a seriation. For example, at Picture Cave #1, there are areas of panels that exhibit faded drawings under more vivid ones. Investigations into the redepositing of minerals over these areas might provide temporal clues to a time-staggered use of the cave. While 1000 B.C. was the earliest date for Southwest rock art according to Schaafsma's chart (1980:18–19), dates for rock art in the Black Hills of Wyoming have now been pushed back to 11,500 B.P. through dating of exposed sandstone surfaces (Weller 1993:1).

Schaafsma (1985:243) states that methods "such as lichenometry, which measures lichen growth (Beschel 1961; Dewdney 1979); neutron activation, which explores possible relative dating of petroglyphs by nuclear measurements of desert varnish (Bard 1979; Bard, Asaro, Heizer 1978); [and] X-ray fluorescence (Bard 1979) have had little success or are commonly inconclusive." She continues by saying that Bard used both neutron activation and x-ray fluorescence to corroborate Great Basin style sequences suggested by Heizer and Baumhoff (1962; cited by Nissen 1982:256). As with patination,

lichenometry figures vary by area. Beschel (1961) points out that lichen growth rates are highly variable depending on species, host rock, and weather factors. Weisbrod (1978:2) later states that "the primary difficulty in using lichenometry to date rock art comes from the sensitivity of lichens to variations in microenvironmental conditions."

Clues evident in vertical placement of graphics in relation to irregular erosional activity of soils are usually unreliable for anything more than a possible relative sequence, and there are few such instances in Missouri's rock art. Chronologically diagnostic motifs such as churches, guns, horses, and other protohistoric and historic items, frequently seen in the rock art of the American Southwest, are lacking in Missouri. Although the state's motifs include an abundance of quadrupeds, none can be positively identified as a horse (historic[2]), except for the horse pictograph at the Lost Creek site. Thus, with the absence of motifs suggesting a European or Euro-Colonial influence, we can probably begin with the supposition that the majority of sites are prehistoric. In addition, superimposition or layering of graphics at a site, as mentioned above, might indicate a long period of use at that site as well as "chapters" in a storytelling sequence.

Wellmann (1979a:156) believes there are no sites in the Eastern Woodlands that can be dated to the Paleo-Indian or Archaic periods. He states, "Those in Missouri and southern Illinois appear to belong to either the Late Woodland culture stage (A.D. 400–900), as suggested by associated archaeological finds (Eichenberger 1944; Peithmann 1955), or to the subsequent Mississippi culture period" (A.D. 900–1600). He then cites the period between 1200 and 1500, referring to Griffin (1967), and the "new religious cult that spread throughout the southeastern United States from its center in the Middle Mississippi Basin."

Muller (1989:12) explains that the "Southern Cult" was not a cult and that the term is actually a misnomer. He continues to use it, however, applying it only to the "complex that characterized the mid-thirteenth-century materials." Muller (1989:14–15) believes that although the "Developmental Cult" occurred earlier (A.D. 900–1150) before the "Southern Cult" (A.D. 1250), it is difficult to date motifs, such as the long-nosed god maskette, because they "persisted into later horizons covered by the Cult rubric taken in its broadest sense." In fact, he later states, "None of these markers is so limited in temporal extent that it can be used alone as an infallible indication of a particular date" (Muller 1989:15).

There are portrayals of somewhat diagnostic cultural materials such as the atlatl (Archaic to historic), bow and arrow (c. A.D. 400 and later), mace (Mississippian, A.D. 1000–1450 [see the Lilbourn report[3]; Chapman and Evans 1977]), monolithic ax (Late Mississippian, A.D. 1200–1450), chunkee stones

(Emergent Mississippian, A.D. 750–900 and later), quartered circle motif (Developmental Mississippian and Mississippian period), and figures prominently in the Southeastern Ceremonial Complex. These aid in the tentative chronological placement of a small number of Missouri's petroglyphs and pictographs. Unfortunately, lack of detail as a result of weathering and vandalism has rendered most of the state's rock art into faint forms, although some motifs are still identifiable. Furthermore, there may have been a number of very early sites that have faded completely of which we are totally unaware. Clues to this possibility, as mentioned above, are found at sites retaining extremely faint remnants of both carvings and paintings.

Comparisons with artifacts have been used in other areas. Schaafsma (1985:243) lists herself (1980:197, 252), Olsen (1985), and Turner (1963) in the Southwest; Lundy (1974:264–65, 327–29) for the Northwest Coast region; and Gjessing (1958) on the Columbia River as a few of the researchers using such comparisons. Salzer, in his 1992 excavations at the Gottschall site[4] in Wisconsin, found a sandstone head painted with vertical stripes. It bears a resemblance to a pictograph figure, also with vertical stripes, at Picture Cave #1 (Figure 6.6a and b); two other pictograph figures from that same cave also show vertical stripes. This congruence suggests a southern manifestation of the same style seen at Gottschall in southwest Wisconsin. Radin (1954:11) states,

> Archaeological evidence indicates that the Winnebago have been living in Wisconsin at least since 1400 and probably earlier. The same evidence demonstrates that they must have pushed their way northward from their original home along the Mississippi, at first together with the Iowa, Oto and Missouri, and entered Wisconsin from the southwest of that state and through northwestern Illinois. It must have been in the early part of this northward thrust that the Iowa, Oto and Missouri split off from them. Their progress northward seems to have been bitterly contested by the Central Algonquian tribes living in this area, particularly by the members of the Illinois Confederacy. After entering Wisconsin they were completely surrounded by Central Algonquian tribes with whom they waged ceaseless warfare and by whom they were finally forced into the general area of southeastern Green Bay.

Wellmann (1979a:156) refers to comparisons in the Eastern Woodlands, listing the Southeastern Ceremonial Cult objects as identical to those found at petroglyph sites in this area. He includes "monolithic stone axes, hafted copper celts, and flint batons [referred to in this study as maces], as well as [objects] in painted or engraved form on shell gorgets, copper plates, stone discs, and pottery ware, at such centers as Etowah (Georgia), Moundville

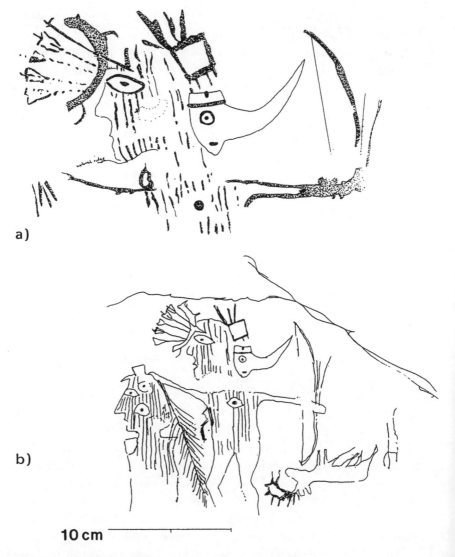

a)

b)

10 cm

Figure 6.6. Red Horn (Picture Cave): *a,* Detail; *b,* Panel.

(Alabama), and Spiro (eastern Oklahoma), and elsewhere in the region." He also mentions the "images of partially anthropomorphized God-Animal representations, especially birds (eagle, pileated woodpecker, and turkey), but also rattlesnakes and felines. Some of the Hawk Beings embossed on copper plates display spread wings and beaked masks, and it may well be that these creatures, rather than the morphologically similar Algonkian thunderbirds, are the ones represented at various Missouri rock art sites."

The abundance of what are commonly referred to as Southern Cult motifs is unmistakable in Missouri rock art. Muller (1986:62), in his reference to "a core of motifs that is limited to the later thirteenth-century horizon that everyone agrees is 'Cult,'" states that the "most distinctive of these horizon markers is the bi-lobed arrow." Later he refines the list, including as "relatively good temporal markers" for "Southern Cult (A.D. 1150–1350) Bi-lobed arrows in any medium, Striped pole, Baton/mace, Fringed apron, Ogee, [and] Chunkey player" (Muller 1989:15). Other than the "Raccoon hindquarters and Bellows-shaped apron," Muller considers the remainder of the motifs too broad temporally, or too limited regionally, to be useful.

With regard to the bilobed arrow, Waring, in Williams (1977:38), refers to the motif as possibly phallic. Hall (1989:250–53), in his later discussion of the bilobed arrow, reiterates that this motif has been considered as referring to a range of things "from a symbolic atlatl (spear thrower) to male genitalia." A number of examples also suggest the configuration of lungs[5] and could tie in with the mythological figure "He-who-is-hit-with-deer-lungs" (Red Horn), who is also associated with the bilobed arrow motif. Another possible association to Red Horn is the copper (red) bilobed arrow hair ornament and the frequently seen (in shell gorgets at Spiro) pileated woodpecker with its red crest—one of Red Horn's magical attributes was to make his hair turn red at will (discussed below).

Head pots, with the hair area painted red, have been found at the Campbell site in Missouri (Chapman and Anderson 1955:cover) as well as at the Parkin site in Arkansas, and elsewhere. Thus, the color red, in association with hair, woodpecker, and bilobed arrow, is of apparent symbolic significance. In addition, most of these pots portray the hair drawn back into a cylindrically shaped swatch (horn?) that sits in a vertical manner down the center back of the head, a configuration that is reminiscent of the possible "ponytail" or "horn." Phillips and Brown (1978:82) illustrate this same hair configuration or "ponytail" and show variations of this hair style from Braden A to Craig C. The flaring top of some of the head pots is reminiscent of the hair roach worn historically by Native American men during ceremonial dances.

The bilobed arrow is present at four of the Big Five sites and at two of their satellite sites: Lost Creek and Bushberg-Meissner. An unusual example of a "bilobed serpent" is on the ceiling of the Groeper Shelter. The mace, also a fairly good marker for the mid to late thirteenth-century "Southern Cult proper" is present at three of the Big Five sites plus several other petroglyph and pictograph sites. In two pictographs (Picture Cave #1 and Willenberg Shelter) it is illustrated with a vertically bisecting line similar to that seen in

the Spiro shell gorgets (Phillips and Brown 1978, 1984), in copper ornaments from Etowah (Byers 1962), and in the graphics at Mud Glyph Cave (Faulkner 1986).

These connections to diagnostic artifacts are acceptable in view of the motifs represented in the Big Five grouping. They do not, however, necessarily apply to the majority of sites with their widely diverse motifs and themes. In view of the agricultural activity taking place, it is also peculiar that we do not find more in the way of representations of plants, seeds, and other "growing things." Many scholars, including James B. Griffin (personal communication 1989), attribute the rock art of the Eastern Woodlands to Mississippian groups who were active in agricultural activities. Many sites in the Southwest, considered to belong to the same general time period (late prehistoric), do portray ears of corn, corn stalks, trees, germinating seeds, and other vegetation.

While the late prehistoric period is undoubtedly the time of origin for much of the rock art in the eastern United States, including Missouri, any temporal significance to locational contexts remains unclear. Because similar motifs have been found on outcrops, on bluff walls, and within caves or shelters, it is impossible with our present knowledge to assign a time association to particular settings or contexts. Whether a place was designated as "sacred" and then the graphics added, or vice versa, is impossible to ascertain (see Chapter 4). Considering the large number (approximately thirty-three percent) of sites located in caves and rock shelters, it is conceivable that these were particularly desirable with regard to ceremonial activities. Faulkner (1988:223) cites a significant discovery of the Mud Glyph Cave research as the "revelation that some eastern North American caves were used for ceremonial purposes, especially during the late prehistoric period."

Watson (1974:186; Crothers et al. 1998), Henson (1986:85–86), and others have discussed the utilization of caves by early Native American populations. Because the caves of the southeastern United States are known to have been used for exploration, for mining raw materials, for mortuaries, and for habitation sites, it is not unlikely that a portion of them were also used for ceremonial purposes. Henson (1986:86) suggests that caves became the places of religious and ritual activities during Mississippian times. Although we believe it is premature to propose a temporal limit on cave use for ritual activity, the point is that they were symbolically significant locations for graphic as well as ceremonial activities.

A site with temporally diagnostic motifs that was unavailable to Grant (1981) and Wellmann (1979a) is Picture Cave #1. In fact, this site has helped to anchor a preliminary chronology for eastern Missouri's rock art sites (Table 6.1). Although it was described and discussed in Chapter 5, it bears special mention in regard to temporal considerations. Among the diagnostic motifs

Table 6.1 Preliminary Chronological Placement of Several Major Rock Art Sites in Missouri

DATES (Calibrated)	CAHOKIA	STYLE	PETROGLYPH/ PICTOGRAPH SITES	AMS DATES (BP) (Missouri-uncalibrated)
A.D. 1400	Cahokia decline, populations disperse*			
A.D. 1250–1350		Craig C		
A.D. 1200	Moorehead		Big Five	
A.D. 1150	Cahokia Florescence Stirling	Braden A**		
A.D. 1100	Late Lohman	Generalized Braden	Rattlesnake Bluff	
A.D. 1050	Early Mississippian		Supernova Sites (AD 1054)	
A.D. 1025***			Picture Cave "Kilted Figure w/Mace"	(940 +/-80)
			Picture Cave "Piasa"	(950 +/-100)
			Picture Cave "Bent Arm w/Pelt"	(1,000 +/-70)
				(1,090 +/-90)
A.D. 1000	Late Emergent Mississippian			
A.D. 800–950	Developmental/Emergent Mississippian		Picture Cave "Red Horn"	

* The populations may have been decentralizing and/or remaining in regions adjacent to the major Cahokia centers.

** Brown (1999)

*** Rowe et al.

Sources: Chapman 1980:1; Diaz-Granados 1993; Hall 1991:10; Kelly 1991:61–80; Phillips and Brown 1978; Pauketat and Emerson 1997:10

contained in the pictographs on the long wall at Picture Cave #1 are concentric-circle shoulder tattoos, hair knots and ornaments, bows and arrows, the long-nosed god maskette, and the falconid/forked eye (other traits are listed below). An "underwater spirit" on an opposing wall is also present.

Picture Cave #1 has figures similar to Braden A style figures (Phillips and Brown 1978, 1984): heads naturalistically and delicately rendered in profile, with falconid and/or oval eyes and concentric shoulder tattoos. One cave figure has a possible ogee headdress and vertical striping on the face and/or body. The main figure is carefully and delicately engraved into the sandstone wall. The areas within the engraved lines of the feather are filled with white pigment. Although there are no dates set for the Braden A style, it was placed relative to other styles at Spiro by Phillips and Brown (1984:xvi) in their "heuristic" Hypothesis D. More recently, Brown thinks in terms of "early Moorehead for the classical or canonical version of the style (Braden A)" but says the "Braden-like images start much earlier" based on pottery data (personal communication, September 8, 1998; Brown and Kelly, n.d.). This style could, in view of other datable motifs, be involved in the Missouri group and a broad time frame of 1000 to 1200 be assigned to this site's major grouping of pictographs. The curvilinear design on a beaker at Cahokia (Stirling phase, A.D. 1050–1150) is equated by Phillips and Brown (1978:173) to the "ceramic" design of Braden A cup 46. A human head from Braden A, cup 17 (Phillips and Brown 1978:91), portrays a long-nosed god maskette as an ear ornament, a long hair lock, and a possible "lightning" eye extension, and the neck shows a denticulated bottom that may indicate it has been severed. This "early" Braden style rendering conforms to the description of He-who-wears-human-heads-as-earrings, or Red Horn, after he wrestled with the "giants." Red Horn's head is described as being carried by one of his sons (Radin 1948:131); this is an unmistakable scene at Picture Cave that is finely and delicately rendered and includes a substantial use of white pigment. Furthermore, Picture Cave #1 contains the only known pictograph that employs white pigment, considered a very powerful color.

With regard to the many depictions of long-nosed characters, from the Plains to the southeastern states, we are not arguing that each and every one depicts the same mythical superhero. However, judging from a widespread and long-enduring theme in the oral traditions of North American Indians that relates to these figures, it is certainly plausible. The time frame assigned to this diagnostic feature would then be debatable. Williams and Goggin (1956:58) believe that because the long-nosed god maskettes "generally do not appear in contexts with well-developed Southern Cult paraphernalia and symbolic devices . . . these masks antedate this development by a recognizable temporal span." They add that it is possible the two symbolic systems "were

not too far apart in time and may in fact converge in some places" (Williams and Goggin 1956:60). Their basis for this latter point is the "Big Boy" pipe from Spiro that incorporates both the short-nosed version of the god mask-ettes and the ogee headdress. Brown (1996:523) views these short-nosed mask-ettes as having all the "essential attributes" of archaeologically recovered ex-amples, except for the elongated nose.

The long-nosed god maskettes, most probably, represent the two brothers called the "children of the sun" or "thunderers" by the Winnebago (Radin 1948:46–55). These ancient spirit beings are part of a widely distributed oral tradition recorded among many Native American groups throughout the eighteenth, nineteenth, and twentieth centuries. The round, staring eyes are the same as those depicted on a nearby water spirit at Picture Cave #1. The wild brother was raised by a water spirit and had the name "Spring Boy" among the Hidatsa (Bowers 1965:349). According to the Caddo, this wild boy had a rather long nose and carried a bow and arrows (Lankford 1987:165–66). This wild brother comes to play with his civilized brother, and together they grow to become great spirit helpers called "two men" who are star people or "thunderers." They wear red war clubs in their belts and kill many monsters, thereby helping human beings (Bowers 1965:465).

Although no artifacts were collected during our survey of Picture Caves #1 and #2, regional collectors who have visited the site claim to have gathered both Cahokia side-notched points and Mississippian pottery. On a survey in 1990, a small collection was gathered from surface debris within the cave by Patty Jo Watson and George Crothers. Items include both Late Woodland limestone-tempered sherds and a body sherd of St. Clair Plain (identified by John Kelly and Jim Duncan, December 1993). This latter type is dated to about A.D. 1050 to 1200 and ties in with the Early Braden period.

Direct Dating of a Missouri Site

Until the beginning of this decade, there was no method for the direct dating of pigments in the pictographic data base. Our Missouri research cave is the first to our knowledge, in the Mississippi Valley, to have pigments dated. Four pigment samples were processed by a method developed by ana-lytical chemists Marvin Rowe and Marian Hyman of Texas A. & M. Uni-versity's Chemistry department. Their plasma-chemical technique extracts carbon from the pigment and converts it to carbon dioxide (Hyman and Rowe 1997). The carbon dioxide is sent to an accelerator mass spectrometry (AMS) laboratory where the amount of carbon-14 is counted and the age of the sample determined (Marian Hyman, personal communication, March 1999).

In November 1996, five samples were taken and processed at the Texas A.

& M. laboratory by Drs. Rowe and Hyman. Three samples (plus a control sample) had sufficient carbon for AMS dating and were sent to the Lawrence Livermore National AMS Laboratory. The four samples resulted in the following (uncalibrated) dates:

Section of Pictograph/Graphic	Date (years B.P.)
Kilted Figure with Mace	940 ± 80
Underwater Spirit	950 ± 100
Bent Arm with Pelt	1000 ± 70
Bent Arm with Pelt	1090 ± 90

These dates correlate to the hypothesized time periods listed in the proposed chronology in Table 6.1.

RELATED ORAL TRADITION, MYTHOLOGY, AND ICONOGRAPHY

The use of oral tradition and mythology for interpreting prehistoric motifs in any context, their structures and their symbolism, is not a new approach but one that has not been applied with any regularity. When this project began, little had been published with regard to the possible links between Native American oral tradition and rock art. We are well aware of the extreme caution that must be employed in the use of such correlations between graphic motifs created in the distant past and ethnographic evidence, especially when the latter is borrowed from other regions. However, cautious efforts can be useful. Muller (1986:65), in referring to the interpretation of the graphics at Mud Glyph Cave, states, "Comparison to historic mythology is not useless nor foolish" (although in the case of Mud Glyph Cave he thought it to be "premature"). Van Tilburg (1983:16) notes, "The search for themes running through the imagery is a major research goal, and mythology plays an important role in this type of investigation." Oral traditions, as part of the greater ideological sphere of many societies, have been tapped to reveal the possible iconography evident in and on artifactual materials.

The iconography is in turn compared with the ideology in available ethnographic documents associated with the early inhabitants of an area. The iconographics communicate group concepts and sacred associations incorporated in a group's oral traditions. This same approach has been applied to various forms of artifactual materials by Hall (1989), Howard (1968), Rudolph (1993), and Vastokas and Vastokas (1973) and to rock art by Hilliard (1992), Lee (1983), Salzer (1987), Steward (1929), Swauger (1974), Vastokas and Vastokas (1973), and others. The reason for this relatively new trend in compar-

ing oral traditions with the content in rock art sites can be attributed to the substantial numbers of recognizable motifs and iconographic images available. Of course, there are no prehistoric Native Americans available to say, "That's correct" or "That's incorrect," but then the situation is much the same with most interpretive material in which the native voice is unavailable to attest to the accuracy of the determinations.

Hudson and Lee (1984) discuss landscape in relationship to Chumash myth, world view, sacred places, and the relationship of this interrelated whole to rock art. As Schaafsma notes, they cite the occurrence of rock art at locations connected to mythic events and discuss how the graphics function to "connect the Chumash with their sacred past. By painting at these locations, the 'antap maintain the sacred in their surroundings" (Schaafsma 1985:262). Schaafsma adds, citing Young (1982), that at sacred locations near Zuni and near the head of Hardscrabble Wash "are places where significant events took place in the mythic Zuni past. . . . The paintings and petroglyphs in all cases serve both to identify and maintain important locations, honor the supernaturals, and in this way, as with the Chumash, tie the Navajo and Zuni to their mythic beginnings" (Schaafsma 1985:262).

To make a general comparison, the Osage offered participants of their naming ceremony a reaffirmation of their tribal history including the oral traditions surrounding Osage origins. Motifs associated with those oral traditions may comprise a portion of Missouri's rock art. Another consideration is that of the Osage belief in which "footsteps became prayers" (Revard 1987:460). If footsteps are considered symbols of prayers, this could be one possible explanation for the numerous footprints carved into outcrops in Missouri, particularly in the southeast quadrant of the state where it is believed some of the Osage lived before 1650. Footprints are also believed to represent "paths taken" by some Plains and southwestern tribes. With regard to hands, not an uncommon motif in the general rock art records, we find this symbol depicted on the blankets worn by eldest daughters. This indicates status as the oldest daughter in an Osage family (Louis Burns, personal communication 1997).

To begin an investigation of the available oral traditions of groups linked to the Missouri area, we explored the state's known native populations, as well as intermittent groups, seeking those with linguistic similarities. For Missouri's more recent native groups we find primarily two linguistic divisions of the eastern Sioux[6]: the Chiwerian Sioux (dialect of the Missouri, native to the Missouri area and responsible for the state name) and the Dhegihan Sioux (dialect of the Osage, also native to Missouri). Both of these groups lived in Missouri before the arrival of the Europeans (Chapman and Chapman 1983; Horr 1974; Bray 1978). At the first European contact, the

Missouri were living just south of the Missouri River in the area of the Pinnacles (Chapman 1959:2) in Saline County. The most prominent Missouri site is that commonly called the Utz site, "which is the location of the Missouri Indian village prehistorically as well as historically. The Missouri Indians in the Protohistoric period had a rich and varied Oneota culture" (Chapman and Chapman 1983:93).

Maps showing the early (1723–1728) locations of the Little Osage, Missouri, and Big Osage villages are illustrated in Horr (1974:256–57). Other Siouan groups, as well as Algonkian groups, used the state, rich in resources, for hunting and habitation. Judging from the wealth of Mississippian materials recovered archaeologically from the region, these groups must have possessed a complex oral tradition.

Because there is a generous amount of ethnographic material available for examination (e.g., Bowers 1950, 1965; Fletcher and La Flesche 1992; La Flesche 1932; Howard 1968; Radin 1923, 1948, 1954, 1984; Witthoft 1949), we may be able to correlate some of the ethnographically known motifs, and their associations, with the rock art. Although Radin has his detractors, his writings and those of Bowers are the best sources of information on the semisedentary agricultural groups of the Winnebago, Mandan, and Hidatsa, who are related linguistically to the Missouri. The works of Fletcher and La Flesche on the Omaha and Osage are also primary resources.

While there are some iconographic references in the oral traditions that relate to rock art sites throughout the state, the enormity of the task mandates that we confine our attempt to the sites within a selected group. Our discussion concentrates primarily on the major grouping of the Big Five sites. Other sites are referred to in surrounding areas, and the major pictographs cited in this discussion are those at Picture Cave, Rattlesnake Bluff, Groeper Shelter, and Willenberg Shelter. These sites not only contain a myriad of motifs but also Picture Cave #1 is structured into sufficiently complex panels that one can obtain additional information regarding connections to the painters' ideology. We also think that ethnographic collections of oral history gathered during the nineteenth and early twentieth centuries reflect at least a portion of the rich western Mississippian oral traditions associated with some of these sites.

We continue with a discussion of Siouan oral traditions because both the Osage and Missouri are part of this major linguistic group. The historic accounts are taken from related Siouan-speaking groups: Hidatsa, Iowa, Mandan, Omaha, and Winnebago. Various of these and related groups are located in the central, Great Lakes, and southeastern (Yuchi and Catawba) regions of North America to the Plains and west. Reference to a Siouan movement, from east to west, is often made by those working in the Southwest and

elsewhere in North America (e.g., Coe, Snow, and Benson 1989:65; Radin 1948:11–12; Schaafsma 1980; Vehik 1993).

In volume one of *The Omaha Tribe,* Fletcher and La Flesche (1992:35) refer to the Dhegihan Sioux as "a group which kept together until within the last few hundred years [and] seems to have been composed of the five closely cognate tribes now known as the Omaha, Ponca, Osage, Kansa, and Quapaw." They later observe: "The five cognate tribes, of which the Omaha is one, bear a strong resemblance to one another, not only in language but in tribal organization and religious rites. This account of the Omaha tribe with incorporated notes taken among their close cognates is presented in order to facilitate a comparative study not only of these groups but of others of the Siouan stock, in the hope of thereby helping to solve some of the problems presented by this extensive linguistic group." For our purposes, we hope that it will shed some light on the possible meaning behind Missouri rock art, at least in this one important area.

Creation Myths and Oral Traditions

The three major areas of our discussion on oral traditions are the creation myths, hero epics, and the Trickster cycle. These three seem to be the ones most likely reflected in the petroglyphs and pictographs and are also those that are strongly associated with the Siouan culture groups who inhabited the lower Missouri region on the western side of the Mississippi River. Included under the above three major headings are the following:

Creation Myths	Earthmaker or Old Man Immortal, First Creator
	Lone Man
	Old-woman-who-never-dies, Corn Mother
Hero Epics	He-who-wears-human-heads-as-earrings, aka He-who-is-hit-with-deer-lungs, aka Red Horn
	The Hero Twins, aka Handsome Boy and Throw-away-boy, aka Lodge Boy and Spring Boy
	The "Children of the Sun," aka the Star Men, the Thunderers
Trickster Cycle	Trickster or Foolish One, and Hare or Grandson

Most of the oral traditions that involve the earliest creation relate to a character called the "First Creator" (Bowers 1965:297). The Mandan, who described the First Creator to Maximilian in 1833, believed that this character had a tail (Bowers 1950:155). According to Bowers, referring to the Hidatsa and Mandan, both Siouan speakers, the earliest creator is called "The First Creator" and created the in-between world—the earth. The earth is referred

to as the "in-between world" because there are basically three levels to the universe: the sky above, sky world, or the heavens; the earth or the in-between world; and the ground below or the underworld. Mathews (1877:47) wrote, "The object of their greatest reverence is, perhaps, Itsikamahidis, which means 'Old Man Immortal,'" a parallel to First Creator. This "Old Man Immortal" or "First Creator" made all things—the sun, stars, earth, and first representatives of each species of animals and plants—but "no one made him" (Bowers 1965:298).

First Creator wandered about by himself until he met another person, also very important in Siouan oral tradition—the "First Man" or "Lone Man." Because First Creator did not know who his mother and father were, he thought that he had come from the water. He encountered Lone Man and the two had to determine who was the older. First Creator was declared the older. First Creator caused the people living below to come up to the surface (climbing a vine), bringing with them their garden produce until one heavy, old woman broke the vine (Bowers 1965:129, 297–98; 1950:194) (note squash vine associated with woman in Birger figurine[7]). The two characters of First Creator and Lone Man, together in possible reference to duality, finish the creation of the world, with First Creator creating the lands west of the Mississippi and Lone Man making those east of the Mississippi (Bowers 1965:298).

There is a common notion of duality within the Hidatsa, Omaha, Mandan, Winnebago, Kansa, Osage, Ponca, Quapaw, and other Siouan groups, which are each divided into two major kinship groups. All trace the duality of their organization to the origin of the earth/universe. The two parts of each comprise the sky people and the earth people. This duality involves two characters, Lone Man and Old-woman-who-never-dies. Lone Man and First Creator created the earth; then Lone Man is connected with the sky above and Old Woman is associated with the earth and underworld. In many of the origin myths, both of them work with the First Creator in finishing the creation of the earth including the spirit beings and people.

According to the Mandan, Lone Man (connected with the quartered circle; Bowers 1950:354–55) made the people from clay that he had a mud hen bring up from under the waters. After these people multiplied and assembled a large village, Lone Man told them he would return from time to time in the form of a slow-moving shooting star (a comet). Lone Man was also reincarnated by hiding in a kernel of corn in a bowl of mush eaten by a young woman who thus became pregnant although she had intercourse with no one. This belief in reincarnation was common to the Osage, Omaha, Kansa, Ponca, and other Siouan groups. Not only was Lone Man born again, but also other spirit beings could be reborn. Reincarnation is a recurring theme in many of the Siouan oral traditions, not only of spirit beings but also of

cultural heros (Bowers 1950:60). In common with other Siouan tribes, the repetitious use of names of great leaders seems to have been practiced as a result of this belief.

Among the Omaha, the sky above was regarded as masculine and the underworld as feminine (Fletcher and La Flesche 1992:134): "The heavenly bodies were conceived of as having sex; the sun was masculine and the moon was feminine." The Osage, according to Mathews (1961), Burns (1984), and Bailey (1995), consider a portion of their people as having originated from the stars. Among the Osage, the two great divisions of the sky (Tsi-zhu) and Earth (Hon'-ga) people exist. Other phratries make a total of five and these five phratries are divided into twenty-four clans (Bailey 1995:36–40). The Omaha also believed in earth and sky people (Fletcher and La Flesche 1992:135) and that all human beings were born from a union of the two: "These divisions were not phratries, as they were not based on ties of blood but on oral traditions as to how creation came about and how life must be continued on earth."

Old-Woman-Who-Never-Dies

According to Bowers (1965:340), the Old-woman-who-never-dies is probably the most common and most widely related and discussed oral tradition of the Hidatsa and Mandan. This oral tradition is intricately associated with the corn rites within the Hidatsa group. Sacred bundles were identified with this deity and were the responsibility of the women in the group. Each was charged with hanging the sacred bundle on a stick in her garden: placing it in the spring and removing it in the fall. Meyer (1977:77) illustrates the cross-cultural importance of the Old-woman-who-never-dies, sometimes referred to as "Corn Mother," and reflects the importance of the corn culture among the Mandan (Siouan) as related to the Pawnee (Caddoan) who borrowed oral traditions from the Osage (Siouan). It may be this strong, female-related oral tradition that is reflected in the numerous vulvar motifs evident in Missouri rock art.

Radin (1948:37), in speaking of the Iowa (Siouan, and closely related to the Winnebago and Missouri), contends that the vulvar motif, or "Uye," represents the female organ of the world: Grandmother Earth or Old-woman-who-never-dies according to oral tradition. The Iowa (Radin 1948:103–4) refer to the vulvar motif as do the Winnebago (Radin 1948:76). Vulvar motifs are prominent in Missouri rock art. Within the Big Five grouping, this motif is present at Washington State Park A (Figure 5.46c), Maddin Creek (Figure 5.44a), and Three Hills Creek. The vulvar motif also occurs at singular sites, such as Bushberg-Meissner Cave (Figure 5.46a) in the southeast region and Miller's Cave (Figure 5.46b) to the west. Ceramic bottles depicting aged

women frequently found in burials throughout southeast Missouri may also refer to the Old-woman-who-never-dies. The outline of the lodge of the Old-woman-who-never-dies is rectangular, according to Bowers (1965:339). The square or rectangular motif is plentiful in Missouri's petroglyphs and pictographs. Examples are shown in Figure 5.45*a* (Schneider), and several others are seen in motifs at Three Hills Creek (Figure 5.8, C-8) and Washington State Park A (Figure 5.8, B-8 and F-8).

Mythologically the Old-woman-who-never-dies is closely linked not only with human fertility but also with fertility in the harvest. Therefore it is not surprising to find a close association with one of the most important rituals known through ethnographic documents, namely the Green Corn ceremony, which takes place usually in July to celebrate the new crop or green corn. We review this important ceremony, its possible connection to the rock art, and will then return to the general discussion on oral traditions.

The Green Corn Ceremony

Chapman (1980:72–78) discusses three possible ceremonial situations that could have taken place in our area in prehistoric times. We concentrate on the Green Corn ceremony because it offers the most ethnographic documentation in areas and within groups related to Missouri. It was, and in a sense still is because it is still practiced. It is associated with the fire-sun deity complex, which is in turn associated with the intensive maize agriculture diagnostic of the Mississippian period.

Howard (1968:88) suggests that the elements (hence, motifs) in the historic ceremonies have their origin in "Hopewellian or other pre-Mississippian cultures. As such, the Southeastern Green Corn probably represents one of the oldest unbroken ceremonial traditions in the New World." In considering the potential connections of the Green Corn ceremony to the implied ideology contained in some of Missouri's rock art, the Big Five petroglyph sites stand out because of their complexity and the abundance of diagnostic motifs they contain. These sites can, in turn, be linked through their content to several smaller satellite sites. Furthermore, all of these rock art locations fit the basic requirements for a sacred ceremonial site; that is (1) isolated and away from village or habitation sites, (2) near water, preferably running water, and (3) having a nearby expanse of open ground. This description fits well with the ritual setting of the Green Corn ceremony.

The Green Corn ceremony was probably the major social event of the year in the lives of most eastern Native American groups during the Mississippian period (Howard 1968:125–37). Swanton (1911) states that practically every tribe in the Southeast had some special ceremony connected with the new corn crop. This ceremony was a time for renewing the sacred fire, naming the children, preserving the life in the medicine (bundle), fostering social unity,

giving thanks to the deities for success in both the harvest and hunt, and purifying the blood, bodies, and souls of the men so that they could partake of the first fruits of the harvest—in particular, the new or green corn. This Green Corn ceremony, or busk, in one form or another, survived into historic times among many of the tribes of the Algonkian, Delaware, Iroquoian, Muskogean, and Siouan groups. Such an important yearly event would presumably have been the cause for the creation of a significant number of ceremonial objects and could feasibly result in graphic motifs on a variety of cultural materials.

Although there is no direct line of historical continuity (Phillips and Brown 1978:103), evidence from ethnographic documents discussing accounts of the ceremony in the eastern United States provides information that is as close as we are likely to come in Missouri with which to assist in the interpretation of particular rock art motifs. The Green Corn ceremony, coupled with the Corn Mother myth—the Old-woman-who-never-dies (but is transformed into maize)—holds potential for interpreting not only the ceremonial objects but also the graphics on those objects such as pottery, shell gorgets, and monolithic axes, as was attempted by Hamilton (1952), Howard (1968), and others. These oral traditions can also be referred to in attempts to interpret the function of the *in situ* petroglyphs from the same general areas where the oral traditions and/or tangible artifacts originated.

It is not our purpose to discuss maize agriculture in Missouri in detail. Suffice it to say that *Zea mays* L. is believed to have been the staple crop and its extensive use to have paralleled that in the American Bottom. To paraphrase Witthoft (1949:2), scholars have failed to elucidate the maize complex in both its material and nonmaterial aspects as a set of related phenomena possessing some unity in each culture of the eastern United States. He suggests that not just corn kernels diffused within this area but also the entire maize complex including growing techniques, botanical knowledge, "a set of magical and ritual precepts and traditions," and oral traditions concerning the origin of maize. Diffusion of such oral traditions might, of course, be somewhat modified in each transmission, but similarities in the historic Green Corn ceremony throughout the North and Southeast are striking.

More relevant to our discussion is the Green Corn ceremony itself and some of the early versions that may be manifest in a group of motifs repeated in the state's major rock art sites. We begin with a "generic" and abbreviated condensation of the Green Corn ceremonies taken from Capron (1953), Howard (1968), Lewis and Kneberg (1958), Speck (1909, 1937), Swanton (1911), Waring and Holder (1945), and Witthoft (1949). We include as many attributes of the ceremony as possible to give a broad picture of its many versions. The ceremony proceeds as follows.

Day 1. The square ground is prepared, the cooking fires in each household

are extinguished, and children are named. Between Day 1 and Day 3, the new sacred fire is lit—created by friction—and fed with four to eight ears of new corn. The fire is dispersed to the households (usually by the women). Preliminary dances take place. The forked pole is erected by the chief Medicine Man or shaman and the sacred medicine bundle is retrieved from its secret place and hung on the forked pole. More dances are performed. The first of the Black Drink (an emetic) mixtures is taken by some groups. Fasting takes place for anywhere from one to six days. Only the men undergo the purification rights.

Day 2. Scratching of all men and boys (in some groups the females are scratched, too) with a sharp instrument, needle, or multiple arrangement of needles takes place to draw blood (thus purifying it), more emetic is taken, and men rub their bodies with it as well as with the ashes from the new fire and then "go to the water" (they cleanse themselves in a nearby river/stream).

Day 3. Much of the above is repeated with the addition of traditional dances and in some groups a "Court Day," which is a period set aside for handing out punishments for crimes committed during the past year (Sturtevant 1954:50–51). Emetic is again taken internally and rubbed or poured over the body as well. The Medicine Man blows prayers into the Black Drink pot with a cane wrapped with three red cloth strips evenly placed.

Day 4. Social dances occur and the bowl game is played. In some groups, the fast is broken with corn from the last harvest or in shorter ceremonies with corn from the new harvest (Creeks) cooked by the women. Men hold their "Feather Dance." There is more "going to the water."

Day 5. Four new logs are placed on the fire (Creek). Men hold mock battles. Young men may hold a mock hunt. "Going to the water" continues.

Days 6 and 7. Men remain in the sacred square. In some groups, Clan dances continue.

Day 8. The Medicine Man and assistants obtain two large pots and put their plants into them with water to concoct the Black Drink or other emetic; they beat the ingredients together and drink. In some groups, the last or third Black Drink mixture is concocted with the most ingredients (approximately fourteen) and boiled before drinking. More emetic is taken. The final "going to the water" occurs (four stones are picked up from the river, four prayers are said, and with each the men cross themselves with one of the stones then throw it into the river). Men go back to the square and put up long canes tipped with white feathers. There is more dancing. The fast is broken and a big feast follows that includes the green corn and other "first fruits."

Within these Green Corn ceremonies are many symbols that could feasibly translate into graphic motifs: seven, in particular, are possibly evident in Missouri rock art:

1. The quartered circle (cross-in-circle), sun/fire symbol
2. The sacred square ground
3. The birds or "thunderbirds" (that bring rain)
4. The mace/baton/blade
5. The ball games/stickball/bowl games/chunkee games
6. The serpent/snake
7. The forked pole

1. The Quartered Circle: The Sacred Fire/Sun/World Motif. Of all the cere-
monial motifs of the Southeast, the quartered circle, sometimes called the
"sun circle," is the one whose identification and representation seem most
secure and widely accepted (Howard 1968:25). "The concept of a sacred fire,
identified with the sun, and fed with four logs oriented to the four cardi-
nal points, thus forming a cross, is the most widespread and basic ceremo-
nial concept in the Southeast," according to Howard (1968:19). This motif is
found in petroglyph form at Washington State Park repeated at least twice,
at Maddin Creek six times, and at Three Hills Creek five times and appears
in pictograph form at Lost Creek and Deer Run Shelter and at other sites.

The center post of the village, made of cedar, represented the body of Lone
Man to the Mandan (Bowers 1950:77). According to tradition, the oldest
clan of the Mandan, the Waxikena, traced its origins to Lone Man (Meyer
1977:72). The Omaha also had sacred poles that probably represented super-
natural beings (Fletcher and La Flesche 1992:217–26). In all cases, these poles
representing supernatural beings had attached sacred bundles and ritual para-
phernalia. They were assigned their own lodge and keeper (an honored elder),
and they were, particularly with the Omaha, the most sacred focal point of
the community. Among the Mandan, the west side moiety was established
by Lone Man, who represented the village activities and peaceful functions
of the group (Bowers 1950:114). At the beginning of the Mandan Okipa cere-
mony, goods were exchanged between various clans. Owners of sacred corn
bundles used in the corn ceremonies were paid in goods for the use of corn
designs and corn songs. Parts of this ceremony took place around the sacred
cedar pole representing Lone Man, the originator of this sacred ceremony
(Bowers 1950:77). The quartered circle (cross-in-circle) is evoked by the cen-
ter post and four pits positioned in such a way as to form a cross. This wide-
spread motif, discussed by Kelly (1990:129) in reference to Cahokia, seems to
have had its origin during the Emergent Mississippian period. Kelly states, "A
central symbol is the cross-in-circle, as evinced by the four central pits or the
large rectangular structure in the community square" (see Kelly 1990:fig. 58).
During the Emergent Mississippian period in the Cahokia area small com-
munities, who traced their descent from a single supernatural being (Kelly's

"single-lineage" [1990:119]), organized their communities around a central post and four offering pits. He maintains that this gave rise to a common Mississippian motif, the cross-in-circle or quartered circle.

Another important and related widespread figure (discussed above) is the "Old-woman-who-never-dies." Among most Siouan groups, the Old-woman-who-never-dies was the originator of all vegetation: "It would appear that the native view of Old-woman-who-never-dies as 'goddess' of vegetation was an early belief that preceded agriculture" (Bowers 1965:338). Bowers claims that this "Old Woman" oral tradition provided the basis for native beliefs and practices for the propagation of the cultivated crops. Radin (1948:37) states that the Iowa (a Siouan group closely related to the Missouri and Winnebago) represent her by the vulvar motif, mentioned in Schaafsma (1980) as a Siouan motif. This motif also alludes to death, mortuary rites, and reincarnation.

According to ethnographic reports, after First Creator, Lone Man, and Old Woman have created the world, a spirit being, "Charred Body," a supernatural being who has the form of a "holy arrow," finds a hole in the sky and looks down to see a new world that looks much like that above. He comes down as a holy arrow and establishes a village of thirteen households, returns to the sky, and invites thirteen different family groups to come down and occupy the lodges. Although village life is thus benevolently instigated, "life is difficult as there are many evil spirits bent on exterminating the village" (Bowers 1965:349). At Wallen Creek there is a large arrow with an anthropomorph adjacent/attached to it (Figure 5.47c), and at the Peene-Murat site (Figure 5.20a) a line with an arrowlike end has several meandering lines extending from it.

Among the Mandan the central structure pertaining to the "first or only man" became the center of a complex ritual called the Okipa that took place on or near the summer solstice (Catlin 1844:155–62). It was during this ceremony that several important supernatural beings were impersonated, the corn bundles were displayed, the Buffalo Bulls danced, and men who had important visions underwent self-torture. Among the Hidatsa this ceremony was also enacted on or near the solstice. The Hidatsa called this event the NaxpikE and it was not as complex as the Mandan Okipa. Pole or pole-centered activities were the principal events.

With the help of First Creator, who volunteered to give a big feast, Charred Body and his sister's two sons, "Spring Boy" and "Lodge Boy," introduced the NaxpikE ceremony (a self-torture ceremony). As Bowers (1965:305–6, 349) relates, Spring Boy and Lodge Boy "were very holy and they destroyed many of the gods residing in the vicinity of Charred Body's village." "Of the two, Spring Boy was considered the more offensive and he was taken back

into the sky to suffer ceremonially, which deed led to the establishment of the NaxpikE ceremony" (Bowers 1965:349). The two boys, or thunderers, returned to the earth, grew to maturity, and adopted Unknown Man as their son, teaching him the NaxpikE ceremony. They also prevailed on "Grandson" to have his grandmother, "Old Woman," put on a ceremony to which all sacred beings were invited who had agreed to adopt sons in the tribe for the future, thus helping their sons to get ahead (Bowers 1965:349). These important religious activities were the scene of large gatherings of villagers and outsiders who had been adopted by various prominent men who were clan leaders. The adoptees engaged in trade, and many goods were exchanged between individuals and clan groups.

Maximilian, writing in his journal in 1833, also relates that the Lone or First Man was represented by a pole (Bowers 1950:151–56). As previously mentioned, this pole was associated with the center of the village, and in the case of the Hidatsa, the pole was associated with the mounds that were built near the human skull circles. Among the Omaha, there were two poles. Each pole was treated with great respect and each had its own medicine bundle and pipe. These poles were associated with war. With regard to where one of these poles was kept, "the ancient cedar pole (Peabody Museum no. 37561) preserved in the Tent of War was the prototype of the Sacred Pole" (Fletcher and La Flesche 1992:457). Both poles had the *zhi'be*, or leg; one was bound with a stick or club; and the other displayed a "device called a bow shield. Both poles were associated with Thunder, and any profanation of either was supernaturally punished by death" (Fletcher and La Flesche 1992:457–58).

Certain rites were associated with the sacred pole called the "venerable man." After a priest anointed it with a mixture of buffalo fat and red pigment, a woman thrust seven arrows into a downy bundle (filled with heron feathers) tied to the sacred pole. Each arrow represented a separate gens. "If an arrow failed to go through, the gens which it represented would meet with misfortune" (Fletcher and La Flesche 1992:347). After the ceremony, the warriors enacted a great war drama, shooting at bundles of grass that represented their enemies. The purpose of this ceremony was to enforce the political unity of the society; it was a common ritual among the Osage and other Siouan groups (Fletcher and La Flesche 1992:245–51).

The above suggests that we might see in the rock art representations of the sacred pole and/or quartered circle, surrounded by various clan or gens symbols. Quartered circle motifs are included at a number of both pictograph and petroglyph sites, particularly within the Big Five grouping as petroglyphs (as well as at the Bushnell Ceremonial Cave) but also elsewhere in pictograph form at First Creek, Lost Creek, and the Torbett Spring–Rocheport sites (see Figure 5.8, chart of geometric and abstract motifs).

2. The Square: The Sacred Square Ground Motif. Although the square is a cultural universal, its use and associations in the Missouri rock art inventory suggest its importance as a symbol. The square is a basic geometric design; it could even be classified as an "element." In any case, it is referred to frequently in connection with ceremonies. It is also associated with the important mythological character of the Old-woman-who-never-dies, discussed above. "The outline of the Old-woman-who-never-dies lodge is rectangular" (Bowers 1965:339).

We believe these relationships might account for its inclusion in many of the state's petroglyphs. Almost every account of the Green Corn ceremony and other harvest and first-fruits ceremonies begins with mention of the preparation of the sacred (square) ground (Howard 1968; Swanton 1911; Witthoft 1949; and others). In some Oklahoma tribes, rites to enroll initiated young men as official members of the "square ground" persisted, at least, until the 1960s, according to Howard (1968). The Tuckabachee Creek are said to retain copper and brass plates that the sacred leaders brought out during the busk. As to their origins, according to Hitchcock (1930:123–24), the plates were "brought by messengers from heaven who sat down in a square and performed some ceremony." In this ceremony human beings were taught how to make fire and how to worship the great spirit, and the plates were then given to the Creek chief (see Howard 1968:68–70 for a Shawnee connection).

In relation to this square motif, the historic Lenape of Pennsylvania, according to a letter from William Penn dated 1683, as part of their harvest festival, prepared a feast that included hot cakes of new corn, wheat, and beans that they made up in a square form. Finally, a reference that is somewhat distant, but interesting nonetheless, is that, according to Will and Hyde (1917) as noted in their book *Corn among the Indians of the Upper Missouri,* the Cheyenne planted corn in square hills with "four grains at the corners of the square and one in the middle." These correlations between corn and the square in associated ceremonies and concerning planting, the Corn Mother, corn products, and so on are too widespread to ignore and should be considered in view of the large numbers of square motifs in Missouri rock art at the Big Five sites as well as at other locations.

3. The Bird/"Thunderbird" Motif. Numerous references are made in the ethnographic accounts to the importance of birds, including birds of prey, the pileated woodpecker, the heron, and others that may be portrayed in the rock art of the Big Five group. Recall that the bird motif is the single most frequently depicted motif. The most prominent clan icon of the Osage, Winnebago, and Omaha (all Siouan groups) was avian. While the bird has been found in great number in Missouri's rock art record, it has also been found engraved on portable artifacts, in particular, on ceramic bottles excavated at

the Campbell site and as a carving on the inside of the long-nosed god maskette found at the Yokum site, forty-five miles east of the Big Five area (Perino 1971:163). The main reason for the abundance of bird motifs is the probable connection of birds to the sky, thunder, and rain, as well as to the deities or spirits that dwell in the heavens.

Incidentally, an important feature of the Green Corn ceremony was to placate the spiritual counterparts of various bird species used for their feathers, beaks, talons, and other parts. The returning birds were also the herald of spring (the planting season) and their departure the signal of the end of the growing season and the onset of winter, and "women as individuals or household groups of females" made simple offerings placed on sticks in the gardens "during the northward and southward flights of the water birds" (Bowers 1965:340). Birds are also widely referred to as "ancestral spirits."

4. *The Mace/Baton/Long Blades Motif.* Ceremonial war clubs were and still are important articles of busk paraphernalia (Howard 1968) and medicine or sacred bundles (Bailey 1995:46–47). There is mention of batons used in the busk and there could be a possible connection to this in petroglyphs at the Big Five and related sites. Additional mace or club motifs are pictured in petroglyphs at Washington State Park Site B (Figure 5.16a) and at the Donnell site and in pictographs at Picture Cave #1, at the Willenberg Shelter, and at Rattlesnake Bluff, among others (see Figure 5.6, chart of weapons and related motifs).

5. *The Ball Games/Stickball/Bowl Games/Chunkee Games.* Four Missouri rock art sites contain anthropomorphs that have been interpreted as stickball or chunkee players: Maddin Creek, Mitchell, Washington State Park, and Wallen Creek. The chunkee game was often part of the Green Corn ceremony, and it was used as well on other special occasions (Chapman and Chapman 1983:80; Howard 1968:61). The stickball game, at least a type of the Siouan version that used just one stick, may be depicted at Washington State Park B (Figure 5.16a), Mitchell (Figure 5.16b), and others. Further discussion of the stickball game, in relation to oral tradition, is found below.

6. *The Serpent/Snake Motif.* The serpent/snake motif is broadly accepted as a symbol of the underworld, water, agriculture, and the earth and fertility, hence its possible connection to a "successful harvest" celebration. In addition, snakes were husbands of the Old-woman-who-never-dies, who is also the Corn Mother (Bowers 1965:334–35; Radin 1954:54). Serpent forms are seen in association with vulvar motifs at a number of sites, including the Plattin Creek, Maddin Creek, and Three Hills Creek sites.

7. *The Forked Pole Motif.* The forked pole motif is documented in ethnographic accounts of the busk as a very sacred symbol controlled by the Medicine Man, who directs the sacred portions of the Green Corn ceremony, along

with his assistant. This motif is conceivably depicted on the Spiro shell gorgets (Hamilton 1952; Howard 1968; Phillips and Brown 1978, 1984). The heron, as well as its severed head, is a symbolic part of this ceremony and may be seen hanging from the belts of figures holding the forked pole (Phillips and Brown 1984:plates 290, 312, 315, 317, and other figures). Judging from its general shape, we think that a heron may be portrayed at the Three Hills Creek site (Figure 5.2, E-3).

Howard (1968:80) believes that all, or nearly all, of the motifs and ritual objects of the Southeastern Ceremonial Complex could fit into a version of the Green Corn ceremony as it was practiced in historic times by the Cherokee, Natchez, and Chicasaw and as it was and still is practiced by some of the Seminole, Creek, and Yuchi of Oklahoma and the Rio Grande Pueblos of Arizona. We believe that many of the motifs of Missouri's Big Five sites and some of the satellite rock art sites could fit comfortably within the realm of the Green Corn ceremony. Unfortunately, because there is no direct historical continuity in our area, this is rather speculative. Nevertheless, the associated set of glyphs seems at this point best interpreted as components of a version of the Green Corn ceremony (whether or not that is any longer perceived to be part of a unified Southeastern Ceremonial Complex) and should be so considered.

The Trickster Cycle

Included among the most ancient mythological characters are Trickster, or the Foolish One, and Hare. These figures seem to be represented in both petroglyphs and pictographs. Hare is possibly represented as rabbit tracks at Peene-Murat, at Washington State Park Site A, and in long-eared figures at Pigeon Hollow (Figure 6.7) and other sites. Hare, according to the Winnebago, is the grandson of Old-woman-who-never-dies (Radin 1948:31). Hare is a notable character because he is the one who developed the Medicine Rite, the reincarnation ritual of the Winnebago. He is associated with his grandmother, the earth, and earth mother, as well as the Old-woman-who-never-dies. He is one of four great supernatural beings created by Earthmaker, who watches over humankind.

Trickster or the Foolish One is often referred to in terms of male genital symbolism. The historic Siouan groups performed ceremonies that included this character. Bowers, in describing the Okipa ceremony of the Mandan, writes, "Just after the performers had completed their first dance on the third day, he appeared on the prairie following a zigzag course to the village. He was scantily clothed . . . He was painted black with white teeth painted around his mouth . . . he wore a rod and two small pumpkins representing male genitals" (Bowers 1950:144–45). Bowers (1950:109) notes Catlin's accu-

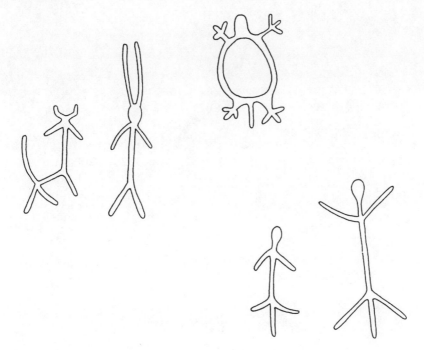

Figure 6.7. Stick figures and rabbit ear figure (Pigeon Hollow) (drawings by Robert G. Stone, from David M. Hinkley [1988]; used by permission).

racy in describing the Okipa ceremony of the Mandan. The Foolish One is described in Catlin (1967) as a character with the name Oxinhede who is depicted as being painted black all over. He has on his lower front a large piece of skin from the mane of a bull buffalo to which is attached a wooden phallus. Picture Cave #1 contains a pictograph originally thought by some to be modern graffiti but that might actually be a portrayal of this character (Figure 6.8a). Catlin does not depict this character in his 1844 publication, but the complete illustration is given in the separate appendix, with a Latin text (Catlin 1844). Among the Winnebago, a similarity is noted between Trickster's penis and the sacred feathered staff carried by chiefs of the Thunderbird and Bear clans (Radin 1948:27, 157).

There is a possible reference to an actual petroglyph within the Winnebago Trickster cycle that bears quoting. It is discussed by Radin (1948:53) and describes the last meal eaten by Trickster.

Finally he made a stone kettle and said, "Now for the last time I will eat a meal on earth. There he boiled his food and when it was cooked he put it in a big dish. He had made a stone dish for himself. There he sat and ate. He sat on

a)

b)

Figure 6.8. *a*, "Oxinhede" figure (Picture Cave); *b*, "kettle with imprint" (Washington State Park).

top of a rock and his seat is visible to the present day. There, too, can be seen the kettle and the dish and even the imprint of his buttocks. Even the imprint of his testicles can be seen there. This meal he ate a short distance from the place where the Missouri enters the Mississippi. Then he left and went first into the ocean and then up to the heavens.

The impressions alluded to could be the natural impressions of the tinajitas formations evident at four of the Big Five sites in southeastern Missouri about thirty miles from the confluence of the two rivers. Figure 6.8*b* shows another type of depression and yet another possible reference to this myth at Washington State Park Site A. Outside the shelter group is a bowl depression with two adjacent ovals. A still more convincing rock art example that might have been carved to reflect this oral tradition is one located in western Illinois at the Fountain Bluff site. Within the configuration of a seat carved into a section of rock, at the upper site, is a carved depression in the form of male genitalia.

Red Horn

At Picture Cave, we find in the graphics the likeness of an important mythical character, as evidenced by the archaeological data in the eastern United States from Florida to Wisconsin. This character is connected to the long-nosed god maskettes and called Red Horn or He-who-wears-human-heads-as-earrings (previously mentioned). The basis of this character is that of a supernatural being who represents the sun and/or morning star and its reincarnation. The most prominent defining feature of this supernatural being is his ear ornaments. A Winnebago informant, Jasper Blowsnake, recorded a story. In it, the principle character was Red Horn. Radin quotes Blowsnake as follows:

> Now the little brother [Red Horn] stood up and said, "Those in the heavens who created me did not call me by this name, He-who-is-hit-with-deer-lungs. They called me He-who-wears-human-heads-as-earrings." With that he spat upon his hands and began fingering his ears. And as he did this, little faces suddenly appeared on his ears, laughing, winking and sticking out their tongues. Then he spoke again, "Those on earth, when they speak of me, call me Red Horn." With this he spat upon his hands, and drew them over his hair which then became very long and red." (Radin 1948:117)

Archaeological evidence of this mythological character, through the long-nosed god maskettes, has been found in at least ten states (Alabama, Arkansas, Florida, Illinois, Iowa, Louisiana, Missouri, Oklahoma, Tennessee, and

Wisconsin). The distribution of these diagnostic artifacts was first noted by Williams and Goggin, then by Hall and Kelly. Williams and Goggin (1956:8) show eight sites where long-nosed god maskettes have been uncovered, Hall (1991:32), focusing on a smaller region, portrays ten, and Kelly (1991:73) gives a complete inventory. There are now at least thirty-eight examples known (their locations are illustrated in this study in Figure 6.9, with an explanatory listing in the legend), or thirty-nine if one includes the motifs on the chest of the figure at the Gottschall site (Salzer 1987:452) believed by Hall (personal communication, April 1993) to be maskette representations.

The Red Horn cycle is part of the oral tradition of the Winnebago and Iowa and probably many of the cognate groups. These groups are closely related linguistically to the Missouri peoples who were living in Saline County at contact (Chapman and Chapman 1983:99). There is probable evidence of this Red Horn myth at four petroglyph sites: Maddin Creek, Three Hills Creek, Wallen Creek, and Washington State Park A, as well as at Picture Cave #1, a pictograph site. At Picture Cave #1, the prominent figure wearing the long-nosed god earring is shown carrying a head, similar to his own. This is a probable representation of the Red Horn character or his son by "Woman-with-the-white-beaver-skin-as-a-wrap" (Radin 1948:129).[8] If it is Red Horn's son, then he is carrying his father's head back to his mother's house to allow it to be reincarnated as described in Radin (1948:129–31). One of the reasons this seems probable is that the reference to Red Horn's hair turning white, the white feather or plume,[9] is very prominent in this panel and may serve as a metaphor. Another factor is the presence of the dead elk/wapiti (upside down) to the lower right of the figure. This is seen at both the Picture Cave #1 (Figure 6.6b) and the Gottschall site (Salzer 1987:450–52). This is yet another important link to the Red Horn oral tradition as described by Radin (1948:133). Red Horn's sons killed many elk (Radin 1948:134). Radin also tells of Red Horn's quiver of arrows turning into snakes when he sets them down at the end of the day. According to Radin (1948), Red Horn's moccasins also had the ability to change into snakes. This part of the oral tradition could be a clue to the frequency of serpents that have heads shaped like arrows/projectile points.

Because the Winnebago, like many of their Siouan relatives, believed in reincarnation, we think that the symbols at three or four of the sites, as previously mentioned, might represent the rebirth of supernatural heros (Maddin Creek, Wallen Creek, Three Hills Creek, and possibly Washington State Park). According to Winnebago tradition, Red Horn was the youngest of several brothers. After a foot race, he plays a stickball game (Bowers 1965:334) and other games with the giants (Radin 1948:123–26). At several sites (as discussed above), figures are seen with a ball and holding a stick. This could well

be the Siouan stickball game described by Catlin (1844). Catlin pictures two players in his plates 235 and 236. The rock art figures were previously interpreted as chunkee players because of the associated circles. Where only circle motifs are present, this might be the scenario.

Red Horn, a continually reincarnated figure, is portrayed in the literature (Radin 1948:123) as playing stickball against the giants. Storms-as-he-walks, a large supernatural bird and Red Horn's companion, is also a stickball player against the giants or underworld supernaturals. Several of the avian figures are pictured with a circular depression (and sometimes a straight groove) near their wings (e.g., Bushnell, Figure 6.10*a;* Maddin Creek, Figure 6.10, *b* and *c;* Commerce Eagle, Figure 6.10*d;* Three Hills Creek, Figure 6.10*e;* and Washington State Park-A, Figure 6.10*f*). Some of these bird figures are associated with an anthropomorphic figure, including Maddin Creek (Figure 6.10*c*), Washington State Park-A (Figure 6.10*f*), and Mitchell (Figure 5.16*b*).

A passage referring to the movement of these Siouan-speaking groups from east to west and east to north bears repeating here. Radin (1948:11) states, "Archaeological evidence indicates that the Winnebago have been living in Wisconsin at least since 1400 and probably earlier. The same evidence demonstrates that they must have pushed their way northward from their original home along the Mississippi, at first together with the Iowa, Oto and Missouri, and entered Wisconsin from the southwest of that state and through northwestern Illinois." This information conforms to Kelly's (1991:76) premise of "the Mississippian elite class's expansion into what were areas to the north (of Cahokia) inhabited only by dispersed Late Woodland populations." We agree in part and also believe interaction between Cahokia and the northern groups was responsible for many shared oral traditions and motifs. Interestingly, Oneota pottery sherds were recovered from the west bank of the Mississippi near the Bushberg-Meissner site by Benedict Ellis (personal communication, June 1993).

Southwestern Wisconsin is the area where the Gottschall Shelter is located. This shelter contains pictographs similar to those in a panel at Picture Cave #1. The excavation of a striped sandstone head at Gottschall during the summer field season of 1992 further argues a linkage between both the sites and the groups believed responsible for their presence—the Winnebago (Iowa, Oto, and Missouri). Fowler and Hall (1978:566) discuss the presence of the Oneota in Missouri and related areas. Coe, Snow, and Benson (1989:54, 65) show the Oneota in northern Missouri and also discuss the movement from east to west. They write, "Oneota communities became the Siouan-speaking tribes known historically as the Oto, Missouri and Iowa. . . . Pawnee, Quapaw, Kansa, Osage, Ponca and Omaha communities all left the fringes of the Eastern Woodlands to take up at least part-time bison hunting on horseback."

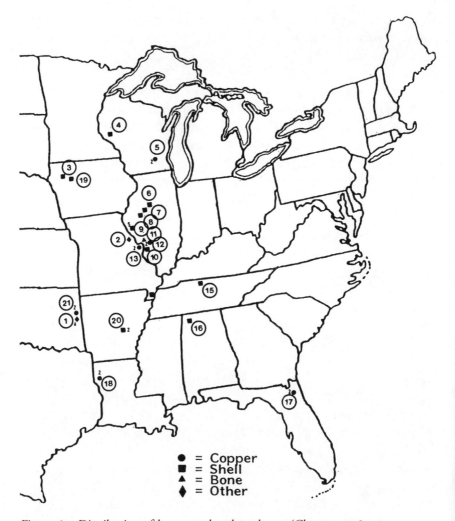

Figure 6.9. Distribution of long-nosed god maskettes (Chapman 1980:1; Diaz-Granados 1993:330; Hall 1991:10; Kelly 1991:61–80; Phillips and Brown 1978; Williams and Goggin 1956:8).

Key: Long-nosed maskette sites

1. Spiro Mound, two on large figure called "Big Boy"
 (Hamilton 1952:134) 2
 One on copper plate fragment (Hamilton, Hamilton,
 and Chapman 1974:88, fig. 51B) 1
 One cup fragment (Phillips and Brown 1978:plate 17) 1
 Two copper masks, one with a burial (Kelly 1991:73–74) 2
2. Picture Cave #1, painted on sandstone wall, partly filled
 line drawing in black and white pigment
 (Diaz-Granados 1993) 1
3. Adrian Anderson's site 12CK1, Iowa, a shell mask (Hall
 1991:fig. 1.7) 1

4. Diamond Bluff site, Pierce Co., Wisconsin, a shell mask
(Williams and Goggin 1956:32) 1

5. Aztalan, Jefferson Co., Wisconsin, two unfinished copper
masks in the Milwaukee Public Museum Collections
(Williams and Goggin 1956:28) 2

6. Dickson Mound, shell (Hall 1985:fig. 6) 1

7. Emmons site in Fulton Co., Illinois, shell mask found on
bluff near the site (Bareis and Gardner 1968:497) 1

8. Crable site in Fulton Co., Illinois, two shell masks
excavated on the site (Bareis and Gardner 1968) 2

9. Yokem (mound #3?), three shell examples excavated by
Paul and Eugene Wright from the mound during the
winter of 1966–1967: three masks and the nose of a
fourth were recovered. Another shell mask was recovered
by Perino in mound #1. A bird was carved on the
inside of one of the masks, which were associated with
multiple burials in a charnel structure that had been
burned. Balls of pigment (approx. 2 inches in diameter,
possibly indicated storage in gourds) included 2 red, 1
blue, 1 green, and 1 yellow. Radiocarbon date from this
site was A.D. 1190 (Bareis and Gardner 1968; Perino 1971) 5

10. Bluff in American Bottom eight miles south of Cahokia
(St. Clair Co., Illinois), two shell masks found by G.
Perino (Bareis and Gardner 1968:497) 2

11. American Bottom bluffs a few miles from Cahokia, one
small bone example found by Larry Kinsella while
surface collecting 1

12. Undisclosed site on the lower Illinois River (Meppen
Mound?), a pair of copper masks with long noses dug
by William Fecht 2

13. Big Mound, St. Louis, Missouri, two copper masks
(Williams and Goggin 1956:10) 2

14. Campbell site, 23PM5, Pemiscott Co., Missouri, a late
shell example in collection of C. Adam, St. Louis. 1

15. Cave near Rogana, Sumner Co., Tennessee, a shell mask,
very similar to the Yokem specimen (Williams and
Goggin 1956:32–33) 1

16. Cave near Mussel Shoals, Colbert Co., Alabama, a
short-nosed shell mask (Williams and Goggin 1956:28) 1

17. Grant Mound, St. Johns River, east of Jacksonville,
Florida, two copper masks (Williams and Goggin
1956:24) 2

18. Gahagan site, DeSoto Co., Louisiana, two large copper
masks (Williams and Goggin 1956:24) 2

19. Siouxland site in Woodbury Co., Iowa, a busycon shell
mask (Galloway 1989:124) 1

20. Shipp's Ferry site, Arkansas, two shell masks (Kelly
1991:73–74) 2

21. Harlan site, Oklahoma, two copper masks (Kelly
1991:73–74) 2

TOTAL 39

Figure 6.10. Birds with discs, balls, and/or sticks: *a,* Bushnell; *b* and *c,* Maddin Creek; *d,* Commerce; *e,* Three Hills Creek; *f,* Washington State Park.

Reincarnation

The belief in reincarnation is a documented common thread among most of the Siouan-speaking groups and could be the reason for the abundance of particular motifs at many of the Missouri rock art sites. According to Bowers (1950:60), the Mandan, another group of Siouan speakers, believed in rebirth as part of their life cycle: "The Mandan cite numerous instances of culture

heroes who selected a mother when desiring to be born into the tribe." The belief in reincarnation is likewise widespread among the Winnebago, another Siouan-speaking group related to the Missouri. Radin (1926:119–20), in speaking of the Winnebago and the Medicine Dance, tells of Earthmaker who sent Hare to the earth with the aid of his friends Trickster, Turtle, Bladder, and He-who-wears-human-heads-as-earrings. Hare teaches human beings how to perform the ceremony properly so that they might be reincarnated. The Winnebago believe that people can return to earth as human beings, join the various bands of spirits, or finally become "an animal under the earth." The Grandmother figure (or Old-woman-who-never-dies) assists Hare in this ritual.

Several rock art motifs could be connected with reincarnation beliefs. Among the related motifs are the snake or serpent, vulvar motifs (procreative figure), puerperal motifs (actual birth), and the arrow associated with anthropomorphic figures. In reference to the snake or serpent, for example, "the great rattlesnake from amidst the bunches of tall grass caused itself to be heard by making a buzzing sound. Then it spake saying: Even though the little ones pass into the realm of spirits, They shall, by clinging to me and using my strength, recover consciousness" (La Flesche 1932:368–69). Another reference comes from Hidatsa oral tradition: "For they and all other snakes represent the husbands of Old-woman-who-never-dies" (Bowers 1965:334). A ceramic pot recovered just south of the southeastern Missouri border and presently in a private collection depicts an elderly woman; the exterior is engraved with snake motifs.

Yet another reference comes from Bowers (1950:184): the Mandan's sacred bundle for the corn ceremony contains "a robe on which was painted a map of the world showing the Missouri River as a large snake and a hole through which the corn people reached the earth." Snakes or serpents are among the most frequently illustrated motifs and figure prominently in the Big Five group. Outside this group's area, the Rattlesnake Bluff site not only portrays a rattlesnake (as its name implies) but the snake can be seen delicately painted in earlier versions that have all but faded (Figure 3.6). While the imagery of reincarnation concerns itself with the underground or "world below" as opposed to the sky or "world above," the adoption ceremony involves moving the candidate through the various clans—symbolically moving the new (reincarnated) person from the underworld to the upper world.

The Adoption Ceremony

The adoption ceremony is discussed by Hall (1991, 1997) and others. We take these discussions a step further and elaborate on the role of the adoption ceremonies (or the Calumet ceremony; Hall 1991:30) and possible connec-

tions to a Missouri pictograph, as well as the importance this ceremony held for the determination of chieftainships among groups using fictional kinship relations, that is, relationships created during the adoption ceremony. A principal figure at Picture Cave #1 (Figure 6.6, *a* and *b*) may be significant in elucidating the role of interrelationships between groups and possible shared motifs. These motifs, as depicted in this figure, include (1) the vertical stripes on the face and upper torso and (2) the arrows inserted into the forelock. The Osage used vertical-striped face painting (as previously mentioned, six stripes on one side of the face and seven on the other), and these markings, as part of the ritual, were dubbed the "sacred hawk" by La Flesche (1932:120).

By being transformed into raptors, the initiates are adopted and it is the adoption ceremony that provides the vehicle for economic and social prestige (see below). During this ceremony, the initiates are described as being "struck with deer lungs," symbolized by two bunches of owl feathers on a pipe stem (the stem is referred to as "Mon-ka" or arrowshaft) (La Flesche 1939:254). This ties together the bilobed arrow motif, the deer lungs, and the feathered pipe stem and is viewed here as an important metaphorical system: bilobed arrow=deer lungs=feathered pipe stem. Hall (1997:50) has a corresponding explanation. This ceremony is widespread and is also found among the Caddoan-speaking groups.

In Caddoan oral tradition, the long-nosed maskettes figure into the plan. The adoption and civilization of a "wild" brother who has a "long nose" is achieved by trimming the nose on the sixth day of an adoption ritual (Lankford 1987:165–66). The altered noses depicted on the long-nosed maskettes (Hall 1991; Phillips and Brown 1978; Williams and Goggin 1956) and the long nose depicted on the figure on the wall at Picture Cave #1 could be interpreted as a Mississippian statement on degrees of adoption and other rites connected with recipients of the long-nosed maskette (Duncan and Diaz-Granados 1996).

The Pawnee and Arikara, Caddoan-speakers, shared many oral traditions, particularly the one concerning "their emergence from the underworld with their vegetable crops, led by an old woman called 'Zacado'" (Hyde 1988:21). Along with the many shared oral traditions, the Pawnee practiced the "splendid Hako ceremony of peace and friendship" (Hyde 1988:24). As in the Osage ceremony, the large feathered pipes are preeminent features. There appears to be a preference for both Osage and Pawnee adopters to be connected with the sky clans. Most of the ritual preference seems to associate the adopted person with avian or world-above symbolism. One of the benefits of the adoption ceremony was to enable "alien" individuals or outsiders to be "reborn" as "sons" with membership in the parent's clan.

Bowers (1965:47–50, 90–125) gives a detailed description of the Hidatsa adoption rites and the resulting friendship or "father and son" relationship that enhanced the prestige of the Hidatsa "father." This model could possibly be applied to the Cahokian economic structure in its connection to a wide-spread trade system. When the time came for the adoption rites to be held, a large accumulation of presents was prepared by both "father" and "son" to be exchanged during the ceremony. The principal ceremonial object was a large wooden pipe stem "decorated with redheaded woodpecker scalps, eagle feathers, and horsetail hair hanging as a scalp" (Bowers 1965:48). The alien "son" candidate was often followed by other members of the alien "band." The band customarily came to trade for corn, robes, and other Hidatsa products.

Elaborate camps with "police" were often set up near the Hidatsa town. Rigid discipline and strict rules of hospitality were followed during these rites of adoption and exchange of goods and ritual activity. These activities were recorded ethnographically as being particularly appealing; conflict during these trading forays was conspicuously absent. The Hidatsa "father" often repaid his "son" with a reciprocal trading trip. These trips were both economic and social in character (Bowers 1965:47–48). To lead a large party or to command the confidence of a large party of visiting foreigners meant that a leader must have distinguished himself on former occasions, and many adoptions would add to this prestige. Generosity with the acquired wealth gained from the adoption rites, good will, and humility were demonstrated by other prominent men as advisors and added even more distinction (Bowers 1965:58).

According to Bowers (1965:91), "The Hidatsa highly respected those of the village who had extensive 'relationships' with alien bands. As far as it is possible to determine, all council leaders had established, by means of the adoption ceremony, 'father-son' or 'father-friend' [note the degrees, our comment] relationships with a number of distinguished men of other tribes." Within their own group the members of Hidatsa ritual societies thought of the next higher societal members as "fathers" (Bowers 1965:94). Women also participated in adoptions. An individual, whether male or female, might adopt many sons and daughters during his or her lifetime. When such a person died it was expected that the many adopted sons and daughters would present gifts to distinguished people in the deceased patron's name (Bowers 1965:172).

This activity of adopting "sons," "daughters," and "friends," and the leadership of trading parties, "provided one of the avenues by which Hidatsa chieftainship was developed" (Bowers 1965:49). All of Bowers's informants agreed that the principal chief or peace chief was one who had honored many

with the adoption rite (Bowers 1965:172). In view of the above, it seems reasonable to suggest that similar activities might have taken place both at Cahokia and among groups engaged in social interaction and trade with Cahokia, as well as in those areas in which the long-nosed maskettes have been found, including eastern Missouri.

7 Conclusion

If we were to name the most distinguishing feature of Missouri's rock art it would be that the styles seen at sites in close proximity often differ more than do some regional styles. There is, of course, the important concentration of major sites in southeast Missouri, in addition to the three associated sites in the northeast quadrant. However, the remainder of the state's petroglyphs and pictographs are very distinctive. Granted, there are similarities among a few sites, and other sites may be discovered that will compare to known styles. Sites in close proximity, nevertheless, can vary greatly in media, content, style, and structure. Some of the motifs are unique to parietal graphics. There are single-motif petroglyph sites, complex petroglyphs or pictographs, and mixed media sites (petroglyphs and pictographs within a single site) in close proximity.

The factors responsible for this marked variability may include the facts that Missouri (1) was a high activity area, (2) had a large, diverse population attracted by its major confluence region, and the rich and complex natural environment, and/or (3) was involved in trade within the greater Cahokia domain (Southeastern Ceremonial Complex influence). On the other hand, the marked diversity in rock art motifs, structures, and contexts could be the result of localized, parochial developments rather than heterogeneity resulting from many different groups passing through.

FUNCTION

Working from our present knowledge, it appears that at least a large portion of the state's sites were ritual or ceremonial in function because they are located apart from known habitation sites. Some have been reported to have burials in relatively close association, but are still apart from habitation sites. This is not to say that ceremonial sites existed only apart from habitation sites but does suggest that remote areas were utilized for a particular ritual activity or activities. Burials have also been reported in at least two of the caves containing rock art. Motifs at several of the rock art sites in the state could fit the function of the creation of clan symbols as they were used in the Southwest. Olsen (1985:16) states,

Clan symbols documented by Mallory, Colton and Colton, and Michaelis were witnessed by Titiev as signatures of participation during the Salt Gathering trip made by Wuwuchim initiates (1937:245). Both initiates and guides left their clan marks on a shrine rock, along with prayer feathers, en route to Salt Canyon in the Grand Canyon. Titiev observed rows of clan symbols. He was told that rows of symbols develop from each person adding a sign to the left of his last mark; a row indicated the number of times that same person had made the trek. Titiev witnessed a Coyote head, a Sand hummock and a Sun shield manufactured during the pilgrimage.

Interestingly, early groups in Missouri were known for their involvement in the salt trade during the Mississippian period as evidenced by the "salt pans" recovered at sites in Ste. Genevieve County, Jefferson County, and other major salt licks on the Ozark fringe. Keslin (1964:5) states, "Archaeological data indicative of salt utilization by prehistoric groups has been available for well over fifty years." He notes that the primary indicators of salt use are the ceramic vessels called salt pans found adjacent to saline springs in the central United States including east-central Missouri (Keslin 1964:5). Even during the historic period, the Illini were known to have crossed into Missouri to participate in the trade. Bushnell Ceremonial Cave, with its various carvings, including the avian motifs, is located in the immediate vicinity of a major salt spring.

Consider another factor. There is no question, in view of the findings at several sites, that the prehistoric peoples in the Missouri region, like those on the Plains, in the Southwest, and at locations around the world, paid close attention to sky phenomena and practiced what Williamson (1989:9) refers to as "naked-eye astronomy." Moreover, these celestial observations were closely linked to religion and oral tradition. In fact, the Osage have numerous terms for "star," "sun," and phenomena associated with the sky (La Flesche 1916:279, 1932). The widely separated sites of Tobin-Reed, Sharpsburg, Lost Creek Shelter, Deer Run, and Picture Cave, none of which have supernova portrayals, all have dot patterns or other motifs that have been associated with celestial phenomena possibly suggesting pictorial calendar graphics.

The three examples of W motifs, previously discussed, resemble the constellation Cassiopeia. One is at the Tobin-Reed site. Because the Tobin-Reed site is a wet shelter at the bottom of a steep hollow, it would logically fit the picture of a spot for the dwelling of the underwater spirit. Finally, the connection between the sun and/or Venus (the morning star) and Red Horn and his son is yet another example of celestial imagery discussed by Radin (1948) and Hall (1989). It provides an additional metaphor and link between ide-

ology, astronomy, and rock art, suggesting a role possibly more vital than was previously suspected.

To answer the questions delineated under our original objectives in Chapter 2, we believe that this study demonstrates two key points. The first is that there are a number of rock art sites in Missouri that are distinctive but that can be described and identified as exhibiting a particular style. Furthermore, some of these styles are clearly diagnostic and important (Limited styles) and may be used as a basis for comparison with sites in surrounding states. Examination of the second point—that of evidence of spatial patterning of specific styles, themes, motifs, and/or elements—reveals that while some patterning of motifs is present, relationships to the movement of early historic people are not currently obvious. That is, group-specific motifs and symbols can only be speculated about at this point.

Wobst (1977:320) emphasizes that the capacity of early populations "to symbolize" allowed them "to respond more readily to environmental stress; it improve[d] their ability to harness and process energy and matter; and it diversifie[d] their options for information exchange." While we may not be able to decipher the details of prehistoric information exchange, we may be able to extract information about the relationship between regional fauna and the groups who created the rock art. However, there has not been sufficient detailed study of the fauna portrayed in the graphics and the available faunal records. The remainder of what can be gleaned from identification and analysis is largely speculative. In some cases we can make tentative associations: for example, between the long-nosed god maskette ear ornaments and Red Horn, between a dead wapiti and Red Horn, between the quartered circle and the sun/fire symbol, and between the vulvar form and the female deity.

To try to interpret the meaning of the myriad quadrupeds would be a difficult and tenuous task. A singular bison portrayal, for example, could be a sign for (1) there are bison in the area, (2) someone desires to kill a bison, (3) someone killed a bison, (4) this is the territory of the Bison clan, (5) this is my tribute to my guardian bison spirit, or any combination of the above. On the other hand, the lack of depictions of fish in the state's rock art record appears odd because fish are believed to have been a major food source. If the lack of fish in the rock art is *not* an indication that they were not used extensively as a food source, or were not as important during the late Woodland and Mississippian periods (the periods attributed to the major rock art activity) as during the Archaic period, then possibly the lack of portrayal simply indicates an important food source that was chosen not to be depicted for some unknown reason.

Evidence of the patterning of sites in regard to environmental data is

much more obvious. The majority of sites appear to be located on vertical bluff walls. However, the major groupings of sites, the Big Five, are all petroglyphs located on horizontal, low-lying dolomite boulders within glades. These could have been highly sacred settings reserved for recounting oral traditions or used in relation to the naming ceremony. Revard (1987:453) discusses this ceremony among the Osage, and he refers to actual dialogue in which the people appeal to "certain great beings of the Earth, the Soft Stone and the Friable Stone":

> First, the people, realizing that although they have reached this earth and received their personal names, they have nothing of which to make their earthly bodies go hurriedly to in-xe-shton-gaai ("the soft stone that sitteth upon the earth"). The Soft Stone answers their appeal: If they make their bodies of him, then when they become ill they may cling to him and receive the heat by which they shall be purified. Reassured, they proceed further, finding "the friable stone," or in-sho-sho-dse, from whom they receive also a favorable answer: If they make of him their bodies, "they shall cling to him as one who can produce the heat by which their bodies can be purified."

Although this passage makes reference to "heated" stone, probably sweat lodge stones, it also refers to stone "that sitteth upon the earth," which may apply to the dolomites and sandstones on which the petroglyphs are carved. These boulders are certainly friable and, carved with motifs, may have played a part in the naming ceremonies of certain groups, including the Osage. Further along in the passage, Revard says, "I assume that we have here references to the 'healing rocks,' of which one is still known to exist on the Osage Reservations, and to the stones of the Sweat Lodge" (Revard 1987:453).

The question of whether the petroglyphs and pictographs, through their motifs, content, and various styles, can be related to Native American groups of shared linguistic stock known to have inhabited the state or surrounding areas during the protohistoric and/or historic period (Figure 6.1) has been answered in the discussion on oral tradition (Chapter 6). There is little doubt that the evidence of oral tradition and related ceremony answers a large portion of the inquiry regarding the functions of rock art, particularly in reference to the major sites. We believe the evidence is strong in the Missouri region, especially in regard to the major complex sites (Washington State Park, Maddin Creek, and Picture Cave). While the correlations of Missouri rock art to oral traditions do not necessarily establish dates, they do suggest indirect evidence of a particular cultural association, namely, Siouan. Vehik (1993:231) seems to support Dhegihan Sioux origins as including, in part, an

amalgamation of Late Mississippian groups from along the Mississippi be-
tween the Ohio and Missouri rivers.

CULTURE HISTORY OF MISSOURI IN RELATION TO THE ROCK ART AND HISTORIC NATIVE AMERICAN GROUPS

Although the earlier periods in Missouri have not previously been thought
of as being associated with rock art, we include a brief overview of the entire
span. The earliest period of human activity in this portion of the North
American continent, poorly represented and defined, is referred to as the pre-
13,000 B.C. late Wisconsin settlement period (Fagan 1991:73) or Pre-Clovis by
Chapman (1975). At present, no archaeological site in Missouri can be accu-
rately dated to this early period. Research on the Miami Mastodon site near
Miami, Missouri, in the early 1970s produced a considerable amount of bone
material and a well-utilized flake tool, but little charcoal, preventing carbon-
14 dating at the time. Chapman (1975:48) placed the site at 20,000 to 14,000
B.C. Recent information on two loess samples obtained by T. M. Hamilton
from the Woods Hole Oceanographic Research Institute in Massachusetts
indicates an average date of 37,000 B.P. (T. M. Hamilton, personal commu-
nication 1993). Recent improvements in dating of bone samples may result in
a more accurate determination for this possible early butchering station.

Chapman places the Clovis complex, 11,000 to 8,500 B.C., in the Early
Hunter tradition, Paleo-Indian period. O'Brien and Wood (1998:55) date
Clovis to 9250–8950 B.C. This complex is represented by fluted projectile
points and knives accompanied by a myriad of flaked stone tools. Several
fluted points have been found on sites near some of the rock art sites (Frank
Magre, personal communication 1993). While Clovis people may have used
several of the shelters that display rock art, it is yet impossible to make con-
nections between existing rock art in Missouri and the known Clovis occu-
pations. Exposed rock paintings in the generally wet climate of Missouri
would not have a chance for survival beyond several generations. It is possi-
ble, however, that the earliest paintings and carvings, as they deteriorated,
were replaced with new ones, at least as long as ritual activity continued at a
location.

The Dalton period is reasonably well documented for Missouri. Chapman
(1975:95–126) dated it at 8000 to 7000 B.C. O'Brien and Wood (1998:81–83)
date Dalton from 8950 to 7900 B.C. Chapman and others have suggested that
climatic change induced the Paleo-Indian hunters to change tool kits and
technologies because of a shift in emphasis from nomadic hunting to a more

sedentary hunting-and-gathering existence. Morse and Morse (1983:80–95) suggest that population increase may also have influenced a major shift in procurement strategies. Dalton sites occur along the Missouri River, Mississippi River, and all their tributaries. The Dalton horizon at Graham Cave contained a ceremonial fire area with a circle of stones, one of which had a polished surface (Chapman 1975:97). No pigmentation on the polished stone was mentioned, but the circle and fire suggest that ritual connected with fire had an early beginning in this area and would remain an important symbol for thousands of years. In close proximity to the fire circle was a reinterred human burial associated with a small drilled canid tooth.

O'Brien and Wood place the beginning of Early Archaic at 8050 to 7550 B.C., the pre-Boreal climate episode. Chapman suggests that some of the Early Archaic traditions achieved full cultural-ecological integration in parts of Missouri. This theory also implies that populations became fully sedentary as continuous seasonal occupations became more prevalent. Chapman proposes that the Dalton aggregate overlaps the Early Archaic and that because of this continuum it is impossible to distinguish between them. O'Brien and Wood (1998:119) see a distinct separation, in some areas, as early as 7430 B.C. and attribute Chapman's overlap to the mixing of materials in the deepest levels at many sites. The appearance of a bannerstone or atlatl weight at Hidden Valley Shelter associated with Hidden Valley stemmed points and the recent findings at the Bull's Eye site in Illinois reinforce the belief that the chronological range of the bannerstone spans the entire Archaic period. In addition, there is the pictograph in southern Missouri, previously mentioned, that we believe depicts bannerstones. Along with the Hidden Valley bannerstones was a gorget fragment with a series of engraved parallel lines and a diagonal cross over the rectangular field (Chapman 1975:154), which brings to mind the "diagonal cross in squares" seen at two petroglyph sites (Fort Hill and Persimmon Hill, in Jefferson County) and at a pictograph site (Deer Run Shelter, in St. Francois County).

The Middle Archaic coincided with the mid-Holocene dry period about 6,000 to 3,000 years B.C. During this period, Arnold Research Cave was inhabited or utilized. The site produced a bone ornament exhibiting interlocking zigzag lines (diamond chain) similar to the pictograph at First Creek Shelter (Chapman 1975:164). A bone pin from Graham Cave has diagonal parallel lines and cross-hatching (Chapman 1975:176). The interlocking zigzag from Arnold Research Cave is similar to a motif found in the pictograph at the First Creek Shelter (Figure 5.53*b*). This may hint at an early use of the First Creek site because, although the artifact is a pictograph, it is well protected, being on a facade located over ten meters back from the low-hanging

shelter opening. It also contains other abstract motifs, and abstractions generally are considered to predate the use of realistic/naturalistic motifs. The fact that a quartered circle is also present might suggest that both this and the interlocking zigzag had a longer time span than previously thought. However, the pigments at this shelter have yet to be dated.

One of the effects of the early Holocene warming was the increased upland erosion that filled the river valleys and caused the geomorphology of the flood plains to approach the present configuration (Ahler et al. 1992:5).

O'Brien and Wood (1998:160) place the Late Archaic at 2880 to 765 B.C. Relatively high population densities and the increased use of cultigens during the Late Archaic period account for the extensive Terminal Archaic deposits on present ground surfaces along the second bottom terraces, levees, and elevated flood plains of the major streams and their tributaries. The appearance of gourd and other native cultigens (marsh elder, chenopod, and sunflower), increased use of riverine resources, and an increase in trade mark the beginning of the Late Archaic period (Ahler et al. 1992; Chapman 1975). Several Late Archaic limestone plaques are engraved with parallel lines or crosshatching (Chapman 1975:221), elements rarely seen in Missouri's rock art. Several bannerstones from the southeastern lowlands have fine, cross-hatched meandering lines engraved on them. A variety of manos and metates from the Terminal Archaic at Modoc Shelter in Illinois have hematite embedded in their working surfaces, possibly indicating frequent use of this pigment in the Mississippi Valley region (Ahler et al. 1992:103).

O'Brien and Wood (1998:168–75) place the beginning of the Early Woodland period at 600 B.C. The earliest pottery in the east central Missouri area is Marion Thick pottery recovered in St. Charles County by Harlan Soenker. The closest site that has dates for Marion Thick pottery is in the American Bottom. Farnsworth and Asch (1986:331) give a date of 600 B.C. for the beginning of this ceramic type. To the west in central Missouri, Early Woodland pottery different from Marion Thick or Black Sand has been found on three sites (Duncan 1981:44). The largest Early Woodland site is the Backes site (23SA447) in Saline County. This site was uncovered by the flood of 1993 and is a Black Sand site with Liverpool Cord-Marked and Chevron Incised pottery similar to the Cypress phase ceramics from the Lower Illinois River Valley (Farnsworth and Asch 1986:332). Chapman (1980:12) dates the Early Woodland period from 1000 to 500 B.C. and illustrates a Black Sand Incised vessel from Carroll County in western Missouri that has four parallel lines incised in a chevron pattern around the neck. Other dot-and-chevron designs are illustrated as a motif often used on Black Sand pottery. Chevron incising on pottery has recently been found at the Backes Black Sand site in Saline

County (Heldman and Duncan 1999; Martin 1998). As mentioned earlier in this study, the nested chevron design is rarely found in the state's presently known rock art inventory, other than in association with avian figures.

Some small groups of Middle Woodland people much like the Illinois River Havana culture inhabited portions of eastern Missouri, according to Chapman (1980:38, 48), particularly in the Hannibal area. The largest group of Middle Woodland occupation begins near the mouth of the Lamine River and extends to the west along the Missouri River. Blake (1942) excavated a Middle Woodland occupation in the St. Louis area. The Missouri Middle Woodland people participated in the type of extensive exchange network often referred to as an interaction sphere. Along with exotic raw materials, ideology and symbols were also shared. Hall (1989:241) speculatively acknowledges the Great Hare engraved on bone from Mound 25 of the Hopewell group in Ohio as a possible early form of the goggle-eyed, long-nosed being often referred to as the long-nosed god. This figure is discussed in Chapter 6 in the section on oral tradition and mythology.

Another important figure that later becomes a subject of rock art in Missouri is the underwater spirit. This supernatural creature is possibly depicted in the round on a "boatstone" type atlatl weight (Kopper 1986:132) and on a later birch-bark drawing (Catlin 1844:plate 310). The underwater spirit/serpent is a supernatural being widely referred to in oral tradition throughout the Southeast, the Missouri River Valley, and the Great Lakes region. The Omaha believe that the underwater spirit gave them the ability to be reborn; they attribute their knowledge of the Shell society ritual to a great underwater spirit (Fletcher and La Flesche 1992:515). There is evidence that the First Creator or Earthmaker might have been a water spirit long ago (Radin 1923:240). At any rate, underwater spirits are ancient in concept, widespread in the graphics and ceramic depictions of the eastern United States, and apparently evident at several of the Missouri rock art sites.

The Late Woodland period from A.D. 400 to 800 (the latter part of which is referred to as Developmental or Emergent Mississippian in certain regions) was a time of rapid change. With the increased reliance on maize agriculture, villages on the terraces adjacent to the Missouri River and its tributaries expanded. Large earthen mounds, linear constructions, and complex dry limestone charnel structures, are associated with the larger villages. A common artifact type found at these villages is the limestone discoidal. More exotic hard stone discoidals are also found, but in smaller numbers. Ceramic containers become more elaborate in surface finish and decoration, displaying, for example, notching and cord-wrapped impressions, and a few have stone-polished exteriors (Duncan 1981:42–47). Clay tobacco pipe fragments and carbonized seeds become more prevalent in refuse pits. Burials are made in

the village midden deposits, occasionally with associated grave goods. Large celt forms and flared bit or spatulate forms appear, mostly as broken or unfinished specimens.

Large amounts of worked hematite are found. Many of the animal pictographs are done in red pigments manufactured from ochre or hematite. These graphics appear on shelter and bluff facades as well as within caves and may have been made by these Late Woodland populations. Woodland pottery has been found in association with the Dry Fork Creek Shelter and Picture Cave #1, both of which sites have deer depicted in red pigment.

During the Late Woodland, the use of maize in the Midwest appears to increase. Sites evolved into more centralized authoritarian groups with changes in ceramics and settlement patterns. Kelly (1990) places a great deal of importance on the quartered-circle motif as a diagnostic of Emergent or Developmental Mississippian, although the motif continues into later periods. The quartered-circle motif, portrayed in the state's petroglyphs and pictographs, is widespread and well represented in the Big Five grouping and at other sites in the general Big Five region. A particularly good depiction is at the Three Hills Creek site (Figure 6.3c), where the motif is immediately in front of the beak of a bird and surrounded by many other motifs. The avian being, a sky clan figure, is believed to represent the clan most closely associated with leadership: thus its association with the quartered circle, a sky/sun symbol. To paraphrase Muller (1989:13), the great similarity between Woodland and Mississippian period graphics suggests "that the latter derives from the former."

Known diagnostic motifs in Missouri's petroglyphs and pictographs include the bilobed arrow, maces, hafted celts/axes, avian figures, and the falconid/forked eye; these are undoubtedly expressions of a complex society with great cultural diversity and social stratigraphy referred to as Mississippian. The Oneota culture extended into the Late Mississippian (Chapman 1980:138) and, in some areas, well into the Historic period (Henning 1961:8). The Oneota period in Missouri is represented by a group of sites in and near Saline County. The best known of these is the Utz site, which was occupied into the early 1700s. Oneota materials include incised, shell-tempered pottery, snub-nosed scrapers, small triangular projectile points, catlinite pipes, and engraved catlinite tablets.

The manifestation of Missouri's Mississippian period, at least in the eastern portion of the state, somewhat parallels that of the better-known and better-preserved site of Cahokia Mounds. The Mississippian period is generally characterized by a reliance on maize-centered agriculture, the exchange of exotic materials, a stratified society with ceremonial centers, a riverine orientation, and large earthen structures as evidenced at Cahokia and similarly

on the St. Louis riverfront before their destruction in the 1800s. Elaborate pottery in a variety of forms both utilitarian and ceremonial and other exotic goods with distinctive motifs abound during this period. Several of the artifacts diagnostic of the Mississippian period are reflected in Missouri rock art as previously discussed and are attributed to the Middle Mississippian period according to Chapman (1980:229). The prehistoric metropolis of Cahokia served a series of dependent villages in the surrounding region and acted as a base for the extensive exchange system for much of the upper and central Mississippi River Valley and the lower Missouri River Valley (Chapman and Chapman 1983:71).

The Late Woodland, Mississippian, and Oneota/pre-contact cultures appear to have created most of the major petroglyphs and pictographs in Missouri, judging from their associated motifs. While there are a few instances in which earlier groups may have participated in rock art activity and may be responsible for some of the smaller isolated sites, most of the large sites seem to be the product of complex, agricultural societies. This finding lends credence to the belief that the florescence of the arts brought about during the Mississippian period also manifested itself in a portion of the rock art activity in eastern Missouri. These Mississippian groups were probably long-time residents of the region and much of the symbolism, as well as the rock art locations, was probably in use for centuries.

Once again, the overall picture of Missouri rock art activity that emerges is one of diversity. It reflects a large and socially diverse population of Native Americans in permanent or seasonal occupation. Situated in the midsection of the North American continent, adjacent to two major rivers and a wealth of streams, and supporting an abundance of game and edible plants, this region drew large populations. Missouri's rock art reflects influence from the north, northeast, east, and southeast, and the petroglyphs and pictographs portray an admixture of motifs used in these other regions.

One thing is certain, judging from the content of the graphics: it appears that Missouri's early inhabitants utilized a variety of places containing workable "rock canvasses" on which to communicate information. These included important events (births, deaths, rites of passage, adoptions, rituals); ownership; honor to deities and guiding spirits; prayers; and information on natural resources. We believe that several of the larger, complex panels were rendered to convey a group's rich oral traditions—but not entirely oral, because of the wonderful graphics that they left behind for us to contemplate. The faintness of the upper rattlesnakes at Rattlesnake Bluff, the layers of graphics at Picture Cave, and the unidentifiable faint areas of pigments at Deer Run Shelter and at many other sites suggest that these areas of rock art activity were used over successive generations. Undoubtedly there were earlier pictographs that have

completely weathered or worn off the exposed rock facades. We hope that more will be discovered, particularly in the protected environments of caves so that we can expand the body of information that is slowly, but finally, evolving.

FUTURE WORK

Although we have spent more than twelve years investigating the state's rock art, we sense that, to make a pun, we have barely scratched the surface. The amount of data awaiting further investigation at existing sites appears never ending, without even thinking of the petroglyph and pictograph sites yet to be discovered and uncovered. We summarize the tasks to be carried out as follows:

1. Further pigment dating and analysis of pictograph sites and related test excavations of dark zone/beyond light pictograph sites in caves and rock shelters
2. Sod removal at glade sites with low outcrops
3. Test excavations related to outdoor sites
4. Detailed analysis and mapping of some of the more complex sites
5. Ongoing survey throughout the state to locate additional petroglyphs and pictographs
6. Search for patterning of motifs in adjacent states (and beyond)
7. Further research on predictive models for locating rock art sites
8. Stabilization, preservation, and protection of Missouri's rock art resources

Detailed analysis of the more complex sites will require months per site. Mapping of these sites, including a careful and thorough analysis of graphic structure, is necessary. In addition, aerial photographs should be taken of the complex, larger sites. Testing at these sites should also be carried out, including the careful removal of soil in areas immediately surrounding the outcrops, particularly at the low-lying flat groups such as Jake's Prairie, Peene-Murat, Winkle, Washington State Park B, and others that have silted over through the centuries. Pigment analysis, as has been done in France by Clottes (Wilford 1990a), in the western United States by Dorn and Whitley (1984), and in the United States and Australia by Chaffee, Hyman, and Rowe (1993, 1994), Russ, Hyman, and Rowe (1992, 1993), Watchman (1993), and others, is an area that needs to be further explored.

Some of the archaeological testing and excavations required to confirm or negate findings may be performed on the sediment immediately adjacent to

and below pictograph panels. Fragments of identical pigments discovered in stratified layers would go far to solidify the proposed chronological data. Although there has been steady growth in the number of publications and interest in general, rock art investigations need to catch up with the mainstream of investigative North American archaeological research. Methods of correlating excavated materials and manufactured soils (anthroseds) are now being developed (Salzer 1987, 1991) that will set a precedent for future investigative studies at other sites.

With the groundwork completed, we believe strongly that two components dominate Missouri's diverse rock art picture. The petroglyph and pictograph sites are multifunctional. In other words, the most outstanding features of the data are the wide variation in styles and the intricacy with which the environment is woven into the graphics, particularly in regard to fauna and the cosmos. This in turn undoubtedly reflects the oral traditions of the carvers and painters. With the distant past, however, there are naturally unavoidable uncertainties.

To attempt to interpret themes and identify characters from the surviving oral traditions may be regarded as tenuous. The reader should be aware of the complexities and occasional contradictions in oral traditions. Each orator, after all, relates his or her own version of a story. In addition, much of the data has been lost over centuries of acculturation. For that reason, it is all the more remarkable to find the many consistent threads of supernatural characters pervading a wide swatch of cultures. We are grateful to the ethnographers and persistent collectors of oral traditions who have left at least fragments that aid us in capturing glimpses of the elusive past.

Appendix A:
Glossary of Rock Art Terminology

There are many different approaches and words used to describe the same thing not only in the field of rock art but also in other fields in which object description and/or stylistic analysis is involved. Together with a few others I would prefer to refer to petroglyphs (rock carvings) and pictographs (rock paintings) as "rock graphics," the reason for which I briefly explain in Chapter 1. Other researchers find it necessary to use other terms, however. For example, Schaafsma (1985:237) states, "I find rock painting preferable to pictograph, even though the latter term is widely used and generally understood to signify a design painted or drawn on a rock." Many heated discussions have taken place and will continue to take place about which words to use.

I requested and received copies of the Nomenclature Committee Reports from A. J. Bock, secretary/treasurer of the American Rock Art Research Association in San Miguel, California. In her accompanying letter she notes, "Since 1981, attempts at creating a standard nomenclature have been abandoned. It seems that no two people could agree on any of the terms or descriptions that Nancy Robertson suggested. She was attempting to standardize the nomenclature so that all site reports, recordings, etc., could be computerized."

Below is a glossary of the basic terms used in rock art studies. Although much thought has gone into these definitions, I welcome comments and additions from other rock art scholars.

Abrade, abrading The technique of using an abrasive tool to grind or rub the stone surface

Abstract graphics Elements that deviate from an object's natural form either slightly or radically, thus becoming a schematic or symbolic representation of the original form (adapted from Schaafsma 1980:3); nonrepresentational: "Abstraction, visually, is simplification toward a more intense and distilled meaning" (Dondis 1974:74) (see Figure A-1)

Animism The belief that everything in nature has a soul; includes the wor-

ship or reverence of animals in order to gain their qualities or their for-
giveness in the kill or sacrifice; can be connected with totemism

Anthropomorphic Having a human form or human attributes; ascribing hu-
man characteristics to nonhuman things

Atlatl A manufactured tool/device used to propel a dart or spear; found to
provide additional thrust

Attribute Measurable characteristic

Clan A matrilineal sib (q.v.); or a unilateral kin group, often exogamous.
Membership in a clan hinges on kinship through one parent. It has been
suggested that the essential similarity between clan and gens (q.v.) should
lead to *clan* being used only for a kin group that hinges on both a rule of
descent and of residence. Clans often live in one locality, but may be mul-
tilocal. Clan members trace descent from their original ancestor, who may
be mythical (human, animal, or a feature of the landscape) (after Winick
1970:118).

Claviforms "A line with a protuberance" (Giedion 1962:241)

Conflation "The unnatural fusing or combining of elements" (Lewis-
Williams 1981:10–11)

Cross-hatching More or less evenly spaced diagonal lines obliquely inter-
sected by a second set of such lines, usually used to fill a space or graphic
field

Cupules A term sometimes used to describe depressions or pits ground into
the surface of rock outcrops or walls either alone or in combination with
other rock art; in Missouri these most frequently occur on horizontal sur-
faces

Curvilinear Consisting of curved lines; a graphic or design in which curved
lines predominate

Desert varnish A dark patination that occurs on rock outcrops in the Ameri-
can Southwest; in regard to rock art it reveals a variation in color density
according to the relative age of the graphics; some rock outcrops in Mis-
souri also retain a dark cortex from chemical reactions with the atmos-
phere

Design Arrangement or composition of elements or graphics

Dolomite A semitransparent sedimentary crystalline mineral consisting of
double carbonates of calcium and magnesium (Nelson 1985:181)

Element Refers to simple, possibly irreducible, self-contained, symbolic, geo-
metric, and/or abstract unit

Engrave To carve into by incising upon stone (wood, metal, or other mate-
rial)

Entoptic Refers to phenomena produced by taking hallucinogens in which
designs, figures, lights, and/or colors appear in the visual field; can occur

also as the result of sensory deprivation, head injury, fasting, exhaustion, or overexertion

Etch To produce designs on metal, glass, shell, or other material by means of a corrosive chemical; this term is ordinarily not applicable to rock art and is often misused (Lee A. Parsons, personal communication, January 1988)

Exfoliation The flaking or spalling of the rock cortex, usually as a result of weathering

Figure type "The specific form and characteristic mode of expression of any given element" or motif, such as variations in anthropomorphic depictions (quote is from Schaafsma 1985:247)

Form Refers to shape or configuration

Freeform A graphic or design that does not resemble any object in the natural world and that is usually asymmetrical, sometimes referred to as an "abstract" form

Gens, gentes (pl.) A kin group, unilinear and exogamous, usually a patrilineal clan (after Winick 1970:229)

Geographical Information System (GIS) A computer system for working with information that is identified by location and can be used for plotting rock art or other archaeological sites. GIS is used for assembling, storing, and displaying the geographically referenced data.

Geometric "[U]tilizing rectilinear or simple curvilinear motifs or outlines in design . . . of or relating to art based on simple geometric shapes (as straight lines, circles, or squares)" (Merriam Webster's Collegiate Dictionary, 10th ed., 1994)

Glyph Term used by some researchers for a single graphic, element, or motif

Graphics Lines, motifs, designs, letters, or a combination of any of these; according to Webster's, "formed by writing, drawing, or engraving," a picture used for illustration or demonstration

Groove A cut (or to cut) into a rock surface with a sharp or abrasive tool

Icon Emblem, symbol

Iconography The traditional or conventional images or symbols associated with a subject, especially a religious or legendary subject; the imagery or symbolism in a work of art, an artist's work, or a body of art

Iconology The study of images or icons in terms of their symbolic meaning

Incise To engrave or cut into a surface with a sharp tool to achieve a fine line

Intaglio A carving or abraded area in which the figure is depressed below the surface of the stone

Manner Characteristic or customary way of doing something or presenting something

Mnemonic device Element, motif, or design theme intended to assist the

memory in relating stories, in carrying encoded messages, or in performing ritual activities

Mode A form of expression or preferred way of carving, painting, or doing something; fashion

Monochrome Of a single color

Motif Broadly recurring and definable depictions of known objects; signifies a major theme, figure, element, or design used repeatedly (Schaafsma 1971:3); the dominant feature, or idea, in a composition or design (Levy 1961)

Myth A legendary, fictitious, or imaginary story that has developed within a group to explain a natural event, a character's adventures, or how a dilemma was solved. Because the term *myth* connotes "unreal," most Native American groups prefer to use the term *oral tradition*. However, the term *myth* is often used interchangeably with the term *oral tradition*.

Naturalistic True to nature, recognizable as representing something in nature (see Figure A-1)

Norms of graphic response The use of certain elements, designs, geometric forms, etc. within particular situations of graphic expression that are evident in widely diverse areas of the world and whose production is not attributable to contact but rather to constraints of the media or to normative outside influences

Oral tradition A culture's stories (origin, hero, etc.) that are handed down, by the spoken word, from generation to generation; oral traditions are handed down as fact rather than as myth

Painted petroglyph A petroglyph that had at least the carved depressions filled with pigment (few of these have survived in the eastern United States)

Panel A grouping of motifs connected through placement and structure, and visibly apart from adjacent groupings

Parietal Relating to rock art, those that are located on standing, stationary walls

Patina In regard to rock art, a mineral deposit of iron and sometimes manganese oxides that results in a thin cortex, usually darker than the matrix of the rock

Pecking Method of direct percussion on the rock with a chisel point that results in observable texture; may be used to create or to remove areas of a design

Phosphenes Lights, colors, abstract designs that can occur on the visual field from a variety of stimuli including pressure to the eyes, a blow to the head, or hallucinogenic drugs

Petroglyph A graphic, design, motif, or inscription carved into a rock wall or surface

Pictograph A drawing or painting on a rock wall or surface (Note: there is no separate term for a painted petroglyph)

Pit and groove A ground or abraded circular depression, connected to a ground or abraded groove extending out from the depression; these designs are often referred to as phallic motifs or symbols

Quadruped Four-legged animal form; term is usually employed when the form is unidentifiable as to genus or species, or used to encompass all four-legged animal forms

Realistic Graphic representation of someone or something without idealization; truthfulness to nature (but not necessarily with attention to minute details) (see Figure A-1)

Rectilinear Consisting of predominantly straight lines; a graphic or design in which straight and angular lines and/or forms are dominant

Representational Depicting, so far as possible, the physical appearance of an object, animal, or person; sometimes interchanged with the word *stylized* (see Figure A-1)

Rock art A popular term (misnomer) used to describe any type of rock graphics, usually petroglyphs and pictographs, whether or not they represent art in a technical sense (i.e., produced for the purpose of aesthetic satisfaction or fulfillment)

Rock graphic Any drawing, painting, carving, or marking done by human beings on a rock surface

Schematic A body of information formed into or reduced to a diagram, but still conveying its original meaning (see Figure A-1)

Scratching A method of incising rock with a sharp object that results in a thin and often observably repeated line, less precise than either engraving or incising

Scutiform "Symbols with more or less straight lines, approaching the form of a rectangle or checkerboard pattern" (Giedion 1962:253)

Shaman A term (orig. Siberia) of convenience, commonly used to refer to a holy person, a priest, cacique, or medicine man/woman. One who acts as a mediary between the spirit world and this or the earthly world; person who is trained/skilled in summoning spirits, healing the sick, predicting events, protecting the people in his/her group.

Sib A relative; blood relation; or "a group of persons unilaterally descended from a real or supposed ancestor" (Webster's)

Sign "A mark having a conventional meaning and used in place of words or to represent a complex notion" (Webster's)

Figure A-1. Examples of styles of rendering (or depicting animals, objects, things, etc.). *Left to right,* naturalistic/realistic; representational/stylized/schematic; abstract.

Structure Arrangement of parts or manner in which items are grouped or organized; pattern; composition

Style A characteristic manner of expression in an evolutionary context, a means of describing forms that do not have detectable adaptive values (Fagan 1985:591); exhibiting a particular, describable form or design, often used as a means of measuring change, identity, ownership, etc.

Stylized A form, often a natural form, that has been changed, usually simplified, without losing its identity (see Figure A-1)

Symbol "Some thing or act that stands for, or suggests something else by reason of relationship, association, convention, or accidental resemblance; esp: a visible sign of something invisible" (Webster's; Child and Colles 1971:xvii), e.g., the Christian cross. The meaning of a symbol is encoded and must be learned.

Symbolic The expression of an abstract idea in terms of lines, form, color, etc.; characterized by symbols

Symbology A system of symbols, the study or interpretation of symbols

Tectiforms Abstract forms with "more or less straight lines. The name tectiform may have had its origin in Font de Gaume's hut or house-like symbols" (Giedion 1962:254).

Theme Design or design groupings that contain recognizable topics such as fertility or hunting

Therianthropic 1. "Being partly bestial and partly human in form"; 2. "Of or pertaining to deities conceived or represented in such form" (Random House Dictionary of the English Language, 2d ed., 1987)

Totemism Belief in kinship or a mystical relationship with or between a group or an individual and an object, animal, or plant that serves as its symbol. "It is primarily a specialized form and example of story-telling and symbol use, used between groups and sections of one culture to maintain and explain certain evolved and storied relations in the group, among the groups, and between these groups and the environment. Where 'totemism'

does not exist, other forms of storytelling and symbol use serve the same basic purposes" (Marshack 1972:340).

Type To designate a formal name to a group of similar artifacts in order to classify them

Typology Study of the shape or form of any artifact or group of artifacts in order to (1) classify them and (2) enable comparative studies

Unit A single element or self-contained mark or simple irreducible design; a synonym for element

Zoomorphic Having animal form or animal attributes, ascribing animal characteristics to human beings or things

Appendix B:
Frank P. Magre and His Research

Frank P. Magre was born in Crystal City, Missouri, in 1906. He was raised and educated in his hometown and married his childhood sweetheart, Helen Lotz, there in 1927. Frank and Helen had two children, a daughter, Marianne (1941), and a son, Jean Andre (1946), and two grandsons (Nathaniel 1972 and Joel 1978). Frank served as a merchant seaman from 1942 to 1944 with the Merchant Marines. Later he served as a major in the armed services in the Army Transport Service. His tour of duty included Costa Rica, Havana, Aruba, Panama Canal, and British Honduras. Before and after active duty he served in the National Guard and worked for the Pittsburgh Plate Glass Company in Crystal City. He retired from the Pittsburgh Plate Glass Company in 1969 with forty-one and a half years of continuous service.

From 1932 to 1942 Frank was active in the Boy Scouts and served as scoutmaster for Troop #425 sponsored by the Lion's Club in Crystal City. Frank was an avid hiker. While hiking by himself and with his scouts he began noticing surface artifacts and thus became interested in archaeology. Along with frequent surface finds of artifacts, he would also encounter occasional rock art. He began making notes of his discoveries, recording his finds, and visiting local farmers to study their collections. He also began putting out the word that he was looking for rock art anywhere in the eastern Missouri–western Illinois area, and over the years many people gave him leads to sites.

He rapidly earned the reputation of local expert on the prehistory and history of Jefferson and Washington counties, particularly the Festus/Herculaneum/Crystal City area and its surroundings. In the late 1930s he was contacted by Robert McCormick Adams, who approached Frank for information on the archaeology of Jefferson County. Adams was preparing a Works Progress Administration grant proposal to survey sites in that county and a few others. Adams, his wife Betty, and Frank went on numerous surveys and archaeological digs in the late 1930s and early 1940s; Betty wrote up most of the site reports.

They continued to survey sites and published two reports (1939, on Jefferson County, and 1941, on Ste. Genevieve County) in *The Missouri Archaeolo-*

gist. They also surveyed St. Francois County. In 1942 Frank collaborated with Eugene Diesing to publish another report in *The Missouri Archaeologist,* "Petroglyphs and Pictographs in Missouri." He assisted in the research for many other books including *Historic Sites of Jefferson County, Missouri* by Eschbach and Drummond (1968) and *Moses Austin* by David B. Gracy (1987).

It was Frank's survey work with Adams that focused his attention on rock art research. This interest continued for more than four decades and resulted in the creation of some 200 pages of notes, drawings, and photographs spanning a three-county region. Frank's training in architectural drafting at Washington University and other institutions served him well in his renderings of prehistoric rock carvings and paintings. It is through his early drawings that we have been able to relocate now faint or vandalized rock art. Some of his drawings, in fact, are the only remaining records for a selection of sites that have been destroyed through major quarrying operations or construction.

Frank Magre's contribution to the recording and preservation of rock art in Missouri is exceptional. In 1967, Campbell Grant, of California, published the first overview of North American rock art (later reprinted in 1981), titled *Rock Art of the American Indian.* In 1979, Klaus F. Wellmann, a New York medical researcher, published *A Survey of North American Indian Rock Art.* Missouri rock art is well represented in both books, which reference Frank and his materials as the main bibliographic source for the state. He is also referenced in many other publications concerning the history of Missouri, Jefferson County in particular, and the historic figures and events in these areas.

Frank was an active member of the Mound City Archaeological Society (former vice president) and a charter member (since 1938) and trustee of the Missouri Archaeological Society. He was named Community Man of the Year in 1968, was appointed that same year to the Jefferson County Parks Commission, and recently served on the board of directors (vice president) of the Jefferson County Heritage and Landmarks Corporation. In 1980, Frank was appointed to the advisory committee of the Jefferson County History Center by the Board of Trustees.

In the spring of 1991, Frank was given the Pioneer Award by the American Rock Art Research Association in San Miguel, California, for his four decades of research to record and save the rock art of Missouri. At the spring 1992 meeting of the Missouri Archaeological Society, Frank was presented that organization's Lifetime Achievement Award for his efforts in preserving the past in Missouri. At the spring 1993 meeting of the Missouri Association of Professional Archaeologists, the Board of Directors awarded Frank the Chapmans' Award for his half century of assistance to the professional ar-

chaeological community. In 1993, the city of DeSoto, Missouri, named September 26 as "Frank Peter Magre Day" and held a moving celebration.

I originally met Frank about twenty years ago at meetings of the Mound City Archaeological Society (the local Missouri Archaeological Society affiliate chapter). It was not until 1987 that I contacted Frank on the urging of Leonard Blake, a mutual friend, with my request for information on Missouri rock art. He was excited at the prospect of his data being used as a basis for my doctoral dissertation and we discussed expanding Missouri's rock art site inventory with additional field surveys. We began making trips to sites with which he was familiar as well as new sites from leads that we were able to obtain. Frank's ease and familiarity with people in southeast Missouri greatly aided the task of obtaining access to sites. We continued to visit, and revisit, sites for the next five years. In that collaboration, I came to greatly admire and respect Frank for both his knowledge and his willingness to help others by sharing information. In 1994, together we attended our first International Rock Art Congress.

Despite his age, Frank was one of the most active and energetic persons I have ever known. In the winters of 1995 and 1996 Frank suffered with bouts of pneumonia that left him physically weakened. He moved from his house overlooking the Mississippi River to a retirement center nearby. Frank took his daily walks, and with the kind assistance of his friend William Reich continued attending meetings and visiting friends, and he even continued to explore some sites. Everyone was expecting Frank to recover, but on September 24, 1997, at age 90, he died.

Appendix C:
Motif Distribution by Site

1. BIRDS, "THUNDERBIRDS"

PETROGLYPH
Boynton
Bushnell Ceremonial Cave
Cedar Hollow Ledge
Commerce Eagle
Corisande Beach
Ditch Creek
Herculaneum Landing
Hidden Valley Shelter
Jakes Prairie
Lohraff
Maddin Creek
Mitchell
Noix Creek
Peene-Murat
Rocky Hollow
Sharpsburg
Striler Lake
Thousand Hills State Park
Three Hills Creek
Washington State Park Site A

PICTOGRAPH

Champion Eagle
Willenberg Shelter

2. QUADRUPEDS

PETROGLYPH
Gil Branch
Maddin Creek
Riviera
Rocky Hollow

PICTOGRAPH
Deer Run Shelter
Katy Trail
Lost Creek
Loutre

Thousand Hills State Park Painted Rocks
Washington State Park Site A Paydown Deer
Washington State Park Site B Picture
 Sugar Creek
 Steinbach Shelter
 White Rock Bluff
 Willenberg Shelter

3. LONG-TAILED, CURLED-TAIL QUADRUPEDS

PETROGLYPH PICTOGRAPH
Thousand Hills State Park Deer Run Shelter
Washington State Park Site A

4. SNAKES, COILED SNAKES, SPIRALS

PETROGLYPH PICTOGRAPH
Bushberg-Meissner Groeper Shelter
Commerce Eagle Rattlesnake Bluff
Lambert
Maddin Creek
Peene-Murat
Riviera
Rocky Hollow
Thousand Hills State Park
Three Hills
Wallen Creek
Washington State Park Site A

5. TURTLES, OTHER REPTILES, FISH

PETROGLYPH PICTOGRAPH
Dry Fork Creek Shelter (turtle) Lost Creek (fish), historic
Maddin Creek (turtle) Picture Cave (frog)
Reed's Cave (turtle)
Rocky Hollow #1 (turtle)
Rocky Hollow #2 (fish)
Sharpsburg (lizard)
Stockton Lake (turtle)
Thousand Hills State Park (lizard)
Washington State Park (turtle)

6. BIRD TRACKS, ANIMAL TRACKS, "PELTS"

PETROGLYPH	PICTOGRAPH

Bird Tracks
Bushberg-Meissner None
Bushnell Ceremonial Cave
Cedar Hollow Ledge
Maddin Creek
Mitchell
Peene-Murat
Riviera
Rocky Hollow
Scaggs
Sharpsburg
Shirley
Thousand Hills State Park
Three Hills
Tobin-Reed
Washington State Park Site A
Washington State Park Site B
Whitelock School

Animal Tracks
Hidden Valley Shelter (bear)
Peene-Murat (rabbit)
Washington State Park Site A
 (rabbit, deer?)

Pelts

Katy Trail
Picture Cave #1

7. ANTHROPOMORPHS

PETROGLYPH	PICTOGRAPH
Bushberg	Big Moniteau
Cedar Hollow Ledge	First Creek #1
Devil's Slide Cave	First Creek #2
Lohraff	Picture Cave
Maddin Creek	Rattlesnake Bluff
Miller's Cave	Salt River
Mitchell	Sugar Creek

Moccasin Spring

Peene-Murat
Reeve's Cave
Reifer
Rocky Hollow
Sharpsburg
Thousand Hills State Park
Three Hills Creek
Wallen Creek
Washington State Park Site A
Washington State Park Site B

Torbett Spring–
 Rocheport
White Rock Bluff

8. FOOT, FEET, OR MOCCASINS

PETROGLYPH

Foot/Feet
Anheuser
Bushberg
Bushnell Ceremonial Cave (removed)
Cedar Hollow Ledge
Ellis
Four Mile Ridge
Herrell
Indian Foot Lake
Maddin Creek
Riviera
Reifer
St. Louis Riverfront
Shirley
Tobin-Reed
Tuskie Station
Wallen Creek
Washington State Park Site A
Washington State Park Site B
Winkle

Moccasins
Moccasin Rock
Plattin Creek
Shot Tower Bluff

PICTOGRAPH

None

9. HANDS, ARMS, EYES (OGEES)

PETROGLYPH	PICTOGRAPH
Hands	
Dogwood	Miller's Cave ("prints")
Ring Creek	
Rocky Hollow (emphasized)	
Schneider	
Three Hills Creek (including hands with "handles")	
Washington State Park Site A (skeletal)	
Arms	
Peene-Murat	Picture Cave
Maddin Creek	White Rock Bluff
Eyes/Ogees	
Commerce Eagle	
Peene-Murat	
Three Hills Creek	

10. PHALLIC/VULVAR, COMBINED, PUERPERAL, ORGANIC MOTIFS

PETROGLYPH	PICTOGRAPH
Phallic Motifs	
Bushberg-Meissner	None (in motif form)
Bushnell Ceremonial Cave	
Maddin Creek	
Riviera	
Sharpsburg	
Tesson Ferry	
Three Hills Creek	
Tobin-Reed	
Wallen Creek	
Washington State Park Site A	
Vulvar Motifs	
Miller's Cave	None (in motif form)
Mount Zion Church	

Scaggs
Shoal Creek
Washington State Park Site A

Puerperal Motifs
Maddin Creek None (in motif form)
Three Hills Creek
Washington State Park Site A

Organic Motifs
Washington State Park Site A

11. ARROWS/SHAFTS/SPEARS, BOWS AND ARROWS, POINTS

PETROGLYPH PICTOGRAPH

Arrows/Shafts
Kelso Farm Picture Cave
Mount Zion Church White Rock Bluff

Bows and Arrows
Kelso Farm Picture Cave
Maddin Creek Willenberg Shelter
Rocky Hollow #2

Bilobed Arrows
Bushberg-Meissner Lost Creek
Maddin Creek
Three Hills Creek
Washington State Park Site B

Points
Maddin Creek
Moccasin Spring
Ring Creek

12. AXES, MACES, ATLATLS, BANNERSTONES, SHIELDS

PETROGLYPH PICTOGRAPH

Axes
Maddin Creek Picture
Reifer

Maces
Anheuser (handled foot?) Picture Cave (held)
Donnell Rattlesnake Bluff
Maddin Creek Willenberg Shelter (held)
Washington State Park Site B
 (handled foot?)

Atlatls, Bannerstones
Moccasin Spring (bannerstone) Deer Run Shelter
 (bannerstone)
 White Rock Bluff

Shields
None Rattlesnake Bluff (held)

13. CIRCLES, JOINED CIRCLES, CONCENTRIC CIRCLES

PETROGLYPH PICTOGRAPH

Circles
Bushberg-Meissner Gourd Creek
Cedar Hollow Ledge Picture Cave
Lambert Salt River
Maddin Creek Steusse Shelter
Maze Creek Torbett Spring–
 Rocheport
Plattin Creek White Rock Bluff
Reifer
Tesson Ferry
Thousand Hills State Park
Three Hills Creek (joined)
Winkle

Concentric
Anheuser Deer Run Shelter
Bushnell Ceremonial Cave Frumet
Cedar Hollow Ledge White Rock Bluff
Church
Plattin Creek
Schneider (within square)
Tobin-Reed
Winkle

14. CIRCLES: QUARTERED,
RAYED, RAYED/QUARTERED

PETROGLYPH **PICTOGRAPH**

Quartered
Bushnell Ceremonial Cave First Creek #1
Cedar Hollow Ledge Torbett Spring–
 Rocheport
Three Hills Creek Willenberg Shelter

Rayed
Peene-Murat Sugar Creek
Sharpsburg White Rock Bluff

Rayed/Quartered
Three Hills Creek None

15. SQUARES: SINGLE, JOINED,
APPENDED, ASSOCIATED

PETROGLYPH **PICTOGRAPH**
Cedar Hollow Ledge Deer Run Shelter
Commerce Eagle Rattlesnake Bluff
Farris Farm Willenberg Shelter
Maddin Creek
Mutton Creek
Three Hills Creek
Washington State Park Site A
Washington State Park Site C

Concentric
Schneider (with concentric circles First Creek #1
 inside)

Joined
Maddin Creek None
Riviera
Three Hills Creek
Washington State Park Site A

Bisected
Mutton Creek First Creek #1
 Picture Cave

Diagonally Crossed

Fort Hill	Deer Run Shelter
Persimmon Glade	

16. EQUILATERAL CROSS, SPINNING CROSS

PETROGLYPH	PICTOGRAPH
Equilateral	
Bushberg-Meissner	Deer Run Shelter
Church	
Spinning	
Bushberg-Meissner	None
Moccasin Spring	
Spinning Cross-in-Circle	
None	Lost Creek
	Torbett Spring–
	Rocheport

17. RAKED LINES, ZIGZAG LINES

PETROGLYPH	PICTOGRAPH
Raked	
None	First Creek #1
	Picture Cave
Single zigzag	
Tobin	Deer Run Shelter
	Picture Cave
Double zigzag	
None	Deer Run Shelter
	First Creek #1
	Mike's Shelter

18. MOTIFS SUGGESTING CELESTIAL PHENOMENA

PETROGLYPH	PICTOGRAPH
Star	
Washington State Park Site A	Deer Run Shelter
	First Creek #1

Crescent
Riviera Torbett Spring–Rocheport
Rocky Hollow #1
Thousand Hills State Park

Star-Crescent
Mount Zion Church Willenberg Shelter
Peene-Murat
Washington State Park Site A

Star Patterns
Tobin-Reed (**W**) Fort Hill (**W**)
 Lost Creek Shelter

Sun
Sharpsburg (painted petroglyph) Lost Creek

Notes

CHAPTER 2. BACKGROUND

1. The painted mural was replaced by a painted thirty-nine-foot *steel* mural that was taken down several years ago. In 1998, a Piasa of similar design and size (forty-eight by twenty-two feet) was painted at a new location on the Alton bluffs.

2. Although the Missouri and Osage are referred to in the literature as "tribes," the term *tribe* is used here and in a few places throughout (including within quoted material), to indicate a major Native American group. Its use is not meant to open the considerable anthropological debate on what does and does not constitute a "tribe." In addition, some Native American groups prefer the title "Confederacy" or "Nation."

CHAPTER 3. THE NATURAL ENVIRONMENT

1. The "Big Five" is the name Diaz-Granados gave to the major sites in an area of particularly heavy concentration along or near the Big River. They include Washington State Park sites A and B, Maddin Creek site, Three Hills Creek site, and Wallen Creek site. These are discussed in detail in Chapter 5.

CHAPTER 4. METHODS

1. Night photography, using electronic flash, is highly recommended and discussed by Wainwright and Taylor (1990a).

CHAPTER 5. ANALYSES OF MISSOURI'S ROCK ART

1. Schaafsma uses the term *element,* which we take to mean the smallest irreducible component in a graphic such as a dot or line, whereas the Missouri inventory is made up of both motifs and elements.

2. Nodelman (1970:83) comments in regard to structural analysis that "the result of such an analysis, radically purified of distorting elements, and shaped solely in terms of the internal structure and dynamics of the work itself, aspires to an objective validity which would hold, as Levi-Strauss says, 'for any possible observer.'"

3. Groenfeldt (1985:23), in discussing style analysis, states, "'Style' as used here refers simply to the *manner* of depicting something rather than to what is being depicted."

4. Repainted in the 1960s, with some liberties, by locals. Red pigments used.

5. The Northeast style grouping may be related to Native American groups referenced in documents and indicated in the northeast section of the map in Figure 6.1. The Northeast style petroglyphs that include Rocky Hollow, Mitchell, and Sharpsburg occur in a general area that encompasses a locality referred to by William Clark in a letter (cited by Bushnell 1914b) in which Clark describes the northeast quadrant of Missouri and its inhabitants:

> Bordering on the eastern shore of the Mississippi, and extending from a point about opposite the mouth of the Missouri on the north, to the Kaskaskia on the south, is a rich alluvial plain, often designated by the name "American Bottom." This is bounded by a line of bluffs which touches the river at the north and south. When first visited by the French this area was claimed and occupied by the Illinois Indians. At the north, some 20 miles below the mouth of the Missouri, were the villages of the Cahokia and Tamaroa. Later, during the year 1703, the Kaskaskia moved southward from the Illinois River, and reared their wigwams near the mouth of the stream now bearing their name. These settlements were often mentioned by the early writers, but no account is to be found of villages on the opposite or right bank of the Mississippi between these points.

Clark described the border to the west, by a line drawn due north from the mouth of the Gasconade, as being the territory formerly occupied by the Michigamea, members of the Illini group that were Algonkian speakers. Snow (1977:47) refers to a site attributed to Algonkian speakers in Maine in phrases that could describe the Rocky Hollow figure: "One figure has an enlarged left hand with fingers splayed, a specific symbol of shamans in Algonkian cultures. The same gesture was common on some historic Ojibwa birchbark scrolls."

6. See Giedion (1962:10–44) for a discussion on theories regarding the use of abstract graphics.

7. This shelter and the area surrounding it were covered with crushed limestone to a depth of approximately eighty feet by the Martin-Marrietta Company of Ohio in the early 1980s during quarrying operations through limestone to reach the St. Peter sandstone used for glass manufacture. Local residents, led by Larry Wegmann, were unsuccessful in their fight to save the Hidden Valley Shelters and their associated archaeological sites. Archaeological excavations at these sites were carried out by Robert McCormick Adams in 1940, assisted by Frank Magre.

8. The Shell society was a secret society of the Omaha that practiced "magic" and "healing" (Fletcher and La Flesche 1992:509).

CHAPTER 6. INTERPRETATION

1. The term *busk* comes from the Creek and is a contraction of their word for their harvest festival or Green Corn ceremony, *puskita* (Spence 1989:133–34).

2. The horse was introduced in the mid-1600s in Missouri.

3. Cottier (1977) reports radiocarbon dates ranging from 1155 to 1450 (not corrected), with a median date of A.D. 1226, for the Lilbourn site (23NM38).

4. In 1996, Salzer obtained a date of A.D. 1060 for the shelter's "E zone," the area from which the sandstone head was excavated (Salzer 1999:20).

5. Hall (1989:251) makes a comparison to human lungs. Virgil Hayes, a Missouri artist, also recognizes the outline or pattern of lungs in several styles of bannerstones that when in place on an atlatl can be compared with the configuration of the bilobed arrow motif (Hayes, personal communication, April 1993).

6. According to Whelan (1990:55), who discusses the Sioux in the western Great Lakes region, "the word 'Sioux' is believed to be a French corruption of the Algonkian word 'Nadoweisiw,' which means snake, adder, or enemy (Hodge 1912[2]:577). The word is considered offensive by some present-day Indians. Rarely did the various members of this group act as a corporate body or define themselves by inclusion in such a large group. When this level of generality was needed, however, the designation they used for all of the divisions was *Oceti Sakowin,* the 'seven council fires' or 'seven fireplaces' (Hodge 1912[1]:378; Howard 1984:3; Powers 1975:3; Riggs 1893:156; but see DeMallie 1982)."

7. The Birger figurine is a large bauxite or red siltstone figurine found near Cahokia during the FAI-270 excavations. This mortuary figure depicts a woman tilling the back of a feline-headed serpent. Squashes (growing from the serpent's tail) drape the woman's back.

8. With regard to Hall's (1997:150) belief that the patterns on the chest of the anthropomorphic Gottschall figure (to the right of the large bird) are long-nosed god maskettes, the following quote from Radin (1948:129) may offer some insight. "At this time, Red Horn's first wife was pregnant and, finally, the old woman's granddaughter gave birth to a male child who was the very likeness of his father, Red Horn, having long red hair and having human heads hanging from his ears. Not long after this, the giantess also gave birth to a male child whose hair was likewise just like his father's. Instead of having human heads hanging from his ears, he had them attached to his nipples" (see Salzer 1987:446).

9. La Flesche (1925:73) discusses the shaft of sunlight being represented by a downy plume and also symbolizing the life of a warrior. Another reference to a "white plume" is made by the Osage during their naming ceremony in which they refer to the "plume-like shaft of light" associated with the sun as it appears over the horizon (Revard 1987:449). These are yet other possible correlations between the Red Horn character and the figure at Picture Cave #1 (i.e., Red Horn=Sun [or morning star]=white plume).

Bibliography

Abramova, Z. A.
 1967 Palaeolithic Art in the U.S.S.R. In *Arctic Anthropology*, vol. 4, edited by Chester S. Chard, 1–179. Moscow-Leningrad: Akademiia Nauk SSSR.

Adam, Leonhard
 1940 *Primitive Art*. Baltimore: Penguin Books.

Adams, Robert McCormick
 1941 Archaeological Investigations in Jefferson County, Missouri, 1939–1940. *Transactions of the Academy of Sciences of St. Louis* 30:5.

Adams, Robert McCormick, and Frank Magre
 1939 Archaeological Surface Survey of Jefferson Co., Mo. *Missouri Archaeologist* 5(2): 11–23.

Adams, Robert McCormick, Frank Magre, and Paul Munger
 1941 Archaeological Surface Survey of Ste. Genevieve Co., Mo. *Missouri Archaeologist* 7(1): 9–23.

Ahler, Steven R., David L. Asch, Dawn E. Harn, Bonnie W. Styles, Karli White, Carol Diaz-Granados, and David Ryckman
 1999 *National Register Eligibility Assessments of Seven Prehistoric Archaeological Sites at Fort Leonard Wood, Missouri*. Illinois State Museum Society Quaternary Studies Program Technical Report 98-1202-28, Springfield.

Ahler, Steven R., Mary J. Bade, Frances B. King, Bonnie W. Styles, and Paula J. Thorson
 1992 *Late Archaic Components at Modoc Rock Shelter, Randolph County, Illinois*. Illinois State Museum Reports of Investigations 48, Illinois State Museum, Springfield.

Althusser, Louis
 1971 Ideology and Ideological State Apparatuses. In *Lenin and Philosophy, and Other Essays*, pp. 123–73. London: New Left Books.

Amsden, Charles
 1936 *An Analysis of Hohokam Pottery Design*. Privately printed for the Medallion Papers, no. 23, Gila Pueblo, Globe, Arizona.

Anati, Emmanuel
 1984 Abstract of Keynote Address, International Conference on Prehistoric Rock Art and Archaeoastronomy. October 7–12, University of Arkansas, Little Rock.

Anati, Emmanuel, Ian Wainwright, and Doris Lundy
 1984 Rock Art Recording and Conservation: A Call for International Effort.
 Review. Symposium, Eleventh International Congress of Anthropologi-
 cal and Ethnological Sciences, Vancouver, August 15–19, 1983. *Current
 Anthropology* 25(2): 216–17.
Anderson, Kenneth H.
 1979 *Geologic Map of Missouri.* Missouri Geological Survey, Missouri Depart-
 ment of Natural Resources, Rolla.
Anderson, Paul
 1965 *The Reptiles of Missouri.* Columbia: University of Missouri Press.
Anderson, Richard L.
 1990 *Calliope's Sisters: A Comparative Study of Philosophies of Art.* Englewood
 Cliffs, New Jersey: Prentice Hall.
 1992 Do Other Cultures Have "Art"? [Commentary]. *American Anthropologist*
 94(4): 926–28.
Arndt, Karl J. R., ed.
 1975 *A Documentary History of the Indiana Decade of the Harmony Society,
 1814–1819,* vol. 1. Indianapolis: Indiana Historical Society.
 1978 *A Documentary History of the Indiana Decade of the Harmony Society,
 1820–1824,* vol. 2. Indianapolis: Indiana Historical Society.
Arnheim, Rudolf
 1954 *Art and Visual Perception: A Psychology of the Creative Eye.* Los Angeles:
 University of California Press.
 1966 *Toward a Psychology of Art.* Los Angeles: University of California Press.
 1969 *Visual Thinking.* Los Angeles: University of California Press.
Arnold, Dean E.
 1983 Design Structure and Community Organization in Quinua, Peru. In
 Structure and Cognition in Art, edited by Dorothy K. Washburn, 56–73.
 Cambridge: Cambridge University Press.
Atwood, W. W.
 1940 *The Physiographic Provinces of North America.* Boston: Ginn.
Aveni, Anthony F.
 1975 *Archaeoastronomy in Pre-Columbian America.* Austin: University of Texas
 Press.
 1977 *Native American Astronomy.* Austin: University of Texas Press.
Aveni, Anthony F., Horst Hartung, and Beth Buckingham
 1978 The Pecked Cross Symbol in Ancient Mesoamerica. *Science* 202(4365):
 267–79.
Bahn, Paul G., and Jean Vertut
 1988 *Images of the Ice Age.* New York: Facts on File.
Bailey, Garrick A.
 1995 *The Osage and the Invisible World: From the Works of Francis LaFlesche.*
 Norman: University of Oklahoma.

Bain, J. G.

 1975 *Techniques and Procedures for Rock Art Recording.* Center for Anthropological Study, Monograph 3, Las Cruces, New Mexico.

Bancroft-Hunt, Norman

 1989 *People of the Totem: The Indians of the Pacific Northwest.* New York: Peter Bedrick Books.

Bancroft-Hunt, Norman, and Werner Forman

 1992 *The Indians of the Great Plains.* Norman, University of Oklahoma Press.

Bard, James C.

 1979 *The Development of a Patination Dating Technique for Great Basin Petroglyphs Utilizing Neutron Activation and X-Ray Fluorescence Analysis.* Ph.D. diss., Department of Anthropology, University of California, Berkeley.

Bard, J. C., F. Asaro, and R. F. Heizer

 1978 Perspectives on the Dating of Prehistoric Great Basin Petroglyphs by Neutron Activation Analysis. *Archaeometry* 20(1): 85–88.

Bard, J. C., and C. I. Busby

 1974 *The Manufacture of a Petroglyph: A Replicative Experiment.* Contributions of the Archaeological Research Facility 20, edited by C. W. Clewlow, Jr., 83–102. Berkeley.

Bareis, Charles J., and William M. Gardner

 Three Long-Nosed God Masks from Western Illinois. *American Antiquity* 33(4): 495–98.

Bednarik, Robert G.

 1988 The Chalking of Petroglyphs: A Response. *La Pintura* (American Rock Art Research Association Newsletter, San Miguel, California) 15(2-3): 12–13.

 1991 Dating Eons with Cations. *La Pintura* (American Rock Art Research Association Newsletter, San Miguel, California) 17(3): 8–9.

Benn, David W.

 1989 Hawk, Serpents, and Bird-Man: Emergence of the Oneota Mode of Production. *Plains Anthropologist* 34(125): 223–60.

Beschel, Ronald

 1961 Dating Rock Surfaces by Lichen Growth and its Application to Glaciology and Physiography (Lichenometry). In *Geology of the Arctic,* vol. 2, edited by G. O. Raasch, 1044–62. Toronto: University of Toronto Press.

Biddle, Nicholas, ed.

 1962 *The Journals of the Expedition under the Command of Capts. Lewis and Clark.* New York: Heritage Press.

Biebuyck, Daniel P., ed.

 1969 *Tradition and Creativity in Tribal Art.* Berkeley and Los Angeles, University of California Press.

Binford, Lewis R.

 1962 Archaeology as Anthropology. *American Antiquity* 28(2): 217–25.

 1973 Interassemblage Variability: The Mousterian and the "Functional" Argu-

ment. In *The Explanation of Culture Change,* edited by Colin Renfrew, 227–54. London: Duckworth.

1982 The Archaeology of Place. *Journal of Anthropological Archaeology* 1:5–31.

1984a An Alyawara Day: The Stone Quarry. *Journal of Anthropological Research* 40:406–32.

1984b An Alyawara Day: Flour, Spinifex Gum and Shifting Perspectives. *Journal of Anthropological Research* 40:157–82.

1984c Butchering, Sharing, and the Archaeological Record. *Journal of Anthropological Archaeology* 3:235–57.

1986 An Alyawara Day: Making Men's Knives and Beyond. *American Antiquity* 51(3): 547–62.

Blake, Leonard W.

1942 A Hopewell-Like Site near St. Louis. *Missouri Archaeologist* 8(1): 2–7.

Blakeslee, Donald J., and Robert Blasing

1988 Indian Trails in the Central Plains. *Plains Anthropologist* 17:17–25.

Blowsnake, Sam

1920 *The Autobiography of a Winnebago Indian,* edited by Paul Radin. Berkeley: University of California Press.

1926 *Crashing Thunder: The Autobiography of an American Indian,* edited by Paul Radin. New York: D. Appleton.

Boas, Franz

1927 *Primitive Art.* Cambridge: Harvard University Press (reprinted 1955, New York: Dover).

Bock, A. J., Frank Bock, and John Crawley

1977 *American Indian Rock Art,* vol. 3. Papers presented at the Third Annual American Rock Art Research Association Symposium, Ridgecrest, California, 1976. Whittier, California: ARARA.

Bodmer, Karl

1970 *Bildatlas: Reise zu den Indianern am Oberen Missouri, 1832–1834.* Frankfurt am Main, Germany: Hermann Bender and Frankfurter Lichtpausanstalt und Druckereigesellschaft.

Borstein, Marc H.

1975 The Influence of Visual Perception on Culture. *American Anthropologist* 77(4): 774–98.

Bowers, Alfred W.

1950 *Mandan Social and Ceremonial Organization.* Chicago: University of Chicago Press.

1965 *Hidatsa Social and Ceremonial Organization.* Bureau of American Ethnology Bulletin 194, Washington, D.C.

Brandt, John C.

1977 Pictographs and Petroglyphs of the Southwest Indians. *Technology Review* 80(2): 32–39.

Brandt, John C., and Ray A. Williamson

1977 Rock Art Representations of the AD 1054 Supernova: A Progress Report. In *Native American Astronomy,* edited by A. F. Aveni, 171–77. Austin: University of Texas Press.

1979 The 1054 Supernova and Native American Rock Art. *Archaeoastronomy, Journal for the History of Astronomy* (Science History Publications, Bucks, England) 10(1, suppl.): S1–S39.

Branson, E. B.

1944 *The Geology of Missouri.* University of Missouri Studies 19, University of Missouri, Columbia.

Bray, Robert T.

1963 Southern Cult Motifs from the Utz Oneota Site, Saline County, Missouri, Incorporating Material from Iowa and Nebraska. *Missouri Archaeologist* 25:1–40.

1978 European Trade Goods from the Utz Site and the Search for Fort Orleans. *Missouri Archaeologist* 39:1–75.

Bray, Warwick

1984 Across the Darien Gap: A Colombian View of Isthmian Archaeology. In *The Archaeology of Lower Central America,* edited by Frederick W. Lange and Doris Z. Stone, 305–40. School of American Research Book. Albuquerque: University of New Mexico Press.

Brewer, Schuyler

1949 Jerico Springs Petroglyphs: Brief Report. *Missouri Archaeological Society, Newsletter* 29:2.

Broadhead, G. C.

1880 Prehistoric Evidences in Missouri, Human Footprints. In *Annual Report of the Board of Regents of the Smithsonian Institution showing operations, expenditures, and condition of the Institution for the year 1879,* pp. 357–59. Washington, D.C.: Government Printing Office.

Brody, J. J., and Rina Swentzel

1996 *To Touch the Past: The Painted Pottery of the Mimbres People.* New York: Hudson Hills Press.

Brown, James A.

1989 On Style Divisions of the Southeastern Ceremonial Complex: A Revisionist Perspective. In *The Southeastern Ceremonial Complex: Artifacts and Analysis,* edited by P. Galloway, 183–204. Lincoln: University of Nebraska Press.

1996 *The Spiro Ceremonial Center,* vol. 2. Memoirs of the Museum of Anthropology no. 29, University of Michigan, Ann Arbor.

Brown, James, and John Kelly

n.d. Cahokia and the Southeastern Ceremonial Complex. Paper, Eleventh Revised Draft. Draft given to authors by Brown and Kelly.

Brown, Joseph Epes

 1989 *The Sacred Pipe: Black Elk's Account of the Seven Rites of the Oglala Sioux* (originally published 1953). Norman: University of Oklahoma Press.

Brownlee, Richard S.

 1956 The Big Moniteau Bluff Pictographs in Boone Co., Mo. *Missouri Archaeologist* 18(4): 49–56.

Bunzel, Ruth L.

 1938 Art. In *General Anthropology,* edited by Franz Boas, pp. 535–88. Boston: D.C. Heath.

 1972 *The Pueblo Potter: A Study of Creative Imagination in Primitive Art* (originally published 1929). New York: Dover.

Burland, Cottie

 1985 *North American Indian Mythology.* New York: Peter Bedrick Books.

Burns, Louis F.

 1984 *Osage Indian Bands and Clans.* Fallbrook, California: Ciga Press.

 1989 *A History of the Osage People.* Fallbrook, California: Ciga Press.

 1994 *Symbolic and Decorative Art of the Osage People.* Fallbrook, California: Ciga Press.

Busby, C., R. Fleming, R. Hayes, and K. Nissen

 1978 The Manufacture of Petroglyphs: Additional Replicative Experiments from the Western Great Basin. In *Four Rock Art Studies,* edited by C. W. Clewlow, Jr., 89–107. Socorro, New Mexico: Ballena Press.

Bushnell, David I., Jr.

 1907 Primitive Salt-Making in the Mississippi Valley. *Man* (London) 1(13).

 1908 Primitive Salt-Making in the Mississippi Valley. *Man* (London) 2(35).

 1913 Petroglyphs Representing the Imprint of the Human Foot. *American Anthropologist* 15:8–15.

 1914a *Archaeological Investigations in Ste. Genevieve County, Missouri.* Washington, D.C.: Government Printing Office.

 1914b Archaeological Investigations in Ste. Genevieve, Missouri. *Proceedings of the U.S. National Museum* (Washington, D.C.: Government Printing Office) 46:641–68.

Butzer, Karl W.

 1980 Context in Archaeology: An Alternative Perspective. *Journal of Field Archaeology* 7:417–21.

Butzer, K. W., G. J. Fock, L. Scott, and R. Stuckenrath

 1979 Dating and Context of Rock Engravings in Southern Africa. *Science* 203:1201–14.

Byers, Douglas S.

 1962 The Restoration and Preservation of Some Objects from Etowah. *American Antiquity* 23(2): 206–16.

Capron, Louis

 1953 *The Medicine Bundles of the Florida Seminole and the Green Corn Dance.* Anthropological Papers 35, Smithsonian Institution, Bureau of American Ethnology Bulletin 151:155–210, Washington, D.C.

Catlin, George

 1844 *North American Indians* (Letters and Notes on the Manners, Customs, and Condition of the North American Indians), vols. 1 and 2. 4th ed. London: David Bogue.

 1967 *O-Kee-Pa: A Religious Ceremony and Other Customs of the Mandans,* edited by John C. Ewers. New Haven: Yale University Press.

Chaffee, Scott D., Marian Hyman, and Marvin Rowe

 1993 Direct Dating of Pictographs. *American Indian Rock Art* (American Rock Art Research Association, San Miguel, California) 19:23–30.

 1994 Radiocarbon Dating of Rock Paintings. In *New Light on Old Art: Recent Advances in Hunter-Gatherer Rock Art Research,* edited by David S. Whitley and Lawrence Loendorf, 9–12. Institute of Archaeology Monograph 36, University of California, Los Angeles.

Chang, Kwang-chih

 1986 *The Archaeology of Ancient China.* 4th ed. New Haven: Yale University Press.

Chapman, Carl H.

 1959 The Little Osage and Missouri Indian Village Sites, CA.: 1727–1777. *Missouri Archaeologist* 21(1): 1–67.

 1974 *The Origin of the Osage Indian Tribe,* vol. 4 of *Osage Indians.* New York: Garland Publishing.

 1975 *The Archaeology of Missouri,* vol. 1. Columbia: University of Missouri Press.

 1980 *The Archaeology of Missouri,* vol. 2. Columbia: University of Missouri Press.

Chapman, Carl H., and Leo O. Anderson

 1955 The Campbell Site: A Late Mississippian Town Site and Cemetery in Southeast Missouri. *Missouri Archaeologist* 17(2–3): 1–121.

Chapman, Carl H., and Eleanor F. Chapman

 1983 *Indians and Archaeology of Missouri* (revised edition, originally published 1964). Columbia: University of Missouri Press.

Chapman, Carl H., and David R. Evans

 1977 Investigations at the Lilbourn Site 1970–1971. *Missouri Archaeologist* 38:70–104.

Child, Heather, and Dorothy Colles

 1971 *Christian Symbols, Ancient and Modern.* New York: Charles Scribner's Sons.

Clark, David H., and F. Richard Stephenson
 1979 *The Historical Supernovae.* Oxford: Pergamon Press.
Clewlow, C. William, Jr., ed.
 1978 *Four Rock Art Studies.* Socorro, New Mexico: Ballena Press.
Clewlow, C. Wm., Jr., and Mary Ellen Wheeling
 1978 *Rock Art: An Introductory Recording Manual for California and the Great
 Basin.* Los Angeles: Institute of Archaeology, University of California.
Coe, Michael, Dean Snow, and Elizabeth Benson
 1989 *Atlas of Ancient America.* Oxford: Equinox Publishing.
Coggins, Clemency Chase
 1992 Review of *The Uses of Style in Archaeology,* edited by Margaret W. Conkey
 and Christine A. Hastorf. *Journal of Field Archaeology* 19(2): 232–34.
Conkey, Margaret W.
 1978 Style and Information in Cultural Evolution: Toward a Predictive Model
 for the Paleolithic. In *Social Archaeology: Beyond Subsistence and Dating,*
 edited by C. Redman et al., 61–85. New York: Academic Press.
 1990 Experimenting with Style in Archaeology: Some Historical and Theo-
 retical Issues. In *The Uses of Style in Archaeology,* edited by Margaret W.
 Conkey and Christine Hastorf, 5–17. Cambridge: Cambridge University
 Press.
Conner, Stuart W.
 1984 Petroglyphs of Ellison's Rock (24RB1019). *Archaeology in Montana*
 25:123–45.
Corner, John
 1968 *Pictographs in the Interior of British Columbia.* Vernon, British Columbia:
 Published by author.
Cottier, John
 1977 Radiocarbon Dates from Southeast Missouri, 23NM38, the Lilbourn
 Site. *Missouri Archaeologist* 38:313–14.
Cover, Del, and Elaine A. Moore
 1986 Mono Alto: A Summer Solstice Site. In *Rock Art Papers,* edited by Ken
 Hedges, 13–18. San Diego Museum Papers 3(20), San Diego Museum of
 Man, San Diego.
Coy, Fred E., Jr.
 1991a Letter to John Clegg, August 3, 1991. Copy in possession of the authors.
 1991b Letter to Robert G. Bednarick, September 4, 1991. Copy in possession
 of the authors.
Coy, Fred E., Jr., Thomas C. Fuller, Larry G. Meadows, and James L. Swauger
 1997 *Rock Art of Kentucky.* Lexington: University Press of Kentucky.
Crawley, John J.
 1981 To Chalk . . . or Not to Chalk . . . [Response]. *La Pintura* (American Rock
 Art Research Association Newsletter, San Miguel, California) 7(4): 1–14.

Cronin, Catherine

 1962 An Analysis of Pottery Design Elements, Indicating Possible Relationships between Three Decorated Types. In Chapters in the Prehistory of Eastern Arizona 1, edited by P. Martin et al. *Fieldiana: Anthropology* (Chicago) 53:105–14.

Crothers, George, Charles H. Faulkner, Jan Simek, Patty Jo Watson, P. Willey

 1998 Woodland Cave Archaeology in Eastern North America. Paper presented at the Sixtieth Annual Meeting of the Southeastern Archaeological Conference, Greenville, South Carolina, November 11–13, 1998.

Crow Dog, Leonard, and Richard Erdoes

 1996 *Crow Dog: Four Generations of Sioux Medicine Men* (originally published 1942). New York: HarperCollins.

Culin, Stewart

 1992 *Games of Skill,* vol. 2 of *Games of the North American Indians.* Lincoln: University of Nebraska Press.

Cushing, F. H.

 1941 *My Adventures in Zuni.* Santa Fe: Peripatetic Press.

Davis, Hester A., ed.

 1987 Sunburst Shelter. *Field Notes* 216(May/June): 2–4 (Arkansas Archaeological Society, Fayetteville).

Davis, Whitney

 1990 Style and History in Art. In *The Uses of Style in Archaeology,* edited by Margaret W. Conkey and Christine Hastorf, 18–31. Cambridge: Cambridge University Press.

Deetz, James

 1965 *The Dynamics of Stylistic Change in Arikara Ceramics.* University of Illinois Studies in Anthropology 4, University of Illinois Press, Urbana.

Delabarre, Edmund Burke

 1928 *Dighton Rock: A Study of the Written Rocks of New England.* New York: Walter Neale.

DeMallie, Raymond

 1982 The Sioux at the Time of European Contact. Paper delivered at the UNIC-3 Conference, Archaeology, Ecology, and Ethnohistory of the Prairie-Forest Zone of Minnesota and Manitoba, University of Minnesota.

Dewdney, Selwyn

 1979 Verbal Versus Visual Approaches to Rock Art Research. *Heritage Record* (Victoria: British Columbia Museum) 8:325–39.

Dewdney, Selwyn, and Kenneth E. Kidd

 1967 *Indian Rock Paintings of the Great Lakes.* Toronto: University of Toronto Press for the Quetico Foundation.

Diaz-Granados, Carol

 1983 Rocky Hollow Revisited. Manuscript on file with the Missouri Depart-

288 Bibliography



ment of Conservation and Missouri Department of Natural Resources, Jefferson City.

1990 Tracking the A.D. 1054 Supernova in Missouri's Petroglyphs and Pictographs. Paper presented at the Annual Joint Meeting of the Missouri Association of Professional Archaeologists and the Missouri Archaeological Society, May 5, Sedalia.

1993 *The Petroglyphs and Pictographs of Missouri: A Distributional, Stylistic, Contextual, Functional, and Temporal Analysis of the State's Rock Graphics.* Ph.D. diss., Department of Anthropology, Washington University, St. Louis.

1996 Missouri's Petroglyphs and Pictographs: Overview of a Statewide Survey and Analysis. In *Rock Art of the Eastern Woodlands: Proceedings from the Eastern States Rock Art Conference, Natural Bridge, Kentucky,* edited by Charles H. Faulkner, 81–86. Occasional Paper 2, American Rock Art Research Association, San Miguel, California.

Diesing, Eugene H.

1955 Archaeological Features in and around Washington State Park in Washington and Jefferson Counties, Missouri. *Missouri Archaeologist* 17(1): 12–24.

Diesing, Eugene H., in collaboration with Frank Magre

1942 Petroglyphs and Pictographs in Missouri. *Missouri Archaeologist* 8:9–22.

Dondis, Donis A.

1974 *A Primer of Visual Literacy.* Cambridge: MIT Press.

Dorn, Ronald I.

1990 Rock Varnish Dating of Rock Art: State of the Art Perspective. *La Pintura* (American Rock Art Research Association Newsletter, San Miguel, California) 17(2): 1–11.

1994 Dating Petroglyphs with a Three-Tier Rock Varnish Approach. In *New Light on Old Art: Recent Advances in Hunter-Gatherer Rock Art Research,* edited by David S. Whitley and Lawrence Loendorf, 13–36. Institute of Archaeology Monograph 36, University of California, Los Angeles.

Dorn, Ronald I., and David S. Whitley

1984 Chronometric and Relative Age Determination of Petroglyphs in the Western United States. *Annals of the Association of American Geographers* 74(2): 308–22.

Draper, Jill

1983 Interview with Rudolf B. Husar. *Washington University Record* (St. Louis: Washington University) 8(29): 2.

Driver, Harold E.

1969 *Indians of North America.* 2d ed. Chicago: University of Chicago Press.

Duncan, James R.

1981 *Central Missouri Prehistoric Ceramics: Types and a Proposed Local Se-*

quence. Master's thesis, Department of Anthropology, Lincoln University, Jefferson City.

Duncan, James R., and Carol Diaz-Granados

1996 Of Masks and Myths. Paper presented at the Plains Conference, Iowa City, and Southeastern Archaeological Conference, Birmingham, Alabama.

Dunnell, Robert C.

1978 Style and Function: A Fundamental Dichotomy. *American Antiquity* 43:192–202.

Eddy, John A.

1977 Archaeoastronomy in North America: Cliffs, Mounds, and Medicine Wheels. In *In Search of Ancient Astronomies,* edited by E. C. Krupp, 131–63. Garden City, New York: Doubleday.

Edmonds, Margot, and Ella E. Clark

1989 *Voices of the Wind: Native American Legends.* New York: Facts on File.

Edmunds, R. David

1976 *The Otoe-Missouria People.* Phoenix: Indian Tribal Series.

Eichenberger, J. Allen

1944 Investigations of the Marion-Ralls Archaeological Society in Northeast Missouri. *Missouri Archaeologist* 19:45–69.

Ellis, Benedict

1969 Rock Art in Missouri: A New Discovery. *Central States Archaeology Journal* 16(2): 53–58.

1971 Maddin Creek: A Southeastern Ceremonial Complex Site in Missouri. *Newsletter, Mound City Archaeological Society* 2(5): 1–2.

Ellis, Benedict, and Frank Magre

1968 The Bushberg-Meissner Petroglyph Site. Unpublished report to the Missouri State Park Board. Manuscript in possession of B. Ellis.

Emerson, Thomas E.

1989 Water Serpents, and the Underworld: An Exploration into Cahokian Symbolism. In *The Southeastern Ceremonial Complex: Artifacts and Analysis,* edited by P. Galloway, 45–92. Lincoln: University of Nebraska.

Emerson, Thomas E., and R. Barry Lewis

1991 *Cahokia and the Hinterlands: Middle Mississippian Cultures of the Midwest.* Urbana: University of Illinois Press.

Environmental Protection Agency

1980 *Acid Rain.* EPA 600/9-79-036, July 1980. Washington, D.C.: U.S. Environmental Protection Agency, Office of Research and Development.

Erickson, William K.

1951 Bowling Green Petroglyphs: Brief Report. *Missouri Archaeological Society, Newsletter* 48(August): 3.

1952 Pike County Petroglyphs: Brief Report. *Missouri Archaeological Society, Newsletter* 64(December): 3.

Eschbach, W. L., and M. C. Drummond

1968 *Historic Sites of Jefferson County, Missouri.* St. Louis: Harland, Bartholomew.

Erwin, Richard P.

1930 Indian Rock Writing in Idaho. *Idaho State Historical Society, Biennial Report* 12:1–79.

Ewers, John Canfield

1945 *Blackfeet Crafts.* Lawrence, Kansas: Haskell Institute.

Fagan, Brian M.

1985 *In the Beginning.* 5th ed. Boston: Little Brown.

1991 *Ancient North America: The Archaeology of a Continent.* London: Thames and Hudson.

Farnsworth, Kenneth B., and David L. Asch

1986 Early Woodland Chronology, Artifact Styles, and Settlement Distribution in the Lower Illinois Valley Region. In *Early Woodland Archeology,* edited by Kenneth B. Farnsworth and Thomas E. Emerson, 326–457. Center for American Archeology, Kampsville Seminars in Archeology 2, Kampsville, Illinois.

Farnsworth, Kenneth B., and Thomas E. Emerson, eds.

1986 *Early Woodland Archeology.* Center for American Archeology, Kampsville Seminars in Archeology 2, Kampsville, Illinois.

Faulkner, Charles H.

1986 [Editor] *The Prehistoric Native American Art of Mud Glyph Cave.* Knoxville: University of Tennessee Press.

1988 A Study of Seven Southeastern Glyph Caves. *North American Archaeologist* 9(3): 223–46.

1996 [Editor] *Rock Art of the Eastern Woodlands: Proceedings from the Eastern States Rock Art Conference.* Occasional Paper 2, American Rock Art Research Association, San Miguel, California.

Faulkner, Charles H., and Jan F. Simek

1996 First Unnamed Cave: A Mississippian Period Cave Art Site in East Tennessee, USA. *Antiquity* 70(270): 774–84.

Feest, Christian F.

1992 *Native Arts of North America.* New York: Thames and Hudson.

Fenneman, N. M.

1938 *Physiography of the Eastern United States.* New York: McGraw-Hill.

Ficklin, Walter H.

1894 The Pictured Rocks of Boone County, Missouri. *The Archaeologist* 2:293–4.

Firth, Raymond

1951 The Social Framework of Primitive Art. In *Elements of Social Organization,* 155–82. London: Watts.

Fischer, John L.
1971 Art Styles as Cultural Cognitive Maps. In *Art and Aesthetics in Primitive Societies,* edited by Carol Jopling, 171–92. New York: E. P. Dutton.

Fletcher, Alice C., and Francis La Flesche
1992 *The Omaha Tribe,* vols. 1 and 2 (originally published 1911). Lincoln: University of Nebraska Press.

Forge, Anthony, ed.
1973 *Primitive Art and Society.* London: Oxford University Press.

Fortier, Andrew C.
1995 The Vogt Petroglyph Complex in Monroe County, Illinois. *Illinois Archaeology* 7(142): 82–101.

Fowke, Gerard
1910 *Antiquities of Central and Eastern Missouri.* Bureau of American Ethnology Bulletin 37, Government Printing Office, Washington, D.C.

1922 *Archaeological Investigations.* Bureau of American Ethnology Bulletin 76, Government Printing Office, Washington, D.C.

Fowler, Melvin L., and Robert L. Hall
1978 Late Prehistory of the Illinois Area. In *Handbook of North American Indians,* vol. 15, edited by Bruce G. Trigger, 560–68. Washington, D.C.: Smithsonian Institution.

Francis, Julie E., Lawrence L. Loendorf, and Ronald I. Dorn
1993 AMS Radiocarbon and Cation-Ratio Dating of Rock Art in the Bighorn Basin of Wyoming and Montana. *American Antiquity* 58(4): 711–37.

Fritz, Gayle J., and Tristram R. Kidder
1993 Recent Investigations into Prehistoric Agriculture in the Lower Mississippi Valley. *Southeastern Archaeology* 12(1): 1–14.

Fritz, Gayle J., and Robert Ray
1982 Rock Art Studies in the Southern Arkansas Ozarks and Arkansas River Valley. Chapter 10 in *Arkansas Archaeology in Review,* edited by Neal L. Trubwitz and Marvin D. Jeter, 240–76. Arkansas Archaeological Survey Research Series 15, Fayetteville.

Fundaburk, Emma Lila, and Mary Douglas Foreman
1957 *Sun Circles and Human Hands: The Southeastern Indians—Art and Industry.* Luverne, Alabama: Emma Lila Fundaburk.

Galloway, Patricia, ed.
1989 *The Southeastern Ceremonial Complex: Artifacts and Analysis.* The Cottonlandia Conference. Lincoln: University of Nebraska Press.

Gardin, Jean-Claude
1980 *Archaeological Constructs: An Aspect of Theoretical Archaeology.* Cambridge: Cambridge University Press.

Gardner, Howard
1993 *Creating Minds.* New York: Basic Books.

Garvin, Gloria

 1978 Shamans and Rock Art Symbols. In *Four Rock Art Studies,* edited by
 C. W. Clewlow, Jr., 65–68. Socorro, New Mexico: Ballena Press.

Gauri, K. Lal

 1978 The Preservation of Stone. *Scientific American* 238(6): 126–37.

Giedion, Siegfried

 1962 *The Eternal Present: The Beginnings of Art, A Contribution on Constancy
 and Change.* Bollingen Series 35, vol. 6, pts. 1 and 2. Washington, D.C.:
 Pantheon Books, Trustees of the National Gallery of Art.

Gjessing, Gutorm

 1958 Petroglyphs and Pictographs in British Columbia. In *Indian Tribes of
 Aboriginal America: Selected Papers of the Twenty-Ninth International
 Congress of Americanists,* edited by Sol Tax, 66–79. Chicago: University
 of Chicago Press.

Godden, Elaine, and Jutta Malnic

 1982 *Rock Paintings of Aboriginal Australia.* Wellington, Australia: A. H. &
 A. W. Reed.

Goldstein, Lynne

 1987 The Context of the Hensler Petroglyphs and Its Implications. *Wisconsin
 Archaeologist* 68(4): 412–18.

Gombrich, E. H.

 1960 *Art and Illusion: A Study in the Psychology of Pictorial Representation.* The
 A. W. Mellon Lectures in the Fine Arts, 1956, Bollingen Series 35. Wash-
 ington, D.C.: Pantheon Books, Trustees of the National Gallery of Art.

Gracy, David B.

 1987 *Moses Austin: His Life.* San Antonio, Texas: Trinity University Press.

Grant, Campbell

 1978 *Canyon de Chelly: Its People and Rock Art.* Tucson: University of Arizona
 Press.

 1981 *Rock Art of the American Indian* (originally published 1967). New York:
 Promontory Press.

Greenhalgh, Michael, and Vincent Megaw, eds.

 1978 *Art in Society: Studies in Style, Culture, and Aesthetics.* London: Gerald
 Duckworth.

Griffin, James B.

 1946 Culture Change and Continuity in the Eastern United States. In *Man in
 Northeastern North America,* edited by F. Johnson, 37–95. Peabody Foun-
 dation, Papers of The Robert S. Peabody Foundation for Archaeology 3,
 Andover, Massachusetts.

 1952 [Editor] *Archaeology of Eastern United States.* Chicago: University of
 Chicago Press.

1967 Eastern North American Archaeology: A Summary. *Science* 156(3772): 175–91.

Groenfeldt, David

1985 The Interpretation of Prehistoric Art. *Rock Art Research* (Australian Rock Art Research Association, Melbourne) 2(1): 20–47.

Guiart, Jean

1969 The Concept of Norm in the Art of Some Oceanian Societies. In *Tradition and Creativity in Tribal Art,* edited by Daniel P. Biebuyck, 84–97. Berkeley and Los Angeles: University of California Press.

Hall, Robert

1977 An Anthropocentric Perspective for Eastern United States Prehistory. *American Antiquity* 42(4): 499–518.

1989 The Cultural Background of Mississippian Symbolism. In *The Southeastern Ceremonial Complex: Artifacts and Analysis,* edited by P. Galloway, 239–78. Lincoln: University of Nebraska Press.

1991 Cahokia Identity and Interaction Models of Cahokia Mississippian. In *Cahokia and the Hinterlands,* edited by T. Emerson and R. B. Lewis, 3–34. Urbana: University of Illinois Press.

1997 *An Archaeology of the Soul: North American Indian Belief and Ritual.* Urbana: University of Illinois Press.

Hamell, George R.

1992 The Iroquois and the World's Rim: Speculations on Color, Culture, and Contact. *American Indian Quarterly, Journal of American Indian Studies* (University of California, Berkeley) 16(4): 444–69.

1998 Long-Tail: The Panther in Huron-Wyandot and Seneca Myth, Ritual, and Material Culture. In *Icons of Power: Feline Symbolism in the Americas,* edited by Nicholas J. Saunders, 258–91. London: Routledge.

Hamilton, Henry W.

1952 The Spiro Mound. *Missouri Archaeologist* 14(October).

Hamilton, Henry W., Jean Tyree Hamilton, and Eleanor F. Chapman

1974 *Spiro Mound Copper.* Memoir 11, Missouri Archaeological Society, Columbia.

Hardin, Kris L.

1991 Review of *Calliope's Sisters: A Comparative Study of Philosophies of Art,* by Richard L. Anderson. *Journal of Anthropological Research* 47(1): 116–21.

Hardin-Friedrich, Margaret

1970 Design Structure and Social Interaction: Archaeological Implications of an Ethnographic Analysis. *American Antiquity* 35(3): 332–43.

Hartley, Ralph J.

1992 *Rock Art on the Northern Colorado Plateau: Variability in Content and Context.* Brookfield, Vermont: Ashgate Publishing, Avebury.

Hedden, Mark

1996 3,500 Years of Shamanism in Maine Rock. In *Rock Art of the Eastern Woodlands: Proceedings from the Eastern States Rock Art Conference,* edited by Charles H. Faulkner, 7–24. Occasional Paper 2, American Rock Art Research Association, San Miguel, California.

Hedges, Ken

1970 *An Analysis of Diegueno Pictographs.* Master's thesis, Department of Anthropology, San Diego State College, San Diego.

1975 Kumeyaay Rock Paintings in Southern California. In *American Indian Rock Art,* vol. 1, edited by Shari T. Grove, 111–25. Farmington, California: San Juan County Museum.

1976 Southern California Rock Art as Shamanic Art. In *American Indian Rock Art,* vol. 2, edited by Kay Sutherland, 126–38. El Paso, Texas: El Paso Archaeological Society.

1982 Phosphenes in the Context of Native American Rock Art. In *American Indian Rock Art,* vols. 7 and 8, edited by Frank G. Bock, 1–9. El Toro, California: American Rock Art Research Association.

1983 The Shamanic Origins of Rock Art. In *Ancient Images on Stone: Rock Art of the Californias,* edited by Jo Anne Van Tilburg, 46–61. The Rock Archives, The Institute of Archaeology, Los Angeles, University of California.

1986 *Rock Art Papers.* San Diego Museum Papers 3(20), San Diego Museum of Man, San Diego.

Heizer, Robert F., and Martin A. Baumhoff

1962 *Prehistoric Rock Art of Nevada and Eastern California.* Berkeley: University of California Press.

Heizer, Robert F., and C. W. Clewlow, Jr.

1973 *Prehistoric Rock Art of California,* vols. 1 and 2. Ramona, California: Ballena Press.

Heldman, Donald, and James Duncan

1999 Preliminary Report on Excavations at the Backes Black Sand Site, 23SA447, in Saline County, Missouri. Manuscript in possession of T. M. Hamilton, Marshall, Missouri.

Henning, Dale R.

1961 Oneota Ceramics in Iowa. *Journal of the Iowa Archaeological Society* (Iowa City) 11(2).

1970 Development and Interrelationships of Oneota Culture in the Lower Missouri River Valley. *Missouri Archaeologist* 32.

Henson, B. Bart

1986 Art in Mud and Stone: Mud Glyphs and Petroglyphs in the Southeast. In *The Prehistoric Native American Art of Mud Glyph Cave,* edited by Charles H. Faulkner, 81–108. Knoxville: University of Tennessee Press.

Hietala, Harold

1984 *Intrasite Spatial Analysis in Archaeology.* London: Cambridge University Press.

Hill, James N.

1966 A Prehistoric Community in Eastern Arizona. *Southwestern Journal of Anthropology* 22:9–30.

1968 Broken K Pueblo: Patterns of Form and Function. In *New Perspectives in Archaeology,* edited by S. Binford and L. Binford, 103–42. Chicago: Aldine.

1970 *Broken K Pueblo: Prehistoric Social Organization in the American Southwest.* Anthropological Papers 18, University of Arizona, Tucson.

1977 Individual Variability in Ceramics and the Study of Prehistoric Social Organization. In *The Individual in Prehistory: Studies of Variability in Style in Prehistoric Technologies,* edited by James N. Hill and Joel Gunn, 55–108. New York: Academic Press.

Hill, James N., and Joel Gunn, eds.

1977 *The Individual in Prehistory: Studies of Variability in Style in Prehistoric Technologies.* New York: Academic Press.

Hilliard, Jerry

1992 Sacred Symbols: Rock Art in Arkansas. Manuscript in files of the Arkansas Archaeological Survey, Fayetteville.

1993 Arkansas Rock Art Landscape. *Field Notes* 255(November/December): 3–4 (Arkansas Archaeological Society, Fayetteville).

Hinkley, David M.

1988 Pigeon Hollow–Site Report, Kansas City, Missouri. In possession of the author.

Hitchcock, Ethan Allen

1930 *A Traveler in Indian Territory,* edited by G. Foreman. Cedar Rapids, Iowa: Torch Press.

Hodder, Ian

1986 *Reading the Past.* 1st ed. Cambridge: Cambridge University Press.

1987a The Contextual Analysis of Symbolic Meanings. In *The Archaeology of Contextual Meanings,* edited by Ian Hodder, 1–10. Cambridge: Cambridge University Press.

1987b *Reading the Past.* 2d ed. Cambridge: Cambridge University Press.

Hodge, Frederick W., ed.

1912 *Handbook of American Indians North of Mexico.* Bureau of American Ethnology Bulletin 30(1-2), Smithsonian Institution, Washington, D.C.

Horr, David Agee, ed.

1974 *Osage Indians,* 3 vols. American Indian Ethnohistory, Plains Indians. New York: Garland.

Houck, Louis

1908 *A History of Missouri,* vols. 1 through 3. Chicago: R. R. Donnelley & Sons.

Howard, James H.

1968 *The Southeastern Ceremonial Complex and Its Interpretation.* Memoir 6, Missouri Archaeological Society, Columbia.

1984 *The Canadian Sioux.* Lincoln: University of Nebraska Press.

Huchet, Bernard

1991 Review of *Rock Art and Prehistory,* edited by Paul Bahn and Andree Rosenfeld, Oxbow Monograph 10. *Journal of Field Archaeology* 18:87.

Hudson, Charles M.

1976 *The Southeastern Indians.* Knoxville: University of Tennessee Press.

1979 *Black Drink: A Native American Tea.* Athens: University of Georgia Press.

Hudson, Travis, and Georgia Lee

1984 Function and Symbolism in Chumash Rock Art. *Journal of New World Archaeology* 6:26–47.

Hultkrantz, Ake

1983 *The Study of American Indian Religions,* edited by Christopher Vecsey. American Academy of Religion, Studies in Religion 29, Crossroads Publishing, New York.

1984 Function and Symbolism in Chumash Rock Art. *Journal of New World Archaeology* 6:26–47.

Hunt, Charles B.

1974 *Natural Regions of the United States and Canada.* San Francisco: W. H. Freeman.

Hunt, David C., and Marsha Gallagher

1984 *Karl Bodmer's America.* Omaha: University of Nebraska Press.

Hyde, George E.

1988 *The Pawnee Indians* (originally published 1951). Norman: University of Oklahoma Press.

Hyman, Marian, and Marvin W. Rowe

1997 Plasma Extraction and AMS 14C Dating of Rock Paintings. *Techne* (France) 5:61–72.

Ilger, W., M. Hyman, J. Southon, and M. W. Rowe

1995 Dating Pictographs with Radiocarbon. *Radiocarbon* 37:299–310.

Jacobson, Jerome

1991 The 1678 Piasa. *Illinois Antiquity* 26(4): 7–8.

James, Edwin

1823 *Account of an Expedition from Pittsburgh to the Rocky Mountains performed in the years 1819–20, by order of the Hon. J. C. Calhoun, Sec'y of War: Under the Command of Major Stephen H. Long, Vol. 1.* Philadelphia: H. G. Carey & I. Lea, pp. 56–57.

Johnson, Tom

1980 *Snakes of Missouri.* Jefferson City: Missouri Department of Conservation.

Jones, Bernard M., Jr.

1986 Preliminary Investigations into a Southern California Summer Solstice Site. In *Rock Art Papers,* edited by Ken Hedges, 157–68. San Diego Museum Papers 3(20), San Diego Museum of Man, San Diego.

Jones, Iloilo M.

1990 The Pike County, Illinois, Piasa Petroglyph. *Illinois Archaeology* 1(2): 121–36.

Jones, Joseph

1970 *Aboriginal Remains of Tennessee.* Knoxville: Tennessee County (originally published 1876: Smithsonian Contributions to Knowledge no. 259, Smithsonian Institution, Washington, D.C.).

Jones, Tim E. H.

1981 *The Aboriginal Rock Paintings of the Churchill River.* Anthropological Series, no. 4, Saskatchewan Museum of Natural History, Regina.

Jopling, Carol F., ed.

1971 *Art and Aesthetics in Primitive Societies.* New York: E. P. Dutton.

Jung, Carl G.

1968 *Man and His Symbols.* New York: Dell.

Kelly, John E.

1990 The Emergence of Mississippian Culture in the American Bottom Region. In *The Mississippian Emergence,* edited by Bruce Smith, 113–52. Washington, D.C.: Smithsonian Institution Press.

1991 Cahokia and Its Role as a Gateway Center in Interregional Exchange. In *Cahokia and the Hinterlands: Middle Mississippian Cultures of the Midwest,* edited by Thomas E. Emerson and R. Barry Lewis, 61–80. Urbana: University of Illinois Press.

Keslin, Richard O.

1964 Archaeological Implications of the Role of Salt as an Element of Cultural Diffusion. *Missouri Archaeologist* 26.

Keyser, James D.

1977 Audrey's Overhang: A Pictographic Maze in Central Montana. *Plains Anthropologist* 21(77): 183–88.

1978 A Lexicon for Historic Plains Indian Rock Art: Increasing Interpretive Potential. *Plains Anthropologist* 32(115): 43–71.

1979 The Central Montana Abstract Rock Art Style. In *Heritage Record No. 8,* edited by Doris Lundy, 153–77. Victoria, Canada: British Columbia Provincial Museum.

1987 A Lexicon for Historic Plains Indian Rock Art: Increasing Interpretive Potential. *Plains Anthropologist* 31:43–71.

Keyser, James D., and Linea Sundstrom

1979 The Plains Indian War Complex and the Rock Art of Writing-On-Stone, Alberta, Canada. *Journal of Field Archaeology* 6:41–48.

1984 *Rock Art of Western South Dakota: The North Cave Hills and the Southern Black Hills.* Special Publication of the South Dakota Archaeological Society, no. 9, Sioux Falls, South Dakota.

Kirkland, Forest, and W. W. Newcomb, Jr.

1967 *The Rock Art of Texas Indians.* Austin: University of Texas Press.

Knight, Vernon James, Jr.

1989 Some Speculations on Mississippian Monsters. In *The Southeastern Ceremonial Complex: Artifacts and Analysis,* edited by P. Galloway, 205–10. Lincoln: University of Nebraska Press.

Koenig, John W., ed.

1961 *The Stratigraphic Succession in Missouri.* Missouri Geological Survey and Water Resources, vol. 40, 2d ser. Rolla.

Koenig, S. H.

1979 Stars, Crescents, and Supernovae in Southwestern Indian Art. *Journal for the History of Astronomy* (suppl., *Archaeoastronomy*) 1.

Kopper, Philip

1986 *The Smithsonian Book of North American Indians: Before the Coming of the Europeans.* Washington, D.C.: Smithsonian Books.

Korn, Sheila M.

1978 The Formal Analysis of Visual Systems as Exemplified by a Study of Abelam (Papua, New Guinea) Paintings. In *Art in Society: Studies in Style, Culture, and Aesthetics,* edited by Michael Greenhalgh and Vincent Megaw, 161–73. London: Gerald Duckworth.

Krieger, Alex D.

1945 An Inquiry into Supposed Mexican Influence on a Prehistoric "Cult" in the Southern United States. *American Anthropologist* 47:483–515.

Krupp, Edgar C.

1977 *In Search of Ancient Astronomies.* Garden City, New York: Doubleday & Company.

Kubler, George

1962 *The Art and Architecture of Ancient America.* Baltimore: Penguin Books.

Kuhn, Herpert

1956 *The Rock Pictures of Europe,* translated by Alan Houghton Broderic. Fair Lawn, New Jersey: Essential Books.

La Flesche, Francis

1916 Right and Left in Osage Ceremonies. In *Holmes Anniversary Volume,* 278–87. Washington, D.C.: Privately published.

1921 *The Osage Tribe.* Bureau of American Ethnology Annual Report no. 36, Smithsonian Institution, Government Printing Office, Washington, D.C.

1925 The Osage Tribe: Rite of Vigil. In *Forty-Fifth Annual Report, 1927–1928,* 523–833. Bureau of American Ethnology, Washington, D.C.

1932 *A Dictionary of the Osage Language.* Smithsonian Institution Bulletin 109, Bureau of American Ethnology, Washington, D.C.

1939 *War Ceremony and Peace Ceremony of the Osage Indians.* Smithsonian Institution Bulletin 101, Bureau of American Ethnology, Washington, D.C.

Lambert, Peter J. B.

1983 *The Northwestern Ontario Rock Art Project: The 1982 Results.* Northwestern Region, Report 2, Ministry of Citizenship and Culture, Ontario, Canada.

1985 *The Northwestern Ontario Rock Art Project: The 1984 Results.* Northwestern Region, Report 8, Ministry of Citizenship and Culture, Ontario, Canada.

Langer, Susanne K.

1957 *Problems of Art: Ten Philosophical Lectures.* New York: Charles Scribner's Sons.

Lankford, George E., ed.

1987 *Native American Legends.* American Folklore Series. Little Rock, Arkansas: August House.

Layton, Robert

1978 Art and Visual Communication. In *Art and Society: Studies in Style, Culture, and Aesthetics,* edited by Michael Greenhalgh and Vincent Megaw, 21–30. London: Duckworth.

Lee, Georgia

1982 Rock Art Recording and Its Place in Cultural Resource Management. Manuscript on file, Rock Art Archives, University of California, Los Angeles.

1983 The Art of the Chumash. In *Ancient Images on Stone: Rock Art of the Californias,* edited by Van Tilburg, 30–37. Los Angeles: UCLA Institute of Archaeology.

Levine, Morton H.

1957 Prehistoric Art and Ideology. *American Anthropologist* 59:949–64.

Levi-Strauss, Claude

1966 *The Savage Mind.* London: Weidenfeld & Nicolson.

Levy, Mervyn

1961 *The Pocket Dictionary of Art Terms.* Greenwich, Connecticut: New York Graphic Society.

Levy-Bruhl, Lucien

1983 *Primitive Mythology: The Mythic World of the Australian and Papuan Natives* (originally published 1935). St. Lucia: University of Queensland Press.

Lewin, S. Z.

1966 The Preservation of Natural Stone 1839–1965: An Annotated Bibliography. *Art and Archaeological Technical Abstracts* 6:1.

Lewis, Thomas M. N., and Madeline Kneberg

1958 *Tribes That Slumber: Indians of the Tennessee Region.* Knoxville: University of Tennessee Press.

Lewis-Williams, J. David

1981 *Believing and Seeing: Symbolic Meanings in Southern San Rock Paintings.* New York: Academic Press.

1983 *The Rock Art of Southern Africa.* Cambridge: Cambridge University Press.

1986 Cognitive and Optical Illusions in San Rock Art Research. *Current Anthropology* 27(2): 171–78.

Lewis-Williams, J. D., and T. A. Dowson

1988 The Signs of All Times: Entoptic Phenomena in Upper Paleolithic Art. *Current Anthropology* 29(2).

1993 On Vision and Power in the Neolithic: Evidence from the Decorated Monuments. *Current Anthropology* 34(1): 55–65.

Lockwood, George B.

1905 *The New Harmony Movement.* New York: Appleton.

Longacre, William

1964 Sociological Implications of Ceramic Analysis. In Chapters in the Prehistory of Eastern Arizona II, edited by P. Martin et al. *Fieldiana: Anthropology* (Chicago) 55:155–70.

1970 *Archaeology as Anthropology: A Case Study.* University of Arizona Anthropological Papers 17, University of Arizona Press, Tucson.

Loomis, F. B.

1937 *Physiography of the United States.* New York: Doubleday, Doran.

Lopinot, Neal

1991 *Archaeobotanical Remains.* Part 1 of *The Archaeology of the Cahokia Mounds ICT-II: Biological Remains,* by Neal Lopinot, Lucretia S. Kelly, George R. Milner, and Richard Paine, pp. 1–268. Illinois Cultural Resources Study 13, Illinois Historic Preservation Agency, Springfield.

Lorant, Stefan

1946 *The New World: The First Pictures of America.* New York: Duell, Sloan & Pearce.

Lorblanchet, Michel

1977 From Naturalism to Abstraction in European Prehistoric Rock Art. In *Form in Indigenous Art,* edited by Peter Ucko, 44–58. Highlands, New Jersey: Atlantic, Humanities Press.

1980 Peintre sur les parois des grottes. *Revivre la Prehistoire, Dossiers de l'Archeologie* 46:33–39.

1991 Spitting Images: Replicating the Spotted Horses of Pech Merle. *Archaeology* 44(6): 23–31.

Lothson, Gordon A.

1976 *The Jeffers Petroglyphs Site: A Survey and Analysis of the Carvings*. Minnesota Prehistoric Archaeology Series 12, Minnesota Historical Society, St. Paul.

Lowie, Robert H.

1918 *Myths and Traditions of the Crow Indians*. Anthropological Papers of the American Museum of Natural History 25, New York, pp. 1–308.

1956 *The Crow Indians*. New York: Holt, Rinehart and Winston.

Lubensky, Earl

1985 Osage Petroglyphs from Vernon County. *Missouri Archeological Society Quarterly* 5(3): 12–13.

Lundy, Doris Marion

1974 The Rock Art of the Northwest Coast. Master's thesis, Department of Archaeology, Simon-Fraser University, Burnaby, British Columbia, Canada.

McAdams, William

1887 *A Record of Ancient Races in the Mississippi Valley*. St. Louis: C. R. Barnes.

McGowan, Charlotte

1978 Female Fertility Themes in Rock Art. *Journal of New World Archaeology* (Institute of Archaeology, University of California, Los Angeles) 2(4): 15–27.

Mackenzie, Donald A.

1968 *The Migration of Symbols and Their Relations to Beliefs and Customs* (originally published 1926). Detroit: Gale Research, Book Tower.

McKinley, Daniel L.

1950 Boone County Petroglyphs: Brief Report. *Missouri Archaeological Society, Newsletter* 43:4.

McMillan, R. Bruce

1964 *Report on the Archaeological Resources in the Bourbeuse River Valley and the Lower Meramec Valley of the Meramec Basin Project Area, Missouri*. Report on file at the Midwest Region, National Park Service, Omaha, Nebraska.

1965 Gasconade Prehistory. *Missouri Archaeologist* 27(3-4): 1–114.

Magre, Frank

1965 Rock Art of Missouri. Unpublished papers.

1971a Salt River Pictographs. *Newsletter, Mound City Archaeological Society* (St. Louis) 2(1): 1–3.

1971b Rune? (The Fort Hill Site). *Newsletter, Mound City Archaeological Society* (St. Louis) 2(3): 2.

1971c The Lost Creek Pictographs: A New National Historic Site. *Newsletter, Mound City Archaeological Society* (St. Louis) 2(7): 1–2.

1971d Salt River Pictographs. *Missouri Archaeological Society, Newsletter* 248:2–3.

Mails, Thomas E.

 1973 *Dog Soldiers, Bear Men and Buffalo Women: A Study of the Societies and Cults of the Plains Indians.* Englewood Cliffs, New Jersey: Prentice-Hall.

Mallery, Garrick

 1886 *Pictographs of the North American Indians.* Fourth Annual Report, Bureau of American Ethnology, Government Printing Office, Washington, D.C. (reprinted 1972, New York: Dover).

 1972 *Picture-Writing of the American Indians,* vols. 1 and 2. Toronto: General Publishing, and New York: Dover (originally published 1893: Tenth Annual Report, Bureau of American Ethnology, Government Printing Office, Washington, D.C.

Maquet, Jacques

 1991 Review of *Calliope's Sisters: A Comparative Study of Philosophies of Art,* by Richard L. Anderson. *American Anthropologist* 93:967–68.

Maran, Stephen P.

 1982 Origin of the Crab Nebula. *Natural History* 91(10): 84–89.

Margry, Pierre, ed.

 1876 *Découvertes et établissements des Français dans l'ouest et dans le sud de l'Amérique Septentrionale (1614–1754),* 6 vols. Paris: Imprimerie D. Jouaust.

Marshack, Alexander

 1972 *The Roots of Civilization: The Cognitive Beginnings of Man's First Art, Symbol and Notation.* New York: McGraw-Hill.

 1985a On the Dangers of Serpents in the Mind. *Current Anthropology* 26(1): 139–52.

 1985b A Lunar-Solar Calendar Stick from North America. *American Antiquity* 50:27–51.

 1986 More on the Endless Serpent. *Current Anthropology* 27(3): 263–64.

Marshack, Alexander, and Francesco D'Errico

 1989 On Wishful Thinking and Lunar "Calendars." *Current Anthropology* 30(4): 491–500.

Martin, Paul S., and Fred Plog

 1973 *The Archaeology of Arizona: A Study of the Southwest Region.* Garden City, New York: Doubleday and Natural History Press.

Martin, Terrell L.

 1998 The Backes Site: A Black Sand Manifestation in Central Missouri. *Missouri Archaeological Society Quarterly* 15(4): 4–12.

Mathews, John Joseph

 1961 *The Osages: Children of the Middle Waters* (originally published 1935). Norman: University of Oklahoma Press.

Mathews, Washington

 1877 *Ethnography and Philology of the Hidatsa Indians.* U.S. Geological and
 Geographical Survey, Miscellaneous Publications 7, Washington, D.C.

Mayer, Dorothy

 1977 An Examination of Miller's Hypothesis. In *Native American Astronomy*,
 edited by A. F. Aveni, 179–201. Austin, Texas: University of Texas Press.

Mayer, Ralph

 1991 *The Artist's Handbook of Materials and Techniques.* 5th ed. New York:
 Viking.

Meighan, Clement W.

 1981 Theory and Practice in the Study of Rock Art. In *The Shape of the Past:
 Studies in Honor of Franklin D. Murphy*, edited by G. Buccellate and
 Charles Speroni, 66–91. Los Angeles: University of California, Institute
 of Archaeology.

Merriam, Alan P.

 1964 The Arts and Anthropology. In *Horizons of Anthropology*, edited by Sol
 Tax, 332–43. Chicago: Aldine.

Merwin, Bruce W.

 1937 Rock Carvings in Southern Illinois. *American Antiquity* 3:179–82.

Meyer, Roy W.

 1977 *The Village Indians of the Upper Missouri: The Mandans, Hidatsas, and
 Arikaras.* Lincoln: University of Nebraska Press.

Middleton, Ken G.

 1960 A Report on Summer Field Work Conducted at Washington State Park,
 8 June to 15 Sept, 1960. *Missouri Archaeological Society, Newsletter* 144:5.

Miller, Wm. C.

 1955a Two Prehistoric Drawings of Possible Astronomical Significance. Leaflet
 of the Astronomical Society of the Pacific, no. 314, pp. 1–8, San Francisco.

 1955b Two Possible Astronomical Pictographs Found in Northern Arizona.
 Plateau (Museum of Northern Arizona) 27(4): 6–12.

Missouri Archaeological Society

 1956 Thousand Hills State Park Petroglyphs. *Missouri Archaeological Society,
 Newsletter* 101:2.

 1959 Washington State Park Petroglyphs. *Missouri Archaeological Society,
 Newsletter* 134:6–11.

 1974a Thousand Hills State Park Petroglyphs. *Missouri Archaeological Society,
 Newsletter* 280:11–12.

 1974b Washington State Park Petroglyphs. *Missouri Archaeological Society,
 Newsletter* 280:15–16.

 1992 Sites Recorded by County at the Archaeological Survey of Missouri.
 Missouri Archaeological Society Quarterly 9(2):Cover.

Missouri Historical Society

 1881 Minutes in Indian Collections Notes, April 21. Unpublished papers,
 Missouri Historical Society, St. Louis.

 1883 Minutes in Indian Collections Notes, September 18. Unpublished pa-
 pers, Missouri Historical Society, St. Louis.

Mithen, Steven

 1996 *The Prehistory of the Mind: The Cognitive Origins of Art, Religion and
 Science.* London: Thames and Hudson.

Molyneaux, Brian L.

 1977 Formalism and Contextualism: An Historiography of Rock Art Re-
 search in the New World. Thesis, Trent University, Peterborough,
 Ontario, Canada.

 1983 *The Study of Prehistoric Sacred Places: Evidence from Lower Manitou
 Lake.* Royal Ontario Museum Archaeology Papers 2, University of
 Toronto Press, Toronto, Canada.

Morse, Dan F., and Phyllis A. Morse

 1983 *Archaeology of the Central Mississippi Valley.* New York: Academic Press.

Moulton, Gary, ed.

 1986 *The Journals of the Lewis & Clark Expedition,* vol. 1. Lincoln: University
 of Nebraska Press.

Mountjoy, Joseph B.

 1974 *Some Hypotheses Regarding the Petroglyphs of West Mexico.* Mesoamerican
 Studies 9, University Museum, Southern Illinois University, Carbondale.

Muller, Jon

 1966 Archaeological Analysis of Art Styles. *Tennessee Archaeologist* 22(1): 25–39.

 1977 Individual Variation in Art Styles. In *The Individual in Prehistory: Stud-
 ies of Variability in Style in Prehistoric Technologies,* edited by James N.
 Hill and Joel Gunn, 23–40. New York: Academic Press.

 1979 Structural Studies of Art Styles. In *The Visual Arts: Plastic and Graphic,*
 edited by Justine Cordwell, 139–211. The Hague: Mouton.

 1986 Serpents and Dancers: Art of the Mud Glyph Cave. In *The Prehistoric
 Native American Art of Mud Glyph Cave,* edited by Charles H. Faulkner,
 34–80. Knoxville: University of Tennessee Press.

 1989 The Southern Cult. In *The Southeastern Ceremonial Complex: Artifacts
 and Analysis,* edited by P. Galloway, 11–26. Lincoln: University of Ne-
 braska Press.

Mundkur, Balaji

 1976 The Cult of the Serpent in the Americas: Its Asian Background. *Current
 Anthropology* 17:429–55.

 1978 The Alleged Diffusion of Hindu Divine Symbols into Pre-Columbian
 Mesoamerica: A Critique. *Current Anthropology* 19:541–83.

1983 *The Cult of the Serpent: An Interdisciplinary Survey of Its Manifestations and Origins.* Albany: State University Press.

Munn, Nancy D.

1962 Walbiri Graphic Signs: An Analysis. *American Anthropologist* 64:972–84.

1966 Visual Categories: An Approach to the Study of Representational Systems. *American Anthropologist* 68:936–55.

Munsell Color

1975 *Munsell Soil Color Chart.* Baltimore: Macbeth Division of Kollmorgen Corporation.

National Wildlife Federation

1982 *Acid Rain.* Washington, D.C.: National Wildlife Federation.

Naylor, Maria, ed.

1975 *Authentic Indian Designs: 2500 Illustrations from Reports of the Bureau of American Ethnology.* New York: Dover Publications.

Nelson, Paul W.

1985 *The Terrestrial Natural Communities of Missouri.* Missouri Natural Areas Committee, Missouri Department of Conservation and Missouri Department of Natural Resources, Jefferson City.

Nissen, Karen Marie

1982 *Images from the Past: An Analysis of Six Western Basin Petroglyph Sites.* Ph.D. diss., Department of Anthropology, University of California, Berkeley.

Nobler, Nathan

1966 *The Visual Dialogue: An Introduction to the Appreciation of Art.* New York: Holt, Rinehart and Winston.

Nodleman, Sheldon

1970 Structural Analysis in Art and Anthropology. In *Structuralism,* edited by Jacques Ehrmann, 79–93. Garden City, New York: Anchor.

Norrish, Dick

1978a [Editor] Woodhenge: Red Cedar Found. *The Cahokian* (Cahokia Mounds Museum Society, Collinsville, Illinois) September: 3, 10–11.

1978b Woodhenge: Work of a Genius. *The Cahokian* (Cahokia Mounds Museum Society, Collinsville, Illinois) February: 2–14.

O'Brien, Michael J., and W. Raymond Wood

1998 *The Prehistory of Missouri.* Columbia: University of Missouri Press.

O'Brien, Patricia J.

1994 Border Markers and Boundaries of the Cahokia Site. *Gateway Heritage* (Missouri Historical Society, St. Louis) 15(1): 30–45.

Odak, Osaga

1991 A New Name for a New Discipline. *Rock Art Research* (Australian Rock Art Research Association, Melbourne) 8(1): 3–7.

Oldschool, Oliver (Nathan Sargeant)
 1816 *The Aborigines of America,* vols. 1 and 2, ser. 5. Philadelphia: Privately
 published.

Olsen, Nancy H.
 1985 *Hovenweep Rock Art: An Anasazi Visual Communication System.* Occa-
 sional Paper 14, Institute of Archaeology, University of California, Los
 Angeles.

O'Neill, Brian
 1988 *Kansas Rock Art.* Topeka: Historic Preservation Department, Kansas
 State Historical Society.

Ontario Ministry of the Environment
 1982 *Effects of Acid Rain.* P.I.B.S. no. 1795, Ontario Ministry of the Environ-
 ment, Ontario, Canada.

Oster, Gerald
 1970 Phosphenes. *Scientific American* 222:83–87.

Otten, Charlotte M., ed.
 1971 *Anthropology and Art: Readings in Cross-Cultural Aesthetics.* Garden City,
 Michigan: Natural History Press.

Owen, David Dale
 1822 Regarding Human Footprints in Solid Limestone: Silliman's Journal.
 American Journal of Science and Arts 5:223–31.

Parsons, Mark L.
 1987 Plains Indian Portable Art as a Key to Two Texas Historic Rock Art
 Sites. *Plains Anthropologist* 32(117): 257–74.

Patterson, Alex
 1992 *A Field Guide to Rock Art Symbols of the Greater Southwest.* Boulder:
 Johnson Books.

Peithmann, Irvin
 1955 A Petroglyph Site at Fountain Bluff, Jackson County, Illinois. *Central
 States Archaeological Journal* 2(1): 11–13.

Perino, Gregory H.
 1971 The Yokem Site, Pike County, Illinois. In *Mississippian Site Archaeology
 in Illinois. I: Site Reports from the St. Louis and Chicago Areas,* edited by
 James A. Brown, 149–86. Illinois Archaeological Survey, Bulletin 8, Uni-
 versity of Illinois, Urbana.

Pfeiffer, John
 1982 *The Creative Explosion.* New York: Harper & Row.

Pflieger, William L.
 1997 *The Fishes of Missouri.* Missouri Department of Conservation, Jefferson
 City.

Pflieger, Wm., and Lawrence C. Belusz
 1982 *The Fishes of Missouri.* Missouri Conservation Commission, Jefferson City.

Phillips, Philip, and James A. Brown

1978 *Pre-Columbian Shell Engravings from the Craig Mound at Spiro, Oklahoma,* pt. 1. Cambridge, Massachusetts: Peabody Museum Press.

1984 *Pre-Columbian Shell Engravings from the Craig Mound at Spiro, Oklahoma,* pt. 2. Boston: Peabody Museum of Archaeology and Ethnology, Harvard University.

Plog, Stephen

1976 The Inference of Prehistoric Social Organization from Ceramic Design Variability. *Michigan Discussions in Anthropology* 1:1–47.

1978 Social Interaction and Stylistic Similarity: A Re-Analysis. In *Advances in Archaeological Method and Theory,* vol. 4, edited by Michael B. Schiffer, 144–82. New York: Academic Press.

Powers, William

1975 *Oglala Religion.* Lincoln: University of Nebraska Press.

Priest, Josiah

1834 *American Antiquities and Discoveries in the West.* Albany: Hoffman & White.

Radin, Paul

1923 The Winnebago Tribe. *Thirty-Seventh Annual Report of the Bureau of American Ethnology,* pp. 33–511, Smithsonian Institution, Washington, D.C. (reprinted 1970, New York: Johnson Reprint).

1926 [Editor] *Crashing Thunder: An Autobiography of an American Indian,* by Sam Blowsnake. New York: D. Appleton and Company.

1948 Winnebago Hero Cycles: A Study in Aboriginal Literature. *International Journal of American Linguistics* (Baltimore) 14(Memoir 1, suppl., no. 3): 1–168.

1954 *The Evolution of an American Indian Prose Epic: A Study in Comparative Literature,* pt. 1. Special Publications of the Bollingen Foundation no. 3, Washington, D.C.

1956 *The Trickster: A Study of American Indian Mythology.* New York: Shocken.

1957 *Primitive Religion: Its Nature and Origin* (originally published 1937). New York: Dover Publications.

1984 *Winnebago Hero Cycles: A Study in Aboriginal Literature.* Baltimore: Waverly Press.

1990 *The Winnebago Tribe.* Lincoln: University of Nebraska Press.

Rafferty, Milton

1981 *Historical Atlas of Missouri.* Norman: University of Oklahoma Press.

Rafter, John

1986 Archaeoastronomy of Agua Dulce Canyon. In *Rock Art Papers,* edited by Ken Hedges, 129–42. San Diego Museum Papers 3(20), San Diego Museum of Man, San Diego.

Redman, Charles L.

1977 The "Analytical Individual" and Prehistoric Style Variability. In *The Individual in Prehistory: Studies of Variability in Style in Prehistoric Technologies,* edited by James N. Hill and Joel Gunn, 41–53. New York: Academic Press.

Reichel-Dolmatoff, Gerardo

1967 Rock Paintings of the Vaupes: An Essay of Interpretation. *Folklore Americas* 27(2): 107–13.

1971 *Amazonian Cosmos: The Sexual and Religious Symbolism of the Tukano Indians.* Chicago: University of Chicago Press.

1978a Drug-Induced Optical Sensations and Their Relationship to Applied Art among Some Colombian Indians. *Art and Society: Studies in Style, Culture, and Aesthetics,* edited by Michael Greenhalgh and Vincent Megaw, 289–304. London: Duckworth.

1978b *Beyond the Milky Way: Hallucinatory Imagery of the Tukano Indians.* UCLA Latin American Center Publications, University of California, Los Angeles.

Revard, Carter

1987 Traditional Osage Naming Ceremonies: Entering the Circle of Being. In *Recovering the Word, Essays on Native American Literature,* edited by B. Swann and A. Krupat, 446–66. Berkeley: University of California Press.

Richardson, John Adkins

1973 *Art: The Way It Is.* Englewood Cliffs, New Jersey: Prentice-Hall.

Riggs, Stephen R.

1893 *Dakota Grammar, Texts, and Ethnography.* Contributions to North American Ethnology 9, Government Printing Office, Washington, D.C.

Rivett, Leo J.

1979 *The Application of Photogrammetry to the Recording of Rock Art and Archaeological Sites in the Kakadu National Park.* Department of Surveying, University of Melbourne, Melbourne, Australia.

Roe, Peter G.

1982 Ethnoaesthetics and Design Grammars: Shipibo Perceptions of Cognate Styles. Paper presented at the Eighty-First Annual Meeting of the American Anthropological Association, Washington, D.C.

Rollins, James.

1970 *History of Boone County, Missouri* (originally published 1882). Cape Girardeau: Ramfre Reprint.

Rowe, Marvin

1996 Clues from Paint Pigments. *Archaeology* (Archaeological Institute of America, New York) 49(6): 63.

Rudolph, Carol

1993 *Petroglyphs and Pueblo Myths.* Albuquerque: University of New Mexico Press (Avanyu Publishing).

Russ, Jon, Marian Hyman, and Marvin W. Rowe

1992 Direct Radiocarbon Dating of Rock Art. *Radiocarbon* 34:867–72.

1993 Radiocarbon Dating of Rock Art. *Archaeology and Natural Science* 1:127:42.

Sackett, James R.

1977 The Meaning of Style in Lithic Archaeology: A General Model. *American Antiquity* 42:369–80.

1982 Approaches to Style in Lithic Archaeology. *Journal of Anthropological Archaeology* 1:59–112.

1985 Style and Ethnicity in the Kalahari: A Reply to Wiessner. *American Antiquity* 50:154–59.

1986a Isochrestism and Style: A Clarification. *Journal of Anthropological Archaeology* 5:266–77.

1986b Style, Function, and Assemblage Variability: A Reply to Binford. *American Antiquity* 52:628–34.

Salzer, Robert J.

1986 Review of *The Northwestern Ontario Rock Art Project: The 1982 Results,* by Peter J. B. Lambert. *Wisconsin Archaeologist* 67(1): 58–63.

1987 Preliminary Report on the Gottschall Site (47Ia80). *Wisconsin Archaeologist* 68(4): 419–72.

1991 *Gottschall News* (March), edited by Ellen McHugh. Department of Anthropology, Beloit College, Beloit.

1999 Gottschall at a Glance. In *Gottschall News* (March), edited by Grace Rajnovich, 20. Logan Museum of Anthropology, Beloit College.

Sanger, Kay Kenady, and Clement W. Meighan

1990 *Discovering Prehistoric Rock Art, A Recording Manual.* Calabasas, California: Wormwood Press.

Sauer, Carl O.

1920 *The Geography of the Ozark Highland of Missouri.* Geographic Society of Chicago, Bulletin 7, The University of Chicago Press, Chicago.

Schaafsma, Polly

1971 *The Rock Art of Utah.* A Study from the Donald Scott Collection, Papers of the Peabody Museum of Archaeology and Ethnology 65, Harvard University, Cambridge.

1975 *Rock Art in New Mexico.* Albuquerque: University of New Mexico Press.

1980 *Indian Rock Art of the Southwest.* Santa Fe: School of American Research, University of New Mexico Press.

1985 Form, Content, and Function: Theory and Method in North American Rock Art Studies. In *Advances in Archaeological Method and Theory,* vol. 8, edited by Michael B. Schiffer, 237–77. New York: Academic Press.

Schapiro, Meyer

1953 Style. In *Anthropology Today,* edited by A. L. Kroeber, 283–311. Chicago: University of Chicago Press.

Schoolcraft, Henry R.

 1825 *Travels in the Central Portions of the Mississippi Valley.* New York: Collins and Hannay.

 1851–1857 *Historical and statistical information respecting the history, condition and prospects of the Indian tribes of the United States,* vols. 1–6. Collected and prepared under the direction of the Bureau of Indian Affairs. Philadelphia: Lippincott, Grambo.

Schuldt, Eric, and Frank Magre

 1974 Possible Chinese Inscription in a Missouri Rock Shelter. *Newsletter, Mound City Archaeological Society* (St. Louis) 5(2): 1–2.

Schwartz, Charles W., and Elizabeth R. Schwartz

 1959 *The Wild Mammals of Missouri.* Columbia: University of Missouri Press.

Scrivner, C. L., J. C. Baker, and B. J. Miller

 1962 *Soils of Missouri.* University of Missouri Extension Division, Circular 823, Columbia.

Shanks, Michael, and Christopher Tilley

 1988 *Social Theory and Archaeology.* Albuquerque: University of New Mexico Press.

Shelford, Victor E.

 1963 *The Ecology of North America.* Urbana: University of Illinois Press.

Sherrod, P. Clay

 1984 *Motifs of Ancient Man: A Catalogue of the Pictographs and Petroglyphs in a Portion of the Arkansas River Valley.* Office of Research in Science and Technology, University of Arkansas, Little Rock.

Sherrod, P. Clay, and Martha Ann Rolingson

 1987 *Surveyors of the Ancient Mississippi Valley/Modules and Alignments in Prehistoric Mound Sites.* Arkansas Archaeological Survey Research Series 28 (W. F. Linp, series editor), Archaeological Survey, Fayetteville.

Skinner, Alanson

 1925 Traditions of the Iowa Indians. *Journal of American Folklore Society* 38:425–506.

Smith, Bruce, ed.

 1990 *The Mississippian Emergence.* Washington, D.C.: Smithsonian Institution Press.

Snow, Dean R.

 1976 The Solon Petroglyphs and Eastern Abenaki Shamanism. In *Papers of the Seventh Algonkian Conference, 1975,* edited by William Cowan, 281–88. Ottawa, Ontario, Canada: Carleton University.

 1977 Rock Art and the Power of Shamans. *Natural History* (American Museum of Natural History, New York) 86:42–49.

Speck, Frank G.

 1909 *Ethnology of the Yuchi Indians.* Anthropological Publications 1, University Museum, University of Pennsylvania, Philadelphia.

1937 *Oklahoma Delaware Ceremonies, Feasts and Dances.* Memoir of the American Philosophical Society 7, Philadelphia.

Spence, Lewis

1989 *The Myths of the North American Indians.* New York: Dover Publications.

Spencer, Sir Walter Baldwin, and Frances J. Gillen

1927 *The Arunta: A Study of a Stone Age People.* London: Macmillan.

Steinbring, Jack, and Gary Granzberg

1986 Ideological and Cosmological Inferences from North American Rock Art: An Exploratory Discussion. In *Rock Art Papers,* edited by Ken Hedges, 207–20. San Diego Museum Papers 3(20), San Diego Museum of Man, San Diego.

Stephen, Alexander

1936 *Hopi Journal* (originally published 1914). New York: Columbia University Press.

Stevens, Walter B.

1921 *Stevens Centennial History of Missouri (The Center State) 1820–1921,* vols. 1–5. St. Louis: S. J. Clarke.

Steward, Julian H.

1929 *Petroglyphs of California and Adjoining States.* Berkeley: University of California.

1937 *Petroglyphs of the United States.* Smithsonian Institution Annual Report for 1936, pp. 404–25.

Steyermark, Julian A.

1959 *Vegetational History of the Ozark Forest* (originally published 1926). The University of Missouri Studies, vol. 31, University of Missouri, Columbia.

1975 *Flora of Missouri.* Ames: Iowa State University Press.

Stoliar, A. D.

1977a On the Sociohistorical Decoding of Upper Paleolithic Female Signs. *Soviet Anthropology and Archaeology* 16(2): 36–77.

1977b On the Genesis of Depictive Activity and its Role in the Formation of Consciousness (Toward a Formation of the Problem). *Soviet Archaeology* 16(3-4): 3–42.

Stuart, David R.

1978 Recording Southwestern Rock Art Sites. *The Kiva* 43(2/4): 183–99.

Sturtevant, William

1954 The Medicine Bundles and Busks of the Florida Seminole. *Florida Anthropologist* 3:2.

Sundstrom, Linea

1982 *American Indian Rock Art,* vol. 3. Papers presented at the Second Annual Rock Art Symposium, El Paso Community College, August 30–September 1, 1975. El Paso, Texas: El Paso Archaeological Society.

1989 *Rock Art of the Southern Black Hills: A Contextual Approach.* Unpub-

lished Ph.D. diss., edited by Kay Sutherland, Department of Anthropol-
ogy, University of Kansas, Lawrence.

1990 *Rock Art of the Southern Black Hills: A Contextual Approach.* New York:
 Garland.

Swanton, John R.

1911 *Indian Tribes of the Lower Mississippi Valley and Adjacent Coast of the Gulf
 of Mexico.* Bureau of American Ethnology Bulletin 43, Washington, D.C.

1942 *Source Material on the History and Ethnology of the Caddo Indians.*
 Smithsonian Institution, Bulletin 132, Washington, D.C.

1946 *Indians of the Southeastern United States.* Bureau of American Ethnology
 Bulletin 137, Government Printing Office, Washington, D.C.

Swartz, B. K., Jr.

1981 Standards for the Recording of Petroglyphs and Pictographs. *Current
 Anthropology* 22(1): 94–95.

Swauger, James L.

1974 *Rock Art of the Upper Ohio Valley.* Graz, Austria: Akademische Druck, u.
 Verlagsanstalt.

1984 *Petroglyphs of Ohio.* Athens: Ohio University Press.

Tatum, Robert M.

1946 Distribution and Bibliography of the Petroglyphs of the United States.
 American Antiquity 12(2): 122–25.

Taylor, J. M., R. M. Myers, and I. N. M. Wainwright

1974 Scientific Studies of Indian Rock Paintings in Canada. *Bulletin of the
 American Institute for Conservation* 14:2.

Teubner, Charles

1882 Indian Pictographs in Missouri. *Kansas City Review of Science and Indus-
 try* 6(4): 208–10.

Thomas, David Hurst, and Trudy Thomas

1972 New Data on Rock Art Chronology in the Central Great Basin. *Tebiwa*
 15:64–71.

Thomas, John L.

1907 Historic Landmarks of Jefferson County, No. 2. *Missouri Historical Re-
 view* 1(3): 171–80.

Thomas, T.

1976 Petroglyph Distribution and the Hunting Hypothesis in the Central
 Great Basin. *Tebiwa* 18:65–74.

Thornbury, W. D.

1965 *Regional Geomorphology of the United States.* New York: Wiley and Sons.

Thwaites, Reuben Gold

1901 *The Jesuit Relations and Allied Documents, Travels and Explorations of the
 Jesuit Missionaries in New France 1610–1791,* vol. 59, p. 97. Cleveland:
 Burrows Brothers.

1906 *Early Western Travels, 1748–1846,* vol. 22. Part 1 of *Maximilian, Prince*

of Wied's, Travels in the Interior of North America, 1832–1834. Cleveland: Arthur M. Clark.

Titiev, Mischa
 1937 A Hopi Salt Expedition. *American Anthropologist* 39:244–58.

Tooker, Elisabeth
 1964 *Ethnography of the Huron Indians.* Bureau of American Ethnology Bulletin 190, Smithsonian Institution, Government Printing Office, Washington, D.C.

Trubitt, Mary Beth D.
 1996 *Household Status, Marine Shell Bead Production, and the Development of Cahokia in the Mississippian Period.* Ph.D. diss., Department of Anthropology, Northwestern University, Evanston, Illinois.

Turner, Christy G., II
 1963 *Petroglyphs of the Glen Canyon Region.* Museum of Northern Arizona Bulletin 38 (Glen Canyon Series 4), Flagstaff.

Turpin, Solveig A.
 1986 Toward a Definition of a Pictograph Style: The Lower Pecos Bold Line Geometric. *Plains Anthropologist* 31(112): 153–61.
 1992 More Sacred Holes in the Ritual Landscape of the Lower Pecos River Region. *Plains Anthropologist* 37(140): 275–78.

Ucko, Peter J., ed.
 1977 *Form in Indigenous Art: Schematisation in the Art of Aboriginal Australia and Prehistoric Europe.* Prehistory and Material Culture Series 13, Australian Institute of Aboriginal Studies, Canberra, Gerald Duckworth and Company, London.

Ucko, Peter J., and Andree Rosenfeld
 1967 *Paleolithic Cave Art.* New York: McGraw-Hill.

Unrau, William E.
 1971 *The Kansa Indians: A History of the Wind People, 1673–1873.* Norman: University of Oklahoma Press.

Van Tilburg, Jo Anne
 1983 *Ancient Images on Stone: Rock Art of the Californias.* UCLA Institute of Archaeology, Los Angeles.

Varney, Milton
 1990 Petroglyphs: Lost Forever. *Missouri Archaeological Society Quarterly* 7(1): 17–18.

Vastokas, Joan M.
 1978 Cognitive Aspects of Northwest Coast Art. In *Art in Society: Studies in Style, Culture, and Aesthetics,* edited by Michael Greenhalgh and Vincent Megaw, 243–59. London: Gerald Duckworth.

Vastokas, Joan M., and Romas K. Vastokas
 1973 *Sacred Art of the Algonkians: A Study of the Peterborough Petroglyphs.* Peterborough, Ontario, Canada: Mansard Press.

Vehik, Susan C.

 1993 Dhegiha Origins and Plains Archaeology. *Plains Anthropologist* 38(146): 231–52.

Vertut, Jean, and Paul G. Bahn

 1988 *Images of the Ice Age.* London: Windward, Bellew Publishing.

Wagner, Mark, Mary R. McCorvie, Brad Koldehoff, and Charles R. Moffat

 1990 *An Archaeological Survey of Fountain Bluff, Jackson County, Illinois.* Cultural Resources Management, Report 143, American Resources Group, Carbondale, Illinois.

Wainwright, Ian N. M.

 1983 Rock Art Conservation Research in Canada (Draft). Canadian Conservation Institute, National Museums of Canada, Ottawa, Ontario, Canada.

 1984 The Peterborough Petroglyphs: Protection, Conservation, Recording. Paper presented at the Sixth Biennial Convention of the Canadian Rock Art Research Associates, Peterborough, Ontario, Canada.

Wainwright, Ian N. M., and John M. Taylor

 1990a Rock Painting and Petroglyph Recording Projects in Canada. *APT Bulletin* 22(1–2): 56–84.

 1990b *NRC's Laser Scanner for Recording and Replication.* Newsletter of the Canadian Conservation Institute, no. 6, pp. 6–9, Ontario.

Wallon, Robert, Jr.

 1968 Investigations of Late Prehistoric Social Organization in New York State. In *New Perspectives in Archaeology,* edited by Sally Binford and Lewis Binford, 223–44. Chicago: Aldine.

Waring, A. J., Jr., and Preston Holder

 1945 A Prehistoric Ceremonial Complex in the Southeastern United States. *American Anthropologist* 47(1): 1–34.

Washburn, Dorothy

 1977 *A Symmetry Analysis of Upper Gila Area Ceramic Design.* Papers of the Peabody Museum of Archaeology and Ethnology 68, Harvard University, Cambridge.

 1983 Toward a Theory of Structural Style in Art. In *Structure and Cognition in Art,* edited by Dorothy K. Washburn, 1–7. Cambridge: Cambridge University Press.

Watchman, Alan A.

 1993 Perspectives and Potentials for Absolute Dating Rock Paintings. *Antiquity* 67:58–65.

Watson, Sister Frances, O.S.B.

 1973 The Place of Three East Central Missouri Petroglyph Sites in the Culture History of the Eastern Woodland Region of the United States. Manuscript in possession of Dr. Alfred Johnson.

Watson, Patty Jo

 1974 [Editor] *Archaeology of the Mammoth Cave Area.* New York: Academic
 Press.

 1977 Design Analysis of Painted Pottery. *American Antiquity* 42(3): 381–93.

 1986 Archaeological Interpretation, 1985. In *American Archaeology Past and
 Present: A Celebration of the Society for American Archaeology 1935–1985,*
 edited by David J. Meltzer, Don D. Fowler, and Jeremy A. Sabloff, 439–
 58. Washington, D.C.: Smithsonian Institution Press.

 1990a Trend and Tradition in Southwestern Archaeology. *Southeastern Archae-
 ology* 9(Special Issue): 43–54.

 1990b The Razor's Edge: Symbolic-Structuralist Archaeology and the Expan-
 sion of Archaeological Inference, with comments by Michael Fotiadis.
 American Anthropologist 92:613–29.

Watson, Patty Jo, Steven A. LeBlanc, and Charles L. Redman

 1971 *Explanation in Archaeology: An Explicitly Scientific Approach.* New York:
 Columbia University Press.

 1984 *Archaeological Explanation: The Scientific Method in Archaeology.* New
 York: Columbia University Press.

Weaver, Dwight H., and Paul A. Johnson

 1980 *Missouri the Cave State.* Jefferson City, Missouri: Discovery Enterprises.

Webb, William S., and Raymond S. Baby

 1957 *The Adena People, No. 2.* Columbus: Ohio Historical Society.

Wegmann, Larry

 1980 Archaeoastronomical Sites in Jefferson County, Missouri. Manuscript in
 possession of author.

Weisbrod, Richard L.

 1978 Rock Art Dating Methods. *Journal of New World Archaeology* 4(2): 1–8.

Weller, Tom

 1993 Wyoming Petroglyphs Dated from 11,500 to 2,000 B.P. *Mammoth Trum-
 pet* 9(1): 1–7.

Wellmann, Klaus F.

 1970a Sextuplets on Maddin Creek: Fertility Symbols in Prehistoric Rock Pic-
 tures of Missouri (Sechslinge am Maddin Creek, translated by author).
 Manuscript in possession of author.

 1970b Kokopelli of Indian Paleology: Hunchbacked Rain Priest, Hunting Ma-
 gician, and Don Juan of the Old Southwest. *Journal of American Medical
 Association* 212:1678–82.

 1975 X-ray Motifs in North American Indian Rock Art. In *American Indian
 Rock Art,* vol. 1, edited by Sharon T. Grove, 133–43. Farmington, New
 Mexico: San Juan County Museum.

 1976a An Astronomical Petroglyph in Capitol Reef National Park, Utah.
 Southwestern Lore 42:4–13.

1976b Some Observations on the Bird Motif in North American Indian Rock
 Art. In *American Indian Rock Art,* vol. 2, edited by Kay Sutherland, 97–
 108. El Paso, Texas: El Paso Archaeological Society.

1979a *A Survey of North American Indian Rock Art.* Graz, Austria: Akademische
 Druck, u. Verlagsanstalt.

1979b "Just Like Graffiti?": A Comparative Analysis of North American Indian
 Rock Drawings and Modern Urban Graffiti. Paper presented at the
 Anthropology Colloquium, Department of Anthropology, University of
 Arkansas, Fayetteville.

1980 Trends in North American Rock Art Research: A Quantitative Evalua-
 tion of the Literature. *American Antiquity* 45:531–40.

Weltfish, Gene

1953 *The Origins of Art.* Indianapolis: Bobbs-Merrill.

Whallon, Robert, Jr.

1968 Investigations of Late Prehistoric Social Organization in New York State.
 In *New Perspectives in Archaeology,* edited by S. Binford and L. Binford,
 223–24, Chicago: Aldine.

Whelan, Mary K.

1990 Late Woodland Subsistence Systems and Settlement Size in the Mille
 Lacs Area. In *The Woodland Tradition in the Western Great Lakes: Papers
 Presented to Elden Johnson,* edited by Guy E. Gibbon, 55–75. Publications
 in Anthropology 4, University of Minnesota, Minneapolis.

Whiteman, William

1937 *The Oto.* Contributions to Anthropology 28, Columbia University Press,
 New York.

Whitley, David S., and Ronald I. Dorn

1993 New Perspectives on the Clovis vs. Pre-Clovis Controversy. *American An-
 tiquity* 58(4): 626–47.

Whitley, David S., and Lawrence L. Loendorf, eds.

1994 *New Light on Old Art: Recent Advances in Hunter-Gatherer Rock Art Re-
 search.* Institute of Archaeology Monograph 36, University of Califor-
 nia, Los Angeles.

Wiessner, Polly

1983 Style and Social Information in Kalahari San Projectile Points. *American
 Antiquity* 48:253–76.

1984 Reconsidering the Behavioral Basis for Style: A Case Study among the
 Kalahari San. *Journal of Anthropological Archaeology* 3:190–234.

1985 Style or Isochrestic Variation? A Reply to Sackett. *American Antiquity*
 50:160–66.

Wilford, John Noble

1990a Scholars See Atelier in a Cave in France. *The New York Times,* Science,
 Tuesday, May 15, 1990, p. B5, B9.

1990b Star Explosion of 1054 Is Seen in Indian Bowl. *The New York Times,* Science, Tuesday, June 19, 1990, p. B9.

Will, George F., and George E. Hyde
1917 *Corn among the Indians of the Upper Missouri.* Cedar Rapids, Iowa (reprinted 1964, Lincoln: University of Nebraska Press).

Willey, Gordon R.
1962 The Early Great Styles and the Rise of Pre-Columbian Civilization. *American Anthropologist* 64:1–11.

Willey, P., George Crothers, and Charles H. Faulkner
1988 Aboriginal Skeletons and Petroglyphs in Officer Cave, Tennessee. *Tennessee Anthropologist* 13(1): 51–75.

Williams, Stephen
1977 [Editor] *The Waring Papers: The Collected Works of Antonio J. Waring, Jr.* (originally published 1968). Papers of the Peabody Museum of Archaeology and Ethnology 58, Harvard University, Peabody Museum, Cambridge, Massachusetts.
1991 *Fantastic Archaeology: The Wild Side of North American Prehistory.* Philadelphia: University of Pennsylvania Press.

Williams, Stephen, and John M. Goggin
1956 The Long Nosed God Mask in Eastern United States. *Missouri Archaeologist* 18(3): 1–72.

Williamson, Ray A.
1981 *Archaeoastronomy in the Americas.* Los Altos, California: Ballena Press and the Center for Archaeoastronomy.
1989 *Living the Sky: The Cosmos of the American Indian.* Norman: University of Oklahoma Press.

Willoughby, Charles C.
1952 Textile Fabrics from the Spiro Mound. *Missouri Archaeologist* 14(October): 107–18.

Wilson, Terry P.
1988 *The Osage.* New York: Chelsea House.

Winick, Charles
1970 *Dictionary of Anthropology.* Totowa, New Jersey: Littlefield, Adams.

Witthoft, John
1949 *Green Corn Ceremonialism in the Eastern Woodlands.* Occasional Papers no. 13, Contributions from the Museum of Anthropology, University of Michigan, University of Michigan Press, Ann Arbor.

Wittry, Warren
1961 *Report of Phase 3 Archaeological Salvage Project FAI 255, Section 60-6-1, Tract 15-A, Project I-70-1 (40)4. The Cahokia Site 3000 Feet West of Monks Mound, Madison County, Illinois.* Preliminary Reports Series 2, Illinois State Museum, Springfield.

1964 An American Woodhenge. *Cranbrook Institute of Science Newsletter* 33(9): 102–7.

1969 An American Woodhenge. In *Explorations into Cahokia Archaeology,* edited by Melvin L. Fowler, 43–48. Illinois Archaeological Survey, Bulletin 7, University of Illinois, Urbana.

Wobst, H. Martin

1977 Stylistic Behavior and Information Exchange. In *For the Director: Research Essays in Honor of James B. Griffin,* edited by Charles Cleland, 317–42. Anthropological Papers, Museum of Anthropology, University of Michigan, Ann Arbor.

Woodbury, Nathalie F. S.

1992 Pictures from the Past: The Study of Rock Art. *Anthropology Newsletter* 33(8): 5, 20.

Wyatt, Ronald

1959 Summer Fieldwork at Washington State Park, Missouri. *Missouri Archaeological Society, Newsletter* 134:7–10.

Yenne, Bill

1986 *The Encyclopedia of North American Indian Tribes.* Greenwich, Connecticut: Bison Books, Crown Publishers.

Young, Jane M.

1982 *Images of Power, Images of Beauty: Contemporary Zuni Perceptions of Rock Art.* Ph.D. diss., Department of Folklore and Folklife, University of Pennsylvania, Philadelphia.

Zeilik, Michael

1984 Sun Shrines, Sun Symbols, and Calendars: Art and Astronomy in the U.S. Southwest. *Abstracts of Papers and Proceedings, 1984 International Conference on Prehistoric Rock Art and Astronomy,* p. 7. Little Rock: University of Arkansas.

Zolbrod, Paul G.

1987 When Artifacts Speak, What Can They Tell Us? In *Recovering the Word: Essays on Native American Literature,* edited by B. Swann and A. Krupat, 13–40. Berkeley: University of California Press.

Index

About the Authors

Carol Diaz-Granados is a Research Associate and Lecturer in the Department of Anthropology at Washington University. James R. Duncan is an educator in St. Louis, board member of the Missouri Association of Professional Archaeologists, and past director of the Missouri State Museum.